ROCK CRITICISM
FROM THE
BEGINNING

MUSIC
(MEANINGS)

General Editors
Steve Jones
Joli Jensen
Anahid Kassabian
Will Straw

Vol. 5

PETER LANG
New York • Washington, D.C./Baltimore • Bern
Frankfurt am Main • Berlin • Brussels • Vienna • Oxford

Ulf Lindberg, Gestur Guðmundsson,
Morten Michelsen, Hans Weisethaunet

ROCK CRITICISM FROM THE BEGINNING

Amusers, Bruisers, and Cool-Headed Cruisers

PETER LANG
New York • Washington, D.C./Baltimore • Bern
Frankfurt am Main • Berlin • Brussels • Vienna • Oxford

Library of Congress Cataloging-in-Publication Data

Lindberg, Ulf.
Rock criticism from the beginning: amusers, bruisers,
and cool-headed cruisers / Ulf Lindberg ... [et al.].
p. cm. — (Music/meanings; v. 5)
Includes bibliographical references (p.) and index.
1. Musical criticism—20th century. 2. Rock music—Periodicals—History.
3. Popular culture—History—20th century. I. Title. II. Series.
ML3880.L56 781.66'117—dc22 2005013512
ISBN 978-0-8204-7490-8
ISSN 1531-6726

Bibliographic information published by **Die Deutsche Bibliothek**.
Die Deutsche Bibliothek lists this publication in the "Deutsche
Nationalbibliografie"; detailed bibliographic data is available
on the Internet at http://dnb.ddb.de/.

Cover design by Dutton & Sherman Design

The paper in this book meets the guidelines for permanence and durability
of the Committee on Production Guidelines for Book Longevity
of the Council of Library Resources.

Contents

Acknowledgments

Today, when the rock era and its canon of "white self-destructive boys" (Nick Kent) more or less belongs in the past, it seems appropriate to ask how it could come about in the first place. It is not that its impact is passé; on the contrary, one could argue that without it the ongoing globalization of popular music would be unthinkable. The problem lies in the once paradoxical notion of a mass cultural avant-garde that rock introduced.

The present volume is an attempt to address that problem by considering the specific contribution made by rock criticism to the construction of rock as "serious" music. It is the outcome of a Scandinavian research project, entitled "Rockkritik i ett historiskt och komparativt nordiskt perspektiv" ("Rock Criticism in a Historical and Comparative Nordic Perspective"). The project was financed by NOS-HS, the Joint Committee for Nordic Research Councils for the Humanities and the Social Sciences, and ran for three years (1998-2000).

We would like to thank NOS-HS for funding the project, but also all the people who have contributed in different ways to making it possible. First and foremost, we want to express our gratitude to our informants, American as well as British, who granted us interview time so willingly. But we are also indebted to Simon Frith for help to put us on the track, to Bernard Gendron, Steve Jones, and John Shepherd for kindly giving us access to works in progress, to libraries in London and New York, to nameless others who have contributed valuable suggestions, and to Peter Lang publishing for professional and friendly cooperation.

Ulf Lindberg
Gestur Guðmundsson
Morten Michelsen
Hans Weisethaunet

Lund, Copenhagen, and Oslo
July 2005

Introduction

In the 1830s, the French aristocrat Alexis de Tocqueville sat down to record his fresh impressions of a visit to the U.S. One of his conclusions was that since new democracies are characterized by a pragmatic approach to life, there is little time to indulge in refined aesthetic pleasures. What the citizens ask for is enjoyment on the spot. Therefore, to this Eurocentric, the Americans possessed, "properly speaking, no literature":

> The only authors whom I acknowledge as American are the journalists. They indeed are no great writers, but they speak the language of their country and make themselves heard. Other authors are aliens; they are to the Americans what the imitators of the Greeks and Romans were to us. (1990:56)

There was in fact a period, in the 1960s, when Americans themselves seemed to think that their literature was spearheaded by journalists. Novelists were held to be lagging behind the age in contrast to reporters such as Tom Wolfe and Hunter S. Thompson, who set out to mirror the drama of cultural change taking place in the wake of postwar affluence with tools borrowed from literary fiction. As voices of a generation raised on rock music and other popular culture but suspicious of academic training, some of these "new intellectuals" began to make "enjoyment on the spot" a subject for serious treatment, first in the press, later in books. In popular music journalism this introduced a new stage: the advent of a critical discourse on rock.

For historical reasons the divide between high and popular culture that was established in 19th-century Europe never reached the same level of institutionalization in the U.S. (which helps to explain both the enormous expectations that rock music gave rise to in the 1960s and the success of postmodernism in the U.S.). But it certainly existed. One of the founding fathers of rock criticism (they were predominantly men) was Robert Christgau, whose 1998 collection of writings called *Grown Up All Wrong* begins with an anecdote that highlights the irony of the title. Christgau, around 30 at the time, is told by "a Marcuse translator just out of grad school" in the course of a film dispute: "'You're really very intelligent. Why do you waste your time on rock?'"

This happened in 1971. Since then rock music—like, for instance, film, photography, the detective story, science fiction and jazz—has moved upmarket in

terms of status. No more does anybody raise an eyebrow at finding rock acts considered fit for the daily newspapers' cultural pages. Not many ask, confronted with the latest global hybrid, "Is it rock?" or "Is it art?" Such questions seem more or less to have lost their relevance. In the terminology used by French cultural theorist Pierre Bourdieu, a legitimation process has occurred that involves several forms of popular culture. Such processes seem to comprise two steps, which tend to overlap each other. The first of these means getting accepted as "entertainment" or, in Bourdieu-speak, "heteronomous" culture. In the case of rock this acceptance came fast—a few years and rock had become *the* main force in popular music. The Beatles' key position in rock history is underlined by the band's double achievement: it both completed this phase and initiated the next, gaining recognition as producers of "art" ("autonomous" culture). In our view this second process has been completed successfully, too, although it is still a matter of dispute how closely the present status of rock matches that of traditional high culture.

It would seem strange if some of the respect bestowed on the music had not rubbed off onto rock criticism as well. But, as Shuker (1994:78) points out, in the fast expanding academic literature on rock, criticism remains a marginal business:

> [R]ock critics perform an influential role as gatekeepers of taste and arbiters of cultural history, and are an important adjunct to the record companies' marketing of their products [...]. Given this role, the music press has received surprisingly little attention in the writing on popular music.

A few years later this still seems to hold true, despite the fact that rock criticism has supplied both popular music studies and cultural studies with useful empiric material and ideas. The subject of rock criticism is still not covered in many rock histories and encyclopedias.[1] By the turn of the millennium the only full-length studies in English were Nowell (1987), a dissertation on the evolution of rock journalism at two American quality dailies, and Draper (1991), which records the history of the rock bible *Rolling Stone*. Several sections in books, most of them belonging to the fields of music sociology or media studies, comment on the subject.[2] So do a variety of articles, ranging from different

1 An exception is the recent *Encyclopedia of the Popular Music of the World*.
2 E. g., Denisoff (1975:282–322), Chapple and Garofalo (1977:154–169), Frith (1981:165–177), Hebdige (1988:155–176), McRobbie (1988:xi–xvii), Weinstein (1991:174–180), Negus (1992:115–125), Aronowitz (1993:185–202), Shuker (1994:72–98), McDonnell and Powers (1995:5–23) and Kureishi and Savage (1996:xxi–xxxiii).

kinds of case studies—for example, Flippo (1974) on *Rolling Stone*, Thébèrge (1991) on musicians' magazines, Martin (1993) on critics' reception of the group Milli Vanilli, Sullivan (1995) on being a woman rock critic—to the more comprehensive approaches of, for example, Stratton (1982), Hill (1991), Jones (1992, 1993) and Regev (1994). However, interest in the subject seems to be on the rise. There are several recent anthologies of rock criticism,[3] and in the last few years at least two academic studies have been published, Gendron (2003) and Jones (2003). In addition, the critics themselves reflect on their trade in books, many of which possess academic qualities. An interesting sign of advances toward academic respectability is the Festschrift dedicated to Robert Christgau, *Don't Stop 'til You Get Enough* (Carson et al. 2002).

As a social institution criticism is a product of what Habermas (1962/1984) calls "the bourgeois public sphere." Its origins lie in 18th-century notions of civilized conversation between equals and is connected to the growth of the press—papers specializing in music also originate in this early modern era. Two hundred years later, in an increasingly global world where electronic media are taking over from the press, the critic's role as an intermediary or guide not only persists (though no one knows for how long) but has even extended into new, popular cultural areas of the consumer society, in which critics operate as experts whose task it is to cultivate a reflexive attitude, develop a language fit for the subject and pass judgments on behalf of their audience. Arguably, these critics' authority is weak in comparison with the power exercised by the representatives of venerable high cultural institutions such as the educational system. But that does not exclude the existence of gurus, battles of taste reminiscent of those fought in high culture, attempts at canon formation, or even the formation of "counterpublic spheres."[4]

The present study is an attempt to compensate for the lack of more extensive surveys on its subject. But it is not an ordinary history of rock criticism insofar as it strives to move beyond an insider's view and situate rock in a wider cultural context. Together with the notion of historical evolution, the themes of cultural geographies and hierarchies, which were introduced by the references to de Tocqueville and Christgau, play a focal part in the book. Its point of departure is the assumption that critics, as Regev (1994) argues, have played an important role for the elevation of rock music into at least "semilegitimate" art. This achieve-

3 E.g., Heylin (1992), McDonnell and Powers (1995), Kureishi and Savage (1996), Jones (1997), Gorman (2001) and Hoskyns (2003).

4 The term derives from Negt and Kluge (1972/1993) and denotes "alternative," institutionalized forms of interaction and discourse, related to counterculture movements.

ment was made possible by diverse alliances: the critics became spokesmen for musicians or trends whose ambitions seemed "serious," as well as for "progressive" social forces (working-class youth, white trash, African Americans); now and then they received support from agents in more established cultural fields disposed to spot nuggets in unexpected places. The outcome was both a construction of rock music as different from and more valuable than other popular music and a parallel construction of criticism itself as a "serious" business.

However, we take this argument further than Regev, suggesting that by the early 1970s, rock music and rock criticism had already reached such a level of relative autonomy that one may speak of weak *fields* in Bourdieu's sense. This means a level of specialization with distinct positions, rules and authorities, and especially the construction of a "pure" aesthetic pole opposing a "commercial" one in ways specific to the field. The primary aim of the present study is to examine the growth of the field of rock criticism (situated at the intersection of the rock field with the journalistic field), major changes in agents' positions over the years and the complex relations between the American and the British (part-)fields.

A secondary aim is to characterize rock criticism as a form of *discourse.* Rock critics have been responsible for the growth of a public aesthetic discourse with strong "heteroglot" traces—a hybrid discourse in which elements of "high theory" mingle with discursive practices derived from everyday intercourse with the music. This "intermediary," tension-based style of writing mirrors its aesthetic and makes it differ from the middlebrow. Here the study focuses on what Bourdieu calls "the space of possibilities," that is, the reservoir of specific assets—schools, genres, styles, works—to which all agents in a cultural field must relate. The social field deals with agent positioning, the space of possibilities with the aesthetic means at the agents' disposal. In the book, attention is paid both to aesthetic ideology and to style in a broad sense ranging from writing to graphic design.

In terms of theory this book approaches rock criticism via an apparatus informed by sociological theories of modernity, globalization and the public sphere, cultural theory, popular music studies and literary theory. As signaled above, it is first and foremost a critical appropriation of Bourdieu's field theory (Bourdieu 1992/1996, 1993) and, to some extent, his understanding of taste (Bourdieu 1979/1984). In our opinion, Bourdieu gives the most systematic account available of a cultural condition that we are departing from but still have not left behind. His basic tenets should be familiar by now. *Distinction*, his most widely read book, advances the thesis that taste and distaste greatly serve social distinction. Taste always hides a will to power, and judgments of taste are strategic investments (in "cultural capital"), determined on the one hand by agents' dis-

positions ("habitus"), on the other hand by social systems of positions, structured as fields. A field has its own rules, institutions and experts, whose battles in the case of cultural fields roughly concern the right to decide what should be counted as "art." Besides legitimate culture, Bourdieu also distinguishes "illegitimate" (everyday, such as cooking) and "legitimable" (popular representational) cultural practices. He assumes the existence of a cultural center, whose backbone is the educational system, but also recognizes a dynamism in the field that allows for movements up and down the market.

Critics have rightly questioned the validity of Bourdieu's theses in an age of rapid cultural change, but sometimes the criticism goes too far. The position of Laermans (1992), who describes the present condition as "polyhierarchic but still centered," seems valid for most Western countries. It recognizes the usefulness of Bourdieu's contribution as well as the need to complete it with others. The present study confronts Bourdieu both with the short-term perspective inherent in the concept of *late modernity*, which includes the erosion of tradition that some theorists term "postmodern" and others "cultural release,"[5] and with a long-term perspective of a struggle between *"high" and "low" culture*, which harks back to premodern times.

From an orthodox Bourdieuan perspective, the founding fathers of rock criticism appear as "new intellectuals," whose outsider positions in relation to the educational system predestine them to specialize in "legitimable" rather than "legitimate" culture. The birth of rock criticism then becomes a market strategy, characteristic of a particular class faction. But the same phenomenon could be interpreted also as an act of popular resistance, a democratization process, or the effect of "uncommon learning processes"[6] triggered by the cultural release. Here the aestheticization of everyday life observed by Featherstone (1991) and others becomes interesting.[7] There is no need to exclude a will to power, but

5 "Cultural release" derives from Ziehe and Stubenrauch (1982). It denotes the effect of late modern capitalist dynamism on the cultural heritage, including the conquests of early modernity, and appears as a release from the binding force of tradition, which instead becomes the object of subjective choice.

6 This notion, which designates learning in a late modern context (that is, with little support from tradition), derives from Ziehe and Stubenrauch (1982).

7 The aestheticization of everyday life is, as Featherstone (1991) points out, a process that may be followed from 19th-century Romantic bohemian artists via the aristocratic figure of the dandy and the historical avant-garde to post–World War II youth subcultures and late modern consumer culture, whose flow of images and signs invests everyday life with the compulsion of as well as the raw material for self-styling.

one should also recognize that the birth of rock criticism indicates an increase in cultural competence—new ways of attaining aesthetic pleasure, the introduction of new objects as aesthetically valuable and the formation of a discourse capable of doing justice to them —that questions Bourdieu's rather static understanding of "cultural capital."

Rock criticism draws on a number of sources, British as well as American: film criticism as well as jazz criticism, discourse on folk art as well as on high art, the Frankfurt school as well as New Journalism. Both this eclecticism and its investment in a form of low culture would seem to make it paradigmatically postmodern (or perhaps "pre-postmodern," being a product of the clashes between neo-avant-garde experimentation, pop culture and political revolt in the 1960s). However, one may question the concept's explanatory power today. Despite the thoroughgoing, unresolved disagreement on the meaning of the term left behind by the leading theorists of the 1980s,[8] "postmodernism" has become another of those master narratives that were its original target. At the same time, the break with modernity implied by "post" has come to seem exaggerated. As Fornäs (1995:35–38) and others have observed, most allegedly "postmodern" traits can be found far back in the modern era. In comparison the concept of "late modern" seems preferable, especially because it designates not only continuity, but also and more accurately the *intensification* of modernization processes (in terms of dynamization, rationalization and universalization) that becomes noticeable from around 1960. In our account, "late modernity" is the primary, epochal level, which provides the background for a secondary level of "cultural release." "Postmodern" appears as a third-degree concept, which roughly indicates the unsettling impact of cultural release in the area of the arts.[9]

8 Thus Collins (1992) observes that postmodernism denotes (1) a specific style (e.g., in architecture), (2) a movement during the 1960s, 1970s or 1980s, (3) a "condition," (4) a specific, deconstructive philosophy, (5) a specific type of "politics" and 6) a form of cultural analysis that involves points 1–5. It is in the aesthetic area that one finds a common denominator for the different uses of the concept: the thrust of postmodernism is directed at a monolithic and exclusive modernism. However, as we will argue, there were several modernisms, and it is quite possible to regard that allegedly "postmodern" characteristic, the dissolution of high/low divides, as a climax of a long process rather than as a break with the past. In the long-term perspective suggested above it seems that the exploration of the abyss of the low, trivial and ugly has been a trademark of modern art from its very inception. In a literal sense, there never was any "Great Divide" (Huyssen 1986) between "high" and "low" culture.

9 It is here that the concept makes most sense. As Featherstone (1991:7–8) points out, it is possible to reach a relative consensus on a number of "postmodern" features in the arts: "the effacement of the boundary between art and everyday life; the collapse of the hierarchical

It should be observed that as used here, "rock criticism" does not equal but is taken as a qualified subdivision of "rock journalism." The term designates printed texts, which have argumentative and interpretive ambitions but are more "journalistic" than "academic." News is not criticism according to this definition, nor is practical information or passing commentary, while reviews, in-depth interviews, overviews, debate articles and essays (or "think pieces," as rock critics like to call them) are. For practical reasons, our prime sources of information have been the specialist press and books. It is true that some well-informed criticism has appeared under the covers of, in particular, novels from Colin McInnes to Irvine Welsh; however, it has been excluded here, and so have biographies and rock histories.[10] Among the different types of magazines categorized by Shuker (1994), we have focused on the consumer press (the established "inkies," the "style bibles," the "new tabloids" and, to some extent, fanzines) rather than on musicians' magazines or "teen glossies" (and electronic magazines, which arrived post-Shuker). Finally, we have privileged two kinds of agents in the subfield: critics and magazines. Our selection is based part on a canon deriving from representatives of the field, part on our wish to isolate distinct and exemplary positions. Other choices and narratives are certainly possible. Little attention is paid to editors, again for practical reasons, though it can safely be assumed that a magazine's image and cultural position is largely the product of editorial decisions.

These limitations deserve some commentary. For instance, it may be argued that many more people form their primary impressions of rock music via other media—primarily daily newspapers, radio, television (particularly since the 1981

distinction between high and mass/popular culture; a stylistic promiscuity favoring eclecticism and the mixing of codes; parody, pastiche, irony, playfulness, and the celebration of the surface "depthlessness" of culture; the decline of the originality/genius of the artistic producer, and the assumption that art can only be repetitious."

10 While rock history is worth a study of its own, biographies are (together with encyclopedias) the big sellers in rock literature. Very few take a critical attitude towards the sources and the artists they deal with. It seems that since the late 1980s in particular, biographies on major stars have become a route to "easy money." They are often written during short periods of time off from academic or critical institutions, or under the conditions of freelancing. Set journalistic standards tend to be more or less discarded, biographies being commonly written without the artist's authorization and often on the basis of very sparse investigation and original material. The framework around which such texts are usually organized consists of data gathered from easily available resources, such as discographies in rock encyclopedias and biographical information drawn from magazine articles. The circulation of such data between various authors promulgates the repetition of many errors and their general acceptance as factual.

introduction of MTV) and, since the mid-1990s, the Internet. This is true, but also beside the point, since criticism in our sense is practically absent, at least in radio and television. The part played by the dailies, however, requires attention, especially in the U.S., but also in other countries where the specialist press has played a subordinate part.

One might also question the exclusion of other rock journalism in favor of criticism on different grounds. It could be argued that this introduces or cements a high/low divide, and that this divide might have dire consequences in terms of, say, gender and/or ethnicity. It would have been very interesting if it had been in our power to show, for instance, that the rise of criticism increased the dominance of white male writers, but to substantiate that would take a different study. What we can say is that the breaking up of the authenticity discourses that prevailed until the late 1970s was favorable to the presence of women critics as well as artists. Another interesting question to which we have not been able to provide more than guesses is why influential African American critics appear so late in the field. In sum, it should be borne in mind that rock critical discourse was shaped overwhelmingly by the pens of white males.

The book starts with a theoretical discussion in two chapters. The first of these contains some basic remarks on criticism as a discourse type, on music criticism and on the frames that rock critics work within. "Frames" are, in our account, not only material (e.g., pressure of time) but also social (e.g., male and white dominance) and immaterial (e.g., rules governing what is fit to print). Chapter 2 is divided into seven sections, the first of which introduces the perspectives of high versus low and late modern versus postmodern culture. The middle sections introduce Bourdieu's cultural theory and its possible application to rock culture. The last sections examine the strategies used to legitimize film, jazz and rock, "authenticity" as a key concept of this process and rock criticism in relation to place.

Part II covers the results of our investigation of the British and American fields. Chapter 3 outlines the social and cultural background for the rise of rock criticism as a discourse in its own right. The beginnings of this process are detailed in chapter 4, which follows the confluence of different sources in Britain leading to the development of a serious critical attitude toward rock, while chapter 5 contends that the ideological elaboration of that attitude into an "autonomous pole" was the contribution of American critics profiting from specific national conditions. As shown in the following chapter, this achievement was fed back into Britain in the early 1970s and made visible the contours of a transatlantic Anglo-Saxon critical field, which was dissolved by the advent of punk.

The first of the two chapters that constitute part III demonstrates how this split deepens as the seed of punk matures into a heterodox criticism in Britain but is largely integrated in the ruling critical orthodoxy in the U.S. In the concluding chapter, which draws a line from the mid-1980s to the present, the key terms are market differentiation and polarization.

The fourth, conclusive part of the study is an attempt at summing up main lines of flight: on the one hand the developments in the social field, on the other hand those pertaining to "the space of possibilities," that is, aesthetic thought and stylistic practice.

Chapter 1

Some Notes on Criticism

1.1. Criticism: An Introduction

Criticism is commonly understood as a professional, mass-mediated discourse that passes judgment on art works or events. However, sports events, services and commodities are also the objects of critical examination. Indeed, as pointed out by Stjernfelt (1998:7), one might talk of criticism in a broad sense whenever open public judgment is lacking in explicit criteria.

The word *criticism* derives from the Greek *krinein*, which means "to discriminate." As early as classical Greece it was used with respect to the study of texts (Davis and Schleifer 1991:3). But discrimination is not the only task of criticism, which becomes clear from a look at its subgenres. Arguably, the review is the prototype of criticism; nevertheless an attempt at definition should also leave room for the in-depth interview, the overview, the debate article and the essay (or "think piece")—genres in which evaluation need not be at all explicit. It is therefore reasonable to suggest simply that critical discourse is characterized by the (professional) *discussion* of matters of public interest, particularly in the area of art and culture. News is not criticism according to this view, neither is practical information nor passing commentary.

"Criticism" needs also to be demarcated from the qualified understanding of the term long in use at Anglo-Saxon universities, where it more or less equals academic scholarship, whether "practical" or "theoretical" criticism. The former's point of departure is usually the (aesthetic) experience, while the latter privileges critical examination of the assumptions underlying specific interpretations or even a specific discipline. Despite the impact of (poststructuralist, feminist, postcolonial, etc.) theory on contemporary cultural journalism, there is still a decisive divide between "academic" and "journalistic" critical discourse.

Some criticism will produce the effect of a sender indulging the deeply human wish of sharing—of wanting others to take part in the same uplifting experience. There are critics who write only about works they like. These critics are fans and pedagogues rather than arbiters of taste. Their self-defined task is to suggest not only what to buy, but also how to make sense of it.[1] Usually,

1 Thus rock critic Chris Welch says: "I always thought of myself as a reporter, who introduced people to new groups I had seen and I thought were great, should be seen and listened to. And

though, the critic's task is represented as that of writing with a clear view to discrimination. The job of such critics is to endow certain works or artists with more value than others. The end product is the formation of a canon.

> What I tell any young person who wants to write rock criticism is, first be certain whether or not you like something. And then, be able to figure out why *you* like it. (Robert Christgau, personal interview, May 22, 1998)

What rock critic Robert Christgau underlines here is the part played by *taste* in the act of judging. To Immanuel Kant (1790/1987), taste is the ability to evaluate an aesthetic experience without resorting to concepts or conscious thinking, which it is the task of reason to supply.[2] That is, judging by pure taste is judging by feeling and does not involve explicit criteria. Arguments come later. On the basis of a particular experience, the critic will typically ask what caused his/her reactions, look for an answer in some qualities ascribed to the object, compare the value of the experience to those of other known objects and thus arrive at an evaluation (cf. Jørgensen 1971:17).

In Kant's account, there is a conformity in the way we pass judgments; therefore he postulates the existence of a "sensus communis," which is simply man's ability to make such judgments. The assumption that anybody can appreciate what I find beautiful, though not necessarily on any occasion, is what makes it possible for me to claim my judgments are universally valid. To Kant, disagreements in matters of taste are just disputes over the right application of the faculty of judgment (58), which in his view takes a contemplative, disinterested— that is, undesiring—attitude to the object.

Modern theorists are more prone to focus on how factors such as class, gender, race and age structure differences in taste. In Bourdieu, class, for instance, is taken to relate closely to taste. Others think that, at least in late modernity, demographic factors relate to taste formations in an indirect rather than a direct way. They

I think, with record reviews, an album review, what I do is perhaps to try and interpret what the composer is thinking, whether it's successful or not, in coming up with something original. That is the job then, and to convey some of the enthusiasm to the reader" (personal interview, Jan. 20, 1999).

2 Kant (1790/1987:148) is explicit on this point: "I shall stop my ears, shall refuse to listen to reasons and arguments, and shall sooner assume that those rules of the critics are false, or at least do not apply in the present case, than allow my judgment to be determined by a priori bases of proof; for it is meant to be a judgment of taste, and not one of the understanding or of reason."

claim that people become participants in "taste games" as members of informal communities: "taste publics," which are strung together by shared values (Gans 1974), or "interpretive communities,"³ which share strategies for ascribing meaning to objects, or both. It seems possible to think, for instance, of the music specialist press in this way and suggest that an all-around music magazine and its readers form an interpretive community, while a fanzine and its readers primarily form a taste public. In the former case, the critic is "authorized" by the forum in which (s)he appears to arrange "a collusion between selected musicians and an equally select part of the public," as Simon Frith (1996:67) puts it. But the critic's position cannot be reduced to any purely representative role; it always contains an "excess" of subjectivity that comes through more or less as an individual voice.

Because (s)he takes part in a public discussion, the critic, in contradistinction to the layman, is obliged to express his/her subjective experience in words, address an absent audience and observe the rules of the genre chosen. From this need for objectification spring other standard demands on a critique: it is expected to *describe, classify* and *interpret* the object, and it should substantiate its judgment with reasonable *arguments*. But in practice none of this is compulsory. Most critical discourse oscillates between the poles of "impressionist subjectivity" and "committed objectivity," sometimes even with the same critic. In the first case, description of the object is toned down in favor of the reactions of the experiencing self. Impressionist subjective criticism relies on suggestion, association and a more or less literary style. Here are some excerpts from Patti Smith's review of Dylan's *Planet Waves:*

> God-bye [*sic*] baby. See I was hoping this one would be the work that severed me off. I been following him like some good dog too long. [...] But you know I never looked on him as my messiah. I don't need no messiah. And no protest singer neither. To me he was always a sex symbol. [...] I like the cover. Mostly because it is black and white. Like Baudelaire's dress suit. [...] Two cuts (side 2) make it completely worth it. One black one white. One that swan dives and one that transcends. The death of friendship the birth of love. [...] "Dirge" is a love song Burroughs could get into. [...] "Wedding Song" is the white one. [...] Sex symbol songs. The ones that never let me down. ("Masked Bawl," *Creem*, April 1974; reprinted in McDonnell and Powers 1995)

3 This concept, with its cognitive slant, was introduced by Fish (1980), who restricted it to academic readerships. Later it has become common in media research and widened, among others by Radway (1974/1991, 1984), to include popular taste formations. For a short overview of these and related concepts, see Bolin (1998:48–50).

What unites critics of the "committed objective" type is that they bother to make the object tangible to people other than themselves, even if they have different audiences in mind and will contextualize it in different ways. The tone may vary but tends towards the respectful approach used by Ann Powers reviewing PJ Harvey's *Rid of Me*:

> P J Harvey calls forth the mythic power of eroticism to move beyond biological constraints. It's there in her mummery of familiar temptresses and mad lovers but it's also in the music. Harvey, Ellis, and Vaughan invoke classical rock forms (power ballad, three-minute thrash, acid overdrive, postpunk discombobulation), blow them out of proportion, then shred them to pieces. Short songs move sickeningly fast; ballads bolt and drag as if they're afflicted with manic depression. From Ellis's wilfully misplaced cymbal crashes to Harvey's gutter yowls, the performances tear apart the structures they're supposed to fit. Steve Albini's production makes sense of this jones for excess through wild dynamic shifts: inaudible passages give way to earsplitting cacophony, effects smother Harvey's words and then she's pressed up against the vocal mike, enunciating for her life. ("Houses of the Holy," *Village Voice*, June 1, 1993; reprinted in McDonnell and Powers 1995)

This basic difference in attitude to the object may also be described in terms derived from theories of literary criticism, as Forser (2002:101–109) makes clear. On the one hand, criticism appears as an attempt at imitation—as a *literary* genre. The object text is taken to trigger and determine the metalanguage used to examine it. On the other hand, the critic's text may be regarded as a *response* in its own right that situates the object text in a proliferating dialogic chain of utterances. In this view, the qualified critic tends towards what Bakhtin (1986:126) calls a "super-addressee," an ideal receiver.

How do critics invest their object texts with meaning? Literary scholar M. H. Abrams (1993) distinguishes between four principal types of criticism. The keyword of *mimetic* criticism is truth; it examines the relation between the real and the represented world. *Pragmatic* criticism deals with effects; for instance, with the moral, political or aesthetic response to a work (to Kant criticism is basically pragmatic). *Expressive* criticism focuses on the work as the product of an authorial subject more or less situated biographically, historically and socially, while *objective* criticism studies the immanent meaning of works, or, in the wake of recent theory, works as intersections of "intertexts." The two former types go back to antiquity, while the latter two are products of early modernity. (It should be remembered that one of the sources of modern criticism is the critical study of the Bible). Though "objective," text-oriented criticism is more common in

academic circles, all four possibilities are still around and contribute to the formation of a kind of "common sense" approach to art.

Historically, criticism as we know it is a child of the rise of the bourgeois public sphere with its specific fora: papers, reading societies, clubs and coffeehouses. The ideal of the early public sphere was the conversation between equals in which differences in social status were, for the moment, suspended. According to Terry Eagleton (1985:21–23), early-18th-century criticism was "incurably amateur" as well as universalist. But the growth of literacy made criticism a professional and specialized business—an institution to which the public, increasingly captured by the lure of mass culture, became the object of educational aims rather than a co-subject. This autonomization has invested some critics from Samuel Johnson to, for instance, Hans Magnus Enzensberger with the prominent roles of "sages," "men of letters" or "intellectuals." Today, for better or for worse, criticism, like public discussion, has become so segmented that it's difficult to talk about *one* public sphere. There are contemporary critics of the cultural studies type who write lucid ideological criticism, and there are critics who stage themselves as stars, but in neither case does their authority stand comparison with that of their forerunners. Eagleton tends to regard this development as a deterioriation, seeing public opinion turn into public relations and criticism retreat into the universities. Such a view seems rather too pessimistic, given that we cannot tell where the explosive restructuring of the media will take us. But of course, what Alexander Kluge calls the "universal provincialism"[4] of a plurality of micropublics, unable to understand each other, is hardly an attractive scenario for the future.

1.2. Music Criticism Before Rock

Like other genres of criticism, art music criticism slowly emerged, becoming a specific part of the general cultural discourse during the 18th-century Enlightenment and early-19th-century Romanticism. Representing music in words has always been a major problem to music critics, pulled between technical description in terms borrowed from music theory and "poetic" interpretation based on literary ideals. Through the years different master metaphors have been used—it was common in the 19th century, for example, to compare music to architecture or to living organisms. Comparisons to other arts, to human feelings and to nature occurred as well. According to Werner Braun the value judg-

4 For a discussion of "the public sphere" and related concepts see Bolin (1998:37–47). The Kluge quotation (ibid., 45) comes from a 1988 interview with Kluge by Stuart Liebman.

ments expressed can be systematized in a few sets of conceptual dualities. Among the most important are: true/false (referring to nature, to rules of music theory or to how the work "really" is), beautiful/not beautiful (referring to the aesthetic experience caused by the work), coherent/incoherent (referring to organic unity, to a "whole" or, more technically, to structural correspondences) new/obsolete (i.e., relevant vs. "only of historical interest') and important/unimportant (referring mainly to originality) (1972:96–109). These dualities, often mixed, were applied to different art music styles throughout the 19th century and fitted into different ideologies as well. Since its inception, art music criticism has moved away from being primarily concerned with general observations (on style, genre, aesthetics) to focusing on the single work of art.

Explaining music metaphorically could take place in small narratives whose literary qualities were highly regarded. In a way, metaphorical writing was pedagogic as the critics explained to their readers how the music could (or should) be understood. It was often termed "poetic." The composer Robert Schumann coined that term, subscribing as he did to Friedrich Schlegel's dictum "that poetry can only be criticized by poetry." This implies that "poetic" criticism is of the same order as art and should be considered pragmatic in Abrams's sense. On the other hand, Edouard Hanslick, probably the most famous critic in the 19th century, was one of the first representatives of "objective" criticism. Unlike Schumann he was an academic (a background that has become increasingly common among critics) and abstained from composing. He objected to feelings being the central aesthetic principle, promulgating instead an abstract beauty as a "measure." This view brought him into conflict with Schumann's heirs, Liszt and Wagner. What has since become Hanslick's catchphrase, the not easily translatable "Tönend bewegte Formen sind einzig und allein Inhalt und Gegenstand der Musik,"[5] represented a further step toward art music's independence from everything external to itself.

In practice, as Ulrich Tadday (1993) observes, criticism had both an aesthetic and a social function, evolving historically in a dialectic between aesthetic and social references. He points out that from the late 18th century onwards the gap widened between periodicals, which were more academically inclined, and criticism in daily papers and general cultural magazines. The first

5 In *Vom Musikalisch-Schönen. Ein Beitrag zur Revision der Ästhetik in der Tonkunst* (1854). This has been translated as "The essence of music is sound and motion" by Robert Pascall (in Abraham, Gerald (ed.) [1990]: *The New Oxford History of Music*, Oxford and New York: Oxford University Press, vol. 9:536).

focused on establishing a select taste public for art music and made sense of the music by referring to aesthetic discourse and music theory; the critics' function was not so much to be pedagogical as to arbitrate taste. The second tendency concentrated on creating a broader interpretative community by stressing music's function within bourgeois culture. This strategy was pedagogical and included publishing news and reviews of the virtuoso performances of the time. Criticism became entertainment and promoted communicative aspects of music culture among the educated (or the chattering) classes as members of the bourgeoisie became able to communicate about music and thus substantiate their claims to class membership, even though they did not have any theoretical or practical musical knowledge (Tadday 1997).

Whereas concert reviews told the educated classes along which lines to think, they could hardly function as guides for future consumers. But the popularization of the gramophone revealed a need for advice for prospective record collectors. The English magazine *Gramophone* (f. 1923) took up this line, and as more recordings of the same work began to appear, it made sense for reviewers to give advice on which one to buy. This area of music criticism—consumer guidance—has always had an inferior status.

As jazz became "serious" to young white middle-class males, jazz criticism began to evolve as well and, as Bernard Gendron points out, by the 1940s "virtually all jazz journals [...] were owned, edited, and composed by whites and were sold primarily to a white readership" (1995:34). The 1930s saw a wealth of jazz magazines appear in the U.S. and several European countries (especially France, Denmark, Sweden and England); the U.S. magazine *Down Beat* (f. 1934) is the most famous. Modeled after the specialist art music journals, they tried to instruct readers about jazz from a variety of angles: history, music analysis, cultural politics, even the social perspective. This implied that jazz criticism was more closely associated with cultural journalism than was (and is) the case with art music criticism. Much early jazz criticism revolved around the continual disputes over which kind of jazz was the authentic one. In England the struggle was fought in *Melody Maker* (1926–2001) between supporters of "hot" and "sweet," between what was conceived of as the original and the popularized stuff (cf. Frith 1988:54–61). In the U.S. there were also numerous battles. Two of them were fought in the 1940s, and they were both formed along the lines of *la querelle entre les anciens et les modernes,* or as the Americans preferred it, the traditionalists (sometimes called "moldy figs") versus the modernists (the "sour grapes"). The first involved proponents of swing against New Orleans jazz supporters, the second bebop versus swing. Gendron argues that the first struggle,

especially, was of paramount importance to the foundation of a specific jazz aesthetics based upon art music aesthetics and the application of terms such as "art," "modernistic," "experimental," "formally complex" and "avant-garde." He concludes: "In effect, what was being constructed in these debates was an aesthetic discourse for jazz, which was later to legitimate its breaching of the 'great divide' between mass culture and art" (1995:34). This discourse was, of course, mixed with other central jazz issues, especially that of race.

Both art music and jazz criticism have, as we will see, provided models for the field of rock criticism, structurally and with regard to central topoi, but apparently without taking up the notion that protracted aesthetic struggles or *querelles* are part of it. Just as jazz mixed traditional critical discourse with new subjects relevant to the music, rock infused the discourse with its own problematics, for example youth, radical politics, sexuality, drugs and instant gratification ("the now").

1.3. The Frames of Rock Criticism

Generally speaking, rock criticism is produced under the same conditions as other journalism. This implies certain constraints: the expectations of owners, editors and readers that articles match a magazine's profile; fairly standardized styles of writing and formats; fierce competition and time pressure. As journalists rock critics are expected to deliver a product that draws the attention of a more or less definite (broad or niche) readership. They have at their hands a set of tools that includes skillful use of language and text-image combinations, the cultural appeal of fame and recognition radiating from rock stars (and sometimes themselves as media acts) plus knowledge in such areas as past and present trends in popular culture, the standards of readers and competitors in the field, and the promotional schemes of the music industry (cf. Negus 1999). This knowhow compensates for their common lack of university education, formal musical training and diplomas from journalism schools. Rock journalists are often self-taught. Being "new," "media" or "pop" intellectuals, many view academic scholarship with suspicion.

Sweeping characterizations of critics' working conditions are seldom fruitful, but Caroline Sullivan's (1995) account of the day-to-day demands of her career suggests that the romantic image of the rock journalist is directly at odds with the realities of the profession—low pay and unsociable hours, solitary trips to gigs, severe limitations imposed by deadlines on the amount of research a journalist can do on a particular artist and so forth. To what extent some writers are allowed more space, resources and "freedom" than others depends on

their position. Many seem to prefer freelancing when circumstances allow for it. As in all fields, positions are the outcome of processes involving hegemony and power. The struggles concern what "chances" are given: who are to review which concerts and records; who are to travel or to interview which acts. Niche-oriented magazines provide more "freedom" in the sense that the areas covered tend to be more finite; hence, critics are given time to concentrate on limited topics. But criticism in a qualified sense of the word does not necessarily benefit from this. Writers are obliged to give their readership "what they want"—a critical stance seems to be in constant friction with the commercial potential of niche markets. Not only the artists' but also the critics' resources and working opportunities are dependent on market decisions. As 1970s *Melody Maker* critic Chris Charlesworth points out, rock journalists used to be quite powerful: "We could stick an unknown artist on the front page, and their album would go into the charts the following week if we said it was good. We had a lot of power. We did that certainly with Roxy Music. We did that, to a certain extent, with David Bowie as well."[6] Today the music industry has found other ways to target consumers (mostly via television) and can afford to deny a critic access to artists if the outcome is expected to be commercially doubtful. At the same time the amount of record releases has become unfathomable. Serious journalism has not profited from these developments.

The commonest types of press coverage are the feature (often interview-based) that heralds an artist's visit or the release of a new record, the record review and news page gossip. In general, it takes time—and some recognition— to be allowed to write "think pieces." And Negus (1992:119) observes that if a feature involves a more established artist, public relations functionaries will supply information but often ask a particular journalist to write the artist's biography; "it signals to the media that there is an act worthy of attention." However, in rock the turnover of acts is rapid—here today, gone tomorrow. This gives rock journalism a stronger bias towards the transient than more established cultural criticism. Since the rules of the field demand the writer be "with

6 Chris Charlesworth, personal interview, September 12, 1998. "At that time, I am talking about 1972–73," Charlesworth (now editor of Omnibus Press) elaborates. "*MM* [*Melody Maker*] was selling 200,000 copies a week. [...] We were the first paper to consider David Bowie seriously. That was my colleague Michael Watts. And it was Richard Williams that did Roxy Music. And in both instances their albums went zooming up the charts the following week, right. Whereas nowadays that is not the case, with either *MM* or *NME* [*New Musical Express*]. *MM*'s circulation now is less than 40,000, I believe. And they have no power at all."

it," a developing scene takes insider reporters. That 25-year-olds may not appear credible enough in the eyes of a young, hip readership is advantageous to young wannabes and tends to establish a division of labor along generational lines. On the other hand, new acts will often fall prey to overenthusiasm or be written down for strategic reasons by youngsters set on making themselves a name. Punk journalism became notorious in that respect.

Another difference is the visibility of commercial interests in the field. Rock critics are part of the promotional cycle of the music industry and dependent on the industry in a number of ways, and if they do not turn to other journalistic genres, they may well wind up their careers at a record company. Major companies have always been ready to supply important writers and magazines with records, tickets to specific concerts and famous resorts, "in-passes" to diverse events and other perks. The press people counter by offering publicity.[7] "It is often a favorable critical review which persuades a radio programmer to begin broadcasting a recording," according to Negus (1992:122). An American study (Jones 1993:88) finds it likely that the industry exerts a "structural influence" on popular music magazines, which means that "editors will perceive advertiser needs and shape content to meet them, or avoid content detrimental to those needs in an effort not to alienate advertisers"—largely music companies.

In principle, though, critics and their editors decide how much and what kind of attention specific acts and releases are to receive. Most of the critics we have interviewed also seem to think that music requires a certain amount of time and "depth listening" in order to be perceived and comprehended. Several maintain that a responsible record review, for instance, demands listening to the disc at least four or five times and describe this as a personally established routine. Before even thinking about writing, they will keep the record spinning for a couple of days. Yet, most critics readily admit that on certain occasions they have written reviews almost without listening at all. As one critic put it, for some records it is quite enough to hear ten seconds to "know what it was all about."

The weak autonomy of the field requires techniques that create an image of critical distance and separation from promotional schemes, either through good reporting or through wit and sarcasm (irreverence does double duty, also providing entertainment value). Among these techniques belong the common staging of the critic as an enlightened (white, male) fan, whose love is passionate

7 Norwegian gonzo journalist Hermann Willis came up with a comparison to "car journalism" as the nearest equivalent when asked to describe the relationship between the music industry and the press in a conversation with Weisethaunet.

but not unconditional. However, in the long run, after a critic has been forced to show up at numerous concerts and to listen to numerous records by artists that (s)he would rather have missed, the discrepancy between fun and work, fan and pro becomes undeniable. This helps to explain why many prefer not to remain in the trade. Robert Christgau, still active after almost four decades in the field, claims he no longer interviews musicians, and if he does, he no longer quotes them: "Partly this is self-respect; people I do not regard as my superiors (which for me means almost anyone, as it should for you) have gotten very controlling indeed about 'access.' [...] But mostly I prefer to keep my fannish distance" (1998:6).

To this picture should be added the specific lessons one has to learn as a female critic. In terms of control and power, the whole rock field is still a white male business. This applies to rock criticism as well.[8] Sullivan's American colleague Karen Durbin even claims that rock criticism is "more overwhelmingly male than rock itself" (quoted in McDonnell and Powers 1995:16). Sullivan thinks that one reason why there are so few women in the trade has to do with the deterrent effect of a critical discourse that "reek[s] of male bonding and footie references" (138). For a number of years the "right" approach, legitimized by the music press, has built on that combination of masculine camaraderie and obsession with factual knowledge that Nick Hornby depicts so convincingly in his novel *High Fidelity* as a defense mechanism against growing up and entering into a lasting heterosexual relationship.[9] Needless to add, success is also a question of whom you happen to know. In sum, until recently the female critic's choices seem to have been limited to becoming a token, identifying with the male-dominated approach of the critical institution or moving into another niche. As for the last choice, Negus observes, "[p]ublications which have a higher female readership and employ more women as journalists tend to be in the teenage pop area, such as *Smash Hits*, or general teenage magazines like *Just 17* and *19* which treat music in a less analytical and more anecdotal manner, and are more concerned with fashion, health and social relationships" (1992:118).

8 For instance, McLeod (2002:94) observes that although the percentage has doubled in the last twenty years, only 15 percent out of the nearly 500 writers contributing to the *Village Voice's* Pazz & Jop poll in 1997 and 1998 were women.

9 "There's a certain religious fervour about it," says critic Simon Reynolds, quoted in Negus (1992:118). "I'm sure that people who are rock critics, if they'd been born in the Middle Ages, would have become monks or priests, and have been fervently discussing all those archaic things like how many angels you can get on the head of a pin." For a discussion of gendered criteria in rock criticism, see McLeod (2002).

Chapter 2

Theoretical Perspectives

This chapter introduces some ways of theorizing the approach to rock music that we have chosen: namely, its rise to the status of more or less "legitimate" culture. It starts with a discussion of the relations between "high" and "low" culture during the last 200 years, with specific stress on the incorporation of the "low" by the "high." This discussion paves the way for a critical reading of Bourdieu's cultural sociology as a theoretical frame for studying the founding of a rock field and a field of rock criticism. It ends by summing up some central themes and questions that our study will aim at clarifying.

2.1. High Culture—Low Culture

> I believe that we should begin from the principle that there is no difference between high and low culture, and then see how such a difference has nevertheless become a social fact [...] The differences lie in the objects at issue (what is culturally interesting to us is socially structured), in the discourses in which judgments are cast, and in the circumstances in which they are made. —Simon Frith[1]

The rough distinction between "high" and "low" culture remains a basic value hierarchy in modern constructions of cultural fields. The dichotomies may change: high art/low art, art/entertainment, elite culture/mass/popular culture, "alternative"/"mainstream," as may what is cast as respectively "high" and "low." But the reproduction of value dichotomies continues, insisting that there *is* a difference, and that it *counts*. The problem with such hierarchies is that their use is inseparable from the exercise of power. Everyday taste games are innocent insofar as they only involve micro power and play; in cultural fields, however, the struggle is for real, as representatives of different social forces strive to make their preferences those of the whole nation or valid even on a global scale.

In the U.S., postmodernism and its rejection of the high/low divide as a dated, modernist invention has been widely embraced. Yet the canon debates of recent years and the attacks that cultural studies has directed against established aca-

1 Frith (1996:19).

demic institutions show that the dichotomy is still alive. The fact that the struggle is waged under the aegis of a politics of representation or "identity politics" that foregrounds questions of gender, ethnicity and sexual preferences should not fool anyone. Nor is it settled, as some observers think (cf. Huyssen 2002), that "low" has won the contest.

In the following, we will make a brief survey of the history of high versus low with some stress on late modernity. Aesthetic value hierarchies are not a modern invention. In the literary field, for instance, the rhetorical tradition that originates in classical antiquity posited certain topics, stylistic levels and genres as higher than others—tenets that were transformed into rules by French classicism.[2] But the dichotomies as we know them presuppose the modern differentiation of the life-world in the 18th century, resulting in the rise of a specific aesthetic sphere and the notion of "autonomous art."[3]

In the late Middle Ages, as Peter Burke (1978) reminds us, official Western European culture was still Latin. Maintained by the clergy and the aristocracy, it was deeply serious as well. Nevertheless, it lived in a kind of peaceful coexistence with the vernacular and carnivalesque folk culture focused on by Mikhail Bakhtin in *Rabelais and His World* (1968). Carnival culture was not merely tolerated by the authorities; all social strata seem to have shared in it. For instance, we are told that on December 28, the day of the Feast of Fools, young clergymen could be seen dancing in the churches, playing cards on the altars and delivering parodies of sermons (Burke 1978:192).

The successive onset of modernity brought about a series of changes in this relationship. In a first step, the civilizing, disciplining and rationalizing processes described by Norbert Elias, Michel Foucault and Jürgen Habermas worked to distance the upper classes from folk culture. To begin with, critics found it blasphemous and immoral, then also contrary to reason and lacking in taste. A secondary differentiation, this time within the culture of the rising middle class, originated in the 18th century. It laid the foundations of the persistent and still familiar opposition between an elite culture for the happy few and industrialized entertainment for the masses, which Andreas Huyssen (1986) has named the "Great Divide"—a dichotomy repeatedly questioned since its emergence, but not really destabilized until the last part of the 20th century.

2 See, for instance, Auerbach (1946/1957).

3 As indicated by the concept of "life-world," this formulation draws on Habermas (1981–1984/1988). The advent of modernity meant, among other things, that art was severed from its links to religion and morals.

It is no coincidence that the birth of the Great Divide connects to 19th-century proto-modernism. Drawing for illustration on Flaubert's novel *Madame Bovary* (1857), in which the heroine devours and is devoured by bad novels, loses her foothold in reality and perishes, Huyssen argues that modernism in the arts "constituted itself through a conscious strategy of exclusion, an anxiety of contamination by its other: an increasingly consuming and engulfing mass culture" (vii). This strategy was to be both fulfilled and contradicted by 20th-century strands of modernism. High modernists, on the one hand, strove to keep things apart. Among these was Theodor W. Adorno, whose belief that autonomous art offered the last refuge of civilization in a barbarian age made him compose an immensely influential critique of mass culture. Avant-garde strands, on the other hand—most notably the so-called historical avant-garde at the time of World War I, including futurism, dada and surrealism—were intent on collapsing cultural divisions altogether. They wanted to do away with the art institution and meld life and art together so they often took an affirmative stance towards mass culture. Brecht preferred the bad new to the good old, and the impossible dream of the Russian futurists was an avant-garde mass culture.[4]

This tradition has also had a major impact on popular culture. Art historian Thomas Crow even claims that "the avant-garde is the research and development arm of the culture industries" (1996:35). In the way avant-garde artists appropriate elements of modern everyday life, they dissociate themselves from popular culture; but as time goes by, their aesthetic is in its turn reappropriated by some popular cultural element, effecting a differentiation between mainstream and avant-garde *within* popular culture. This was, for instance, the fate of cubism, turned first into art deco and then into a set of resources for commercial fashion and design. The time gap between avant-garde appropriation and its commercial feedback may be very long, as in the case of punk rock, whose roots go back to dada. But it may also be very brief, as it was with pop art (cf. Whiting 1997).

Following Huyssen, one could say that the avant-garde tradition hibernated in the U.S. and was brought to life again along "a Duchamp-Cage-Warhol axis" around 1960. In its rejection of high art aestheticism in favor of performance experiments, its McLuhanite technological optimism and its pop art advances

4 Huyssen goes along with Peter Bürger (1974/1984) in drawing a sharp distinction between modernism and avant-gardism. However, the way of dealing with these concepts chosen here, which stresses the heterogeneity of modernism by making it contain also avant-gardist strands, is the prevailing one in literary modernism research. Different strands flow together at an early stage, providing an arsenal of subversive techniques.

to mass culture, this movement was both a harbinger of postmodernism and a neo-avant-garde reaction against a high modernism increasingly perceived as dated. The decisive turn, argues Huyssen, occurred in the following decade. For then postmodernism started raising issues of tradition and renewal that went beyond modernist experimentation, questioning the teleological view of progress at the base of the modern project and giving birth to the now familiar notion of contemporary culture as "a field of tension between tradition and innovation, conservation and renewal, mass culture and high art, in which the second terms are no longer automatically privileged over the first" (217).

This widely embraced diagnosis marks the third and last step in the differentiation process we have described, following Boethius (1990). Late modern culture has more or less freed itself from the bonds of traditional aesthetic hierarchies. Today nobody really "knows" what is high and what is low—or lacks the authority to make a certain conviction binding. Instead of a few strongly hierarchical cultural divisions we are confronting a horizontal plurality of part cultures, each with its own hierarchies, distinctions and preferences, as well as an increasing amount of cultural hybrids. Also, it seems that high culture has not only become decentered, one pocket among others, but increasingly—or perhaps more openly—dependent on other sponsors than the state for survival.

While there is no denying the broad relevance of such a scenario, the leveling effects of this "postmodern turn" should not be overrated. One may readily conclude that the distinction between high and low culture has had its day. But as Brian McHale (1992:225) has observed, this thought is one of the most vivacious myths of postmodernist culture and criticism—"one that postmodernist writers themselves [...] seem to find irresistibly attractive." Ironically, it is easy to recognize in the "jumbling of codes" used by postmodernist artists, writers and composers a new, experimental, high cultural market strategy.[5] Above all, the fact that nobody "knows" for certain what is "high" or "low" has by no means made us stop thinking of culture in hierarchical terms, although we may prefer other oppositions to verbalize the differences we perceive (for instance, "alternative" vs. "mainstream"). Though yesterday's Great Divide is no more, high/low divisions remain—predictions of what will become of them vary depending on whom you ask.

5 See, for instance, Laermans (1992:253–254) and Regev (1994:98). The "high" connotations of "postmodern" also became conspicuous as the now obsolete label of "postmodern rock" was launched around 1990; according to Goodwin (1991), it became a synonym for "art rock" or "alternative rock" in the dominant usage established by the music industry.

There is a risk, too, that the vogue of "postmodernism" makes us overlook things that do not fit comfortably into the perspective of a break with past practice. At least three points may be made. First, that at any juncture in history, "high" and "low" culture will subdivide into minor categories (currents, schools, genres, oeuvres, etc.), each endowed with its specific status, leaving us with two poles on a scale rather than with two monolithic bodies; second, that cultural status is subject to historical change, so that the canon of one generation of arbiters of taste risks being upset by the next generation;[6] and third, that it is extremely difficult to differentiate between "high" and "low" culture on purely aesthetic grounds—the best bids, which have sprung from cultural sociology, focus on the simple fact that "the low" is what attracts a large public at the same time as it is considered dubious.[7] It is tempting to exchange this formula for a causal relation: low culture is considered dubious *because* it attracts a large public. In any case, under the circumstances even the Greatest of Divides cannot but appear provisory. The implications may be taken far into the realm of relativism, where Barbara Herrnstein Smith (1988) turns against the prevailing Kantian paradigm, arguing that any value ascribed to a work of art is radically contingent and dependent on its historical ability to fulfill certain desirable functions for certain social groups. (A similar view, which also serves to remind us that the high-low opposition is but a projection of social difference on to aesthetics, is advanced by Simon Frith in the introductory quotation.)

Turning to rock, we wish to focus on two separate movements, one downward, the other upward, which have both had a formative impact on the development of the music and the rise of rock criticism. The first of these consists in the trickling down of "high" *aesthetic ideology* into the domain of "low" practice. In late modernity such ideology has, above all, been mediated through the rise of mass education, both to critics and musicians. While rock criticism is to a large extent a child of the aesthetic, intellectual and political climate of the 1960s, the familiar argument of Frith and Horne (1987) is that on both sides of the Atlantic, but most conspicuously in Britain, art schools have played a decisive role in directing artists towards the legacy of Romantic Bohemia as well as pop art.[8] Thus it was at the Liverpool Art College that "van Gogh, even more

6 Lawrence Levine's *Highbrow/ Lowbrow: The Emergence of Cultural Hierarchy in America* (1988) offers an interesting account of such displacements, focusing on the way Shakespeare's plays were made safe for high cultural consumption in 19th-century America.

7 Boethius (1991:5) discussing popular literature.

8 Cf. also Pattison (1987).

than Elvis Presley, [...] became the hero against whom John Lennon measured the world."[9] The scope of Frith and Horne's argument becomes clear as the authors suggest a distinction between

> the first wave of art school musicians, the London provincial r&b players who simply picked up the bohemian *attitude* and carried it with them into progressive rock, and a second generation, who applied art *theories* to pop music making (this may be the best way to distinguish "authentic" and "artificial" concerns). (100)

The second, opposite movement leads back to premodern times. The set of various social practices that Bakhtin summed up as carnival culture was based on the trope of a grotesque human body, which privileged the lower regions and degraded all conceivable manifestations of the head by bringing them "down to earth."[10] Departing from Bakhtin, Peter Stallybrass and Allon White (1986:5) argue that carnival was not simply eradicated by the advent of modernity but rather *displaced* on to other symbolic domains, such as "psychic forms," "geographical space" and "the social order":

> A recurrent pattern emerges: the "top" attempts to reject and eliminate the "bottom" for reasons of prestige and status, only to discover, not only that it is in some way dependent upon that low-Other, [...] but also that the top *includes* that low symbolically, as a primary eroticized constituent of its own fantasy life. [...] It is for this reason that what is *socially* peripheral is so frequently *symbolically* central (like long hair in the 1960s).

By this Freudian back door, representations of "low" *subject matter* have made their way into modern high culture if, at least initially, only by negation. Indeed, the pursuit and sublimation of the ugly has become one of the distinctive traits of modern forms of art. There are ample representations of the big city as the very image of filth, corruption and mental disorders in the novel from Dickens over Strindberg to hard-boiled pulp fiction. Similarly, Flaubert's dissection of the Woman and Bad Literature nexus in *Madame Bovary* inscribes this "low-Other" in high literature at the same time as it dissociates itself from it. A parallel process, originating in the 18th century, takes place in *aesthetic theory* via the introduction of a series of categories, ranging from the sublime (Burke, Kant),

9 Philip Norman's *Shout!* (1981); quoted from Frith and Horne (1988:85).
10 Cf. the introductory chapter in Bakhtin (1968).

the interesting (Diderot), the grotesque (as revised by Hugo) and the "modern beautiful" (Baudelaire) to the "shock aesthetics" of the historical avant-garde, camp, kitsch and pop art, paving the way for a growing acceptance of certain "low" *expressive forms* as "legitimate" culture—most notably film, photography, science fiction, jazz and rock. Using film as a model, Stanley Aronowitz (1993:172–173) outlines some crucial steps in such a legitimation processes:

> Products of a culture industry are appropriated by an emerging critical group, the members of which have "discovered" among the welter of films commodities a few nuggets that qualify as Art. A few directors and their films are anointed with the status of canonical works, about which issue a plethora of studies, commentaries, and theoretical writings which, together, elaborate the aesthetic criteria that mark status in an otherwise banal field [...]. Gradually, the members of the academy, rather than the newspaper and magazine critics, are the official arbiters of taste. In the case of film as in journalism and, later, in rock music, some of the academics are recruited from among journalists. However, a fairly large cohort holds degrees in English or other language disciplines [or] American Studies [...]. Typically, they bring with them the methodological precepts of their "native" discipline and impose it on film.

To reach a more systematic understanding of these issues, especially those pertaining to the legitimation of rock, we will now turn to the cultural sociology of Pierre Bourdieu.

2.2. Introducing Bourdieu

Bourdieu's reflexive sociology has become one of the most influential strands in modern cultural theory. Its appeal lies not least in the comprehensive and applicable theoretical framework that it offers and in its relational perspective, by means of which Bourdieu claims to have transgressed the opposition between subjectivism and objectivism. Thus social reality is conceived as a dynamic unity of the agents' *dispositions* (habitus) and *systems of positions* (fields), which are both subject to historical change. Within sociology Bourdieu has contributed to transcending the antinomy between mainstream status analysis and Marx's theory of class antagonism through his explorations of the embeddedness of class domination in status hierarchies.

The two main strands of Bourdieu's oeuvre, his dissection of cultural tastes and his studies of different fields of cultural production, are both relevant here. This means we will focus on the relations between such key concepts as symbolic capital, field, habitus and taste.

Bourdieu's concept of capital refers to different kinds of assets, economic, material and immaterial. Insofar as an asset is recognized as valuable by a society, it becomes symbolic capital, and as we shall see this suggests that all forms of capital have a symbolic aspect. Subdivisions of symbolic capital appear as specific educational, cultural, political, social or scientific capital. Within these subdivisions the nexus of cultural capital (which may in turn be subdivided into artistic, literary and other forms) holds a particularly prominent position. It is characterized by its close ties to higher education, distinguished taste and high cultural competence—resources that are highly valued by the middle and upper classes, and which separate themselves from economic assets and have defied time under the aegis of national institutions (cf. Broady 1990:171–173).

Any acquisition of capital demands investments. Families transfer cultural capital from generation to generation—but never without effort. In order to increase the cultural capital such efforts have to be strategic, usually coupled with investments in education. Grades from acknowledged institutions are the most visible results of such investment, but Bourdieu is more preoccupied with the less visible results of embodied dispositions. To him, all socially relevant dispositions may be summed up by the aforementioned concept of habitus. Habitus is embodied knowledge—a person's taste, style and way with words. It determines how people think, perceive, evaluate and act, not as a fixed prescription but rather as adjustable dispositions, which are internalized very deeply and change only slowly. Habitus is embodied socialization, determined by background, present circumstances and future prospects. Departing from habitus, one may speak of likely life trajectories, though the market value of a certain habitus is settled only as it is realized in a social field (Bourdieu 1979/1984:110).

Economic assets are valued and realized in the market, but noneconomic values have to be validated by other kinds of social processes, usually in coexistence with economy. Thus modern works of art are commodities that defend themselves against their commodity character by claiming "autonomy"—freedom from any practical function and dependence only on an aesthetic sphere, governed by its own laws. In this respect Bourdieu's analysis is in line with Adorno's theory. When Bourdieu proposes that the aesthetically transformed world becomes socially readable through the field concept there is a further resemblance to the Habermasian theory of *bürgerliche Öffentlichkeit*, but the stage is the cultural, not the political sphere and the theory is put forward in more general terms. Donald Broady (1990:270) offers a "minimum" definition of a social field as a "system of relations between positions occupied by specialized agents and institutions engaged in a battle on something they have in com-

mon." There are fields of production and consumption, dominant and dominated fields. The fields of cultural production, populated by different kinds of artists, directors, producers, publishers, gallery owners, journalists, critics, editors and professors, plus a number of institutions and corporations are regarded as dominated fields within the so-called field of power. All fields demand a certain habitus. In order to have any success in the game/struggle of the field the participants must have incorporated certain ways of thinking and acting, some of it consciously but always to a high degree unconsciously.

A primary opposition between aesthetics and economy, small-scale and large-scale production structures all cultural fields. At the first "autonomous" pole (also referred to as "small scale," "intellectual" or "pure") the producers seek recognition with a public largely consisting of colleagues and critics, which paves the way for artist-critic alliances; at the second "heteronomous" ("large scale" or "commercial") pole, producers hunt public success. There will also be a secondary opposition at the autonomous pole between the old and the new as established, "orthodox" producers battle the "heterodoxy" of the next generation. In a well-developed cultural field, where the exclusivity logic of the "pure" standards celebrated at the autonomous pole tends to subdue those of the opposite pole, public success may even provoke suspicion.

What is produced in a cultural field is not only artifacts, but also genres, schools, standards, even the producers themselves, their habitus and the lifestyles cultivated in professional coteries. All this takes time to develop. A field constitutes itself only slowly, by successive specialization, until it has attained a certain degree of autonomy. This usually implies that positions have been established, including a "clergy" endowed with enough cultural capital and authority to set standards, that there is a widespread consensus about what the main discourse of the field is about, that the rules of procedure in the battle between actors have been agreed upon and that admission criteria have been developed. Thus, in Bourdieu's account, it took several decades and a great amount of labor to move from Kantian aesthetics via the doctrine of *l'art pour l'art* to the final establishment in the 1880s of the literary and artistic fields in France—a process outlined in *The Rules of Art* (1992/1996). It should also be noted that a field's autonomy is always relative. It may be strong as in the case of mathematics, where the producers' sole customers are their competitors, or it may be fatally weak, which Bourdieu thinks is the case with the field of journalism, into which we will briefly look.

The journalistic field, according to Bourdieu (1996/1998), is first characterized by the agents' monopoly on the production and spread of information. This offers them unique possibilities of forcing their problem formulations on

the whole of society. A second characteristic is the weight of the commercial pole, measured in sales. In an era under the sway of television, Bourdieu argues, there are imminent risks that the principle of "pure" professionalism, which once gave rise to the field as such, will be overthrown. Thirdly, this highly dependent field also exerts "a structural pressure" on other fields of cultural production (for instance on their admission criteria) that works to strengthen their commercial poles. In all, Bourdieu takes a very critical view of the present state of the field: "This way all may be threatened that was made possible by a field's autonomy."[11]

The field concept is not uncomplicated. It should be noted that, like capital and habitus, it is a tool designed for empirical studies that can be reflected within a comprehensive theory, so it must be adapted to the object and developed theoretically through such studies. It has been used on such small enclaves as the circle around *Les temps modernes*,[12] in line with a note in *On Television* (1996/1998:102, n. 20) stating that any press organ works as a "subfield," in which the opposition between culture and commerce reappears. However, it is more commonly applied to national studies, and although Bourdieu originally developed his gaze through studies in Algeria, he has concentrated his work around French fields. As has frequently been pointed out (e.g., Broady 1990:303–305), the strong centralism and the hierarchical system of education in France support the construction of *one* field of fashion, *one* sociological field and so on. Such a centralist situation cannot be presupposed, however, in empirical studies carried out in other countries. Furthermore, Bourdieu has not addressed the question if it makes sense to refer to transnational "superfields" in addition to national fields.

Taste is a key concept for the analysis of the structure of any cultural field. In the last instance, taste is what the agents of a cultural field struggle about (though this is not always apparent to them), while what unites them is the belief that such struggles are important. What is good art, literature, science, journalism? And not least, what is bad? It has been maintained that taste is "a purely negative category in Bourdieu" (Hebdige 1987:59) as it constitutes itself by the refusal of other tastes. Bourdieu analyzes taste strictly from the perspective of social distinction. Because taste is misrecognized as a "natural" faculty, the "cultural bourgeoisie" is capable of wielding symbolic power over other social groups whose access to legitimate

11 Bourdieu (1996/1998:108). He admits that his defense of autonomy may seem elitist, but rejects the label, stressing that if esotericism is necessary, particularly in science, so is exotericism: that autonomous producers join forces to improve the possibilities of circulating their products as well as the general level of education (92).

12 In a study by Anna Brushetti. Cf. Broady (1990:272).

taste is limited, unlike their own. Thus Bourdieu's most read work, *Distinction* (1979/1984), becomes a radical riposte to Kant, who considered aesthetic judgments disinterested and therefore entitled to claim universal validity.

Bourdieu's argument is that taste "classifies the classifier" (6). His French studies discern three basic taste formations: legitimate, middlebrow and popular (16). The first of these is characterized by a preference for classical works and "the most legitimate of the arts that are still in the process of legitimation." It "increases with educational level and is highest in those fractions of the dominant class that are richest in educational capital." Middlebrow taste "brings together the minor works of the major arts" with "the major works of the minor arts"—in short, any works "organized to give the impression of bringing legitimate culture within the reach of all" (323). Popular taste, finally, indulges in the pleasure of the senses and relates negatively to educational capital. It is marked by carnivalesque insolence as well as a search for emotional and communal experiences. Dick Hebdige has observed that this taste appears Nietzschean in its physiologism (Hebdige 1987:63). Because it tends toward a "reduction of the things of art to the things of life" (5), it becomes the very opposite of Kant's "pure" aesthetic disposition, which "perceives as art that which it nominates as art" and is a must for admission to legitimate taste. The question is to what extent and in which sense the upmarket movement of various forms of "low" discourse described in the previous section can be seen as a legitimation of such popular taste. Have we to do with an extension of the "pure" gaze onto new objects?

In no area have Bourdieu's assumptions been under fire as much as in that of taste. Is distinction the only or even the most important aspect of taste? Of particular interest to us is the question of whether Bourdieu underrates popular understanding of and resistance to the mechanisms whereby a particular regime of taste is maintained. Such a reduction could be explained by his knowledge interest in the study of the *reproduction* of cultural dominance.

But before we discuss further problems related to the application of Bourdieu's theory to the fields of popular culture, we wish to make some critical remarks on his approach to history.

Firstly, Bourdieu's work can be seen as divided between historical studies (Bourdieu 1992/1996, 1993) and structural studies (Bourdieu 1979/1984). Whereas the former draw upon historical sources and sometimes span long periods, the latter are based on large quantitative material gathered over a short time span. In the total body of Bourdieu's work there is a certain tension between these perspectives. Our study gives priority to the historical approach—that is, the rise and development of fields—and emphasizes the changes that take place.

Secondly, Bourdieu's distaste for "grand theory" is a double-edged sword with respect to historical studies. On the one hand, it contributes positively to a sensitive treatment of empirical material; on the other, it blocks the passage to conceptual development based on dialogue with other approaches. In general we recommend that this passage should be open and Bourdieu's basic concepts confronted with similar concepts of sociological grand theory,[13] but here we can only hint at the necessary encounter with theories of modernization that follows upon an emphasis on the historical. It depends on the particular perspective whether the absence of modernization theory is seen as a strength or a weakness in Bourdieu's theory. We will explore the question by framing the historical periods under study with some relevant theories of modernization and see how these affect the historical analysis.

As a consequence, Bourdieu's theories cannot serve as an undisputed guide to our field of study. We will be looking for mechanisms of the cultural field as depicted by Bourdieu, but we shall primarily explore the material in an open way, ready to evoke other possible theoretical explanations and themes.

2.3. Applying Bourdieu to the Study of Popular Culture

Although Bourdieu did not formulate an explicit modernization theory, he identified a general tendency of capitalistic development: the growing importance and relative autonomy of cultural fields, cultural practices and cultural capital. He also demonstrated some general mechanisms in these developments, for instance that the sphere of culture combines subordination and opposition to the dominant sphere of economy. As part of these mechanisms, new cultural fields are bound to rise and ambiguously contest older fields and seek legitimacy by adopting the standards of the older fields. Gradually such fields tend to merge into the dominant hierarchy, but at the same time new fields will emerge, particularly in times of social upheaval and mobility.

An early example of these mechanisms is to be found in Bourdieu's analysis of the important role that young provincial "lumpen-intellectuals" played in the making of the French literary field in the 19th century (Bourdieu 1992/ 1996). An example from a later epoch can be found in *Distinction,* in which Bourdieu studied the class structure of France in the early 1970s in terms of cultural capital. Here he identified a new faction within the petite bourgeoisie,

13 For instance his concept of practice should be discussed against the sociological tradition of "social action" and his "capital" concept against the concept in the tradition from Karl Marx to economic sociology (see Gudmundsson 2004).

whose home is in marketing, advertising, the media, fashion, decorating, medical and social assistance and within a whole range of new professions, often with an aura of alternative practices. Sidestepping the educational system but aspiring to a higher class position, these "new intellectuals" have entered social fields with weak autonomy, liberal admission rules and comparably small investment demands. Therefore they have specialized in "legitimable" cultural capital:

> Guided by their anti-institutional temperament and the concern to escape everything redolent of competitions, hierarchies and classifications [...] these new intellectuals are inventing an art of living which provides them with the gratifications and prestige of the intellectual at the least cost; in the name of the fight against "taboos" and the liquidation of "complexes" they [...] systematically adopt the cultivated disposition to not-yet legitimate culture (cinema, strip cartoons, the underground), to everyday life (street art), the personal sphere (sexuality, cosmetics, child-rearing, leisure) and the existential (the relation to nature, love, death). (Bourdieu 1979/1984:370–371)

Linking the rise of the new intellectuals to the 1960s generation gap, Bourdieu views the agents' very hostility to classification as a specific distinction mechanism. Thus he points out that, like high culture, counterculture was "still able to fulfill functions of distinction by making available to *almost* everyone the distinctive poses, the distinctive games and other external signs of inner riches previously reserved for intellectuals" (371). Bourdieu's description of the new intellectuals bears the stamp of the 1970s, but obviously it has more general implications. Thus Bjurström (1997:537) does not hesitate to extend this description to a general glide in the taste hierarchies of the cultural field, giving room for new, embryonic fields of cultural production, where at least some forms of popular culture have become respectable—"areas for criticism, analysis and interpretation within established autonomous cultural fields of production, like, for instance, the scientific academic field and the field of journalism." The rise of cultural studies and rock criticism respectively fits neatly into this description.

Although we cannot jump directly from the description of countercultural French intellectuals in the 1970s to the general field of popular culture, Bourdieu's analysis suggests a promising approach to the question. At the same time, our general discussion of Bourdieu has pointed to the need for widening the approach, reflecting broader societal changes that have been at stake in the cultural struggle of the last decades.

Some commentators on the postmodern turn (Collins 1989, Jameson 1991, Frow 1995) have jumped to conclusions by proposing that the boundaries between high and low culture should be in the process of being erased. In an influential response Rudi Laermans (1992) points out that such a diagnosis "completely overlooks the institutional embeddedness of the struggle over legitimate culture." He states that postmodern culture "still has a power center" founded on the educational system, though a center "surrounded by an intricate network of peripheral subcultures, each with their own legitimating bodies and autonomous hierarchies of legitimacy," giving rise to a "polyhierarchical but still 'centred' situation" (256). Laermans concludes that

> Bourdieu's central thesis concerning the symbolic power of the educational system is still valid, but the struggle over the general definition of legitimate culture no longer "over-determines" the conflicts of evaluation within the fields of pop music, film, science fiction, or detective-story writing. In these "autonomised" fields, strictly internal borders between "high-brow" and "low-brow" products are emerging. These hierarchies are based on and legitimated through internal canons, which consecrate certain musicians, moviemakers, or writers as "classic." In sum, alongside the general legitimate culture passed on by the educational system, there are now several "subcultural" forms of legitimacy. It remains to be seen if, in the long run, this change will have particular consequences for "the cultural center" and the general struggle over legitimate culture. (259)

Thus, the integration of the educational system has been matched by a diversification of the cultural fields; new groups of intellectuals have not been forced to compete for a place in established hierarchies, but have had the opportunity to develop new hierarchies in new fields. This opportunity has for decades been intrinsically linked to the growth in consumption and mass culture. The development is a mixture of "new" and "old." The new elements are not least produced by growing (mass) cultural consumption in the working class and the new middle strata, the old elements in the reproduction of habitual strategies and structures.

By pointing to the longevity of processes of distinction, Laermans has made the Bourdieuan approach impossible to bypass in a discussion of popular culture. However, his discussion of popular culture is confined to efforts to cross the borders between popular culture and high art. He points to a series of distinctions that have been made within the rock discourse—between, for example, rock and pop, authenticity and commercialism—but does not examine any further whether such distinctions are fully comparable with the distinctions of high art. Therefore "the Bourdieuan mission" in popular culture studies is far from complete.

The doubleness of rock culture as both subordinated and opposed to dominant cultural fields is reflected in most sensitive accounts. It has often been addressed through the concept of capital, for instance by John Fiske (1993) who has identified specific forms for "popular cultural capital" and "fan capital." Sarah Thornton (1995) has coined the term "subcultural capital" for cultural competence specifically related to certain subcultures, in her case the British club culture of the early 1990s. As mentioned below, she is frequently criticized for portraying this subcultural capital as existing in an autonomous field and for not discussing its relations to dominant forms, whether within broad popular culture or in a dominant cultural field. However, elsewhere Thornton (1990:87) has pointed to the mixture of conventional and alternative elements in rock culture, for instance through drawing attention to four criteria that are used to assign historical weight to a rock cultural event: "sales figures, biographical interest, critical acclaim or amount of media coverage." Within a field analysis only "critical acclaim" belongs strictly at the pure pole, indicating that we are dealing with a "bastard field" with an ambiguous relation to legitimate culture.

Bjurström (1997) has criticized Fiske and Thornton, arguing that they fail to show how the forms of capital they identify can be converted into legitimate cultural capital (or enter into other relations to it). Bjurström's own study reinforces and adds to earlier studies of the relation of taste for popular music to cultural capital and legitimate taste that generally paint a differentiated and changing picture (Trondman 1990, Roe 1993). Some genres of popular music, especially jazz and blues, have become linked to high academic capital and taste for classical music. Other genres, for instance heavy metal, form an anti-taste, while rock and mainstream popular music show a differentiated picture. It seems as if some social milieus incorporate pop and rock as part of "the good taste" while such preferences constitute an anti-taste to other groups. One of Bjurström's conclusions is that popular cultural competence tends to be of value as a distinction strategy and cultural capital primarily to agents already in possession of a certain amount of symbolic capital. At the same time his analysis points to the existence of "countertastes," but it does not reveal how such tastes relate to legitimizing processes. Other research designs than the mapping of cultural tastes are needed to explore to what extent countertastes are crushed by hegemony, maintained as resistance or have become part of the aestheticization of everyday life. Such studies should also have a certain ability to predict an official legitimacy.

Bjurström (1997:480) explores another avenue by bringing comments on the convertibility of "popular cultural competence" to bear on a discussion of fields. He distinguishes between three possibilities. One is that an embryonic

field, formed around some kind of popular cultural competence, strengthens its autonomy and weight in the field of cultural production. A second way out is that such competence is integrated into an established field and comes to share in its power of consecration. Yet another, slower strategy challenges and redefines dominant negative attitudes to such competence within certain established subfields. In the case of rock, there might be partial success with respect to the first possibility. The embryonic rock field has acquired "semiautonomous" status. This means that more or less authorized standards, arbiters of taste, investments (in styles and artists), symbolic gains (recognition as artists or critics), educational institutions, attempts at canon formations and the like may be distinguished.

It should be added that this development is also reflected in public funding. Since the 1970s, rock music has gained support from some of the advanced welfare states, as a leisure activity and a contributor to "public enlightenment." Recently such funding has been extended into giving prestigious prizes to rock musicians as, for instance, in 1997 when Björk received the Nordic Music Prize and in 2000 when Bob Dylan received the Polar Prize from the Swedish king.[14] However, such examples of inclusion in the general cultural field should not be overemphasized. In terms of dominant fields, rock is still characterized by low admission thresholds, a weak consecrating power and a dominant commercial pole, and its aura of subversion and opposition to these fields has not totally vanished.

Thus, large studies of taste and cultural capital have not clarified the relation of popular or rock culture dominant cultural forms, and obviously, more than a general discussion of field logic is needed. However, a major step was taken by Motti Regev (1994) in a study that examines the legitimation process of rock music and points out the key role of important rock critics in the construction of rock as an "authentic" form of popular music. We shall look more closely into Regev's contribution, but before that something should be said about similar processes that took place in relation to the fields of film and jazz a little earlier.

14 The Nordic Music Prize is given to a Nordic composer or performing musician by the Nordic Council every year and draws much attention in all the Nordic countries. Björk (1997) and Mari Boine (2003) are the only artists so far from the field of popular music to receive the prize (the prize committee described Björk as a "pop singer" and Boine as an "artist"). The Polar Prize was instigated by Abba manager Staffan Anderson and intended as a musical Nobel Prize. Each year it is awarded to a popular music artist and to an art music artist.

2.4. Rock Criticism as a Legitimizing Discursive Practice

Early jazz was primarily functional, local or regional black music. By becoming entertainment and sold as a commodity, it crossed over into an increasingly white and international market. In the 1930s, this triggered debates that ran both in music magazines like *Melody Maker* (Britain) and the new specialist magazines—most notably *Down Beat* (U.S.) and *Jazz-Hot* (France). At issue was which jazz should be considered "hot." In an essentialist view defended by *MM* as early as 1927 (and repeatedly dusted off in popular music discourse), the answer was black jazz, which was considered a "natural" and therefore essentially noncommercial expression of the black community (Michelsen 1993:31). To its white middle-class audience, this meant the music could only represent otherness: "the 'other' defined by bourgeois culture itself, the 'low' produced by the high," in other words, "the listeners' own 'repressed' emotions."[15]

The 1940s are widely recognized as a watershed that gave rise to "modern jazz" in the shape of bebop. For the first time there existed a small-scale, avant-garde form of jazz, around which could be developed a modernist art discourse in books and magazines. Its cultivation of a "hip," black bohemian lifestyle, celebrated in the prose of the Beat Generation and later in films such as *Bird* and *'Round Midnight*, also made be-bop attractive to white intellectuals. However, in the years to follow, the jazz elite developed an increasing consciousness of its black African roots at the same time as it became even more "arty." The vacuum it left was filled by the advent of rock.

According to a 1995 anthology, *Jazz Among the Discourses*, not only does jazz in contemporary advertising signify refinement and upper-class status, it has also entered the mainstreams of the American academy. But as editor Krin Gabbard points out, there are weak points in its academic position. While other related disciplines have thrived on the death of the author and started questioning canon formation as such, jazz studies are credited with a lingering fixation upon the music's canonization as "America's classical music" and lack of a professional metalanguage. In comparison, film studies is an example of rapid professionalization (Gabbard 1995a).

Until the 1960s, the differences between these two fields-in-the-making were not striking. Although there were some early attempts at theorizing cinema, serious treatment occurred mainly in a handful of magazines. Among these the

15 Frith (1988:58). This romanticized black/other returns in Norman Mailer's essay "The White Negro" (1957).

French *Cahiers du Cinéma* was to be particularly influential, for it was here, towards the end of the 1950s, that different impulses were brought together by the "auteur theory."[16] Auteurism offered a way to distinguish an authorial agency in film, a director whose vision was capable of penetrating what appeared on the screen, and then set off these autonomous creators, the auteurs, against the lot of commercial "metteurs-en-scène." Auteur theory paved the way for canon formation, and in 1968 came Andrew Sarris's magisterial work *The American Cinema: Directors and Directions, 1929–1968*, which identified an avant-garde within the commercial film industry.

Although the first steps toward a language of film art were also taken by *Cahiers*, it remained widely readable. In the early 1970s, the British journal *Screen* became the center of a more distinct academic approach under the aegis of French (post-) structuralism—Roland Barthes, Louis Althusser, Jacques Lacan. Rejecting the subject, and therefore auteurism, *Screen* theorists developed a textual understanding of cinema, which allowed for new interpretations of classic Hollywood films, especially by feminists, during the years to follow. Today many universities have their own film departments, and if not, film is likely to constitute the core of media studies.

However, there have also been attempts at legitimizing film in its own terms, that is, as mass entertainment. In 1960s American film criticism, one very influential representative of this view was Pauline Kael. Here, the contours of an intermediate aesthetics that was to penetrate rock writing emerges. Working for the *New Yorker*, Kael forcefully opposed the high/low distinction and the concept of autonomous art, giving weight instead to subjective reception and the pleasure of sharing in a mass experience, which did not have to be taken seriously. Her populist consumer guide criticism seems only to know quantitative differences. Thus film art is "what we have always found good in movies *only more so*. It is the subversive gesture carried further, the moments of excitement sustained longer and extended to new meanings."[17]

Rock discourse in the 1960s liked to claim that rock was in itself an authentic music form and culture that fought a never-ending war of resistance against commercialization. Throughout the present book, different interpretations of this rhetoric and different ways of contesting it are examined. It may, for instance, be turned upside down. Thus Simon Frith suggests in *Performing Rites*

16 The concept was launched as early as 1948 in an essay by Alexandre Austruc. Cf. the introduction to Jørholt (1995:10).
17 Kael writing in 1968; quoted from Aronowitz (1993:174); our italics.

(1996:42) that if rock has "been corrupted by commerce," as the saying goes, one could just as well claim that a commercial music form has been "recuperated in the name of art and subculture."

In the article "Producing Artistic Value: The Case of Rock Music" (1994), Motti Regev concludes that film, like photography, was acknowledged because its proponents accepted the existing "parameters of art" (87). According to Regev, the same thing could be said about rock, though here value was less based on an explicit, "pure" aesthetic theory than on the "subversive" social meanings ascribed to the music and culture (89). There was an original stress on the socially subversive essence of rock, but at the same time critics applied some standards of established cultural fields, which in the end changed the focus. The subversive fight against hierarchies turned into "a struggle over the contents of hierarchies [...] a struggle to redefine aesthetic criteria" (98).

This process starts around the mid-1960s with the pointing out of an "authentic" pole in opposition to a "commercial" pole. Such divisions were old hat in the history of popular music.[18] However, this time the division was not limited to a subcultural context as its agents, in Regev's words, formed "a critical apparatus" spanning FM radio, feature programs and a wave of underground and specialist periodicals (90). These advances were followed by books—article collections, artist biographies, rock histories and encyclopedias, record guides— that is, responses written or compiled at some distance to their objects. Most of the authors were between 20 and 30 years old and combined insider positions with journalistic and sometimes academic credentials as both "participants and observers of the rock revolution" (Aronowitz 1993:196). Together these factors may explain the authority their works came to exert:

> In the way they categorize entries (in encyclopedias) and divide chapters, in their choice of musicians and topics worthy of lengthy articles, in their taken-for-granted periodizations, in the adjectives they use, in their ranking of records in terms of quality—these books (and others) contain, and therefore construct, the accepted truths about rock music up to 1980. (91)

The result was the aforementioned discursive construction of rock as an "authentic" form of popular music. The concept of authenticity will be discussed below. Here it should be pointed out that the quest for cultural legitimacy inherent in the authenticity argument need not equal a surrender to high art.

18 See, for instance, Riesman (1950/1990).

Reaching cultural legitimacy is a process. At the start it just means that agents with a certain amount of consecrational power agree that some specimens of a "low" art form are worthy of and allow for serious discussion. As we will show, this evaluation involves recognition of their specificity. Therefore "low" art forms may well reach a legitimate status, yet keep their distinctive character and sub-cultural credibility.

Regev contends that the discursive strategies of the 1960s rock clergy contained the claims (1) that rock was "subversive," (2) that it was produced by autonomous authorial subjects, (3) that it allowed for canon formation, and (4) that it was in possession of its own means of artistic expression.

"Subversion" is a left-wing notion that can be traced back to Marx. Its primary connotations are political, even military. In art discourse, the term connects to the heritage of a Romantic bohemian, civil avant-garde, characterized by the tension-filled confluence of aesthetic and political radicalism. Subversion thus evokes a *particular* kind of art discourse, in which the celebration of revolt plays a conspicuous part. Regev pays less attention to this than it deserves. Visual art scholar Diana Crane (1987:14–15) argues that an avant-garde may try to redefine either the *aesthetic content* of art (by upsetting artistic conventions), its *social content* (by embodying oppositional values—for instance, those of an "alternative" culture, of "low" culture, of an iconoclastic approach to "high" culture) or the *rules for the production and consumption of art works*. Arguably, though rock culture has drawn on all these possibilities, it seems reasonable to say that it has privileged what Crane calls "the redefinition of social content." From its early beginnings rock was endowed with a specific "anti-hegemonic" aura, which set it off from most other popular music. According to Gillett (1970:21), "There were three main grounds for mistrust and complaint: that rock and roll songs had too much sexuality (or, if not that, vulgarity), that the attitudes in them seemed to defy authority, and that the singers either were Negroes or sounded like Negroes." When rock became the music of 1960s counterculture, expectations of subversion were made explicit, invested with new life and sustained. Increasingly, though, it grew obvious that rock's claims to express the spirit of a rebellious generation were on the wane, which gave rise to a disillusion discourse with keywords like "co-optation," "incorporation," "the death of rock" popping up whenever attempts to cast, for instance, punk, grunge or rap in a mass avant-garde role have failed. Regev (1994:88) thinks this disillusion may be the prize over which the contest for artistic value has been conducted.

In comparison, the other strategies are routine in art discourse. Art ideology commonly assumes some source of meaning "behind" the work, an *autono-*

mous authorial subject. In film discourse this problem was dealt with by auteur theory. Among the founding fathers of the rock field only few tried explicitly to apply the *metteur-auteur* distinction to rock. Nevertheless it may be said to have informed the field via the pop/rock opposition, which, in its turn, was materialized in the transitions from singles to albums, from AM to FM radio. In the beginning, two kinds of authorial subjects were pointed out as creative units, the group and the individual artist. As Regev observes, "[t]he ideal type of the group contains four to six musicians who compose the music, write lyrics, play and sing" (92). The group, then, appears as a collective version of the artist, as "individuals who master all components of production"; later producers like George Martin would be acknowledged as authors, too. Not least, autonomy was confirmed by the writing of one's own, "serious" material instead of making cover versions of or mimicking 1950s rock 'n' roll songs. The move duplicated that of the 19th-century Romantic poets, as they passed from "repertoire" to "work" writing. John Lennon puts it like this:

> I'd have a separate songwriting John Lennon who wrote songs for the sort of meat market, and I didn't consider them—the lyrics or anything—to have any depth at all. Then I started being me about the songs, not writing them objectively, but subjectively. (quoted in Wenner 1981:148)

Once autonomous subjects—that is, a "pure" pole—have been constructed, the road lies open to further constructions. Rock can now be subjected to historical narratives, which point out traditions, strands, turning points—in short, redraft the opposition between "old" and "new" in noncommercial terms. Such work implies evaluation and comes out as *canon formation*. In the dominant narrative, Regev (1994:93) finds three privileged moments, which we have already touched upon: original rock 'n' roll (1954–1958), 1960s rock (1964–1972) and punk rock (1976–1979). He further distinguishes a number of artists who have been consecrated as masters in the field—what Trondman (1990) calls "a selective tradition": Elvis Presley, Jerry Lee Lewis, Chuck Berry, Buddy Holly, Little Richard, the Beatles, the Rolling Stones, the Beach Boys, the Who, the Band, the Velvet Underground, Bob Dylan, Jimi Hendrix, Van Morrison, the Sex Pistols, the Clash, Patti Smith, Elvis Costello, and, exceeding the privileged moments, Pink Floyd, Led Zeppelin, Bruce Springsteen, a number of black, mostly soul artists and a few women artists. Finally, Regev enumerates some albums designated as "masterpieces." His inclusions and exclusions may be objected to (in later years, particularly the white and male supremacy of this canon

has been rightly questioned), but Regev's aim is only to show what names "represent a general consensus within rock music's production of meaning apparatus" (94) during its formative years.

Finally, there is the question of how rock music comes to signify. The answer is that it has evolved its own *means of expression*, among which Regev (95–97) distinguishes four as typical and salient. These are electric sound, studio work, the voice-lyric relationship and stylistic eclecticism. As for electric sound, the decisive moment was when, in the 1960s, guitar distortion came into use, giving rise to a particular, "dirty" quality, which inverted classical music conventions. In general, sound manipulation, enabled by the exploration of technology, has come to play a seminal role in rock. This is nowhere as obvious as in the amount of studio work put down in a recording. Here, as Regev observes, the Beatles and the Beach Boys were forerunners. Also, 1960s rock brought about new claims on lyrical content, which made it approach written poetry with some songwriters; Dylan's is the first name that comes to mind. These claims would sometimes clash with those that privileged sound: what Barthes would later call "the grain of the voice," that is, the idiosyncratic qualities of a singer's voice as it works on his/her native tongue. Stylistic eclecticism, at last, has been a feature of rock from the beginning. Itself a bastard, it has incorporated or influenced widely different musical idioms on a global scale.

2.5. "Authenticity" in Rock Critical Discourse

"Authenticity" is a notoriously slippery term. It has a double philosophical background: in the tradition of existentialist thinkers from Kierkegaard to Camus, and in the Frankfurt school, where it appears most notably with Adorno and Marcuse. At least the latter strand has had some impact on the "low" use made of the concept in the rock field.[19] The strong status of the term and its syno-

19 Walter Benjamin famously made the point in "The Work of Art in the Age of Mechanical Reproduction" (1936) that reproduction techniques destroyed the "aura" of the work of art—a concept connected with authenticity as that which reminds of the art work's origin in cult. Adorno went further, exploring authenticity in several of his 1940s writings. Here the autonomous work of art may briefly be said to bridge the past, the present and the future. That is, the art work carries within itself both the memory of an archaic past, which knew no division between subject and object, the rise of the subject in modernity and the negation of this irreversible process in a utopian promise. It is this promise that Marcuse was to focus on. A similar rhetoric informs the writings of LeRoi Jones (*Blues People*) and Jack Kerouac, who could be thought of as early mediators. Jon Landau and other early rock writers were directly inspired by Marcuse. For discussions of authenticity in rock, see, for instance, Frith (1981:48–55, 1988:94–101, 1996:21–46), Stratton (1982), Bloomfield (1992), Grossberg (1992a, b), Michelsen (1993), Zanes (1999) and Keightley (2001).

nyms in the critical discourse on rock, as compared to the negligible part it plays in more established fields of cultural production, reveals the weak autonomy of the field. In rock, "authenticity" appears constantly under threat from the Other of commercialism, against which it defines itself.

As Keightley (2001:132–133) points out, "authenticity" adds an ethical dimension to aesthetic experience. Good music is also "true"; however, distracted music listeners seldom worry about truth. Authenticity becomes crucial only when communicative aspects are foregrounded—when somebody out there seems to be trying to tell you something. Insofar as listeners reconstruct the author's intentions as serious, as in a conversation, this explains why even clearly "artificial," ironic or parodying acts may be found "authentic." So far, any music that seems to "mean what it says" is "authentic" and vice versa.[20] But the usage of the term in the rock field slides from the particular (individual experience) to the universal, causing certain artists or musical idioms (folk music, 1960s soul, grunge, old school rap) to be designated "authentic" per se. This fixation of certain stylistic features on the signified—which means that authenticity becomes an essence inherent in the music, not the interpretation of a *relationship* between historically situated producers and consumers of music—takes place through the mediation of authenticity discourses.

In the history of rock, two different authenticity discourses flow together (Frith 1981:48–55). One originates in a folk art paradigm, the other in a (basically Romantic) version of high art. In the first case, "authenticity" is closely woven together with notions of community, roots, tradition. Works are valued because they represent a *shared* experience, for which the artist becomes the mouthpiece—the culture of the people, the black community, a youth generation. In the second case, it works the other way around: works are appreciated as "authentic" because they *deviate* from a tradition, reducing it to the background against which an individual makes appear his or her own subjective vision. In both cases, notions of truth play a seminal role. "Folk" truth comes from the underdog, "art" truth from the unique qualities of a gifted mind. Regev stresses the impact of high art discourse, but in the 1960s, folk authenticity was equally useful to attempts to set rock off from mainstream popular music. There were moments when the two seemed incompatible, as in the famous "Judas" addressed to Dylan in the act of moving from folk song to rock. But as adults

20 Both "author" and "authenticity" are etymologically related to "self" (Keightley 2001:134). In the context of the mass society, observes Keightley, "rock's search for authenticity underlines a general anxiety about the status of the modern self."

became the foremost representatives of an alienating mass society, casting youth as "other," rock was able to claim affinities with the cultures of the disempowered despite the fact that it sprang from within the mainstream and was exclusively youth-oriented (Keightley 2001:124).

During the construction of the field attempts were also made to outline another kind of authenticity discourse, designed to give justice to the sensuous qualities of rock ("body authenticity"). The music's impact on the body, its disorientation of the senses, and the ensuing pleasure of non-meaning was then theorized in the above-mentioned article by Roland Barthes, "The Grain of the Voice" (translated into English in 1977), which boosted this line of argument. Spanning the whole gap between "merely" sensuous enjoyment and the ecstatic transgression of bodily limits, "body authenticity" made it possible to include the club and dance scene of the 1990s in rock (cf. Bloomfield 1992).

The aesthetic of rock is intermediary in the sense that it thrives on tensions, which distinguishes it from "middlebrow." If, on the one hand, it puts forward the hedonist demand that to be "authentic" the music must "kick butt" (Walser and McClary 1990), it also tends to save its highest praise for works and artists that are "important" as well—that is, "original," capable of making "relevant" observations on contemporary phenomena, or even "utopian" in their effects. It would have made little sense to say in the mid-1950s that rock 'n' roll was "authentic," since the artists were considered entertainers, paid to deliver a good show.

It was the same thing with British pop when it emerged (besides, it was secondary, a derivative of American rock 'n' roll). Historically it has been the task of the word "pop" to recall precisely those connotations of consumer culture that "rock" tried to sever. It derives, of course, from "popular," which ambiguously hovers between a folk and a mass cultural meaning. "Pop" also refers to sudden sounds or movements, hence the notion of "popping up," for instance, is not irrelevant in this context, nor is popcorn. Around 1950 "pop" began to occur in connection with both art and music in a familiar way. It was occasionally used by the postwar U.S. music industry as short for "popular" (music), and towards the end of the decade the term "pop music" broke through in British media. And, as early as 1947, the artist Eduardo Paolozzi made a famous collage, *I Was a Rich Man's Plaything*, that anticipated pop art in its use of mass cultural icons (the term was not launched until 1956). In Swinging London of the mid-1960s these strands then flowed together into a celebration of transient, stylish, knowing consumerism.[21]

21 This overview draws on Savage (1995).

"Knowing" is particularly important because it connects to artifice. Keightley (2001:136) argues that it is "never the artificial alone that is the point of arti- fice"; in rock, artifice rather involves a rejection of Romantic directness in favor of modernist indirectness. What is clear is that self-conscious pop artifice brought a fundamental ambiguity to rock from its very beginnings, blurring the Ro- mantic's demarcation line between "true" and "commercial" music. But it has never been able altogether to rule out authenticity as a means of drawing dis- tinctions, and Regev is certainly correct in extending the dominant influence of rock's founding fathers till at least 1980. After punk, the insight that "authentic- ity" is an effect rather than an essence has pervaded, if not the rock field at large, at least rock criticism (cf. Zanes 1999). But in the 1970s, questions concerning who were posers and who were not still made sense, and the answers could often be agreed on. If artful dodgers like Bryan Ferry and David Bowie both passed the test, using irony to draw critical attention to themselves as subject constructions, Gary Glitter and Sweet seemed too engulfed by their images and did not. This way one could claim, following Grossberg (1992b:63), that the authenticity paradigm has been enriched with yet another, a "meta-authentic" dimension, whose truth lies in its deconstruction of "plain" authenticity.[22]

The early construction of "authenticity" as the basic paradigm of rock included an understanding of rock as American, often with some emphasis on its roots in African American music; and to the present day the belief that English is the only authentic language of rock has been sustained. In later years, though, authenticity has often been reinterpreted in terms of relations between the global and the lo- cal, a theme that will be explored in the next subchapter. Here the rock idiom can be said to provide a sort of "aesthetic infrastructure" that mediates between the modern-universal and the local-national.[23] "The real thing," which used to be American rock, has undergone a series of displacements, ranging from copies to

22 Grossberg's (1992b) very influential diagnosis situates meta-authenticity ("authentic inauthenticity") in the context of a "postmodern sensibility." To this sensibility, "boredom (the absence of affect) has become terrifying" (210), so efforts are directed towards making *something* matter. "[A]ny pose can gain status by virtue of the commitment to it" (226). In rock this means that "authenticity is seen just as another style" (234); it has lost its aura and become a matter of indifference, effecting a taste crisis. In our view, this analysis is slightly flawed, among other things by its perspective on the history of rock as constituting a fall and by a tendency to underrate the possibilities for what the author calls "a privileged marginal- ity" (227) to exercise power by contrasting its own taste with that of a mainstream. This snobbery remains the very core of pop sensibility.

23 Regev (1997:138). See also Gudmundsson (1999).

different expressions of a local identity that distance themselves from older, more orthodox versions of that identity. Thus a process is taking place,

> which, through its relationship with the institutions of the field of popular music, produces a history that draws a growing number of popular musics from different parts of the world into participation—as agents, as positions—in one field, the international field of popular music. (Regev 1997:139)

2.6. The Spatial Distribution of Rock and Rock Criticism

Usually rock music is considered to have been invented in the U.S. In terms of the origin of leading rock artists the American hegemony has mainly been challenged by British acts, and artists from Canada, Australia and Ireland have had easier access to the mainstream of rock music than have others. The dominance of the English language is a central part of the explanation, which also involves domination of multinational companies centered in the U.S. and the size of the American market in the main period of rock's expansion. The discourse on rock took off with reciprocal influences between the U.S. and Britain, and today these two countries remain the centers of criticism as well as academic discourse on rock.

At the same time recent developments indicate that the rock field is far less centered than the field of rock discourse (cf. Burnett 1996). During the 1990s the largest growth of the market has been in Asia and Eastern Europe, but the 2000s have seen a major crisis within the music industry due to the shift in music carrier technology from CDs to the Internet. The multinational companies controlling the market are, with one exception, no longer in the hands of Americans.[24] Although "world music" was constructed by the business centers, it is an indicator of changing times. Reflexive modernization dissolves the self-evidence of cultural constructions, such as the origins of rock, and removes several obstacles for non-English-speaking people to find their voice in the lingua franca of rock (cf. Gudmundsson 1999).

Within the discourse on rock the dissolution of center/periphery constructions has often been proclaimed during the last 30 years. In a couple of reviews

24 The one company registered in the U.S. is Warner Music Group, which was sold off from Time-Warner to a group of private investors in 2003. As this book goes to press, the company remains unaffiliated with any larger conglomerate. The other companies are EMI (based in Britain), Universal Music Group (whose French corporate parent is Vivendi Universal), Sony (based in Japan and owned by the consumer electronics firm of the same name), and BMG (a privately held German conglomerate). Sony and BMG merged in 2004 and the shares are divided 50/50 between the two parent companies.

in *Rolling Stone* in 1970–1971 the critic Lester Bangs pointed to the Netherlands, Germany and the Nordic countries as new growth centers, and ever since critics have now and then signaled the end of the Anglo-American domination. A significant shift within academic discourse is to be found in the writings of Simon Frith. As late as the early 1980s (1981:11) he defined rock as American music with the only challenge coming from England, but ten years later he had changed his view:

> We can no longer sensibly define the international music market in nationalistic terms, with some countries (the USA, the UK) imposing their culture on other. […] The cultural imperialist model—nation versus nation—must be replaced by a postimperial model of an infinite number of local experiences of (and responses to) something globally shared. (Frith 1991:267, 268)

This construction of the international music scene is idealistic. It can serve as a critical position, departing from a view of an emerging "glocalization," but it certainly is misleading as a picture of the actual structure of the field of popular culture. The notion of cultural imperialism may be dead, but we must not ignore the fact that the "globally shared" culture is inherited and in the case of popular culture, the inheritance is Anglocentric. Besides, the institutional structures of the rock field are founded in the past and perpetuate structures of the past. To put it briefly, the field is characterized by a homology between an Anglo-Saxon canon, English as the only international language of rock music, English as the dominant language of the international research community and American and English magazines as the only international journals in the field. Such an all-embracing global hegemony is not to be found in other cultural fields such as literature, classical music or even film.

However, at the very core of this homology lies the quality of rock that contradicts its formation as an Anglo-Saxon empire—meaning that, from the very beginning, rock has been a manifestation of place. In Europe, Elvis was definitively about "America," and in the U.S. he was definitively from the South. As the "first" American rock critic, Paul Williams, writes in 1967:

> There is a geography of rock; San Francisco *is* different from New York musically, different because the music made by the Grateful Dead would be different if they had developed in New York, playing the night Owl or Action City, trying to get a master sold, living on East 7th Street […] ("The Golden Road," *Crawdaddy!* 10:5)

We will later see how the leading rock journals developed national and international profiles, while at the same time the privileged position of the spatial and cultural closeness remained intact; a great part of the credibility of the writers of *MM, New Musical Express* (*NME*) and *Rolling Stone* derived from their image as worldly-wise frequenters of the clubs, pubs, and high streets of the metropoles of rock.

Even a passing examination of the leading rock journals reveals that we cannot distinguish a global field of rock criticism or rock journalism. While records and CDs are distributed worldwide, the written word is to a high degree distributed within national markets. The only magazines and books on popular music to gain a certain global distribution are written in English and published in the U.S. or Britain. As we shall see, rock criticism emerged in the mid-1960s along separate paths in the two countries, but from the end of the 1960s and through the 1970s these paths were in many ways intertwined, and critics in both countries exerted strong influence on each other (see part II). However, different preferences and different styles prevailed on each side of the Atlantic, as described by Simon Frith:

> American rock writers are mythologists: they comb music for symbolic significance, and their symbols are derived from a sweep through American culture in general. These rock critics write (and are read) as American culture critics. British rock writers, by contrast, are still pop fans, still isolated in a cult world. (1981:10)

Since the 1980s this reciprocal influence has diminished, and neither American nor British discourse on rock has been explicitly influenced by discourses in other countries, while the opposite is an obvious fact. However, vital rock criticism is to be found in many regions, almost always written in the native languages and mediating between local culture and impulses from abroad.[25] These national discourses are important arenas in the processes of globalization within the rock field, but they will not be examined in this book. As these discourses do not relate to each other, but to the U.S. and British discourses, a study of the field development in the U.S. and Britain is a natural starting point for the study of an emerging global field of rock criticism.

25 We have examined the development of the rock criticism fields in the Nordic countries (and in Scandinavian languages) in Lindberg et al. (2000:305–459).

2.7. Themes and Questions for a Historical Study of Rock Criticism

> When I started writing about music, I did it because I was so in love with music
> that was being made or happening around 1965–66, and I wanted to find some
> way to express that delight. The idea that I had then at the very beginning was
> that music was a gift from one person to another, and within that gift there was
> a secret, and writing about music could be a way of making people feel that
> sense of a gift, but also discovering the secret.
>
> —Greil Marcus[26]

The discursive construction of rock within rock criticism seems to have started
with a strong sense that rock *mattered* in a way that surpassed pure entertain-
ment, breeding an equally strong need to understand and explain to others why
this was so. In the critics' view, rock was as much art as jazz, but, like film, far
more democratic. In some cases they explicitly claimed art status for rock. In
others—the majority—they did not, since rock was valued among other things
because it *differed* from high art in being antielitist. If it was "art," then it was
popular art. Yet, because of its dependence on mass mediation and commerce, it
could not be classified as clear-cut folk music either. In the end, rock aesthetics
was more or less bound to turn out a motley blend of different impulses, mostly
of Romantic origin: avant-garde ideas of art as nonautonomous and subver-
sive, the hegemonic notion of art as subjective expression, folk art's contrary
emphasis on shared experience, the entertainment apparatus's claims on acces-
sibility—to mention some of the most important. The specific *routes* by which
these sources came to have an impact on rock criticism is an empirical problem
that will be dealt with in the later parts of this book.

Our purpose is to examine the roles and strategies of rock critics as a force in a
wider process, involving the legitimation of vital forms of popular culture. This
implies a demand for societal and theoretical reflection that includes but goes be-
yond investigating rock criticism as a (potential) cultural field among others. As
stated above, we aim at an open-minded investigation of our subject, anticipating
that unexpected themes will arise from our material. However, the theoretical ap-
proach developed in this chapter serves both to demarcate the material to be stud-
ied and to qualify the main goals of the study as outlined in the introduction.

One problem concerns whether rock criticism has become a cultural field in
its own right. Here it is our intention to identify strong positions and turning

26 Personal interview, April 17, 2004.

points in the historical development of such a field. Has rock criticism developed its own standards, its own themes to dispute, its own criteria for access? Has it fostered distinct positions in the combat over the understanding of rock: a space for developing new positions on the grounds of those already existing? Has it bred a clergy capable of setting the agenda for other players? In the battles waged can we identify underlying assumptions and a silent consensus about "doxa"—what is to be discussed and what is beyond discussion?

We also aim to examine the aesthetic beliefs, discursive strategies and stylistic means of focal players in such a field, on the basis of the view that it is a meeting place between "the high" and "the low." How does rock discourse differ from criticism in established cultural fields? How do critics relate, for instance, to the literary field? Can we talk about "schools" in British and American rock criticism? To what extent have American and British critics influenced each other? In which ways have new aesthetic values and writing styles contributed to the establishing of new positions?

In our conclusions we will return to the theoretical issues at stake, but in between comes a long historical journey. It is not our aim to write the history of rock criticism; our theoretical framework rather involves a focus on distinct positions—that is, to single out individual rock critics and magazines with strong profiles. We have been looking for writers who are cited more than others, writers whom other writers recognize as influences. Consequently, this is not a narration of forgotten voices and admirable outsiders, although such writers may crop up along the way. This is a story of those who have defined the field, and our task is to try to explain what forces made that possible—including biases and prejudices. It should be added that during the research process it has become rather obvious that certain names do become fixtures in a moving landscape, confirming the hypothesis of a field with distinct positions.

Chapter 3

The Social and Cultural Background
of Rock and Rock Criticism
in the 1960s and 1970s

Rock is such an integral part of the social and cultural change of the past five decades that to write a full account of its social and cultural background would be to write the social and cultural history of the era. In order to place our study in a broader context we find three aspects of social and cultural change especially important: first, the specific phase of modernization as thematized in sociology and general social theory; second, the transformation of the lifeworlds of Western youth and the social mobility of the new generations in the national contexts of the U.S. and Britain; and third, the aesthetic climate of the 1960s and the early 1970s.

3.1. The Discontents of Modernization: Cultural Release

The social changes of the 1960s and 1970s are reflected in an extreme fashion in the radical transformation of social theories. In the 1950s ideas of evolutionary modernization and models of society as an organism in an inner balance formed a hegemony. In the 1960s these ideas were challenged by cultural criticism, utopian perspectives and growing skepticism about the superiority of Western rationalization. Social theory has been a battlefield of heterogeneous positions ever since. For our purpose we have found it useful to introduce the notion of "cultural release" put forward by the German scholar Thomas Ziehe (1975, 1989, Ziehe and Stubenrauch 1982).

According to Ziehe classical and mainstream sociology has not grasped the full consequences of the modernizing processes. Karl Marx and Max Weber both overemphasized the detraditionalizing effects of capitalism. Marx saw all of precapitalistic society "melt into the air" and Weber saw no alternative to rationalization and disenchantment. Emile Durkheim and Talcott Parsons responded that rationalization of economy, institutions and social life did not dissolve the moral and cultural ties of society. Moral integration was no longer self-evident and reproduced in a mechanical way but had to be defined and

monitored by agents of the state and civil society through education and other institutions and social bonds, basically fueled by the increasing interdependence caused by division of labor. While most radical strands in sociology simply rejected this structural functionalism, Ziehe followed the tradition of the Frankfurt school and changed it into a critical insight into the marriage of capitalism and the social heritage of precapitalistic societies. Patriarchy was not only maintained within the middle classes, but was also reborn within the working class through the definition of the male breadwinner. Cultural and moral patterns of country life had been transformed into urban settings in which working class neighborhoods often resembled clusters of villages. Drawing upon the theories of Sigmund Freud, Ziehe maintained that precapitalistic culture for a long period became a buffer, protecting individuals from the tendency of capitalism to change every relation into a monetary one.

An important aspect of the dramatic conflicts of the interwar period, between liberalism, fascism, communism and social democracy, were the different principles of organizing this buffer zone. After World War II, such conflicts seemed mostly resolved in Western Europe and North America, since the victorious societies were all based on the privacy of the family and the support of the welfare state. The code of moral conduct and cultural meanings, accepted with apparent unanimity, could be monitored by schools and other institutions. But under this quiet surface, Ziehe argued, the buffer zone was losing its self-evidence as it referred to vanishing material relations and to an illusion of coherence and stability in a rapidly changing world.

The generations growing up after World War II experienced a burgeoning discrepancy between what they sensed and what they were told, between, for instance, an enormously expanding horizon of consumption and an upbringing emphasizing moderation. The first generations of wage laborers had been economically and socially released from a more or less feudalistic agricultural society, but culturally they carried habitual meanings and moral codes, which after a period of upheaval and adaptation became taken for granted in the long period of cultural and moral stability in early modern societies. Several generations later, the self-evidence of these meanings and codes started to disappear under heavy pressure from increasing consumption, changed urban milieus, mass communication, greater social mobility and several other social developments. The discrepancy between long-term social change and relative stability in the spheres of culture and morality led to swift changes in many areas, not least among the Western youth of the 1960s. Thomas Ziehe termed this change "cultural release," linking it to early wage labor and emphasizing the swift effect

of "setting free." His analysis (Ziehe and Stubenrauch 1982, Ziehe 1989) also emphasizes that this release did not make every human relation a monetary one, as Marx had suggested, nor did it imply the total disenchantment and rationalization of the life-world of individuals, as critical Weberians would have it. On the contrary, Ziehe pointed to a frantic search for new meanings and new codes taking place in the late modern world of the last part of the 20th century. This search could take many forms. When the cultural codes of the immediate surroundings lost their self-evidence, one response might be to look for "authentic meaning" in the past or in other cultures. On the contrary, Ziehe pointed to a frantic search for new meanings and new codes taking place in the late modern world of the last part of the 20th century. Such "search movements" are ambivalent and can take many forms. When the cultural codes of the immediate surroundings lost their self-evidence, one response might be to search for authentic meaning in the past or in other cultures. The immediacy of experience is undermined by the general rise in education and by medialisation, so that everything seems already thematised.

As this new wave of modernization and release tore down the buffer zone that had hitherto protected the individual selves, the search for new meaning produced an extended passage of intense identity work involving not only specific social groups like artists or intellectuals but also the broad strata of new generations that could not simply reproduce the cultural meaning of their parents. The walls between everyday life and cultural production started to crack. Who was creating the cultural meaning of these new times—the painter dispersing colors on the canvas dancing in a trance, or the teenager carefully forming his greased hair before going out? Avant-garde art and mass culture became the cultural forms to express and explore the social changes—the former through its quality of testing boundaries, the latter because of its close connection to the forces behind the dissolution of the buffer zone.

This cultural release was an uneven process. In some areas and social spheres it hit social structures and meanings that had stabilized during generations of industrialized life. In other areas it coincided with the original release from the bonds of agriculture and traditional society. A common feature was social mobility. Everywhere the middle strata of society were growing due to prosperity, commerce, service and the growth of science. Children of workers and farm hands were filling the new jobs in offices or even attending universities, and the culturally productive middle strata of society were going through a changing of the guards.

3.2. The Social Background of Rock Culture and Rock Discourse

In the vast literature on rock, there is basic agreement about the fact that during the 1950s and the 1960s rock was intrinsically bound to the lifestyle of teenagers and young people in their early twenties. However, most writers are content to treat the social background of rock with general remarks or through the life stories of individuals. Rock history is written as the history of artists and the industry. Sometimes contextualized and sometimes not, it only offers glimpses of the perspectives of audiences' changing preferences and tastes in their search processes, just as youth culture research offers only glimpses into the multiple meanings of rock.

Likewise, the extensive discussions on the differences between American and English rock tend to overlook their basic differences in social background. Here we will point to some of these differences and extend the comparison to the U.S. versus Western Europe where appropriate in order to provide a background for the development of the discourse on rock in these two areas.

"Affluence" has been a key word in the history of youth during recent decades, and obviously greater spending power and expanding possibilities for consumption are an important part of young people's lives. However, generalizations should be made with caution because affluence had different faces at different times and places. Spending power, disposable time and the relaxation of control over young people expanded at different intervals for different groups in different countries. The American teenagers were far more affluent than their European counterparts in the first years after 1945 and they had the means to develop a youth market. In England the earnings of young people grew steadily during the 1950s and 1960s, and workers under 21 had even greater wage rises than the older generation (Osgerby 1998). Married couples invested in housing and durable goods, but young people tended to use their growing spending power on leisure goods connected with a youthful life style. Import restrictions limited the scope of such spending but made it more desirable and loaded with meaning.

In Britain the tradition for an early transition to the labor market continued as the majority started in unskilled or semiskilled jobs at the age of 15 or 16. In the U.S. the high schools kept most youngsters until the age of 18, and college education, leading to bachelor degrees at university levels, became increasingly common. In 1930, the U.S. and Western European countries had a similar percentage of young people involved in higher education, but in 1960 the percentage going to college had risen to 35 percent in the U.S. while less than 10 percent pursued a university education in Europe (Edelstein 1988). On the other hand, in Europe, a much greater proportion of youth, often around 25 to 30 percent of each cohort, went through vocational education and training. Furthermore,

the physical and cultural space of youth was constructed in quite different ways in North America and in Europe.

In the U.S. a much larger proportion of teenagers had their own room in the 1950s and early 1960s, but in many ways they were more restricted by parents, at least in the middle classes and many ethnic groups, until they moved away to college campus. The American teenager had the freedom of her/his room and by moving to campus at around 18 (s)he could "unfold" within a sheltered youth community. The European teenager had less space of his/her own at home but the boys, at least, had more freedom to move around town. Together, these three conditions reveal great differences in the conditions of youth, which had wide repercussions for youth culture, including rock 'n' roll and the discourse on it.

In the U.S. rock 'n' roll culture filled the vacuum accompanying longer school attendance and its concomitant dependency. As a cultural and social sphere it was a hybrid of different activities, from entertainment to various secret activities within the peer group. Rock 'n' roll became the tapestry of fantasy as lonely teenagers tuned in to Alan Freed or Wolfman Jack on their bedside radio. It contained a vague promise of joy and fun and suggested the danger of sexual and racial encounters.

In Britain rock 'n' roll was adapted by the working class culture of early school leavers and shaped into a long tradition of a stylish everyday culture of the working class youth, hanging around and "doing nothing." In the late 1950s and early 1960s a growing proportion of youngsters found white collar jobs in the expanding commercial and service sectors, but they carried with them the instrumental and antagonistic attitude of the British working class looking to resolve the tension between their background and the changing conditions in the leisure oriented youth culture, the mods being an extreme variant.

A closer look would reveal further differences—for instance, in the degree of urbanization, access to trade channels and more specific economic differentiations. But the contemporary public discourse chose rather to emphasize generalizations and myths, in which the "affluent teenage consumer" was seen at the heart of all youth cultures in North America and Europe. In the latter half of the 1960s this oversimplification was increasingly replaced by another cliché, that of a "youth rebellion" associated with countercultures and the growing social implications of the youth cultures. Again, there was some truth to the cliché but it covered over large differences linked to the various paths of modernization in the Western world.

In the 1950s American teenage high school culture had been isolated from the college youth culture, which among other things, fostered beatniks, folk music fans, jazz aficionados and political activists. In the early 1960s these were

usually situated in the proximity of college campuses and in some areas R & B, soul and rock 'n' roll became a natural ingredient in campus life (Guralnick 1986). In 1965, disillusioned with politics, college students were reported to be turning to "more introspective forms of intellectual and emotional growth" (Landau 1972:92), for instance, activities such as smoking pot, reading literature and listening to popular music. It was against this background that Paul Williams wrote that "[p]erhaps the favorite indoor sport in America today is discussing, worshipping, disparaging, and above all interpreting Bob Dylan" (1969:59).

American campuses were far less elitist than European universities and became social melting pots. Large groups of college students carried with them a high school experience with rock music, now melding with left-wing flavored interpretations of folk music. In Europe there was no significant connection between popular music and intellectual and political milieus before British art schools became cradles for a more serious occupation with popular music. These schools were intended to be part of the vocational system but became oases where upwardly mobile youth from the working class and the lower middle class could experiment with artistic expression. Pop art became a channel for developing popular music further through the incorporation of an avant-garde sensibility—seen most clearly in the case of the Who and later Pink Floyd (Frith and Horne 1987).

The subversive threat of early rock lay in the adaptation of musical forms from marginalized groups (African Americans and poor southerners), but the entertainment industry had managed to keep this threat under control. The racial and social tensions of rock were largely hidden in the reworkings made by British rock musicians, but much to their surprise, these tensions came out in the open when the British bands made the leap into the American market.

In Britain the Campaign for Nuclear Disarmament had been on the fringe of political life, while the Civil Rights Movement in the U.S. had mobilized large groups. This pattern was repeated in the Vietnam protests and in the British underground, which was a small world compared to the American counterculture. The basic explanation for this difference lies in the rigidity of the social structure and cultural cleavages of Britain, whereas the greater social mobility in the context of cultural heterogeneity in the U.S. set more people on the move in the 1960s. When kids from the lower classes and the popular youth culture invaded the British universities in the 1970s, the counterculture moment was over.

So, processes of social mobility traveled different routes within different cul-

tural, social and political contexts in the two areas under study here. The "low culture" of entertainment had higher status in the U.S. than in Europe; it contained a stronger inner division and young artists and intellectuals started to cross the border between rock music and avant-garde art earlier than in Europe. Notably, the left-wing folk movement and pop art became gateways as artistic bohemians and intellectuals entered rock culture without cutting their ties to high art. New Journalists like Tom Wolfe took the spirit of American novelists like John Steinbeck further by writing about the excitements and cultural innovations of everyday life. Such gateways were not available in Britain as is apparent in Jeff Nuttall's description of the situation of young, radical British intellectuals in the 1950s:

> Popular culture was, at that time, not ours. It was the province of the young adult, contrived and modified by the promoters and impresarios and aimed at the mid-twenties age group [...]; popular culture was utterly separate from highbrow culture; the avant-garde was part of highbrow culture and both were posh. (1970:21)

From the early 1960s rock music and its associated lifestyles in Britain became a bricolage of elements from African American music, white rock 'n' roll, Italian looks, local street culture and other elements (Hebdige 1979). Even though pop art was one of these influences, at first it opened no doors into high art. Neither the in-crowd of Swinging London nor the wider audience of rock music in England in the mid-1960s wanted to break into the temples of high culture, although there was a widespread feeling that there was more to youth culture than just having a good time. The tastes of Swinging London were formed in subtle symbolic activities at the clubs and only slowly reflected in print by, for example, Nik Cohn. To a larger degree, the American rock audience consisted of students with the habitus of defending their taste in print.

From its beginning as a mixture of black and white musical styles in the southern U.S., crossing borders and building bridges has been a vital part of rock. From 1964 the traffic across the Atlantic became central, and in later chapters we will see that the cross-influences of rock writing were also present in this cultural exchange. From the perspective of social history rock has played a remarkable role as the cultural focus of whole generations growing up in very different cultural settings, facing different challenges but somehow being united by this music.

3.3. The Aesthetic Climate of the 1960s

Goodbye deprivation, welcome utopia. By the mid-1960s notions of endless possibilities seemed to pervade a whole generation of white youth. This excitement at finding the world lying open at your feet can be heard already in the first records by the Beatles or the Beach Boys, and it resounds in rock criticism. "In the beginning," writes Robert Christgau (1973:9), "rock seemed to unfurl in front of me like some magic tapestry or endless circus poster, and sometimes all I could do was marvel." This climate bred a cultural egalitarianism that cleared the path for postmodernism in the arts. In the U.S., the high modernist border patrolling of New Criticism, Clement Greenberg and others came to look remarkably dated as neo-avant-garde experimentation, pop culture and political revolt were opening dialogues, clashing and flowing together everywhere. It is appropriate, then, that Christgau claims his aesthetic thinking was informed by two "epiphanies" in his early twenties, both of a border-crossing character. The first one took place in an art gallery, which is no coincidence; some of the most important contemporary contributions to aesthetics, such as making reception part of the design in happenings and other performance art, had to do with the development of visual art. Here is his account:

> [I]n 1963, I walked into the Green Gallery on West 57th Street. The show was eight or ten of Tom Wesselmann's *Great American Nudes*—sprawling flat-pink ladies surrounded by outsized magazine-ad images, with vistas from Better Homes and Gardens pasted behind each window and with miniature Mondrians and Mona Lisas on the walls. The paintings exhilarated me, but what really turned me around was something I heard—Connie Francis singing "V-A-C-A-T-I-O-N." [...] Into one of his paintings Wesselmann had built in a real radio, and there in that art gallery it was tuned to WABC. [...] Like all pop art, the *Great American Nudes* played with context, suggesting some kind of continuity—or even equation—between the Green Gallery, Connie Francis and Piet Mondrian. They were the beginning of my theory of pop. (1973:2)

A couple of years after Christgau's experience, star critic Susan Sontag suggested that contemporary literature had lost ground to other art because of its heavy burden of "content." Against literary culture she posed a "new sensibility," to which art was a sensuous widening of life. Thus a memorable sentence in the McLuhan-inspired essay "The Only Culture and the New Sensibility" celebrates the beauty of as different objects as a machine, a problem solution, a painting by Jasper Johns, a film by Godard and a Beatles record. But Sontag's main contribution to a transgressive aesthetic was the 1964 piece "Notes on Camp."

Camp, writes Sontag (note 45), is the answer to the question how to be a dandy in the era of mass culture. It is a form of aestheticism, a taste for the artificial that doesn't distinguish between unique and mass-produced things. It is democratic, then, like pop art, yet aristocratic, because dandyism connotes noblesse. The camp outlook (a clear case of the extension of Kant's pure aesthetic gaze) is not available to everybody. Thus, as Andrew Ross has pointed out, it allows heterodox intellectuals to approach mass culture and yet remain on top in matters of taste. This function is accentuated as Sontag particularly indulges in "naïve" camp, which makes the critic, not the producer, the one who invests it with value.[1] But to her the camp avant-garde consisted of homosexuals (note 51). Indeed, gender bending was the main if not the only route by which camp entered rock and pop.

According to Sontag, camp privileges dated things (note 31). The camp effect is created by their "redefinition according to contemporary codes of taste," or, in Marxist terms, the "re-creation of surplus value from forgotten forms of labor" (Ross 1989:139, 151). As Ross (152) observes, in relation to pop art's celebration of transience, camp therefore became something of an antidote: history as a junkyard is still a kind of history.

Beginning in London in the 1950s and extending to the U.S. in the early 1960s, pop art was a very loose visual art movement (according to some critics, it was never a movement at all). As one of its British spokesmen, Lawrence Alloway, declared (1975:119), it was "neither abstract nor realistic," but "essentially, an art about signs and sign systems," which dealt with "pre-coded material." This material was afforded by "the modern consumer-oriented/media-saturated environment" (Cagle 1995:59). In part, pop art built on the avant-garde tradition from dada, which introduced popular images in fine art. Yet, despite its European roots, it came to be celebrated as a product of the same American culture that it depicted. However, according to art critic Nancy Marmer (1966:148) the central novelty of pop art was to be found neither in its concentration on common objects or popular culture subjects, nor in its "questioning" of the nature of the relationship between depiction and reality. Instead it re-

1 Ross (1989:145). According to Ross, the word comes from the French *se camper*, "to posture." "Kitsch" and "schlock" are different; the former has pretensions to artistic taste, while the latter is characterized as "truly unpretentious." Thus Ross argues that the British flag and Victoriana became camp objects in 1960s Britain, because they signified a power of cultural influence in decline, while the Stars and Stripes and other Americana could only be kitsch, as they represented true cultural power (140).

sided in its "sanction of advertising, illustration, and commercial art conven-
tions as well as techniques for the presentation of these, or any figurative sub-
jects, in a context of 'high art.'"

Pop artists such as Richard Hamilton and Peter Blake in England and Andy
Warhol, Roy Lichtenstein and others in the U.S. applied the pure aesthetic gaze
to trash and denied there was any distinction between the pure and the com-
mercial poles of the art field, between art and design. This is perhaps no won-
der, since most of them came from advertising. In Hamilton's famous 1957 defi-
nition pop art was cast as popular (designed for mass consumption), transient,
expendable, low cost, mass-produced, aimed at youth, witty, sexy, gimmicky,
glamorous and big business (Frith and Horne 1987:103). To Warhol, market
success was the only valid aesthetic criterion. Consequently, he called his studio
the Factory, serialized production and sometimes reduced authorship to sign-
ing the works. This, Frith and Horne (110) suggest, was a lesson he had learned
from the conditions of mass communication: "[W]hatever artists want to say
will be trivialized by the media it must pass through, and so the only honest
thing for the artist to do is trivialize everything." The effect was one of flatness
and dehumanization, of obsession with surfaces and absence of commitment.

In art, the shock effect of pop art was transient. But as pop culture it would
make an influential contribution to the reflexive aestheticization of everyday
life. As George Melly (1970) argues, the emergence of pop art provided an al-
ready existing sensibility, which had been long under formation among work-
ing-class youth before it surfaced after the war, with an intellectual justification.
Melly characterizes this sensibility as "the idea of instant success based on the
promotion of a personal style" (6–7), dedicated only to pleasure and intent on
translating the spirit of the time into music, fashion or behavior and goes on to
claim that "[i]t was not the pop intellectuals who made the first effective move
towards the creation of a neutral zone in which the idea of an experience oper-
ating in 'the gap between art and life' could put on flesh. This was the work of
the uneducated but moneyed adolescents of post-war London" (20).

The confluence of high and low pop worlds was to climax in a rather un-
reflecting manner in Swinging London, where Blake created sleeves for the
Beatles' late albums and Hamilton designed the visual appearance of the Who,
while in New York Warhol did both things for the Velvet Underground. Pete
Townshend declared, naively: "We stand for pop art clothes, pop art music and
pop art behaviour [...] we don't change offstage; we live pop" (Jones 1965/1995).
A second, more self-conscious step was taken with the advent of punk, informed
by the mod subculture as well as by Situationism. However, what remained of

the punk avant-garde's conscious conflation of art and commerce around 1984 was only mainstream New Pop. A third, postmodern stage was to foster the cool pop sensibility of the 1990s, to which any act might be appointed "cult" and nothing was necessarily more "important" than anything else. This stage, argues Karin Petersen (2000), could not be reached until the "material," in Adorno's sense, had been brought up to date, which happened with the spread of digital technology and sampling. In Petersen's account, the free appropriation of its material as "quotations" that characterized pop art thus was not fully realized in popular music until some 30 years later with the appearance of "sonic objects."

With the founding fathers of American rock criticism, pop art seems in the first place to have been but part of the cultural change that was in the air. It was contemporary, it was democratic and in spirit, if not in origin, it was American. Besides, it was smart: "Reading Blake's Sergeant Pepper sleeve—name the faces, spot the cannabis, decode the lyrics—was like reading the underground press" (Frith and Horne 1987:57). Robert Christgau, who in his own words "melded the communitarian rhetoric of the counterculture and the populist possibilities of pop into a sort of improvised democratic radicalism," was perhaps the one best equipped to deal with it. To him hippies were "pop bohemians" (Christgau 1973:5–6). Such insights should have made it easier to accept the waning of the authenticity paradigm in the 1970s.

The differences between cultural journalistic positions in the 1960s U.S. have been stressed by, among others, Aronowitz (1993:185–202). Sontag's critical approach, as manifested in her magnum opus, the collection *Against Interpretation* (1969/1990), was essentially avant-garde. Against the high modernist values of seriousness and truth it posed the frivolous pleasure registered by the mind of the trained fortune hunter, moving from the top and down the cultural ladder. By contrast, most of the "new intellectuals" who appeared during the second half of the decade argued that culture and politics were inextricably linked and opposed the contradictory melee of liberal democracy and aristocratic culture that characterized the defenders of high culture. They also broke with the "scientism" of traditional journalism in a way that brings Christgau's second epiphany to the fore:

> Epiphany two occurred a little while later when I read an essay by A.J. Liebling, ever hear of him? Great American journalist, who worked for the *New Yorker*. He wrote an essay called "Ahab and Nemesis," which was a description of the 1955 heavyweight championship fight between Rocky Marciano and Archie Moore, in which Marciano was the whale and Archie Moore was Captain Ahab, trying to

destroy this implacable white object. It is an absolutely bravura piece of criticism about an utterly…abject subject, and I realized—writing fiction was hard for me, and I wasn't producing very much—that I could write journalism. (personal interview, May 22, 1998)

As "affluence blew the lid off" (Wolfe 1973/1990:44), it seemed that journalists were there to record the excitement, while novelists were not. Around 1965 that magic phrase, "New Journalism," was coined. It came to stand for a fictionalization of reporting that signified a strengthening of the journalistic field's "pure" pole, achieved by the application of techniques used in the field of literary production. First and foremost, "the new journalism constitutes the object through its encounter with it," as Aronowitz (1993:187) puts it. Something is made an event by the journalist's intervention. The idea is to transport the reader into medias res, but not stop at a simple on-the-spot narrative. In his classic essay "The New Journalism," Tom Wolfe, who became the mouthpiece of the movement, specifically mentions four devices that work to undermine common "objective" reporting. All of them were picked up (by "instinct," Wolfe suggests) from Fielding, Dickens, Balzac, Gogol and other novelists in the tradition of literary realism.[2] Stories should (1) progress scene by scene rather than by synthetic narrative; (2) record dialogue in full; (3) use a third-person point of view, based in the perspective of a particular character, so that scenes are introduced to the reader through the eyes of that character; and (4) introduce a wealth of symbolic detail capable of situating the characters in their environment (1973/1990:46–47). This way they were bound to be long, but entertaining. The most controversial device was, of course, the third-person point of view: how can a reporter profess to offer a literal representation of people's thoughts? Wolfe thought probability was enough. To this aim the New Journalists put in a great deal of "legwork," ranging from interviews to living with their informants, sometimes for long periods of time.[3]

2 Wolfe also mentions other genre sources—the autobiography and the travel literature of the late 18th and early 19th centuries.

3 Commenting on the reception of his renowned essay on Phil Spector ("The First Tycoon of Teen," *New York Herald Tribune*, February 1965; reprinted in Heylin 1992:57–69), Wolfe recalls that some journalists at the time regarded the projected third-person point of view as dubious. Spector was even asked if he did not think a particular passage employing the technique was merely fiction. Spector replied that, to the contrary, he found it quite accurate. "This should have come as no surprise," adds Wolfe (1973/1990:33), "since every detail in the passage was taken from a long interview with Spector about exactly how he had felt at that time."

What Wolfe, Hunter S. Thompson and other innovators did was celebrate popular culture as American culture (while most pop art Americanism was a spin-off effect). This move included a few excursions into rock.[4] Wolfe, a Yale Ph.D. in American studies, mostly wrote in low-status Sunday supplements, and his heroes were common people "with ratty hair," who made enough money after the war to indulge in their creative desires, of which Las Vegas seemed to be the monument. There is a touch of Nietzschean ressentiment to Wolfe's account of their rise to cultural power. Basically a populist, as Aronowitz points out (1993:192), Wolfe came to appear an anti-intellectual tribune in a climate of successive political radicalization. The rock critics were no less occupied than him by themes of nation, class and generation, but their vision of the popular was different, since it involved a (basically modernist) quest for transcendence, for the spiritual significance of sensuous experience.

The vulgar excess and the inverted power relations that so fascinated Wolfe bring Bakhtinian notions of carnival to mind. Roughly, one can distinguish between two aspects of "carnivalesque" writing that rock critics picked up from New Journalism. One might be named the "carnival of events," which goes by the name of "gonzo journalism" and, in a literal sense, stages the journalist as the focal character of the narrative (cf. Wolfe 1973/1990:184, 195). This is the route Thompson, master of the genre, explores in *Fear and Loathing in Las Vegas* (1972) and his other post–*Hell's Angels* writings. The other aspect is the "carnival of words," whose origin, we guess, is to be found in American tabloids. It manifests itself in a highly mannered prose, marked by excessive rhyming, erratic spelling and typography, neologisms and other intensifying devices, all of which overflow Wolfe's pieces. Among rock critics, Lester Bangs (who passed on the word to his British colleagues Charles Shaar Murray and Nick Kent) became the prime exponent of both types.

As the counterculture established itself, it did so on the contradictory ground of Rousseauan primitivism and electric music, caught in slogans like "turn on, tune in, drop out." The gist of such a *coincidentia oppositorum* was already known to the Canadian professor Marshall McLuhan, who wrote *Understanding Media* in 1964. McLuhan's basic idea, inherited from earlier literacy scholars but taken to extremes, was that our senses are differently developed under different media regimes. To this development he brought an optimistic twist. Behind us lies the "mechanical" age, ruled by the printed word, which has fragmented hu-

4 E.g., Wolfe's "The First Tycoon of Teen" (on Phil Spector; in Heylin 1992) and "Noon Day Underground" (on mod culture; in Wolfe 1968).

manity; in front of us extends the "electric" age, which represents the return on a higher technological level of a primeval, oral community, summed up in that famous expression, the "global village."

Siding with Benjamin rather than with Adorno, McLuhan also celebrated mass reproduction as a democratic innovation and insisted, against the grain of mass culture criticism, that popular audiences are active participants, not passive consumers. "For McLuhan," writes Ross (1989:124), "the new electronic culture of intense involvement and participation would be 'tribal,' populated with 'information hunters and gatherers,' and characterized by the kind of communal equilibrium 'enjoyed' by less complex cultures." For all their ethnocentrist romanticism, these were important statements at a time when most intellectuals demonized technology and its blessings. Yet Aronowitz goes a bit far when he states that McLuhan's futurism "turned out far more appealing than the evocations of an integrated past by, among others, the Frankfurt school and John Dewey" (1993:169).

Just as McLuhan pointed towards older and simpler cultures in order to describe his future utopia, the Frankfurt school pointed towards a distant, utopian past, where man was still whole and undamaged in order to criticize the present dystopia. To Horkheimer and Adorno this utopia was irredeemably lost because of ruthless and total enlightenment. From this insight they formulated an influential and scathing critique of mass society and what they christened "the culture industry." But others related to the Frankfurt school held a less pessimistic view of the situation, and it was primarily through their efforts that critical theory reached a broader audience.

Especially Herbert Marcuse outlined the contours of a utopia, first in *Eros and Civilization* (1955), later in the extensive essays from 1968–1972. What made Marcuse resume the utopian theme in the late 1960s was the African American inner city uprisings, the students' movements, and youth rebellion in general. In these radical politics he found reasons for a slight hope. Both Marcuse's critique of consumer society and his utopian vision found resonance with many young people looking for a political criticism of totalitarian tendencies and for the formulation of new ideals (which turned out to be quite old). He became known as "the philosopher of the youth rebellion" and "the erotic pedagogue of the revolt."[5]

5 Apart from the large quantities of books sold and his status as an intellectual star on most Western campuses, there are a few direct connections between Marcuse and figureheads of the counterculture. Angela Davis of the Black Panthers studied with him (and with Adorno in Frankfurt), as did Abbie Hoffmann of the Youth International Party (the Yippies).

"The Aesthetic Dimension" in particular is central to Marcuse's utopian vision. Based on Kant's three critiques (1781, 1788, 1790) and Schiller's *On the Aesthetic Education of Man* (1795–1796), it represents the age-old wish for a reconciliation of art and life—a life based on the principles of philosophical aesthetics and the organization of "society as a work of art" (Marcuse 1969:145). The utopian aspect of the aesthetic dimension is thus roughly equivalent to philosophical aesthetics itself and is even inherent in the term, as it describes

> [...] the inner connection between pleasure, sensuousness, beauty, truth, art and freedom—a connection revealed in the philosophical history of the term aesthetic. There the term aims at a realm which preserves the truth of the senses and reconciles, in the reality of freedom, the "lower" and the "higher" faculties of man, sensuousness and intellect, pleasure and reason. (Marcuse 1955/1969:143)

The diagnosis of the dichotomy and the promise of a reconciliation with the opposition are of Kantian origin, pointing towards a "non-repressive civilization, in which reason is sensuous and sensuousness rational" (148). The motive force of the reconciliation is Kantian imagination, the place for the free play of thought and, in Marcuse, also for the memory of the original utopia. From Schiller Marcuse got the idea that the goal is an actually existing, aesthetic culture where the sense of time is abolished, because it hinders the lasting gratification necessary to a nonrepressive civilisation.[6] In a culminating passage Marcuse writes:

> If the "aesthetic state" is really to be a state of freedom, then it must ultimately defeat the destructive course of time. Only this is the token of a non-repressive civilization. Thus, Schiller attributes to the liberating play impulse the function of "abolishing time in time," of reconciling being and becoming, change and identity. In this task culminates the progress of mankind to a higher form of culture. (155)

To Marcuse, the material conditions and intellectual knowledge in the fully developed capitalist countries had reached such a level that only political power was a hindrance, and around 1970 he optimistically saw African Americans and radical students as possibilities to crack open that power bloc. However, even though the eventual realization of the aesthetic dimension as a model for civilization will render art superfluous, the primary function of contemporary art is

6 Marcuse connects lasting gratification to the myths of Narcissus and Orpheus describing the "conservative nature of the pleasure principle" (1955/1969:155, see also 132–142).

that of the concrete negation of repressive society. For the time being, art must necessarily stay confined within its own area in order to remain critical. Therefore Marcuse puts down pop art and happenings, which are taken to conflate art and repressive reality (1969:47–48), while he praises the capacity of the historical avant-garde (especially surrealism) and "black music" (presumably free jazz) to "desublimate" art (peeling off the layers of bourgeois art ideology).[7] "Life music has indeed an authentic basis: black music as the cry and song of the slaves and the ghettos [...] the music is body" (1972:114). What Marcuse likes in popular culture is what is not à la mode. He is looking for something that he can interpret as oppositional in a political sense and as a desublimation of art. And in his view, African American culture and white youth culture fit in both by turning their backs on bourgeois ideology and by creating art based on the music of the oppressed, whether slaves (the blues, jazz) or white working class (the folk movement). Sometimes Marcuse conflates high and low culture, probably in an attempt to desublimate the high:

> Strange phenomenon: beauty as a quality which is in an opera of Verdi as well as in a Bob Dylan song, in a painting of Ingres as well as Picasso, in a phrase of Flaubert as well James Joyce, in a gesture of the Dutchess of Guermantes as well as of a hippie girl! Common to all of them is the expression, against its plastic de-erotization, of beauty as negation of the commodity world and of the performances, attitudes, looks, gestures, required by it. (1972:121)

Interestingly, Marcuse is quite critical of rock music because of its alleged lack of authenticity, its mass character and its "pseudo-cathartic" effects. But among prospective critics within popular culture, these reservations were largely ignored (admittedly, they are not central to his late 1960s essays), and rock was designated as "art according to Marcuse." The rock critic who stands closest to Marcuse is probably Ralph Gleason. A cofounder of *Rolling Stone*, he was one of the most eloquent defenders of a stance that saw rock taking upon itself the role of politically radical art within a Marcusian paradigm. There are connections also to Jon Landau (with his predilection for "body music") and to Carl Belz, both students at Brandeis University when Marcuse taught there.

7 See Marcuse (1972:114) for references to the rupture caused by free jazz with its promise of a new social order and its exasperated "aesthetic of the cry."

Chapter 4

The Formative Period: Absolute Beginners (1964–1967)

4.1. Introduction

Having a brand new Rolling Stones album in your hands is like being a virgin, on the brink.

—Paul Williams[1]

When does rock criticism begin? Obviously, the question begs for a definition of what is meant by the term criticism.[2] From the emergence of rock 'n' roll in the 1950s, commentary, but not necessarily criticism, has followed its stylistic traits and innovative events. In fact, only after 1964—in the wake of the massive success of the Beatles and with a new quest for "originality"—do writers take on a strategy of treating pop and rock music "seriously." From the moment when Dylan turns folk upside down into the electric and the Rolling Stones turn Muddy Waters into English rebellion, triggering a new quest for Satisfaction for their following on both sides of the Atlantic, an era of *rock criticism* is born—at least as a possibility.

Moreover, not only the criticism but the general view of rock music changes. Generally the critics of the mid-1960s were struggling to develop metaphors and descriptive categories that might catch up with the musical development. As one of the most prominent British writers of this period, Chris Welch, puts it, the music scene changed so quickly and dramatically that it took the press a long time to follow up and "understand" what this new music was all about:

I think the journalism was slower to develop than the music, looking back. I think the musical development was going at tremendous speed. And it took a

1 Williams, Paul (1967): "Outlaw Blues," *Crawdaddy!* 13, February:8.
2 From the outset, we have reserved the term *criticism* for texts displaying interpretive and argumentative ambitions.

while for the music press to understand that this was more than just a three minute form of a popular entertainment, it was something deeper going on. (personal interview, December 9, 1998)

Within this period a brand new kind of "enthusiasm" seems to be what motivates the writing, reviewing and promoting of rock music. With the birth of rock magazines like *Crawdaddy!* (f. 1966), *Mojo Navigator Rock and Roll News* (f. 1966) and *Rolling Stone* (f. 1967) in the U.S., and more attention being paid to rock in *Melody Maker* (*MM*) and *New Musical Express* (*NME*) in Britain, rock music and the rock lifestyle found a press platform from which it could be propagated.

The critics of this period generally assume what we have classified as a *naive* attitude, to which high/low oppositions make little sense. Their basic interest corresponds with their understanding of the nature of their object: an obligation to inform, entertain and enthuse their readers. Yet there are also certain attempts at elevating specific kinds of music and artists during this period, in which the foundations are laid for a stratification of "art" as opposed to "commerce"—or, more precisely, the canonization of certain artists as being more "serious" than others. Central discourses revolve around concepts of "authenticity," "revival" strands and new conceptions of style and authorial originality.

Rock criticism in this period is not yet a field. Nevertheless, significant strands and perspectives come together in a kind of formative process. This process emerges in uneven stages, and by means of different strategies by writers in Britain and the U.S. Five areas seem seminal to the prehistory of rock criticism in this period:

- *Popular culture.* In the wake of the growth of the American film industry, numerous magazines and papers started catering to a young audience, escalating the impact of what might be termed fan culture. American trade papers such as the leader, *Billboard,*[3] and others, like *Cash Box, Variety,* and *Record World,* were influential in that they focused extensively on popular music; yet as far as criticism was con-

3 The first copy of *Billboard* appeared in Cincinnati, November 1, 1894. Beneath the logo it declared itself the "Monthly Resume of All that is New, Bright and Interesting on the Boards," and on the front page the editor stated the prospective readers: "Devoted to the Interests of Advertisers, Poster Printers, Bill Posters, Advertising Agents and Secretaries at Fairs." *Billboard* turned slowly away from advertising and began to concern itself with entertainment, and by 1910 it stated that it was America's "Leading Amusement Weekly" (January 1, 1910). At that time entertainment was mainly stage-related, including reports from London, Berlin and Paris. It was only after World War II that *Billboard* began to focus on the music industries.

cerned music was reviewed almost solely from the point of view of its sales potential. *Hit Parader* (f. 1955) perhaps came closest to an American pop newspaper.

– *Jazz criticism.* The influences from jazz criticism were significant both in Britain and the U.S., specifically through the application of concepts of "quality" and musical "competence." Yet in England, and in particular in *MM*, jazz was conceived of at a greater geographical and cultural distance than in the U.S. Jazz criticism in Britain involved a different, more exotic, conceptualization of the "other," the African American originators of jazz. Here various "revival" strands came to embrace conceptions of "tradition" and "authenticity" that were to have great impact on rock criticism as well.

– *Folk authenticity.* Whereas jazz criticism was specifically concerned with "competence" and "quality" and to some extent influenced by "high art" values and classical music criticism, folklore discourses were consolidated almost solely around the idea of "authenticity." In Britain, blues enthusiasts, among them Alexis Korner, had an impact on mediating these concepts and initiating the R & B revival scene in London from the late 1950s throughout the 1960s. American scholars, such as John and Alan Lomax, had an immense influence on the reception of the African American blues as a "folk tradition." In this discourse, jazz conceptions of musicianship and skill (in particular heightened with the emergence of bebop in the 1940s) were contrasted by metaphors referring to expression, such as "lived experience" and "feeling." In the U.S., folklore identifications were also greatly influential, not least in Cambridge, Massachusetts, and in Minnesota in the milieu where the young Bob Dylan established himself as a folk act. Apart from publishing songs, the folklore magazine *Sing Out!*,[4] cofounded by Pete Seeger in 1950, advocated the ideology of "folk" as the "true expression" of not only Americans, but proletarians all over the world. In short, inspired by Marxism and social (as well as socialist) movements, "folk" singing was conceived of as a vital force in the processes of political liberation of the repressed classes.

4 From the beginning the magazine featured the subtitle *A People's Artists Publication*, which was later changed to *The Folk Song Magazine*.

– *Academic influences.* Academic influences on early rock criticism are undoubtedly more indirect than direct. Yet, William Mann's vanguard review "What Songs the Beatles Sang," which for the first time put a pop/rock group onto the arts pages of *The Times* (London) (December 27, 1963:4), bears definite imprints of musicological terminology as well as attempts at discussion of musical form, scales and harmonic analysis. Academic appraisals were also clearly present in literary reviews of John Lennon's early books, *In His Own Write* (1964) and *Spaniard in the Works* (1965), which brought out comparisons to pop art and James Joyce.[5] Tom Wolfe hailed Lennon as "exceptional" and as "a highbrow under all that hair."[6] Such intellectual appreciation, however, prevailed only during a rather short period, whereupon it more or less disappeared. Rock critic Richard Goldstein then brought in references to both Marshall McLuhan and Susan Sontag in his early *Village Voice* essays (1966–1968), even though his approach seemed more of an outcome of the "carnival of words" of New Journalism than attempts at theoretical analysis.

– *Counterculture, subculture and new conceptions of "style."* No discussion of 1960s culture can bypass the concepts of British subcultures, American counterculture and "hippie" culture, or the politicized Black movement and the anti-Vietnam movement. These influences are complex and important, yet often not so explicitly manifested in 1960s rock criticism as one might perhaps expect. The subcultural youth "rebellion" that surfaced with the British "Teddy Boys" already in the early 1950s bore the double imprints of American popular culture and British class society. As Chambers (1985) points out, cross-Atlantic cultural traffic grew because of the media expansion (radio, records, film and later television) and in the 1960s it bred new conceptions of "Britishness" and British style. Then, in 1964–1965 we see the emergence of a discourse enhancing the construction of a specific British

5 John Wain wrote in the *New Republic*, August 7, 1965, "that it all comes out of one source, namely the later work of James Joyce. [...] Mr. Lennon has, at one stroke, put the young non-reader in touch with a central strand in the literary tradition of the last 30 years in every English-speaking country"; quoted from Thomson and Gutman (1987:61).

6 Wolfe, Tom (1964): "A Highbrow Under All That Hair?" *Book Week*, May 3:4–10; quoted from Thomson and Gutman (1987:44–47).

"authenticity" as opposed to the American "folk authenticity" first copied. This goes along with new concepts of the rock musician as author (in part informed by "art school" ideologies) and myths of the "transgressive" rock star (the Rolling Stones were described by *MM* in 1964 as "the group parents hate"[7] and the guys you don't want your sister to hang out with[8]). American "underground" cultural influences on rock criticism chiefly belong in the latter part of the 1960s.

All in all it might be argued that rock criticism was slower to develop in the U.S. than in England. In *MM* writers such as Chris Welch and Ray Coleman aspired to treat the new forms of popular music more "seriously" from the moment the British R & B revival and beat "boom" took off in 1963–1964. On the other hand, the emerging American criticism was perhaps in sum more poignant than the British. For instance, Tom Wolfe could wax ironic over the British reception of Phil Spector as "The First Tycoon of Teen" with "photographers all over the place, for him, Phil Spector,"[9] upon the producer's visit to London in 1965. Yet when the American "summer of love" arrives, *Village Voice* columnist Richard Goldstein takes as his point of departure Janis Joplin's statement that "San Francisco is live," while the whole report is informed by the metaphor that "San Francisco is the Liverpool of the West."[10] In this sense, the emergence of new rock "centers" was also subsuming the myths of others. Transatlantic crossfertilization reached such a peak that "English rock enthusiasts sometimes seemed to know more about the California rock scene than musicians from New York and Chicago" (Lewis 1972:98). And as Lewis points out, "it took a blues revival in England to make white American musicians aware of the talent and tradition that they had largely ignored" (1972:94).

In many ways the interaction between musical events and writers reporting on them in Britain and America is far more complex than is usually pointed out. Editor Clinton Heylin claims in *The Penguin Book of Rock & Roll Writing* that the emergence of *Crawdaddy!* in the U.S. in 1966 represents "the true

7 Coleman, Ray (1964): "Group Parents Hate Makes Big Hit," *MM*, March 7:1.
8 Coleman, Ray (1964): "Would You Let Your Sister Go with a Rolling Stone," *MM*, March 14:8.
9 Wolfe, Tom (1965): "The First Tycoon of Teen," *New York Herald Tribune*, February; quoted from Heylin (1992:66). This is probably also one of the most anthologized articles in all of rock criticism.
10 Goldstein, Richard (1967): "San Francisco Bray," *Village Voice;* quoted from Goldstein (1970:117, 115).

genesis of rock criticism" (1992:xi). Commonly reckoned as the first "rock critic," the founder of *Crawdaddy!* magazine, Paul Williams, nevertheless looked to England for material and even included a quote from the British magazine *Music Echo* on the cover of his first mimeographed issue of *Crawdaddy!* in February 1966.[11]

What characterizes Paul Williams's early writings in *Crawdaddy!* is first and foremost his fresh and overwhelming enthusiasm, paired with what seems, in retrospect, an overtly naive insistence on the significance of listening to rock albums. His intentions as a writer are explicitly manifest already in the opening lines of the first issue of *Crawdaddy!* in February 1966. Here Williams announces a new era of "criticism," freed from "teenage-magazine perspectives," pin-ups as well as music industry news briefs. As he proclaims, the time has come for "intelligent" writing on rock.

> You are looking at the first issue of a magazine of rock and roll criticism. *Crawdaddy* will feature neither pin-ups nor news-briefs; the specialty of the magazine is intelligent writing about pop music. *Billboard, Cash Box,* etc., serve very well as trade magazines; but their idea of a review is: "a hard-driving rhythm number that should spiral rapidly up the charts just as (previous hit by the same group) slides." And the teen magazines are devoted to rock and roll, but their idea of discussion is a string of superlatives below a fold-out photograph. *Crawdaddy* believes that someone in the United States might be interested in what others might have to say about the music they like.[12]

This statement is important, not least because Williams formulates a distinction between criticism and writings that are not to be understood as criticism in a qualified sense. Apart from sharing some of the enthusiasm for the music of the day, what sets Williams apart from his British colleagues—at *MM* most notably Chris Welch and Ray Coleman—beyond the fact that they were professional journalists, is his insistence on the rock listening experience as something "brand new." Historically, it might be argued that not only rock criticism but also rock listening and engagement rises to an unprecedented level in this period. There is a massive increase and a shift in rock consumerism, as listening not only to 45s but to rock LPs comes to be perceived as an overall new experience. This is described with great excitement by Williams:

11 Williams, Paul (1966): *Crawdaddy!* 1:1.
12 Williams, Paul (1966): "Get off of My Cloud," *Crawdaddy!* 1, February 7:2.

During 1967 rock music, thanks to Beatles Doors Airplane etc., greatly expanded its audience to the point where maybe two-thirds of the people buying any records at all were buying rock albums. Meanwhile, also thanks to Beatles Doors Airplane etc., the number of creative musicians and groups within the field grew even faster. Situation: during the summer of 1967, by some awesome coincidence, the size and interests of the buying audience coincided nicely with the quantity and quality of rock albums newly available to them, and hence the considerable success of people like Jimi Hendrix, Country Joe & the Fish, the Doors, the Mothers, the Moby Grape, and so on. Lots of creative people making it pretty big with creative stuff, and this in turn led to unrestrained enthusiasm on the part of large record companies, who've been spending unbelievable amounts to make sure that any group that sounds talented to them will in the future record on their label. […] I wrote a whole article in *Crawdaddy!* 11 about the aspects of listening to rock in a particular environment, the extent to which the context can be part of the musical experience. Groovy. ("Outlaw Blues," *Crawdaddy!* 13, February 1968:5, 17.)

What writers like Paul Williams tell us is that rock is nothing less than the "real" experience of life. Paradoxical as it may seem, rock in his writings is portrayed as an explicit manifestation of antiestablishmentarianism and the counterculture as well as a representation of "true" experience and expression aligned to the category of "art."

In a period when Eric Clapton emerges as "God" on the London subway graffiti, rock critics are definitely "fans."[13] They start out as "fans"—as record buyers, listeners and collectors—and continue as "fans," even after they become writers. Yet, both stylistically and intellectually the early rock critics distinguish themselves from the so-called pop fan of earlier periods. They no longer simply write about the star, be it Elvis, Little Richard, or the Beatles; they focus just as much on themselves and their own experiences in relation to musical listening, on popular music history, on the significance of the music to contemporary society, and not least on the future. With Dylan they believe that *The Times They Are a-Changin'*.

13 Scholar Roy Shuker has defined "fandom" as "the collective term for the phenomenon of fans and their behavior: concert-going, record-collecting, putting together scrapbooks, filling bedroom walls with posters, and discussing the star with other fans" (Shuker 1998:116). As he writes, "fandom is a complex phenomenon, related to the formation of social identities" (117). In youth research and popular music studies "fans" are commonly also described in terms of pathology and deviance, however, the significance of being a "fan" is in our view more complex.

Whereas Williams may readily be characterized as a "fan writer,"[14] other critics were more familiar with journalistic standards. Richard Goldstein was already in possession of some journalistic capital when he became the first rock critic to be given regular columns in the *Village Voice*. Tom Wolfe, later reckoned as the father of New Journalism, wrote on rock lifestyle in the *New York Herald Tribune* already in 1965. In England, Nik Cohn stands out with his more blunt assertions and often ironic descriptions of rock characters in the *Observer, Sunday Times* and *Queen* magazine, and later with his collection of essays in book form. Then a new period is initiated in November 1967 when Jann Wenner and founding partner Ralph J. Gleason begin shaping *Rolling Stone* magazine.

4.2. The English "Gentleman" Critic: Chris Welch and the Prehistory of Rock Criticism at *Melody Maker*

> I certainly campaigned personally on behalf of a lot of musicians, quite deliberately, because I liked them and thought that they were fantastic. I wanted people to know about Stevie Winwood, for example. And I used to drive Rod Stewart around London when he was broke. That was the great thing about being a rock writer in the 1960s. If you were seeing an artist you thought had fantastic potential, the fun was writing about him, saying "listen to this guy, he is great, you should go and buy his records!"
>
> —Chris Welch[15]

Chris Welch, born in London in 1941, is perhaps alongside Ray Coleman (1937–1996) the first among critics to cater to a more "serious" pop music or rock journalism. He started his career as a music journalist at *MM* in 1964, after having his application for a job turned down by the other leading British music weekly, *NME*. Welch, trained as a news reporter in Fleet Street,[16] was already a musical addict, having closely investigated his elder brother's collection of 78s from an early age and played washboard and drums in a skiffle band. Welch came to stay with *MM* for more than 16 years during which he wrote articles, news, interviews, reviews—in short, all kinds of genres featured by the music

14 Likewise, Williams's choice of title for a collection of *Crawdaddy!* essays in book form in 1969, *Outlaw Blues*, marked a reference to a little known, however, often bootlegged Dylan song rather than any actual attempt to engage with "outlaw" culture. The song is included on Dylan's *Bringing It All Back Home* (1965).

15 Personal interview, January 20, 1999.

16 Welch first worked as an assistant on the *Scotsman*, later as a reporter for the *Kentish Times*.

weekly. Welch is one of the most widely read music biographers in rock history with numerous books on his account, among them the first biography of Jimi Hendrix (1972), as well as books on Cream, Steve Winwood, Bob Marley, Led Zeppelin, Paul McCartney, Tina Turner, Pink Floyd, Yes and many others.

The point of this section title is not to suggest that the English are generally more polite than Americans. However, a "gentlemanly attitude" seems a fitting way to describe Welch's relation to the music and artists he has written—and continues to write—about. Welch quite deliberately confesses his likes and dislikes as a gentleman would. His taste, though, is never snobbish. Nor can he be accused of narrowness, being a self-proclaimed Charlie Parker fan from the age of ten; an early agent of the greatness of 1960s British pop and rock, embracing bands such as the Rolling Stones, Kinks, Graham Bond Organisation, Spencer Davis Group, Cream and the Who; and a fan of Megadeth by the late 1980s. For five years (1988–1993) Welch was also the editor of the heavy metal magazine *Metal Hammer*. Since then he has worked as a freelance writer and through the years he has authored the liner notes for quite a few LP and CD releases.

The centrality of Welch's criticism, from a historical perspective, is greatly due to the fact that his writing career developed at the same time as the British beat and R & B boom really took off, and the fact that *MM* was the first paper to apply more critical journalistic standards as well as musical criteria in describing these events. Hence, in the case of Welch the cliché "right place, right time" seems to apply well. As he describes, it was an "exciting" time:

> The Beatles and the Stones, The Who, the Kinks, there were so many groups. It was very exciting. And every week there was a new band to write about. You'd hear about some great new group coming up in the club scene, and half the fun was actually discovering new groups and helping to encourage them and write about them in their early days. A lot of those groups became fantastically successful over the years. (telephone interview, December 9, 1998)

It should be kept in mind that the music industry looked very different in the early 1960s than it did in the 1980s and 1990s. Before the Beatles, and even into the 1970s, not only critics but the industry as a whole was more naive in the sense that promotional campaigns and economic investments in artists were of an altogether different dimension, if they existed at all, than in the MTV age. Therefore the role of the critic was also different, in that the greatest thrill of the job might very well be—as Welch describes above—to discover and inform the public about new and exciting bands.

Chris Welch's "gentlemanly attitude" nevertheless implies more than a wide musical taste and the encouragement of new artists. He also deliberately tries to avoid "sour" criticism, not wanting to offend either the artists he writes about or their fans. For Welch, criticism is entertainment, just as he thinks musical listening should be entertaining. Welch's distinctive mark as a critic is his striving to understand the "intention" of the artist. His aim is to write from a position of closeness—or, as he expresses it himself, "the best he can do" as a critic is to "understand what a musician or band is after." He conceives of his job as interpreting and mediating these "intentions" to the readers, whom he envisions as potential fans (personal interview, January 20, 1999). Thus in his texts Welch never aims at representing rock as "art" or endowing it with "high art" values. His obligation to treat the "incredibly fascinating music" he came to know from 1964 onwards more "seriously" is rather directed towards the artists, because they deserve better, and the fans, because they deserve to get to know the good stuff. Some of the discussions on "value" and "authenticity" anticipate discursive strategies to be employed by writers of later periods. At times these strategies apparently emanate from the "intentions of the musicians" (which Welch is eager to mediate) particularly as regards the construction of their image: an aspect that Welch not only circulates but also co-constructs and adds to as a writer.

His own "intentions" aside, Welch, through his idea of capturing "what the musicians are after," signals a new "era" of rock criticism that aims at treating the music as a more complex form of expression rather than simply as entertainment or a teen phenomenon. In Britain this change takes place first and foremost in *MM* and somewhat later in *NME*. As critic Chris Charlesworth (b. 1947) of *MM* (later editor of Omnibus Press) maintains:

> Until the mid 1960s, or late 1960s, there was no serious rock criticism in the music magazines, they were more trivial, if you know what I mean. [...] In 66 all you could read in America was teen papers, like *Sixteen* magazine, and it was just kind of "what is your favorite color?," you know what I mean, and "look at George's new hair style," "look at Paul's new suit," you know it was not talking about John's lyrics, right? (telephone interview, December 9, 1998)

Hence, Charlesworth concludes that "*MM* was the first to treat rock music as a serious art form." Moreover, as Charlesworth points out, Chris Welch was probably the 1960s British music journalist who came to "know the artists best" not only through listening and writing but also on a personal level (ibid.). This is evident also in Welch's texts, as he did not simply write news and reviews, but

also challenged genres by developing more "live" forms of reportage. For instance, he would accompany artists on their tours and late night parties, which made possible reports like "Spencer Davis—King of the Ravers." As he writes, "anybody who joins them on the rave belt is liable to end up penniless at 5 a.m. on the Thames Embankment unsteadily thumbing a lift home."

A central characteristic of Welch's criticism is that he comprehends the music both as a serious matter and as entertainment. In other words, he embraces the "fun" as well as the musical and the "fan" aspect of it. As the Spencer Davis report continues, we find out —under the subtitle "Bottles"—that the boys in the group are geared up to visit several places during the night, among them a "famous beat people's youth club" where the chief Beatle, Lennon, "roared off into the night." And as the story ends:

> Came 4. a.m. All the money gone, and the bar closed. "Does anybody want to come and hear Alex Welch," demanded Pete. "Yeah!" shouted Stevie, but for once Muff's will prevailed and it was argued to bomb back to the hotel. I sadly waved farewell as their van rattled away. Sadly because it was time to make that walk to the Embankment.[17]

Welch often also adopts an attitude common in jazz criticism; for instance, he comments on the individual *skills* displayed within a group performance, be it a drummer's or guitar player's standard in comparison with other well known performers of the day. By profession he is definitely a journalist, and as he admits today, whenever he goes to a concert—even if he is not called to do a job—he cannot avoid bringing a notebook and taking notes (personal interview, January 20, 1999). As he also admits, it might sound like a silly thing to do, but the act of taking notes wherever he goes to hear music has become part of the man's habitus.

Welch most often works within fixed journalistic genres. Yet during the 1960s there was also a considerable development of these genres, and as Welch points out, writing processes changed with the development of new technology. In the early 1960s, interviews were usually short in length and often based on standard questions. "We were using typewriters. And as a newspaper we were limited in space. The most you could write would be about 400–500 words, maybe less. A long article would be center spread, and that would only be about 750 words maybe, if you were lucky!" (telephone interview, Decem-

17 Welch, Chris (1965): "Spencer Davis—King of the Ravers," *MM*, September 25.

ber 9, 1998). With the invention of the portable cassette recorder in the 1970s it became easier to record interviews. According to Welch, this had an immense influence on the development of rock criticism, but he himself definitely belongs to the caste of "scribblers":

> In the 1960s everything was done by notes. You had to scribble. That made it quite hard and difficult—in a way it was good because it meant that you only got the important points of what somebody said, the nitty gritty. Now people do interviews with tape recorders, and you get an hour of words [laughter]. (personal interview, January 20, 1999)

In many respects, Welch's strength is that he possesses what is referred to as a "good pen," which often results in rich and entertaining pieces. A good example of this is his description of the atmosphere surrounding a home interview with a not quite prepared Eric Clapton. We quote a larger segment in order to illustrate Welch's ability to take his readers along with him to his meetings with the musicians portrayed, in this case Cream's front man. Welch employs a number of narrative strategies to underscore the excitement of the meeting, and not least, the distance between reporter and "star" guitarist already annointed as "God" by fans and fellow musicians.

> When Eric makes his rare visits home he lives in a rambling collection of art studios in Kings Road, Chelsea, reached by twisting, dark staircases covered in chickens. A ghostly voice whispered through the intercom in answer to my ring: "He is asleep." But the door was opened by remote control, and I picked my way up the stairs through clouds of chicken feathers. Not a soul was to be seen. Silence prevailed.
>
> I stood uneasy in a corridor trying not to look at fearsome modern paintings glowering and gibbering from the walls. Suddenly the ghost materialised from a room, a pale faced, slim young woman, looking as if she had just been in spiritual contact with Edgar Allan Poe.
>
> "He is in there." A dropping arm indicated another room. "Will you go in," "Well, actually, I wonder if you would mind going?" I tried to force a smile, and inwardly cursed myself for not having brought garlic and a small wooden stake. But the girl seemed to understand my request and without raising objections or indeed making any sound at all, drifted towards Eric's chamber and opened the door.
>
> "Eric—are you awake? There is a gentleman to see you," she called softly. I caught a glimpse of a white face, covered in long black hair, lying on a pillow. A deathlike croak emitted from the lips of the prostrate figure, followed by a groan of recognition.

As he was probably on an astral flight and was hauling his spirit back into his body by the old silver cord trick, I adjourned to yet another room to wait for the completion of such tasks as the donning of trousers and the cleaning of teeth. Meanwhile the girl had vanished. [...] Eric appeared some minutes later, moustached and cheerful, the bright sunshine fighting through the studio windows obviously having a refreshing effect. ("Clapton—Back to the Blues," *MM*, May 4, 1968:11)

As far as Welch's later efforts are concerned, his biographies are often very straightforward, yet informative. Among the best is probably the Winwood biography (1989), which is based on a lot of original interview material. Others, like the ones on Tina Turner (1986/1994) and Cream (1994) seem a bit short on research and material.[18]

Yet, in order to contextualize Welch's position as a critic and describe the historical significance of the criticism evolving in *MM* during this period, some further historical lines have to be drawn. These lines, which lead to the genesis of rock criticism in *MM*, are chiefly: (1) the reception of popular music in Britain and the rise of various popular music magazines and papers; (2) the tradition of British jazz criticism in *MM*; (3) "folklore" discourse and notions of "authenticity" embraced by musicians and critics from the 1950s on; and (4) a shift in notions of "authenticity" from "folk authenticity" ("authentic blues," "real R & B," etc.) to new conceptions predicated on "originality" and "Britishness" mediated by musicians and writers in the mid-1960s.

Changes in the Reception of the Popular
When Chris Welch joined *MM* in October 1964 he was the periodical's youngest reporter. *MM* had been founded as the house journal of London music publisher Lawrence Wright in 1926, yet very soon the paper became an independent monthly aimed at dance band musicians. In 1933 it became a weekly and gradually developed to focus on jazz and the dance music of the day. According to Welch, in 1964 most of the staff were still jazz writers. From the middle of 1963, and particularly in 1964, *MM*'s front pages reveal a change of policy with the introduction of color photos, primarily depicting the Beatles. The man behind this, who also wrote most of the Beatles interviews featured in *MM* during

18 The Cream biography seems very much based on Welch's interview material from the 1960s, yet the style is unmistakably that of "fan" literature. The same could be said about the Hendrix biography (1972), though this book is interesting not least because it is the first biography on Hendrix, and apart from Hunter Davies's book on the Beatles (1968), one of the first rock biographies in history.

this period, was the then news editor Ray Coleman. The week Welch began on the paper there were even rumours that *MM* was soon to close as its circulation was down to around 40,000 a week.[19] The same year (1964) the circulation of its competing music weekly, *NME*, was 269,000, a figure that reached its all-time high a year later at 307,000.[20] Much of the difference between the papers had to do with the popularity of the Beatles and the fact that *NME* from its start in 1952 was much more oriented towards dance music and pop than *MM*. *NME* was a relaunch of the original *Musical Express*, which had been struggling along for the previous six years. Nevertheless, under its new owner, Maurice Kinn, it reached a new market and throughout the 1950s it covered the events of pop and rock 'n' roll to a far greater extent than did *MM*.[21]

It is important to note how the increasingly popular American rock 'n' roll, in particular in the wake of the success of Bill Haley and Elvis Presley, was received by the British press. In 1955 the emergence of rock 'n' roll was more or less silenced in the pages of both *MM* and *NME*. However, in the May 5, 1956, issue of *MM*, critic Steve Race describes in detail the "terrifying" threat rock 'n' roll represented to the jazz aesthetic of the day:

> Viewed as a social phenomenon, the current craze for Rock-and-Roll material is one of the most terrifying things ever to have happened to popular music. [...] Musically speaking, of course, the whole thing is laughable. All the composer has to do is to remember the 12-bar blues, dot it out with the usual melody line, and put the copyright stamp on the bottom. [...] The Rock-and-Roll technique, instrumentally and vocally, is the antithesis of all that jazz has been striving for over the years—in other words, good taste and musical integrity.[22]

One interesting point is that the breakthrough of rock 'n' roll here is described in derogatory terms as a symptom of "Americanization," whereas the popularity of American artists such as Frank Sinatra, Billy Eckstine and Sarah Vaughan,

19 According to Welch. According to *Benn's Press Directory* (1964) the average sale of *MM* in 1964 was 77,000. Yet, as Welch reports, "The week I joined, they were talking about closing the paper, the circulation was down so low, I think it was about 40,000, and somebody said, you know it's gonna close soon—the day I joined! Oh, yeah, great! Thanks! Ha, ha. Bad news!" (personal interview, January 20, 1999).

20 According to *Benn's Press Directory* (1965).

21 A retrospective look at the first 20 years of *NME* is offered in an article by Derek Johnson (1973): "The Day They Put the New in Musical Express," *NME*, March 10:15.

22 Race, Steve (1956): "Steve Race," *MM*, May 5:8.

all featured on the front pages of *MM* or *NME* in 1955–1956, are not considered to represent such a trend.[23] In the same piece quoted above, Race writes:

> Comes the day of judgment, there are a number of things for which the American music industry, followed (as always) panting and starry-eyed by our own, will find itself answerable to St. Peter. It wouldn't surprise me if near the top of the list is "Rock-and-Roll." […] It is a monstrous threat, both to the moral acceptance and the artistic emancipation of jazz. Let us oppose it to the end.[24]

Race's review of Elvis Presley's single "Hound Dog," from the October 10, 1956, issue, seems the classic example of how this new music was conceived of as the opposite of what was reckoned to be "good" popular music.

> When Hound Dog was released—and believe me "released" is the word—I sat up and took rather special notice. Lo these many times have I heard bad records, for sheer repulsiveness coupled with the monotony of incoherence, Hound Dog hit a new low in my experience. […] There must be some criteria left, even in popular music. If someone is singing words, which have been set to music, one surely has the right to demand that the words are intelligible? […] How much further can the public be encouraged to stray from the artistry of Ella Fitzgerald, and the smooth swinging musicianship of Frank Sinatra?[25]

Cultural theorist Iain Chambers argues that "the apparently effortless transition between the different worlds of Britain and "America" had by the late 1950s become a distinctive feature of much of the former's youth culture" (1985:1). As he points out, African American music has been crucial to developments in white popular music since the beginning of the century. Nevertheless, in Chambers's view, "writers in *MM* began a campaign to silence rock 'n' roll."

> The musical language of rock 'n' roll was foreign compared to what had previously dominated British tastes. The majority of objections raised by the popular

23 *MM* critic Tony Brown is more positive in his interpretation of Elvis, if only a bit, as he writes: "It is one of the embarrassments of democracy that this is the age of the common man. The achievement of fame in popular music today demands a rabble-rousing technique. Elvis Presley has it. […] Though I shall never buy a Presley disc, I don't hate him; and I can listen to his records without either foaming with ecstasy or fuming. Vaguely, they depress me" (Brown, Tony [1956]: "Elvis Presley," *MM*, July 21:3).
24 Race, Steve (1956): "Steve Race," *MM*, May 5:8.
25 Race, Steve (1956), *MM*, October 10; quoted from Chambers (1985:30).

music establishment insisted that rock 'n' roll was loud and brash, that, quite simply, it was not music but a noise, and worse still, a vulgar commercial noise. (21)

Thus, in the mid-1950s British music critics found themselves caught between be-moaning the "low quality" of the new American music and being forced to cover it because of its popularity. On April 7, 1956, *MM* introduced the American practice, inspired from *Billboard's* "Hot Hundred," of carrying a weekly Top 20 chart of the best-selling records. Its rival, *NME* had introduced its "Top Twelve" already in 1952.

In sum, throughout the 1950s *NME* was the British paper most oriented to-wards the expanding pop and rock 'n' roll scene, even though the angle was to treat it as a youth phenomenon. One minor competitor from this period was *Disc*,[26] a national pop weekly that started in 1958 and mainly covered teen idols. Another, which expanded dramatically during the early 1960s was *Merseybeat*, which was launched in Liverpool in 1961. Following the success of the Beatles and other Merseyside groups, *Merseybeat's* readership grew from some 5,000 to around a quarter of a million in a few years (Betrock 1991:36). In 1965 it changed its name to *Music Echo* and began featuring color covers, lots of gossip columns and a full page per week on Merseybeat groups. In 1966 *Disc* and *Music Echo* merged into one magazine, still very teen and pop oriented. Another British magazine that gained some popularity was *Record Mirror*, started in 1954 and operated un-der various names[27] until it was finally incorporated into *Disc* in 1972. As the editor stated in its first issue in 1954, "[t]he *Record Mirror* is designed to appeal to music fans of every taste."[28] In 1963 *Record Mirror* jumped on the British beat wagon. The paper also featured interviews and reviews, whereas the front pages were typi-cally covered by pictures under headings such as "Names and Faces."[29] Its August 10, 1963, issue features a large picture of the Beatles under the title "The Beatles on the Beach," with the additional question: "Could this latest picture revive the Victorian swimsuit style?" The interviews, likewise, deal less with musical ques-tions than with remarks such as "The Beatles, four young men with haircuts un-like Elvis' for a change."[30] Finally there was *Pop Weekly* (1962–1966), a guide to

26 Known as *Disc* (1958–1964), *Disc Weekly* (1964–1966), *Disc & Music Echo* (from 1966), and *Disc* (1972–1976; incorporated with *Record Mirror*).

27 *Record Mirror* (1954–1959), *Record and Show Mirror* (1959–1961), *The New Record Mirror* (1961–1963) and *Record Mirror* (1963–1972).

28 "Editorial for the Record" (author not indicated), *Record Mirror*, June 17, 1954:2.

29 *New Record Mirror*, March 23, 1963:1. The front page carries pictures of the Beatles, the Cou-gars, Tornado George Bellamy, the Cascades, and Ruby and the Romantics.

30 "The Beatles on the Beach" (no author indicated), *New Record Mirror*, August 10, 1963:1.

British pop events, focusing on idols like Cliff Richard and Billy Fury. A great number of fan magazines also followed in the footsteps of the greatest idols of the rock and pop world, namely Elvis in the 1950s and the Beatles in the 1960s. Yet all of these featured pure fan material rather than any sort of music criticism.[31]

The change initiated by *MM* in 1964 effected an application of critical standards to pop and rock instead of simply dismissing the music as "low," or one-sidedly treating it as "popular" from a trade or teenage idol perspective. *MM* was also able to maintain its reputation as more of a "musician's paper" than any of its competitors. The decision to hire a youngster and start covering the new beat groups at the expense of jazz coverage, was obviously a deliberate market-oriented strategy, but it did not mean that *MM* had "sold out." As Chris Welch points out:

> That is why they employed me, they wanted somebody to write about that music. They needed a younger reporter to cover the rock and pop groups. It definitely was a change from on top, editorial change, to brighten up the paper and make it more up to date. (personal interview, January 20, 1999)

MM critic and news editor Ray Coleman managed to combine the massive public interest for the Beatles with music criticism by inviting the Beatles members themselves to review the new records of the week. In the initial installment of the series "A Beatle A Week," on January 18, 1964, John Lennon reflectively evaluated 12 new record releases by artists ranging from locals, such as Georgie Fame and Manfred Mann, to Ray Charles.[32] The reviews are accompanied by pictures of the famous Beatle as he responds in various ways throughout the listening process. The next week featured McCartney as reviewer, and so on. The idea was to hold on to both sides of the coin, as Chris Welch describes it, to secure "commercialism" and "musical integrity" at the same time.

> A "Beatle a week," in the 60s, would be wonderful because, you know, nobody could get enough of the Beatles. And you could have four weeks, per week guarantee, then it was four weeks sales guarantee. So, it was a kind of commercialism, and musical integrity, hopefully at the same time. (personal interview, January 20, 1999)

31 Among magazines outside the U.S. and Britain worth mentioning are the French magazine *Disco Review*, started in Paris in 1961, chronicling French pop but also covering the British/American beat and rock explosion in the mid-1960s.

32 Lennon, John (1964): "John Lennon Reviews This Week's New Pop Records," *MM*, January 18:9.

Coleman also followed the Rolling Stones closely very early in their career, and in a detailed "on tour" reportage with the band from March 1964 he makes the Stones listen to and comment on the latest record by the Beatles.[33] Most significantly, Coleman poses more critical questions in his interviews than is usual for the period, and he makes use of descriptive and narrative techniques which aim at depicting the character of the artists as well as the distance between artist and journalist. For instance, as he writes in his tour reportage on the Stones: "Charlie Watts, the drummer, sidled over and eyed me with suspicion, as if I was about to sell him a second hand car."[34] In many respects Ray Coleman paved the way for the kind of music journalism that Chris Welch would represent. And as Welch points out, Coleman, not least because he was a professionally trained journalist, posed tougher questions than most other critics of the day. What is interesting is that also the artists seemed to appreciate that:

> Ray Coleman had a special relationship with the Beatles, he knew them very well. He knew everybody from Liverpool, and Brian Epstein, their manager. And Ray got very good interviews with them, because as a journalist he asked some direct questions in a way that was much more professional than the average music paper journalist. He was a trained Fleet Street journalist. He was tougher in his questions with the Beatles, and they actually liked that rather than being asked "what will you have for breakfast?" Ray Coleman and the Beatles had a special relationship that helped *MM* an awful lot. So we could have front page interviews every week. And that certainly boosted the circulation.[35]

In retrospect, the criticism of Welch and Coleman seems more in accord with what would become the canon of rock than most of their *MM* colleagues from this period. Several examples might be given, yet Bob Dawbarn's review of Dylan's single "Like a Rolling Stone" in 1965 (titled "THANK GOODNESS WE WON'T GET THIS SIX-MINUTE BOB DYLAN SINGLE IN BRITAIN") will suffice to illustrate the point. In his review, Dawbarn describes the lyrics of the song as a main "problem"; he does not have much positive to say about the musical performance, either. As Dawbarn writes:

33 Coleman, Ray (1964): "Would You Let Your Sister Go with a Rolling Stone?" *MM*, March 14:8.

34 Ibid.

35 Chris Welch, personal interview, January 20, 1999. Coleman also wrote a biography on John Lennon (1984) as well as biographies on several other artists.

To start with, Dylan is saddled with a quite horrific backing dominated by syrupy strings, amplified guitar and organ. Mick Jagger fans will also be distressed to learn that the song title refers to a rolling stone and not a Rolling Stone. The lyric has its moments of typical Dylan imagery, but the monotonous melody line and Dylan's expressionless intoning just cannot hold the interest for what seems like the six longest minutes since the invention of time.[36]

As we now recognize, "Like a Rolling Stone" set a new standard for the length, style of performance and character of a rock tune. In this sense, Dawbarn's review is reminiscent of Steve Race's reception of Elvis in the 1950s, in that rock is evaluated by a different set of criteria than those evolved by critics such as Welch and Coleman.

What is at stake in this period is the development of a critical discourse trying to get in tune with the emergence of new stylistic criteria among musicians and the public. And vice versa: new stylistic criteria develop within the discourse circumscribing a musically innovative practice, a process in which the "clergy" of critics play a crucial role. A significant change had taken place in that British musicians and audiences had gradually steeped themselves more in African American influenced popular music. Hence, these musical styles were conceived much differently in 1964–1965 than in 1954–1955. Central to this picture is the fact that African American music (such as blues and R & B) had a different impact on young British musicians than it had on their American counterparts, and that the rock criticism evolving at *MM* was anchored in the attitudes of the musicians themselves more than in anything else.

In sum, we see in this period a significant shift in criteria and attitudes, from the way the mid-1950s Elvis, or Dylan's mid-1960s escapades into rock, were at first received by conservative critics such as Steve Race and Bob Dawbarn. For writers such as Welch and Coleman, the main point was no longer that the music was "popular," but that the "popular" music they were engaged in had qualities that might be evaluated more or less regardless of its popularity. As Welch maintains, there was so much "good music" they could write about. At the same time Ray Coleman would even confront the Beatles with critical questions, a hitherto unheard of practice in fan and trade magazines.

36 Dawbarn, Bob (1965): "THANK GOODNESS WE WON'T GET THIS SIX-MINUTE BOB DYLAN SINGLE IN BRITAIN," *MM*, August 7:7.

Influences from Jazz Criticism
The long tradition of jazz criticism exerted significant influence on the fledg-
ling pop and rock criticism at *MM* in this period. In this context it should be
remembered that the classification of musical styles into categories such as
"jazz," "pop" and "rock" always deals with labels in flux within discourse and
not with concepts of an ontological character. As we know, swing and big
band jazz was the "pop" of its day. Nevertheless, as we have stressed, it is not
simply a game of changing names for the same content. Any analysis of style,
in order to claim validity, has to be situated in a historical and cultural con-
text.[37] Hence, in the interpretation of Iain Chambers, the emergence of Elvis
Presley and rock 'n' roll in the 1950s signals not only a new era of "pop cul-
ture" but more generally what he terms "living in the modern world" (1985:1):
"The shiny surfaces of contemporary urban culture mock earlier aesthetic
securities and bounce previous criteria back in the shocked faces of its critics,
effectively locking them out" (1985:2).

It seems important to emphasize that the so-called transition between Ameri-
can and British culture (Chambers 1985) is more complex than simply a meet-
ing between "cultures," as technological changes and the development of "me-
dia culture" anticipate the processes that Hannerz (1992) comes to describe as
"cultural complexity" and that Appadurai (1990) terms a new "global economy."
Nevertheless, the American influence on popular music in Britain in the 1940s
and 1950s was not new, since *MM* was very much a jazz paper already in the
1930s. The interesting point is that in many respects the rock criticism emerg-
ing at *MM* from 1964 onward was not so much of a break with the tradition of
jazz criticism as a prolongation of it. This is what distinguished the criticism
emerging at *MM* from that of its main competitors.

In jazz criticism a set of criteria for writing about and evaluating jazz had
already been established in the 1930s and 1940s.[38] As *MM* critic Bill Elliot wrote
in an article titled "20 years of Recorded Jazz," celebrating *MM*'s 20th birthday
in 1946: "To mention only half of the discs issued during the last 20 years would

37 For further references and discussions on the musical and cultural significance of the concept
 of style, see Feld and Keil (1994).
38 Some highlights of jazz criticism are collected by Gottlieb (1996) and Walser (1999). In Eu-
 rope, one in fact finds jazz criticism dating as far back as 1919, when the great conductor
 Ernst-Alexander Ansermet (who led the first performance of Stravinsky's *The Rite of Spring*)
 wrote a review of Sidney Bechet's visit to Europe that appeared in the French journal *Revue
 Romande* in 1919. It was reprinted in the journal *Jazz Hot* and a translation of the article is
 featured in Gottlieb (1996:741–746).

take up most of the paper for the next twenty."[39] The strategy adopted by Elliot is rather to summarize a canon by outlining the initiators of specific styles and singling out records that appear "good." A central point in this early period of jazz criticism is the canonization of certain records considered "hot" as opposed to those considered simply "popular" or, as Elliot writes, "commercial": "Columbia, who up till then had pursued a strictly commercial policy, began to see the trend of things and started a hot catalogue, issuing in the first list, sides by Nichols, Venuti, Ellington and Fletcher Henderson."[40] The conceptualization of certain records as "hot" undoubtedly seems imprinted by "otherness" in anthropological terms.[41] There is a certain mystery and exotic element ascribed to the listening experience and not least to the act of collecting these records. Even if the concept of "authenticity" was not employed by the critics at this stage, the establishment of the poles "hot" versus "commercial" anticipates the constructions of the "serious" versus the "commercial" (and later "progressive rock" versus "pop") to be developed within the field of rock criticism by the late 1960s.

Being a paper catering to musicians, the impact of jazz criticism at *MM* grew with the increasing jazz interest in Britain throughout the 1930s and 1940s. The British "Dixieland" revival in the 1940s, based on 1920s New Orleans–style jazz, was predominant, until "revival" musicians like Chris Barber entered the skiffle scene. The most prolific and influential jazz critic to have worked at *MM* is undoubtedly Max Jones (1917–1993), who had a direct impact on rock critics such as Chris Welch and Ray Coleman. As Welch recalls, Jones and Bob Dawbarn were inspirational not least because they represented a certain journalistic standard: "They knew so much about music and they knew so many people, and you felt like you had to come up to their standards. You had to be as knowledgeable as they were" (telephone interview, December 9, 1998). The central point here

39 Elliot, Bill (1946): "20 Years of Recorded Jazz," *MM*, January 26:5.

40 Ibid. In his account of a canon Elliot mentions the appearances of Paul Whiteman and the first releases of "hot" records, for example those of Jelly Roll Morton and his Red Hot Peppers (in 1927), as well as the first records of Bix Beiderbecke, Red Nichols and Bing Crosby (in the article spelled respectively as Bix Bidlebeck and Byng Crosby). Within this period there had also been controversies. For instance, at first, Duke Ellington's band had been received as "lacking in tone and musical finesse" (ibid.).

41 Another early critic, the Belgian Robert Goffin, invoked similar "noble savage" stereotypes in a 1934 article titled "Hot Jazz" (collected in Cunnard, Nancy (ed.) [1934]: *Negro: Anthology Made by Nancy Cunnard*, London: Wishart and Co.; reprinted in Walser 1999:82–86). The same year, the editor of the French journal *Jazz Hot*, Hugues Panassié, released his influential book *Le jazz hot*.

is that Chris Welch—who was also a jazz fan—would apply jazz critical criteria to a rock or pop performance.[42] In fact, Welch points to the tradition of jazz criticism at *MM* as a most empowering factor for the development of a new kind of rock criticism:

> That's where *MM* scored because we had that jazz tradition, so we would listen to contemporary music from a jazz critic's point of view. That was a central difference between us and *NME*. We applied jazz standards to rock musicians. You know, saying well, can this guy play? [...] We applied the same sort of standards in reporting about rock music that we did writing about jazz, taking it seriously. (personal interview, January 20, 1999)

In terms of creating a legitimating discourse, this point seems quite important. Since jazz was already considered as more "serious" than other forms of popular music, the strategy employed by the critics at *MM* indicated that rock was worthy of close attention in the same manner. Before this, the performance of rock 'n' roll or pop was not thought of as requiring any particular competence, since the music was judged primarily in terms of sales potential and entertainment value by critics as well as fans. Therefore it indicates a major shift that rock musicians from now on are also judged in light of their "competence" and "skill," criteria adopted from jazz criticism. As noted above, Chris Welch would also adopt the jazz critic's practice of evaluating individual performances within a band in terms of musicianship and individual expressive abilities. This marks a very significant increase in "respect" for the musicians.

> If I was writing about the Spencer Davis Group or Georgie Fame's Blue Flames, I would adopt some of the jazz writer's way of looking at a band, you know. I would think about how good the musicians were, like the drummer or the guitar player. And apply some kind of jazz standard to the writing and appreciation of the music [...] give them the same respect as you would give to a jazz group, I think that's the important thing. And they appreciated that, the bands appreciated that, because for most pop interviews people would say "what did you have for breakfast and what is your favourite toothpaste," you know. (telephone interview, December 9, 1998)

42 As Welch points out: "I liked jazz as well. I always liked traditional jazz, modern jazz, swing, big-bands, so it was perfect really. Although I was supposed to concentrate on pop and rock music I could occasionally write about jazz too. It was very few boundaries then, say, one day I could write about The Shangri-Las, and then maybe interview Roland Kirk, or Dave Brubeck's drummer, Joe Morello" (ibid).

By applying what he terms "jazz standards" to rock criticism, Welch also received sympathetic response not least from the musicians he wrote about. This recalls Welch's main "intention" of trying to write sympathetically, and of trying "to understand what they were trying to do" (personal interview, January 20, 1999).

Another important point is that not only critics but also many musicians had a background in jazz. During the early 1960s there was a close affiliation between British jazz and the emerging R & B scene. Some musicians also began playing what was then termed R & B mainly because it offered a better income. As Welch wrote, under the explicitly ironic heading "The Brain Drain! The Men Jazz Lost To Pop," in *MM*, January 23, 1965: "[S]everal jazzmen, in the spirit of 'if you can't beat 'em, join 'em,' turned their talents to R & B." Among the musicians mentioned in Welch's article are Georgie Fame, Brian Auger, Ronnie Scott and Graham Bond. This implies that the musicians' choice of "genre" was often pragmatic as they wanted to reach a potential audience.

In sum, the impact of jazz criticism is considerable because (1) jazz critics' criteria were applied to rock criticism; (2) writers such as Welch and Coleman were influenced by the journalistic standard and musical knowledge of jazz critics like Max Jones and Bob Dawbarn; (3) a new sensibility regarding individual musical skills and expressive abilities among beat, rock and R & B musicians was adopted from a jazz listener and critic's point of view—an approach unforeseen in earlier "fan" or "trade" magazines; and (4) the idea of conceiving of rock as more "serious" music (not simply "commercial") was apparently influenced by jazz criticism.

As such, rock was no longer simply "easy" listening, "dance" or "teen music"—in order for people to engage in the music there was a demand for more "serious" involvement and investigation. Throughout the 1960s, Chris Welch points out, the central issue becomes that more "in depth" music demands more "in depth" criticism:

> When Frank Zappa and the Mothers of Invention came along, I mean, that was clearly music that required a lot of understanding and in depth analysis. And bands like Cream and the Jimi Hendrix Experience, they were making music that demanded people to take it more seriously and investigate it. (personal interview, January 20, 1999)

Apart from what has been mentioned here, jazz criticism in Britain had been strongly influenced by American jazz criticism. For instance, *Down Beat* (started in Chicago

in 1934) was read on both sides of the Atlantic.[43] At the same time, in the 1950s and 1960s, jazz critics generally had the least favorable views of pop or rock.

The Impact of "Folk Authenticity"

Just as jazz criticism seemed to inspire writers to consider rock as more "serious," the influence from "folklore" discourse—and not least the construction of the African American bluesmen as living legends—illuminates certain ideas of "authenticity" that were central to the burgeoning rock discourse. This influence was of fundamental importance to the discourse as well as to the development of the British rock scene (then known as R & B) in general. The late 1950s experienced a booming interest in other American musical traditions than those embraced by the jazz "revival" scene, such as the folk music movement and not least what was considered the more "authentic" part of it, the African American blues.

The British music press started to take some interest in the subject just after the war, and in 1946 Max Jones wrote an article, "On Blues," for Albert McCarthy's *Yearbook of Jazz*. With Rex Harris he started a "Collector's Corner" column in *MM*, which included articles and discographical listings for such artists as Blind Lemon Jefferson, Barbecue Bob and Leroy Carr. The first African American solo blues singer to come to Britain was Josh White, in July 1950.[44] The most influential visit, however, was paid in 1951 by the legendary Big Bill Broonzy, who returned in 1954 and 1955. A concert review in *MM* praised jazz promoter Bert Wilcox for having the "courage" to bring Broonzy over. As Shapiro notes, "such were the expectations that one review described the singer's naturally stiff-legged gait as the cleat legacy of shifting bales of cotton" (Shapiro 1996: 59).

It was during Broonzy's visit in 1955 that Alexis Korner (1928–1984)—later reckoned as the pioneer and initial motor of the British blues scene—met Broonzy. A central aspect of the British apprehension of the blues was the experience of the blues as a "real" and "authentic" form of musical expression. The

43 The critic Leonard Feather (1914–1994), for instance, wrote for both British and American publications, among them *Down Beat*, the *Los Angeles Times*, *Playboy*, *Metronome*, *Esquire* and *Jazz Times*. Yet, also in America, jazz critics were predominantly white, with the exceptions—like LeRoi Jones (Amiri Baraka) (b. 1934) and Frank Kofsky (1935–1997)—being late (the 1960s on) and few. Jones was the first writer to question the problematic aspects of this misrepresentation in his article "Jazz and the White Critic," *Down Beat*, August 15, 1963:16–17, 34. See also Kofsky (1998).

44 Shapiro (1996:57). Guitarist and singer Lonnie Johnson had come to Britain as early as 1917 with a New Orleans review show. He came back in 1952, backed by Tony Donegan and his Jazz Band at the Royal Festival Hall (58).

blues was conceived of as "natural" and as the direct embodiment of "feeling" and lived experience. This apprehension of the "authentic" took on an almost religious dimension. As Korner later commented, "I got as close to worshipping Bill Broonzy as I've ever worshipped anyone in my somewhat unworshipful life" (quoted in Shapiro 1996:60).

To begin with, it was *MM* writer Max Jones who had to persuade Korner to go and talk to Broonzy, due to Korner's shyness and awesome respect for the "real" and "authentic," albeit living, bluesman. Korner and Broonzy soon became better acquainted, and a few days later Broonzy moved in to stay with his new British friend (Shapiro 1996:61). Korner would go on to exert a massive general influence on the British blues-rock scene in the 1960s through his playing with Cyril Davies and the Blues Incorporated, featuring numerous later-to-be-famous musicians, among them Jack Bruce, Mick Jagger and Charlie Watts. He also played with and inspired John Mayall, later to be held as "the father" of the British blues. This early R & B scene's appraisal of the "authentic" blues would lay an important foundation for the understanding of rock music—including the rock myths that were to flourish in the 1960s. What is less remembered is that Korner wrote journalistic articles on the blues on the side, in which he discusses questions of technique as well as questions of origin. The central criterion introduced by blues criticism is the concept of "feeling." Having "lived the blues," the performer is thought to be capable of mediating this "feeling" of life through his performance. This introduces a set of criteria that contrasts with most jazz criticism. For instance, as Korner writes in an April 19, 1958, article in *MM* on the bluesmen Sonny Terry and Brownie McGhee—with whom he played on their tour in England—"the twisting and mouthing of notes [...] gives ample proof of his [Terry's] feeling for the blues."[45]

Most of the article is devoted to a description of the background of these men and the fact that Sonny Terry recorded with Blind Boy Fuller in 1937. In many ways the mythologies of places and origins comprise the essence of the "authenticity" ascribed to the blues. As Korner mentions, Alan Lomax and John Hammond were the two men responsible for Terry's and Fuller's initial meeting. Blues criticism in Britain, as in the U.S., seems heavily influenced by the work of Alan Lomax,[46] who also figured as a writer in *MM*.

45 Korner, Alexis (1958): "The Terry-McGhee Blues Team," *MM*, April 19:6.

46 John A. Lomax (1867–1948) and his son Alan Lomax (1915–2002) created the Archive of American Folk Song at the Library of Congress in Washington, D.C., in 1928. Their work has been greatly influential on a number of writers, not least when it comes to how the blues has been rendered as American folklore. John Lomax also recorded more than 10,000 songs for the archive.

In the February 20, 1954, issue of *MM*, Lomax wrote a long and detailed article reviewing various blues records released in Britain. In many respects, blues mythology and blues criticism have not changed much over the years. The basic idea of the blues as a style and concept is depicted by Lomax in the opening lines of the article:

> Big Bill Broonzy makes the following sage observation about blues singers: "It takes a man that *has* the blues to *sing* the blues." Big Bill was thinking, first of the blue *feeling* of the uprooted, exploited and outcast Negro working men of the post-bellum South. And, secondly of the moaned and muttered complaints, workchants and hollers created by these men—songs which had their roots in African scales and which were decorated with embellishments foreign to Anglo-American music.[47]

The main criterion that sets the blues apart from jazz is that the blues is seen as a "natural" form of expression, whereas jazz is thought of as constructed, and, in Lomax's terms, as "artificial." As he writes:

> The early New Orleans Creoles, like Morton and Keppard, had never had the blues at all; their first arrangements of the blues are more Cuban than Missis-sippi. [...] All sorts of people, who had never had the blues in Big Bill's sense, began to perform and dilute them. With every step they took away from their country origins they lost some of their melancholy, some of their musical distinction: yet the blues are still powerful enough to add colour and punch to any jazz arrangement, no matter how artificial.[48]

As in early jazz criticism, one may see the construction of an "authentic" versus a "commercial" pole in this discourse. Yet the "commercial" in this context is the "arranged jazz." This polarization becomes explicit in Alan Lomax's description of the female blues singer Ma Rainey, whom he accuses of "selling" the blues rather than singing "from her heart."[49] Another significant criterion is that the blues can not be learned or mediated in a formalized way. As Lomax writes, the blues can not come "off a paper."

47 Lomax, Alan (1954): "Alan Lomax Reviews the 'Archives' LPs," *MM*, February 20:13; italics in the original.

48 Ibid.

49 As Lomax writes about Ma Rainey: "That Ma Rainey was the first woman singer to make a hit with blues recordings is, in my view, as unfortunate an accident as the early popularity of [Blind]

In this sense, the techniques of the blues—primarily associated with vocal stylings, acoustic (slide or bottleneck) guitar and harmonica—are thought of as the antithesis of the arrangements of jazz. In the expression of "blues feelings" there is no point in being clever. Rather the opposite: learned competence is eyed with suspicion.[50] The "blues" has to come "naturally," from lived experience, depression and the hardships of picking cotton. Thus, the "real" blues is less "commercial" and more "authentic" than jazz. What is at stake is a specific adoring construction of "the other" in an anthropological sense. On the other hand, it might be argued, due to the racism in America, it took the width and breadth of the Atlantic to comprehend African American music—like blues and R & B—as great musical forms worthy of attention also for a white public.

The criteria and distinctions embraced by American folklorists such as Alan Lomax seem important as they informed the disputes around "revival" traditions in Britain. Taking up similar claims for authenticity, Alexis Korner, in his July 28, 1956, *MM* article "Skiffle or Piffle?" trounces the British skiffle as a "monotonous mass of handclapping yahoos."[51] As Korner here claims, skiffle started in Britain after Ken Colyer's return from New Orleans in 1952, when Colyer, Lonnie Donegan, Bill Colyer, Chris Barber (or Jim Bray) and Korner himself formed the first British skiffle group. Initially the style was thought to represent a copy of "skiffle parties" known from the Chicago South Side. Yet, as Korner points out, this is a misleading assumption. Informed by Big Bill Broonzy's statement that "they used to have regular dance on Saturday night in his part of Mississippi which was called the Saturday Night Skiffle," Korner concludes that to produce skiffle sessions at British jazz clubs is "complete nonsense":

Lemon [Jefferson] was a fortunate one. Ma Rainey, whatever her background, spent her life in the Southern Negro vaudeville circuit, singing to straight piano accompaniment and "putting her songs across" in noisy theatres, *selling* them, so that many of the musical and emotional nuances are simply absent in her performances. [...] Often in these blues the rhymes are so pat, and delivered with such woodenness, you know that Ma had learnt them off a paper, instead of from her heart, from where the blues most come" (ibid.; italics in the original).

50 Nevertheless, Lomax also points out that playing guitar in the style of Blind Lemon Jefferson is not "simple" (ibid.). As such, one may be talking about different kinds of competence as well as a different set of criteria. At this stage, this is not theorized by Lomax. Keil (1966/ 1991), in musicological terms, claims that the difference is a matter of texture rather than formal structure: of "idiosyncratic qualities of sound" (Keil, 1966/1991:53).

51 Korner, Alexis (1956): "Skiffle or Piffle?" *MM*, July 28:5. In his Korner biography Shapiro claims that Korner "made his début as a journalist" in 1958, yet this skiffle piece appears two years before that.

Skiffle is, basically, an instrumental, not a vocal music and, furthermore, it is private music. To produce "Skiffle Sessions" as regular interval spots at jazz clubs, and worse still, to produce these same sessions at concerts is complete nonsense. On both these scores British skiffle—as I think it had better been known—is so far out of line that it bears but a superficial resemblance to the music which inspired it.[52]

An important aspect of the British skiffle scene was the amateurist movement it represented. Nevertheless, in the wake of the increasing popularity of the style, people like Korner would dismiss it on the grounds that it was no longer an "authentic" practice.

As within jazz criticism, one may also here see a polarization of the "real" and "authentic" as opposed to the "commercial." What is at stake in this process is therefore the construction of hierarchies of value—of "high" versus "low"— where the "authentic" becomes constructed as "high" in opposition to the "commercial" and "popular." The main strategy employed is that of the connoisseur demarcating a distance towards the "inauthentic." On these grounds the whole skiffle scene is dismissed by one of its original mentors, Alexis Korner, as nothing less than "abysmally low." As he writes, "British skiffle is, most certainly, a commercial success, but, musically, it rarely exceeds the mediocre and is, in general, so abysmally low that it defies proper musical judgement." On the positive side, Cyril Davies is said to play "fine Texas-style blues guitar" and perform in a way worthy of note.[53] In other words, as skiffle is dismissed a new "revival" is embraced. At first the only "authentic" blues was the acoustic "country blues," and in particular the style originating in Mississippi.[54]

This point leads us to some of the most crucial discussions at the initial stage of rock criticism at *MM* in 1964, forefronting controversies around the concept of "R & B." Influenced by various "revival" traditions and not least ideas from folklore about "real" forms of musical expression such as the blues, the concept

52 Ibid.

53 Ibid.

54 Influential on the blues criticism of this period were also Samuel Charters's *Country Blues* (1959) and Paul Oliver's *Blues Fell This Morning* (1960). At first, acoustic country blues was considered the only form of "authentic" blues by the folklore community. Later the electrified Chicago blues made a tremendous impact on the British scene, through the emergence of bands such as the Yardbirds, Rolling Stones, John Mayall's Bluesbreakers and Fleetwood Mac. The British blues and R & B record label Blue Horizon emerged as an outgrowth of Mike Vernon and Neil Slaven's dedicated revival magazine *R & B Monthly*, started in February 1964.

of "authenticity" is at the core of this discourse. In an article Ray Coleman sets out to answer the question "Just what is R & B?"[55] Coleman maintains that for weeks *MM* readers—having been informed "that Chuck Berry, Bo Diddley, and the Rolling Stones are R & B boys"—have been asking this question. In order to come to grips with the term, Coleman turns to the "knowers," Chris Barber and Alexis Korner, for proper definitions and explanations. As he writes, "to get the gospel truth, I asked Alexis Korner." And, at this stage Korner's answer is clear and explicit: "Rhythm-and-Blues is the popular music of the Negro at any given time."[56]

The most interesting part of the article, however, is Chris Barber's description of the turn from acoustic "purity" to the acceptance of electric instruments in British R & B. At first a "horrifying" thought to the purists, their conversion came only after a confrontation with Muddy Waters's own words and electric instrument on his visit in 1958:

> Getting down to the music, Barber recalls that when R & B giant Muddy Waters arrived here in 1958 to tour with Chris's band, he brought an amplified guitar. "Many blues purists were horrified, and asked Muddy why he did not bring a simple acoustic guitar." Last year, Waters arrived here for a tour—with the requested acoustic. But [...] "everyone's playing electric guitar—trying to sound like me," Muddy told Chris.[57]

Such American visitors had a great impact on the early 1960s British R & B scene. On the same page as Coleman's attempt at defining R & B there is another article on the New Orleans–born "barrell house" piano player Champion Jack Dupree, who claimed that he wanted to open a club in London.[58] Apart from those already mentioned, other influential visitors were Willie Dixon, Memphis Slim, Sonny Boy Williamson II,[59] Curtis Jones and John Lee Hooker. As the

55 Coleman, Ray (1964): "Just What Is R & B?" *MM*, May 9:7.

56 Ibid.

57 Ibid.

58 "I Want to Open a Club in London Says Dupree" (no author indicated), *MM*, May 9, 1964:7. Dupree had played with Alexis Korner already in the late 1950s and moved to Europe, playing with numerous young musicians all over Europe.

59 The harmonica virtuoso Rice Miller used the stage name Sonny Boy Williamson—he is known as "the second" because he first recorded after another blues harmonica player, John Lee Williamson, who was well-known as Sonny Boy Williamson (Alan Lomax made recordings with the first Sonny Boy in the 1940s). Many of those blues artists who came to England extended their influence as they played with numerous young British musicians, among them Eric Clapton and the Yardbirds.

young Brits did their best to copy and catch up with their mentors, Coleman quotes Chris Barber saying that "the Rolling Stones do a splendid job of country blues in the Bo Diddley style," whereas "Manfred Mann is playing a sophisticated form of blues, but it's still an authentic style of R & B."[60]

The impact of the concept of "authenticity" was of great significance to the nascent critical discourse in this period. The "folklore authenticity" embraces a different set of criteria than those inherited from jazz criticism as well as from writings embracing the "popular" as entertainment. The most significant difference is the stress laid on expression as "authentic feeling" based on cultural origins as opposed to learned skills or competence. As the criticism in this period illustrates, there is already a struggle going on with "authenticity" as its locus. In Britain it becomes fairly uncomplicated to embrace the original Mississippi blues as well as African American R & B as "authentic." But then there is the controversial question: How can British acts be "authentic"?

What is "Real" R & B Then?

At *MM* the disputes around "authenticity" continued, not least as the Rolling Stoes emerged as the main rivals to the Beatles. *M* critic Ray Coleman even had Muddy Water state that "they are my boys":

> Muddy Waters says [...] "They're my boys. I like their version of 'I just want to make love to you.' They fade it out just like we did. One more trip and they'll have it. Believe me, I'll come back one more time and then I won't need to come back no more."[61]

The main question was still whether Brits could play "real R & B" or not. This in turn lent itself to a discussion of the competence of the Rolling Stoes as musicians, and to judgements of the Stones' performances and music in general. At this point, the difference in opinion between the elder and younger generation of critics becomes apparent. As Bob Dawbarn writes, "as far as I'm concerned the Stones can keep on rolling—straight past my gramophone."[62] Dawbarn describes the musical performance of the Stones as "rubbish":

> My chief complaint against the Rolling Stones—and against virtually all of the so-called British R & B movement—is its utter lack of originality. There are doz-

60 Coleman, Ray (1964): "Just What Is R & B?" *MM*, May 9:7.
61 Coleman, Ray (1964): "Muddy Waters Says [...] " *MM*, May 23:9.
62 Dawbarn, Bob (1964): "Stones Stoned! Rubbish Says Bob Dawbarn," *MM*, May 23:8.

ens of Americans doing the same thing, only better. […] Now we have painful imitations of the Chicago Negro singers—listen to Mick Jaggeron "Walking the Dog" for a typical example.[63]

Ray Coleman, on the other hand embraces the Stones n musical grounds, just as he contributes to the construction of their image as the "rebels" who "move against conformity." Musically speaking, Coleman claims that the important thing is that Mick Jagger "has mastered the style, the feel of his music."[64] As Coleman writes, Jagger has "passion" and "drive" as opposed to "swing." Thus, one may see here the appearance of a set of criteria that clearly depart from those of jazz criticism:

> His singing is impolite. It has passion. He gets his message across, and imprints a song with his personality. […] Collectively, the Stones make a good old rip-snorting bluesy noise that thousands like, and I am among them. They don't swing much, but they drive and they generate. Their choice of songs looks pretty good to me.[65]

During this period, the Rolling Stones themselves were pretty outspoken on the matter as well. Mick Jagger even wrote his own article in the March 21, 1964, issue of *MM*, in which he underlines that the Stones mean business with their approach. The Stones know more about "real R & B" than their critics think. At the same time Jagger distinguishes their music from "real R & B," but defends the Stones by claiming that they have helped to rediscover many almost forgotten black masters.

> To the critics, then, who think we're a beat group who came up overnight, knowing nothing about it, we invite them to examine our record collection. It contains things by Jimmy Reed, Elmore James, Hooker, and a stack of private tapes by Little Walter. That's a good start. My big point, I think, is that these legendary characters wouldn't mean a light, commercially, today, if groups were not going round Britain doing their numbers. […] We feel strongly about our music in the Rolling Stoes. We love what we play. I get niggled about all this talk of desecration of real rhythm-and-blues. We don't claim to play real R & B.[66]

63 Ibid.
64 Coleman, Ray (1964): "Hands Off Says Ray Coleman" *MM*, May 23:9.
65 Ibid.
66 Jagger, Mick (1964): "The Rolling Stones Write for *Melody Maker*. We're Not on the Wagon! […] So Will the Shout-up Merchants just Belt-up." *MM*, March 21:3. And as he further claims: "But two years ago, I was an R & B purist. And I mean just that. I used to write thousands of letters to Pye Records, pleading with them to release Chuck Berry and Bo Diddley records, long before this beat thing got commercial" (ibid.).

The British R & B scene, exemplified by the Stones, was impregnated with conflict centering on the idea of the "authentic" in a "blues-roots" sense. At the same time, some critics cultivated another strategy, which connected up with the 1950s construction of rock 'n' roll as outrageous. The interesting point is that in this period is found the genesis of one of the most central and lasting myths in the rock field: that of the Stones—and "rock stars" in general—as the main "rebels" against the acceptable norms of the music industry and society at large. Coleman is once again at the forefront, depicting the Stones as the "band parents hate":

> What is your conception of the far out figures who make up the Rolling Stones? Nice boys—or ugly cave men? Do you wake in the night screaming with horror at the faces that stared at you from the TV screen a few hours earlier?[67]

Interestingly, the Stones themselves were at this stage a bit wary of such descriptions by the critics. As Mick Jagger told Coleman in an interview, "The first I knew about images was when the *MM* started asking us questions and there was a big thing in your paper about it."[68] Stones guitarist Keith Richards put it a bit differently:

> We're not deliberately untidy, said Keith. We think a lot of this "rebel" thing has been brought up by people thinking too much about it. People like you come up to us and say "are you rebels?" The answer is no.[69]

Nevertheless, the "rebel" image seemed important for the discourse, and as the myth was established, it took on a life of its own. Ray Coleman seemed a step ahead of the Stones themselves, if not of their manager Andrew Loog Oldham, in this respect. In the long run, the band members' initial "intentions" were to matter little; instead, the Stones seemed to live up to their reputation, adopting the attitude of a band that simply "did not care."[70]

67 Coleman, Ray (1964): "Mick Jagger of the Rolling Stones Asks [...] WHY DO PARENTS HATE US? I Can Tell You This Much—MY Parents Like ME!" *MM*, March 7:9. And as he wrote in another piece, the Stones hardly bother examining themselves before they wander out on the stage, hair-combing is rare, and they have the "anger of parents" on their side (Coleman, Ray (1964): "Would You Let Your Sister Go with a Rolling Stone," *MM*, March 14:8).

68 Coleman, Ray (1964): "Would You Let Your Sister Go with a Rolling Stone," *MM*, March 14:8.

69 Coleman, Ray (1964): "Rebels with a Beat!" *MM*, February 8:11.

70 An attitude exemplified already in 1964 by Keith Richards's answer to Coleman's question about the "hate of parents": "Another girl fan wrote to the Stones saying her parents had banned her from going to their concerts. "We don't particularly care," replied lead guitarist

The Emergence of Rock Criticism at Melody Maker

Thus, when Chris Welch entered *MM*, certain rock myths as well as the notion that some forms of popular music are more "authentic" than others were already established. In the years after 1964 some of these notions would be further enhanced and established as cornerstones of the discourse on rock. These were the idea of "musicianship" inherited from jazz criticism; the idea of the "subversive" "rock star," capable of transgressing all boundaries of social behavior; and the conception of "authenticity," inspired by folkloric ideology.

Even if this early period of rock criticism may be characterized by naïveté, certain tendencies appeared that were to anticipate some of the strategies employed by later agents in the field. The central point in this context is perhaps how the autonomous pole during the 1960s was enhanced, not least, by the arrival of what came to be termed "progressive rock." By the mid- to late 1960s, "the progressive" and the "authentic" almost became the antithesis of the "commercial." At the same time, critics felt free to consider "qualitative value" more or less regardless of "popularity" and sales numbers. Thus, the Beatles—who were undoubtedly the most "popular" of all 1960s bands—were held in high esteem by critics due to "qualitative" rather than "popular" criteria.

The last, yet significant, point to be brought up in this context is how the discourse of "authenticity" was gradually to expand and—in a chameleon-like manner—turn into a conceptualization of "artificiality," anticipating some of the critical strategies of early 1980s discourse. To begin with, the British R & B artists did the best they could to copy their American mentors. Gradually, however, the emphasis shifted from performance to "originality" and "authorship." An important factor in this context is—as Frith and Horne (1987) have described—the influence that British art schools exerted on pop and rock musicians in this period. The main point became not simply how well "the numbers" were performed (as in the review of the Stones above), but also how "creative" bands were in composing their original material. Here the Beatles were at the forefront, whereas the Rolling Stones gradually followed, and in their footsteps, a great number of bands, like the Kinks, Yardbirds, Animals, Spencer Davis Group, Who and Small Faces, and eventually bands like Cream and Fleetwood Mac, to mention only a few.

This move was initially very much linked to a shift in notions of "authenticity." It appears again with Chris Welch, among whose favorites was the young

Keith Richards, asked if they wanted to appeal to parents as well as to young people" (Coleman, Ray [1964]: "Would You Let Your Sister Go with a Rolling Stone," *MM*, March 14:8).

multi-instrumentalist and singer Stevie Winwood of the Spencer Davis Group, liked for the idiosyncratic qualities of his voice. As Welch maintains, the 17-year-old Winwood had a voice that made all his colleagues "rave about him," among them "Uncle Baldry, Pa Burdon, Old Man Farlowe and Big Daddy Lennon":

> Steve's voice alone comes as a big shock to the first time listener—not just because it can be described as "authentic," which usually means the singer is not entirely clueless, but because it is utterly devoid of pretension and is delivered at the same time with compelling authority.[71]

In his later biography of Winwood, Chris Welch elaborates on this point, claiming Winwood's voice to be the most "authentic" of the British performers', even though initially he had copied Ray Charles. To "explain" this impression, Welch consults Stevie's brother Muff, who says:

> When his [Stevie's] voice broke, just at the time he first heard Ray Charles, I think it made a very significant difference to how his career went. As his voice was breaking he kind of moulded it to sound like Ray Charles. While most people's voices break naturally, he forced his voice to sound like Ray and the moment it had finally broken it became *natural*, with a deepness and raspy sound that no other kid had got. If he had discovered Ray Charles two years later his voice may never have been what it is today. But as his voice changed from a child's to a man's suddenly, overnight he became a singer! (quoted in Welch 1989:40)

By magic, art or artifice, Winwood produces something "natural" or "natural-sounding." From this moment on a new tendency prevails. What was initially a concern with roots "authenticity" gradually becomes a question of expressive "originality." In other words, it becomes possible to be "authentic" even if one is British. One way to deal with this is through the adaptation of local dialect; as Welch and others point out in *MM*, the new take on "authenticity" is "blues in a Cockney accent."[72] One significant example of this move is Mick Jagger. Others are Chris Farlowe and Eric Burdon, writes Welch:

> Strong accents seem to be a vital factor in the production of authentic blues voices. Not fruity Oxford tones or distilled essence of BBC, but the cheerful,

71 Welch, Chris (1966): "The New Wave of Beat. Like Guitarist-pianist-singer-hitmaker Stevie Winwood [...]," *MM*, January 8:3.
72 Welch, Chris (1965): "Chris Farlowe: Blues in a Cockney Accent," *MM*, July 10:7.

gruff sounds of Islington and Newcastle. Two examples are Chris Farlowe and Eric Burdon, Chris and Eric both achieve realistic blues intonation and feeling in their singing without resorting to the dread mid-Atlantic drawl affected by some olde worlde poppers [*sic*].[73]

When Welch writes about Chris Farlowe, "who, it can now be said, has made it,"[74] the point made is that it is of course possible for whites to "have soul." Again, Welch's considerations and engagement in these questions emerge directly from conversations with the musicians. And as Farlowe points out in the interview by Welch, not even African Americans sing well for reasons of race— and being born in London represents "hard times" too. The point of departure is a dispute over a comment by Dionne Warwick, against which Farlowe argues:

> She implied coloured people sing the blues best because they have known hard times and poverty. Their singing came through life's experiences. So I asked her about Stevie Wonder, who made amazing records when he was only twelve. She couldn't answer that. What experience of life did he have, aged twelve? They don't realise we have hard times, too. I was born in London when the war started. I lived through a blitz and food rationing, so you could say I'm singing blues through my experience. [...] Of course you can have white soul singers. What has race got to do with voices? I've seen some Americans and they can be unbelievably bad.[75]

Thus, after a while, the state of affairs was that British musicians no longer felt inferior to their American musical mentors. Today Welch is a bit more reserved concerning some of the artists he wrote about in the 1960s: "I suppose, if you get down to it, all the original voices in music came from America" (personal interview, January 20, 1999). The crucial point, however, is that the Brits managed to copy their idols so well that some of them made what they heard "their own." Confronted with his ascription of "authenticity" to Stevie Winwood's voice, Welch elaborates this theme as follows:

> Welch: Steve, the way he did it, it was still Stevie Winwood, but he had the feeling for Ray Charles which was quite magical really, when he sang things like Georgia

73 Ibid.
74 Welch, Chris (1966): "Soul Scene Going [...]Beginning with Chris Farlowe—Who, It Can Be Said, Has Made It," *MM*, February 12:3.
75 Ibid.

[On My Mind], which was a Ray Charles number. Being Stevie Winwood, but he still had that tremendous "black" sort of "timbre" to his voice, or expression to his voice. Ah, Muff says, I think it is the combination of listening to Ray Charles and his voice breaking: as it grew up, cracked, and then turned into this extraordinary authentic "black American" voice.

Weisethaunet: But I was a bit amazed, you know, that it was done so intentionally as it is described in your biography.

Welch: Oh, is it intentional? Yes, I don't know. Maybe that was Muff being practical. Muff is the more practical member of the family, you see, he might see it in black and white terms, more practical terms. While Steve might think of it more, ah, I don't know—as a lucky accident I think (ha, ha, ha). (ibid.)

The significant turn in the "authenticity" discourse of the mid-1960s, then, is the point where the British artists—and their critics—came to think that what they had adopted from the Americans belonged just as much to themselves. With this confidence, it was no longer a question of "copying" but of doing it "our own way" (Welch titles his portrait of Stones frontman, Mick Jagger, in 1966, "The Unique Mick").[76] This marks a shift in focus from "folk"/"roots" "authenticity" to an appreciation of certain artists based on "originality." In short, the Brits have finally "made it" to an extent where the copies may even be found to surpass the originals. Even though it feels like "an awkward thing to say," Welch, after having seen Ray Charles live in the 1960s, confesses he no longer would subscribe to Charles's unconditional greatness:

I saw Ray Charles in the 1960s playing a concert, and by that time his voice wasn't so hot, whereas you have a young scene interpreting that star, doing it better actually than the original. An awkward thing to say, but that's the way it is with me. But that happens with jazz music too. You get younger artists coming on, actually interpreting the originals in a better way. (personal interview, January 20, 1999)

Likewise, as Jagger is persuaded to comment on the pop scene in 1966, "creativity" and "originality" are the elements held in highest esteem:[77]

76 Welch, Chris (1966): "Jagger '66. The Unique Mick Jagger Looks at Today's Pop Scene," *MM*, April 2:3.

77 In sum, the Rolling Stones play a much more central role in the pages of *MM* from this period on than the Beatles. According to Welch, this did not have so much to do with preferences as with the fact that the Beatles were generally less available for interviews (ibid.).

Let's start with England—The Beatles, I think they are our most creative song writers and performers. Not only do they create material for themselves they practically throw song ideas away for others.[78]

What has occurred is a shift in attention, from leaning on the "authentic other" to individual creativity. It is still important to be "authentic," yet "authenticity" may now be secured by various techniques of vocal expression, local dialect inflection, song writing, performance, clothing and so forth. Informed by ideologies of "art," agents place new emphasis upon the significance of the rock musicians as "authors" of their music as well as their lyrics, idosyncratic performance styles and images. Such influences are put forward both within the critical discourse and by the musicians themselves. As Ray Davies of the Kinks announces in an interview in *MM* in 1964:

I mean the jackets—you know, we wear hunting jackets, in dark pink. We imagined ourselves as characters from a Charles Dickens book, and we all think it suits us. [...] Well, said Ray, we're a bit kinky.[79]

In *MM*, "art" influences gradually become more apparent, for instance, as explicitly formulated in a 1966 portrait of the Who by *MM* critic Nick Jones under the heading, "Look out Dylan, Dolphy, Debussy and Diddley."[80] The source for the claims made are utterances by the artists themselves—here guitarist, and ex-art student, Pete Townshend. At the same time, the article also illustrates the naïveté of the day. It is not just that rock musicians might be inspired by "art"—in the case of Townshend, Jones claims, without irony, we are dealing with someone who "completely understands it all, as well":

Pete Townshend, the tall lean mind behind most of the Who's musical madness has been absorbing "sounds" for a long while. They range from Dylan, Debussy, Dolphy and Diddley. The deciding factor is that at last he got beyond absorption. Not only does he dig the music, he completely understands it all as well.[81]

78 Mick Jagger, quoted by Welch in *MM*, April 2, 1966:3.
79 Coleman, Ray (1964): "Ray Davies of the Kinks Owns Up. IF YOU WANT TO GET AHEAD— REBEL!" *MM*, September, 19:3.
80 Jones, Nick (1966): "Who; Where To? Look out Dylan, Dolphy, Debussy and Diddley," *MM*, September 10:9.
81 Ibid.

Other "art" influences concern altogether new ideas about what rock lyrics should read like. The most conspicuous innovator and influence in this respect was of course Bob Dylan, described as "the modern folk poet."[82] In sum, the main trend in criticism in this period goes towards treating rock more "seriously," and in the process, rock musicians are taking themselves more "seriously" too. As Steve Winwood told Chris Welch in the fall of 1966: "But basically we're still all heading in the same direction to be musically good and progressive, rather than just being screamed at."[83] Other *MM* critics who followed the path paved by Coleman and Welch were Nick Jones, Alan Walsh, Michael Watts and not least Richard Williams (who became *MM*'s deputy editor and then chief editor in the 1970s).

Nevertheless, though Welch contributed greatly to making rock more "serious," he personally feels that other and later critics have taken rock and rock criticism far "too seriously"—that the fun aspect of it sort of fell by the wayside: "I read *Rolling Stone* interviews of artists and I thought, 'oh, this isn't the person I know,' this is, they are taking it too seriously" (personal interview, January 20, 1999).

4.3.The Serious Fan: Paul Williams and the Birth of Rock Criticism in the U.S.

If we say that rock criticism was initiated in Britain, its originator in the U.S. was undoubtedly the 17-year-old Paul Williams. His first mimeographed issue of *Crawdaddy!*, dated February 7, 1966, set the record straight by postulating that "you are looking at the first issue of a magazine of rock and roll criticism." By "criticism" Williams meant "intelligent writing," "providing buyers with critiques" and "offering rock and roll artists some sort of critical response to their work."[84] Williams's attitude was that of a fan. However, he strongly distinguished himself from ordinary fans, by claiming rock listening, writing and "criticism" to be "serious" business.

Paul Williams was born in Boston, Massachusetts, in 1948. Before starting *Crawdaddy!* he had already started his own science fiction magazine, and in our interview Williams claims his interest in science fiction to be the main impulse for starting a magazine on rock criticism.[85] Williams, greatly influenced by the

82 Coleman, Ray (1965): "Beatles Say—Dylan Shows the Way," *MM*, January 9:3.

83 Welch, Chris (1966): "Winwood 66," *MM*, September 17:9.

84 Williams, Paul (1966): "Get off of My Cloud!," *Crawdaddy!* 1, February:2.

85 The term "fanzine" was used among science fiction readers already in the 1930s and was later picked up by music fans. The term has also been applied to Williams's writing and *Crawdaddy!* However, according to Williams this term was not in use in the 1960s, but applied to amateur rock outlets much later

folk music scene in Cambridge, Massachusetts, was at first a "folk music fan rather than a rock music fan."[86] However, in 1965, he describes, everything changed:

> In high school, I started to listen to the Rolling Stones, the Kinks, the Beatles etc. By the fall of 1965, I was quite into this new music that everybody was discovering. [...] I happened to start the first American rock magazine, while I was a freshman in college. [...] It was the right moment to do it, and if I hadn't done it, somebody else would have. [...] (telephone interview, November 24, 1998)

Williams's interest in rock writing was so overwhelming that it soon led him to drop out of college to make rock listening and writing a full time occupation. Several of Williams's articles have later been collected into books, and he still continues to write rock criticism, mostly in the form of essays. Of the more than 30 books to his name, the most read are undoubtedly *Outlaw Blues* (1969), a collection of early *Crawdaddy!* articles, as well as his various books on Bob Dylan (1990/1994, 1992, 1996). In *The Map* (1988) he rediscovers rock in the 1980s, and in a recent book, *The 20th Century's Greatest Hits* (2000), he gathers together "great art," placing, for instance, Picasso and the Beatles side by side. He has also published books on Neil Young (1997b) and Brian Wilson (1997a), as well as a number of "spiritual books" like *Das Energi* (1973), *Waking Up Together* (1984) and *Remember Your Essence* (1987), a portrait of the science fiction novelist Philip K. Dick (1986), and books covering both astrology and the philosophy of the I Ching. In the 1990s he also restarted *Crawdaddy!*, writing again in "small scale" fanzine format and advertising his rock criticism on the Internet.

It is Williams's writings in the 1960s *Crawdaddy!* that are of interest here. From the first quite amateurish issues of the magazine in 1966 to early 1967, both its size (as well as the quality of its writing) and its readership expanded remarkably. *Crawdaddy!* grew quickly, from a few hundred copies in early 1966 to around 50,000 in October 1968.[87] It gradually came to include ads from major record companies, although Williams had made it clear already in the first issue that this was no "service magazine" for the industry. Pretty soon Williams was

86 Telephone interview, November 24, 1998. An illustrative account of the Cambridge folk music scene that blossomed from the late 1950s through the mid-1960s is given in Smith and Rooney (1979).

87 According to Williams (ibid.). A history of *Crawdaddy!* has also been written by Williams himself: Williams, Paul (1996): "A Brief History of *Crawdaddy!*" *Crawdaddy!*, new series no. 12, spring:1–4.

receiving positive responses from musicians.[88] By January 1967 the magazine featured a number of writers alongside Williams, among them Jon Landau, Sandy Pearlman and Peter Guralnick. Other significant writers such as Richard Meltzer, Peter Knobler, Paul Nelson and Tony Glover soon came to write for the magazine.[89] The magazine reported from events on both the East and West Coasts, and it soon relocated from Massachusetts to New York City, maintaining staff reporters in both Boston and San Francisco. Within this short period the coverage of musical genres greatly expanded to include everything from the Doors and the Velvet Underground to British bands (e.g., the Stones, the Animals, the Kinks, Traffic) and American soul and blues (e.g., Wilson Pickett, Otis Redding, the Temptations, Howlin' Wolf). Negative commentary hardly features at all as the policy was to include only reviews and interviews with artists considered as "serious" acts. By the end of 1968, however, the criticism era was, at least for a long period, over for Williams, who by then felt that rock criticism had already become "too serious" (telephone interview, November 24, 1998).

What most characterizes Williams's texts is his overwhelming enthusiasm for the music he writes about, and not least the idea that the music is terrifically "important" to its listeners. Put simply, the turn from youth pop music magazines (to a large extent functioning as a marketing tool for record companies) into an "alternative" rock press (initiated with *Crawdaddy!*) represents a shift from (pop star) *admiration* to a new quest for (rock) meaning as social *experience*. At the same time Williams strongly opposed the idea of considering the value of popular music according to sales numbers: "Certainly the quality of something is not measured by multiplying it by the number of people who dig it."[90] The idea of considering rock music a "serious" matter was—at least in part—picked up from folk music convictions. There is little doubt that the American folk music movement represented an important impulse for the rise of rock criticism and Paul Williams lists the local folk music magazine *Boston Broadside* among the magazines that inspired him to start *Crawdaddy!* (telephone

88 Paul Simon called up Williams personally to thank for his adoring review in the first issue of the magazine in 1966, and after having read the first couple of issues Dylan was so enthusiastic that he gladly allowed for a personal interview with the young writer (telephone interview, November 24, 1998).

89 It might also be mentioned that the ninth issue marked the first appearance of a freelance staff photographer, Linda Eastman, and her arty photo (in black and green) of Paul McCartney on the cover of the 11th issue of *Crawdaddy!* October 1967, marked the first meeting between Linda and her future Beatle husband.

90 Williams, Paul (1968): "Outlaw Blues," *Crawdaddy!* 13, February:18.

interview, November 24, 1998). He had also read *Billboard* and a few issues of the British weeklies *MM* and *NME*, yet does not regard any of these as a direct influence on his own writing.

His *Crawdaddy!* contributors Paul Nelson and Tony Glover had both been instrumental in starting another local folk music outlet, the *Little Sandy Review*, in Minnesota, in the early 1960s.[91] Primarily a folk and blues magazine, with a readership that probably never topped 300, it also took up earlier rock 'n' roll and R & B. Bob Dylan's deliberate transformation from acoustic folkie to electric rock 'n' roller undoubtedly helps to explain the new rock following. Tony Glover, who came to write for both *Crawdaddy!* and *Rolling Stone*, came from the folk scene and had played with Dylan already in 1960. However, as Glover has since claimed, both he and Dylan already had an affection for rock 'n' roll before going "folk."[92] Irwin Silber, then editor of the influential American folk music magazine *Sing Out!*, had dismissed Dylan as "inner directed," "inner-probing" and "self-conscious" in the November issue of 1964, even addressing Dylan directly: "You said you weren't a writer of protest songs [...] but any songwriter who tries to deal honestly with reality in this world is bound to write "protest" songs."[93] But as Williams's texts illustrate, this view of "reality" was radically challenged in 1966, not only by Dylan, but also by the brand of rock writing that Williams initiated.

The first issues of *Crawdaddy!* mainly consisted of short reviews of new records, though the writing soon expanded into longer and more reflective essays. *Crawdaddy!* 4, August 1966, features a long essay, "Understanding Dylan," in which Williams examines Dylan's output up through his latest album, *Blonde on Blonde* (1966).[94] "Perhaps the favorite indoor sport in America today is discussing, worshipping, disparaging, and above all interpreting Bob Dylan," Williams observes (3). He then takes on the task of discussing various interpre-

91 From 1960 till 1966 a total of 30 issues of the magazine (which was definitely of a fanzine format) came out, mainly distributed around the campus at the University of Minnesota. Another American magazine covering the roots of rock 'n' roll and early R & B was *Rhythm & Blues* (started in 1952, in Derby, Connecticut) with its concentration on African American artists. In the 1960s the magazine oriented itself more towards rock and especially soul music.

92 Glover, Tony (1998): liner notes for CD booklet, Bob Dylan: *Live 1966*:8.

93 Quoted from ibid., 12. Shelton (1987) offers a detailed account of the relations between Dylan, Glover, Paul Nelson and other agents of the early 1960s folk music scene in Minnesota. The *Little Sandy Review* was also the first publication to reveal that Dylan had "invented" his personality and name (ibid.,74).

94 This article earned Williams wider recognition as it was also soon reprinted in *Hit Parader*.

tations of both music and lyrics, and even comes to consider more fundamental problems of interpretation of textual and receptory "meaning." A song like "Visions of Johanna" or "Sad-Eyed Lady of the Lowlands" "is full of pictures, moods, images, persons, places and things," Williams informs us in typewritten letters, "but it doesn't mean anything...there is no explanation because the line is what it is...but certainly the line, the image can turn into something living inside your mind" (6). What Williams is getting at is that lyrics, like poetry, do not have a fixed referential meaning, and in addition to judging Dylan's merits he goes on to illustrate this as well as to describe the limitations of critical interpretation:

> It is difficult to be a critic; people expect you to explain things. [...] But if you do understand a poem or a song, then chances are you also understand that you're destroying it if you try to translate it into one or two prose sentences in order to tell the guy next door "what it means." If you could say everything that Dylan says in any one of his songs in a sentence or two, then there would have been no point in writing the songs. So the sensitive critic must act as a guide, not paraphrasing the songs but trying to show people how to appreciate them. [...] But people go right on looking for the "message" in everything Dylan writes, as though he was Aesop telling fables. (5)
>
> Take a great painting or a Polaroid snapshot. Does it have a message? A song is a picture. You see it; more accurately, you see it, taste it, feel it. Telling a guy to listen to a song is like giving him a roller coaster. It's an experience. A song is an experience. [...] And you can feel it without knowing what it is. (ibid.)

For Williams, the keyword is "experience," but what does he mean by that? First, it might be noted, Williams does not use the term "aesthetic experience." Second, in order to explain what he means, he usually resorts to picking up the word "art." As he continues, "we have established I hope, that art is not interpreted but experienced" and "whether or not Dylan's work is art is not a question I am interested in debating at the moment. I believe it is; if you don't, you probably shouldn't have read this far" (7). Hence, Williams's stance is typical of a fan aesthetic in which personal experiences and excitement are what count in life. A premise for such a position, moreover, seems to be that music (as "art") simply cannot be explained, only "experienced." In May 1967 Williams postulates that the Doors' first record is "too good to be explained" and that "rock has absorbed mainstream music, has become the leader, the arbiter of quality."[95] At this stage, according to Williams, "the Doors, Brian Wilson, the Stones are mod-

95 Williams, Paul (1967): "Rock Is Rock. A Discussion of a Doors Song," *Crawdaddy!* 9, May:42–43.

ern music, and contemporary 'jazz' and 'classical' composers must try to measure up."[96] At the same time, Williams's approach in 1966–1967 was without doubt more reflective than that of most of his contemporary colleagues, including Robert Shelton[97] at the *New York Times* and Al Aronowitz at the *New York Post* and the *New York Herald Tribune,* who still strived to understand rock's "meaning" in ways that Williams rejected.[98]

Williams's trademark as a writer is the long, "personal" essay. His style is never stringent; there is always a lot of sidestepping entering into the sphere of the private. He generally seems to prefer a method of free association over structure. At times he even takes on a diary-like form, including references to his personal state of mind. Apparently, this is also a quite deliberate strategy—as he claims in our interview, "I never thought of myself as a journalist." Elsewhere he defends himself against editors, some of whom obviously have considered him a sloppy writer:

> Most editors consider my style too personal or unprofessional or self-indulgent. Oh well. But I could defend myself by pointing out that most A&R people and record producers would not have been inclined to let Bob Dylan get away with doing things in the unprofessional and unpredictable manner he's always favored [...]. (1996:11–12)

Williams is among the first of a generation whose greatest experience in life seems related to the indoor activity of listening to rock albums. And he is obsessed, most of all, with Dylan. As Williams's texts evidence, he has been following Dylan to a great many places and concerts, and he often comments on particular versions of particular songs at particular events. This also leads him to argue for the "performative" aspect as the most significant element of the rock "experience." As he had observed early in 1967, "in a concert in Boston he [Dylan] got the lines to the verses mixed up, but he didn't seem to think that was very important."[99] In his later books on Dylan, Williams comes to emphasize this aspect in order to explain Dylan's greatness as "performing artist" (1990/1994, 1996).

96 Ibid., 42.

97 Shelton is often acclaimed as the critic who "discovered" Dylan due to his rave review in the *New York Times,* September 29, 1961, under the headline "Bob Dylan: A Distinctive Stylist," in which he describes Dylan as "bursting at the seams with talent."

98 Aronowitz was an uncredited coauthor of "A Night with Bob Dylan," in the *New York Herald Tribune,* December 12, 1965, in which he tries to untangle Dylan's "motivation" through the interview. A part of the article is reprinted in Eisen (1969:193).

99 Williams, Paul (1967): "Rock Is Rock. A Discussion of a Doors Song," *Crawdaddy!* 9, May 1967:44.

However, at one point Williams's understanding diverges from that of most of his contemporaries. While *MM* critic Chris Welch took upon himself the task of mediating to the readers the "intentions" of the artists, it seemed clear to Williams already from the outset that an artist's "intention" does not converge with the experience of the listener. In a recent book, Williams sums up this stance, by explaining why he found it better "not to talk with Dylan":

> I have spent time with Dylan backstage, in Philadelphia in 1966 (an afternoon and two evenings) and in San Francisco in 1980 (four visits of a couple of hours each, after his shows at the Warfield), and on both occasions he was friendly and generous with his time and attention, perhaps because I wasn't trying to get anything from him (it would have been different this summer, me with a book to write). But the illusion we all suffer under, as we go to the interviews or read stories about our heroes, is that the person backstage, the private person, has the answers, holds the key, to the mysteries of the public person. This is not so. The two are related to each other, but in ways that the artist as much as the observer finds difficult to understand. The man on stage speaks to us constantly of his inner life; the private man on the other hand, seldom knows much more than we do about the mystery and power of his public self. (1990/1994:xv)

As Williams sums it up, "to get to know the person on stage you must watch him on stage" (ibid.). Hence, what Dylan would have to say about his songs would, after all, have little relevance.

For Williams, writing rock criticism (in 1966–1967) was very much the outcome of a "community feeling." At the same time, his texts unquestionably represent an orientation more towards individual subjectivity than any sort of politics. One reason for this, according to Williams, was that he belonged to "a community which was discovering itself more through the music than anything else."

> The word political to us in the 1960s had to do with your position in relation to the Vietnam war, how you felt about the president of the United States and things like that. You didn't find much direct reference to that sort of thing in *Crawdaddy!* because it wasn't necessary. Everybody who read the magazine already shared the same opinions. […] In this community, the use of marijuana and psychedelic drugs was a big factor, and then the opposition against the Vietnam war had a very strong community building effect. (telephone interview, November 24, 1998)

Williams was definitely a representative of the pre-Woodstock hippie era, where, as he puts it, "everybody smoked and was against Vietnam" (ibid.). In the last

1960s issue of *Crawdaddy!* that he edited, in October 1968, before leaving "society" to live "in the woods," he writes: "my mind is beginning to reel. There are unexpected implications in this whole rock thing. We are on the edge of something."[100] Here, for the first time in his writing career, his overt optimism as regards the impact of rock music seems to have momentarily abandoned him:

> I'm beginning to think I'll have to make this jailbreak unaided. Fight my way out by myself. The Byrds have gone country and *Big Pink* is out, and it's beautiful stuff, man, beautiful. Cream released a side or two just full of boss licks. But country is just more relaxation, wonderful stifling inertia, and I am not that much of a boss licks fan, and I guess this isn't the summer to look to be rescued by music.[101]

Williams left *Crawdaddy!* and criticism for a total exploration of his hippie ambitions, living with various self-sufficient communities in remote areas of Canada for almost three years, until spring 1971. His "period" in rock criticism was perhaps in many ways over already with the establishment of *Rolling Stone* in late 1967. In his very last 1968 *Crawdaddy!* essay, the "first American rock critic" sums up his manifesto in relation to the development of a more professional field of rock criticism: "Well, haven't you noticed that so far we people writing about rock, Crawdaddies and R. Stones and Goldsteins, Christgaus, whatever, have said very little about what rock actually does to you, personally, as experience."[102] Still, to this day, Williams *writes* to insist that this "personal experience" is all that matters, that rock 'n' roll is "a living force, resilient and stubborn, outlasting all those who seek to control it, explain it, pigeonhole it, exploit it, own it or understand it. The only thing to do with rock and roll is participate in it" (1988:19).

4.4. "Reporting the Counterculture": Richard Goldstein

While Williams entered journalism as a fan, Richard Goldstein (b. 1944) came to the *Village Voice* as a graduate directly from the Columbia School of Journalism in 1966. By then he was already in possession of some journalistic capital as the author of a book on drugs on campus (1966). New Journalism had yet to become a term, just as rock criticism was still unrecognized as a field. Nevertheless, Goldstein was already familiar with "the breathless tropes of Tom Wolfe,"

100 Williams, Paul (1968): "Love Street ... So Far," *Crawdaddy!* 19, October:25.
101 Ibid., 21.
102 Ibid., 24.

"the Great Satan of journalism schools" (1989:xvii), when, in Bernard Gendron's words, he became "the first of a spate of young rock critics to secure a column in a prestigious high-middlebrow publication" (2002:193).

His *Village Voice* column, "Pop Eye" (1966–1968), is perhaps Goldstein's primary claim to fame: it made his name and did so with a readership that knew little about the subject. As a contemporary critic, Robert Shelton of the *New York Times*, put it, in 1966 Goldstein was regarded as "America's hippest rock critic" (Shelton 1987:378). Goldstein also wrote for the *New York Times*, the *Los Angeles Times* and the magazines *New York, West* and *Vogue* during the same period. Later he became a contributing editor at *New York* and *Us*, and he continues his professional journalist career to this day as an executive editor at the *Village Voice*. Goldstein is the author and editor of numerous books, among them a widely distributed early collection of lyrics, Richard Goldstein's *The Poetry of Rock* (1969), *Goldstein's Greatest Hits: A Book Mostly About Rock 'n' Roll* (1970), *America at D-Day* (1994) and *Mine Eyes Have Seen: A First-Person-History of the Events That Shaped America* (1997).

In 1966 Goldstein was already more than a rock critic in the sense that rock and pop culture represented only one of his targets. The first essay that gained him some reputation, "Gear," anthologized by Tom Wolfe in *The New Journalism* (1973/1990), concerns media culture, youth and the realm of teenage experience. The impact of pop and rock culture is fully contextualized:

> He sits on his bed and turns the radio on. From under the phonograph he lifts a worn fan magazine. [...] He turn to the spread on the Stones and flips the pages until he sees The Picture. Mick Jagger and Marianne Faithfull. [...] Marianne, eyes fading brown circles, lips slightly parted in flashbulb surprise, miniskirt spread apart, tits like two perfect cones under the sweater. He had to stop looking at Marianne Faithfull a week ago. [...] Brian Jones thoughts in his head. Tuff thoughts. [...] Because clothing IS important. Especially if you've got braces and bony fingers and a bump the size of a goddam coconut on your head. And especially if you're fourteen. Because—ask anyone. Fourteen is shit. (99–100)

It is above all such an approach of situating the individual pop/rock experience in a larger cultural and symbolic frame that characterizes Goldstein's portraits. But he also has a knack for metaphoric description. In 1966 he depicts the meeting between the Velvet Underground, "not a first class car on the London transit system, but Andy's rock group," and Andy Warhol, with Andy watching "from the balcony." The Velvets' sound is "a savage series of atonal thrusts and elec-

tronic feedback. Their lyrics combine sado-masochistic frenzy with free-asso-ciation imagery." The whole thing seems to be a product of "a secret marriage between Bob Dylan and Marquis De Sade,"[103] Goldstein observes. Nico, "half goddess, half icicle," "sounds something like a cello getting up in the morning. All traces of melody depart early in her solo."[104] In sum, the "Velvets demon-strate what distinguishes an act from a band," while a girl in "three-bark stock-ings" is "leaning against the stage."[105] Commonly the technique is that of de-picting a character while everything that happens or everything that is said, by everyone present, is collected into a collage in order to provide a many-faceted image of the star. Even though Goldstein often keeps a firm observational dis-tance in the text, he is always present to shoot events that matter. In 1966 "Shango, the African God of thunder" (Mick Jagger) arrives in New York City;[106] in 1967 Ravi Shankar "finds himself not the prophet of an elite but a universal guru";[107] when "Janis [Joplin] scowls, her whole face closes up around her mouth and even her eyelashes seem to frown";[108] and, in 1968, Jim Morrison has become "the Shaman as Superstar."[109]

Another characteristic of Goldstein's journalism is that his reports take the form of "snapshots" and montage rather than interpretation and explanation. "I don't know what this is," one professor had told Goldstein in journalism school, "but you owe me a story" (1989:xvii). He reports on events rather than objects, and his style is greatly influenced by the narrative techniques not only of Wolfe, but also of Gay Talese and Norman Mailer. One conspicuous feature of New Journalism is that the writer places himself in the middle of the action. How-ever, as Tom Wolfe has pointed out, "most of the best work in the form has been done in third-person narration with the writer keeping himself absolutely in-visible" (1990:58). This is generally the case in Goldstein's writing.

Even though the early essays seem unquestionably naive today, Goldstein's observations are at times overtly satirical, biting and reflective. His description of the reception of Indian "raga" in the West definitely has such qualities, and he observes the rock-sitar hysteria also from the Indian position of Ravi Shankar:

103 Goldstein (1966): "A Quiet Evening at the Balloon Farm," *New York;* quoted from Goldstein (1970:17).

104 Ibid., 18.

105 Ibid., 18–19.

106 Goldstein (1966): "Shango Mick Arrives," *Village Voice;* quoted from Goldstein (1970:27–32).

107 Goldstein (1967): "Ravi and the Teenie Satorie," *Village Voice;* quoted from Goldstein (1970:84).

108 Goldstein (1968): "Next Year in San Francisco," *Village Voice;* quoted from Goldstein (1970:53).

109 Goldstein (1968): "The Shaman as Superstar," *New York* ; quoted from Goldstein (1970:92–100).

"He wears the expression of a man who has been complimented many times for speaking English well, even though it is his nation's official language."[110] In another essay, "The Politics of Salvation," Goldstein pictures the workings of Maharishi Mahesh Yogi at an ironic distance, centering the text on one core question: "Can an honest man still be a fraud?" The answer is straightforward: "If he allows himself to fill a fraudulent role—yes."[111] Goldstein has also been critical towards his own reception of black artists (he had dismissed the early Hendrix as "vulgar") and towards his own tendency to "demand dignity from a black performer" (Otis Redding vs. Wilson Pickett).[112]

Like Williams, Goldstein was on an optimistic rock trip; a trip where the music is viewed as an incarnation of collective feelings, of participation and, possibly, revolution. Then, also like Williams, he became disillusioned by late 1968. "There isn't going to be any revolution. Let's be realistic," Country Joe McDonald informs the young reporter one Saturday afternoon at the Algonquin Hotel. Goldstein had come to "rap about the revolution" with one of its musical leaders, with one who had "come to represent the quintessence of commitment in a rock group." Yet, all McDonald has seen is "a lot of people wearing Che Guevara teeshirts [...] what a bunch of tripped-out freaks." "Two years ago we believed in music like god," they could both agree, but Goldstein leaves, abruptly shattered by McDonald's final statement: "I'm in the entertainment business right now. It just happens that the people I entertain are freaky."[113] David Thorburn, professor of literature and editor of a collection of Goldstein essays, sums it up: "Goldstein's articles and columns in *The Village Voice* [...] trace a passage from hopeful expectation to disillusionment that some will read as a reluctant and overdue maturing and others as a tragic or at least melancholy adjustment to historical reality" (1989:ix).

In retrospect this development brings into question the role of rock criticism in the construction of the late 1960s as the age of counterculture. As Goldstein himself has remarked, this construction concerns the "recycling of the recent past as raw material for a brand new mythology," in which "the sixties is presented as an era of purposeful solidarity, [or] a cautionary tale of social chaos" (Goldstein 1989:xiii–xiv). In the end, Goldstein confirms, "the promise

110 Goldstein (1967): "Ravi and the Teenie Satorie," *Village Voice*; quoted from Goldstein (1970:83–84).
111 Goldstein (1967): "The Politics of Salvation," *Village Voice*; quoted from Goldstein (1970:113).
112 Goldstein (1968): "Electric Minotaur," *Village Voice*; quoted from Goldstein (1970:166–170).
113 Goldstein (1968): "C.J. Fish on Saturday," *Village Voice*; quoted from Goldstein (1970:133–136).

of rock music—its vision of a multiracial community of the young—had been subverted by a record industry bloated on profit" (xix). There is little doubt that there was such a "vision," yet the early underground press, represented by publications like the *Berkeley Barb, Los Angeles Free Press* and *East Village Other*, took on a more radical political agenda that was often directly hostile to the romanticism of early rock critics expecting to be rescued by music.[114] Consequently, there is a discrepancy in the use of terms such as "counterculture" and "underground" between rock critics and more politically oriented activists.[115] What everybody could agree on was the need for an "alternative society"; the relations between the elements—dope, sex, revolution and rock 'n' roll—were not sorted out undoubtedly because the 1960s political struggles were articulated from very different social positions among which rock listening largely represented the white middle-class youth segment.

For Goldstein, the alternative "vision" was paired with the technological optimism of McLuhan, "The Wizard of Oz" as Goldstein named him in a 1967 article:

> Ask a simple question and the Wizard answers with a left jab to his ego. You find yourself boxing with his books and wrestling with his wordgames, but Marshall McLuhan's ambiguity is an essential part of his magic. After all, it is not his ideas but his cryptic cool that sets him apart from the academicians. […] McLuhan crosses the style barrier which separates iconoclasts from mischief makers.[116]

McLuhan is "cool,"[117] because he is into performance and style in an unacademic way, or as Goldstein puts it: his words "sound as though they belong."[118] Yet "style" in the 1960s unquestionably implicated social meanings in a way quite different from 1980s and 1990s posing. As Goldstein tries to sum it up in 1989:

114 At the same time, the underground press's account of music seemed equally reductionistic and delusive. Cf. the account of the rise of the American underground press in the 1960s given by Peck (1991). See also Lewis (1972).

115 For instance, when critic (and former editor of *Mojo Navigator Rock and Roll News*) Greg Shaw sums up the impact of "the real rock 'n' roll underground" in an article in *Creem* (Shaw, Greg (1971): "The Real Rock 'n' Roll Underground," *Creem 3/3,*:23–26). It is the small and obscure rock fanzines that are of interest rather than "underground" papers in a broader sense of the term.

116 Goldstein (1967): "Breaking Bread with the Wizard of Oz," *Village Voice*, quoted from Goldstein (1970:78).

117 A term with a double meaning as it refers also to McLuhan's theory of "hot" and "cool" media.

118 Goldstein (1967): "Breaking Bread with the Wizard of Oz," *Village Voice*, quoted from Goldstein (1970:79).

For my (mostly white, ethnic, and male) cohort at the Voice, it was existential-ism and roses. Our parents' struggles could be forgotten and their identities ig-nored. We were finally free to invent ourselves. The number one song in the whole United States said the answer was blowing in the wind. [...] Sixties style has a tantalizing expressiveness next to the depersonalized contours of mass cul-ture now. But what we notice most is cogency. Within the sanctioned parameters of sensibility, the most radical aspirations achieved a form and function they were denied in politics. In art and style, the sixties worked. (1989:xviii–xiv)

Another interesting question has to do with the status of rock criticism in mid-1960s journalistic hierarchies. As Bernard Gendron (2002) shows, the Beatles were seminal to the legitimation of rock in the U.S. in 1966–1967.[119] Their ac-ceptance was spearheaded by the lower middlebrow press (*Time* and *Newsweek*), which, argues Gendron, had picked up that an informal Beatle fanhood was budding among high cultural celebrities and taste makers. Interestingly, *Newsweek* devoted feature articles to both Goldstein and Williams. In 1966 Goldstein had been among the first in the U.S. to praise the Beatles in his *Village Voice* review of *Revolver* as "a revolutionary record...a key work in the develop-ment of rock 'n' roll into artistic pursuit."[120] A year later, however, he was overtly critical in his review of *Sgt. Pepper's Lonely Hearts Club Band,* writing that "like an over-attended child, this album is spoiled."[121] In the meantime, people with more "highbrow" accreditory power, among them literary critic Richard Poirier,[122] British musicologist Wilfrid Mellers and composer Ned Rorem, had intervened on the side of the Fab Four in order to stand up for high culture's right to have the last word. Goldstein was an obvious target, and Rorem wrote to the *Voice,* reproaching him for his *Sgt. Pepper* review, an act which made the *New York Review of Books* commission an article on the subject from Rorem in which he declared that "[t]he Beatles' superiority" was "as elusive as Mozart's to Clementi."[123]

119 Unless other sources are given, the information in this section stems from Gendron (2002:139–224).

120 Goldstein (1966): "On Revolver," *Village Voice,* August 25:26.

121 Goldstein (1967): "I Blew My Cool Through the New York Times," *Village Voice;* quoted from Goldstein (1970:147).

122 Poirier, Richard (1967): "Learning from the Beatles," *Partisan Review;* reprinted in Eisen (1969:160–179).

123 Rorem, Ned (1968): "The Music of The Beatles," *New York Review of Books;* quoted from Eisen (1969:155).

The new generation of young rock critics had a very different take indeed on their topic than the classically trained composers, musicologists and high cultural critics, mainly because their conception of rock departed from the established norms of what made music worthwhile, even as "art." The musicologists would try to dissect the music—of the Beatles, for instance —in search of harmonic complexity. For Wilfrid Mellers, the central category is "primitivism," opposing a modernism become toothless: the new music is attractive—like the music of "exotic" cultures and jazz—because it represents a "collective unconscious" (1968:141). To him, rock discovers "authentic affinities with music of a relatively less "harmonic" stage of evolution, and thereby reinforces the primitivism of their rhythm" (144). He goes on to compare Cage and Feldman with Dylan and the Beatles—"in the music of Cage there is virtually no corporeal rhythm left; the Mersey beat has nothing much except corporeal rhythm" (141)— and the success of the latter is viewed as a result of this corporeal "primitivism." It is not a very convincing analysis. The same could be said about those cases when a rock critic tried to steep the music in a high aesthetic discourse. The confusion of Richard Meltzer's essay "The Aesthetics of Rock" (*Crawdaddy!* 8, March 1967), a collage of private opinion and aesthetic theory dating back to Plato and Aristotle, which had grown into a book of the same title three years later, is symptomatic.[124] Yet Meltzer was keen to underline that his concern for "rock aesthetics" was far from "any of that Richard Goldstein asswipe."[125] Obviously Goldstein was not highbrow enough to the real highbrows, but in the eyes of some colleagues it looked as if he aspired to be one of them.[126]

The picture is complicated by the fact that New Journalism was about to break into the "high" from below. As Wolfe (1973/1990) notes, the triumphant literary genre of the 20th century had been the novel, its writers representing a literary upper class. The middle class consisted of literary essayists, historians, scientists, biographers, possibly some of the more authoritative critics. The lower class were the journalists, and they were "so low down in the structure that they were barely noticed at all" (39). According to Wolfe, the "New Journalists" were

124 As pointed out by Paul Williams (telephone interview, November 24, 1998), both Richard Meltzer and Sandy Pearlman had taken classes with art professor Allan Kaprow, known for his "happenings," at the State University of New York.

125 Meltzer, Richard (1968) (no other author indicated): "R. Meltzer Interviewed," *Crawdaddy!* 14, March–April:11.

126 It is clear that Goldstein thought of rock as art; for instance, he writes, "Once a pariah of the musical world, [rock 'n' roll] has evolved into a full-fledged art form, perhaps the most preened and pampered of our time" (1969:1).

a bunch of would-be novelists who had little idea of the acclamation their work would finally gain. Although he exaggerated the success of the genre—"they never guessed for a minute that the work they would do over the next ten years, as journalists, would wipe out the novel as literature's main event" (22)—there is little doubt that the outcome of New Journalism represented a jumbling of status positions in the hierarchy of writers. And even though Richard Goldstein was perhaps not the most prolific of these new stylists, the *Village Voice* (founded by Dan Wolf, Ed Fancher and Norman Mailer in 1955) gained an accreditory position within this emerging brand of journalism.

In sum, as Goldstein appears in the journalistic market, there arises a split between various "high" and "low" approaches to rock in the U.S. The participants in the battle somehow seem to agree that the new music "matters"; what they disagree on is how and why. A need for renewal is felt, which favors Goldstein and his "new intellectual" colleagues. "With the withdrawal of highbrows from the arena of debate," writes Gendron (2002:208), "it was left to the young rock critics, who now monopolized the high middlebrow discourses, to attempt to elaborate a consensual aesthetic of rock, in effect to consolidate the gains from accreditation."

4.5. Rock 'n' Roll as "Style": Nik Cohn

> From nothing, London had made itself almost the pop centre of the world. [...]
> All of a sudden, you could dress like a rainbow, grow your hair down your back,
> make noise, act most any way you felt like, and you didn't automatically get your
> face pushed in.
> —Nik Cohn, "London 1964–65"[127]

Since the breakthrough of rock 'n' roll in the 1950s the music has been part of subcultural styling among British lower-class youth. The teds—who first emerged in the London East End and in North London, in Tottenham and Highbury around 1952 (Cohn 1971:29)— the skins, the mods and the rockers all adopted some version of rock, pop or black music compatible with the values of the subculture. In different ways they all went for the right sound, the right looks, the right accessories. By the mid-1960s affluence had made self-conscious consumption possible to larger sections of British youth. As Ray Davies observes in the lyrics of an early 1966 Kinks single: "He flits from shop to shop

127 Cohn (1969b:203–204).

just like a butterfly, 'cause he's a dedicated follower of fashion."[128] In the words of cultural theorist Iain Chambers, "pop stopped being a spectacular but peripheral event, largely understood to be associated with teenage working-class taste, and became the central symbol of fashionable, metropolitan, British culture" (1985:57).

The first writer to sum it all up, as well as the first to really write a rock 'n' roll history, was Nik Cohn. Cohn (b. 1946) grew up in Derry in Northern Ireland although he was born in London, weaned in South Africa and Scotland, and by nature "a loner."[129] When his family moved on to Newcastle, Nik packed for London. At 17 he had decided that writing "looked less like real work than anything else in prospect,"[130] and after arriving in London he soon got a job at the *Observer*. At age 18, he published his first book, *Market* (1965), a series of studies in street market characters. The *Sunday Telegraph* declared it "astonishing" for its "professional assurance" and individual tone and the *Daily Telegraph* said it begged comparison with Zola.[131] A year later he wrote his first novel, and from 1965 onwards, at the *Sunday Times* and the British fashion magazine *Queen*, he made himself one of the most eloquent voices of Britain's new "stylish" pop culture. In *Queen* (f. 1861)— which featured reviews on books, theater, films, art and opera—Cohn contributed a regular column with record reviews under the heading "Pop Scene" from 1966 on.[132] Then, in the spring of 1968, he was sent off to a remote spot in Ireland for seven weeks by his publisher to write the first rock 'n' roll history, published the following year as *Pop from the Beginning* (in the U.S. as *Rock from the Beginning).*[133]

Cohn has continued his writing career to this day. His book on male fashion, *Today There Are No Gentlemen* (1971), anticipated the posture of style magazines such as *The Face* and *Blitz* by more than a decade. His second novel, *Arfur: The Teenage Pinball Queen* (1970), laid the conceptual basis for his friend Pete Townshend and the Who's song "Pinball Wizard" and the rock opera *Tommy* (1969).[134] *Rock Dreams* (1973), in collaboration with the Belgian painter Guy

128 The Kinks: "Dedicated Follower of Fashion," PYE single, 1966.
129 Brown, Mick (1992): "A Brit on Broadway," *Telegraph Magazine* (Saturday supplement to *Daily Telegraph*), March 21:21.
130 Ibid.
131 Ibid.
132 In fact, another critic, Patrik Kerr, wrote pop and rock reviews in *Queen* before Cohn.
133 Cohn (1969/1996). The book has been reissued also as *Awopbopaloobop Alopbambboom: The Golden Age of Rock* (Cohn 1996). In 2004 (Pimlico edition) it regained its original English title, *Pop from the Beginning*. See Cohn (1969a).
134 Brown, Mick (1992): "A Brit on Broadway," *Telegraph Magazine* (Saturday supplement to *Daily Telegraph*), March 21:21.

Peellaert, is an astonishing pictorial realization of rock myths, and a later anthology, *Ball the Wall* (1989), decisively sums up Cohn's rock 'n' roll attitude.

In the early 1970s Cohn found that London had "run out of gas"; he moved to New York. Here, one of his first short stories for *New York*, "Another Saturday Night" (reprinted in Cohn 1989:321–342), became the film *Saturday Night Fever*. Needless to say, this story brought him more financial return than anything else he ever wrote. By then he had completely withdrawn from rock criticism and for a long period he almost retreated from writing at all. At present Cohn still lives in New York, and among his later books are *The Heart of the World* (1992), a novel that sets out to do for Manhattan what he did for London in the 1960s; its successor, *Need* (1996), is based on a series of interviews with outrageous street characters. *Yes We Have No* (1999) encapsulates the multicultural and alternative "other England" of the 1980s and 1990s. Finally, *20th-Century Dreams* (1999) revives his successful collaboration with painter Guy Peellaert in order to portray "the ultimate expression of celebrity worship gone mad."

Cohn is not only a rock critic; he is a writer. As such he became capable of carrying the "attitude" of rock 'n' roll into the style of criticism itself. Through the use of short sentences, clear-cut, yet powerful language, Cohn conveys the belief that writing should "drive" just like the music. Writing, like rock, is a matter of style. This helps to explain why Cohn is among the first rock critics to cross the boundaries between rock journalism and literary writing—as does what he learned in the very beginning: that rock 'n' roll was all about myths and utopian dreams.

For Cohn, life began the first time he heard Little Richard's "Tutti Frutti" on a local coffee-bar jukebox in Derry. Here he had his first glimpse of "sex, and danger, and secret magic. And I had never been healthy since" (1996:2). "In a craze of flashing fluorescent socks and shocking-pink drapes, drain-pipes and blue suede shoes," he discovered the local teen hoods, the so-called teddy boys (1989:4). His father was a professor, who in the 1960s wrote a paradigmatic study of the medieval expectations of the second coming of Christ,[135] "his mother had an accent," and Nik himself was neither Protestant nor Catholic, which meant "not Irish but nothing definable else" (5). That is, like the teds he had to make it up for himself: "They were, in every common sense, non-persons. And yet, here on The Strand, in neon night by Rock 'n' Roll, they were made heroic." At age 11, Cohn had already learned that "style" mattered because, behind the mask, he observed, there was not much. In their daytime incarnations, "the Teds were only Papist scum, the delinquent flotsam and jetsam of Bogside" (8).

135 Norman Cohn (1961/1970): *The Pursuit of the Millennium*.

From 1963 onwards, Cohn reported from the front line of "style"; from the boutiques and salons on Carnaby Street and Kings Road, from the recording studios, from wherever the "in people" were to be found. What had fascinated Cohn about rock 'n' roll in the first place was its glamour and wildness, but in London he learned that style was serious business. As Cohn noted "it was the Mods who first made Carnaby Street happen, 1962–3, and they used to change their clothes maybe four times each day. It was fierce, dedicated stuff" (1969b:242). After this, Cohn claims, the initial commotion was over and Carnaby Street "deteriorated into one more American tourist shop" (ibid.). "Swinging London" was definitely a myth, in part created by journalism, as the term was coined at firm distance by American *Time* magazine in April 1966.[136] Its observations had nevertheless been predated by a year by an English-based American, John Crosby, in an article in London's *Daily Telegraph* titled "London, the Most Exciting City in the World."[137]

The important point in this context, however, is the possibility of "self-invention" through style. As Cohn notes, before the war, working-class and most middle-class kids "had shared everything with their parents" (1971:28). The teds changed this by the style of their clothes alone, essentially a bowdlerization of the Savile Row Edwardian style. The term *mod* was initially used to describe a distinct group of South London middle-class kids (many of them Jewish) dressing up "smart." Cohn describes how from the suburbs the mods spread all over London, and established a new mecca in Shepherds Bush. The stylishness of the early mods had a far wider public appeal thanks to the Stones and especially the Who, who in 1964, with their Union Jack jackets and pop art T-shirts, became "the Mod group" (1969b:243). And as Cohn noted about the Stones in 1965, they were "like creatures of another planet, impossible to reach or understand, but most exotic, most beautiful in their ugliness" (quoted from Kureishi and Savage 1995:178). And even though Cohn's preference is for the early and fiercely dedicated dandies, the "real" teds and mods, he observes the fact that it was the Beatles who turned Carnaby Street from a "backwater cult" into a "massive worldwide madness": "the Beatles were more important in the rise of

136 The article, "You Can Walk Across It on the Grass," appeared in *Time*, April 15, 1966. It was announced on the cover as "London: The Swinging City" and backed by a collage mixing images of pop idols and Pop art. "The expression 'Swinging London' just came out of the blue," Andrea Adam, one of the writers of the theme who assembled the piece, recalled (Green 1998:71).

137 Crosby, John (1965): "London, the Most Exciting City in the World," *Daily Telegraph*, April 26; quoted from Green (1998:70).

Carnaby Street than [John] Stephen himself," called "King Carnaby" by the *Daily Mirror* and "the Million-Pound Mod" by the *Observer* (1971:67).

In this sense, it was not only a question of slogans like "Swinging London" and "Merseybeat." In music as well as "image," the new and overwhelming impact of Britishness bred a very different kind of "authenticity" than the mostly American styles copied up until 1964–1965. Whereas critics like Welch and Coleman were "serious" about the musical aspects of this move in *MM*, Cohn was perhaps the first critic to conceive of musical performance and the stylish construction of images as equally important. It is not what artists think their image to be—or musical intentions—that matters, but rather how they are perceived and used by the larger community of fans. For Cohn, music is about "image" as a whole.

During this period, the British daily press's coverage of the popular music scene was mainly limited to what might be termed gossip, news or sensations. Willam Mann's pioneering 1963 review of the Beatles in the arts pages of the *Times* was definitely more an exception than a trendsetter. Invoking metaphors like "pandiatonic clusters" and "flat submediant key switches," the message of the article is that Lennon/McCartney in fact are innovative composers even though "their noisy items are the ones that arouse teenagers' excitement."[138] Mann's analysis might seem somewhat confused also musicologically, however, his message is that the Beatles possess a highly developed harmonic competence and that they make pop songs "distinctively indigenous in character."[139] Other critics, like Derek Jewell at the *Sunday Times,* were more reserved. By and large, Jewell dismisses the Beatles musically. The background is that the Beatles had received the *MM* award as the top vocal group of the year and the best pop record: "the music industry's most tangible accolade."[140] However, the fact that they "make the hearts of promoters, customers, instrument-makers and electricity meter-men smile" does not, in Jewell's view, help the situation:

> As music, it is vigorous, aggressive, uncompromising and boringly stereotyped. It is exaggeratedly rhythmic, high-pitched, thunderously amplified, full of wild, insidious harmonies. It scalds over the listener as the screams of its devotees scald back at its performers.[141]

138 "What Songs the Beatles Sang," *Times* (London), December 27, 1963:4. The article has later been credited to William Mann.

139 Ibid.

140 Jewell, Derek (1963): "Beatles Breaking Out," *Sunday Times*, September 15; quoted from Jewell (1980:22).

141 Ibid.

According to Jewell, the Beatles place themselves "within a well-established mainstream of younger-generation cult and fashion which began in the fifties, when the mass-producers of clothes, coiffures and canned music began to court the multi-million teenage market."[142] In short, they are dismissed because they are mass culture. Others were of course more positive, like the *Daily Mirror's* Patrick Doncaster, who reports with great enthusiasm on the Stones in an article in the *Daily Mirror,* June 13, 1963, employing terms like "twang and bang" and "pulsating rhythm and blues." "No one needed a partner," he observes, "it was simply shake rattle and roll on your square foot."[143] Among the most reported sensations were of course those of Beatlemania, screaming girls, the Fab Four's meetings with celebrities, royals and other fans (among them Elvis in 1964). The Beatles receiving their MBEs from the Queen in June 1965 made good copy for several front pages, and nothing caused as much controversy— on both sides of the Atlantic—as Maureen Cleave's 1966 article in the *Evening Standard* in which John Lennon stated that "Christianity will go" and that "we're more popular than Jesus now."[144] The Rolling Stones' 1964 fining for "public insult" was, of course, also widely covered.[145]

In this context, Nik Cohn managed to look behind the formation of rock "images"—to point at their constructedness—at the same time as he deliberately expanded his impressions of characters into his own ubiquitous construction of rock myths. While writers like Welch and Williams had kept themselves busy explaining what rock really meant, Cohn sees the participation in pop/rock as a way to break with reality: as an entry into its own narrative dream world. *Pop from the Beginning* (1969a) gives a blunt and interpretive historical account of the rock style: from Little Richard and Bill Haley to the then latest music industry degeneration exemplified by the Monkees. What was new about rock "was its aggression, its sexuality, its sheer noise and most of this came from the beat" (1969b:9). And as he admits in a new preface to the book, what he was

142 Ibid.

143 Doncaster, Patrick (1963): "Twitching the Night Away," *Daily Mirror,* June 13:25.

144 Cleave, Maureen (1966): "How Does a Beatle Live?" *Evening Standard*, March 4. The remark went largely unnoticed until the American teen magazine *Datebook* reproduced the article on July 29, 1966, which in turn led to great uproar and a banning of the Beatles by 22 American radio stations (Lewisohn 1992:212). Long before this (from 1963 on), Maureen Cleave had also written positive reviews of the Beatles' music in the *Evening Standard*.

145 Other significant critics of the British daily press in the 1960s were Tony Palmer at the *Observer* and Geoffrey Cannon at the *Guardian*, who both, as George Melly puts it, tried to "establish a critical apparatus" (Melly 1970:215).

after was "guts, and flash, and energy, and speed," hence, "accuracy did not seem of prime importance" (1969/1996:4). Even though (or perhaps because) he is not pre-occupied with factual data, such as recording dates and which musicians were present at what events, Cohn ends up being quite accurate in his description of characters, of how rock works as music, as culture, as well as an industry—of rock as an expression of individuality as well as the arbiter of collective images and sentiments.

Frequently Cohn places himself at the center of the action and comments just as much on the surroundings as on musical details. Often he depicts the atmosphere of particular clubs where the event or act of waiting is given just as much attention as the actual concert: "[E]very time I go to the Flamingo I make a solemn vow never to go again." Then, when Georgie Fame did "finally" get going, "it was scarcely worth waiting for—four of the first numbers were in-strumental and the band played with a total lack of drive."[146] When Cohn enters the Empire Pool, Wembley, he notes that this is "the last place on earth for a show like this.... I could imagine it being all right for Nazi rallies and religious conventions, but for a pop show, where you need direct contact with the artists, it's a dead loss."[147] Some of the artists on the bill—among them the Who, Dusty Springfield, Cliff Richard, the Rolling Stones and the Beatles—were, of course, favorites. However the sound was "thin and distant," and as Cohn puts it, the overall experience was "like listening to goldfish inside a soundproof bowl."[148]

What further distinguishes Cohn from *MM* critics like Welch and Coleman is that Cohn did not care whom he offended. Almost certainly he was the first rock writer to make wham-bang characterizations like "Bill Haley was large and chubby and baby-faced" (1969b:17), and to judge authenticity by bodily aspects of the rock performance: "Little Richard was the real thing. Bill Haley wasn't. Haley kept grinning but he soundedlimp by comparison,looked down-right folish" (19). With Elvi, on the other hand, it was a different matter: "[W]ithout even trying, he became one of the people who have radically affected the way that people think and live" (22).

Kit Lambert, comanager of the Who, labeled Cohn the "speed-writer of pop" due to his ability to write punchy characterizations. Nevertheless, Lambert observes, Cohn was "half-martyr to his own myth," also "making enemis along the line."[149] Cohn was undoubtedly rough with everyone, even the ones he adored,

146 Cohn, Nik (1966): "Pop Scene," *Queen,* August 4:24.
147 Cohn, Nik (1966): "Pop Scene," *Queen,* May 23:20.
148 Ibid.
149 Lambert, Kit: "Introduction," reprinted in Cohn (1996:9–10).

like the Who and the Rolling Stones. Cohnwrote that Mick Jagger was more a projection of Stones manager Andrew Loog Oldham than of himself—that is how it often is with managers: "[T]hey us the singers they handle as transmitters, as dream machines. Possibly, that's the way it was with Jagger and Oldham" (1969b:170). He characterizes the Who in summary fashion: "Lambert is neurotic. Townshnd is neurotic. Keith Moon is neurotic. Most everyone involved is a maniac, most everyone is extremely bright and, for years, hardly a week would go by without some kind of major trauma" (245). Moreover, Cohn was not about to compromise his opinions because of his personal friendship with Townshend and the other members of the group:

> The thing was, Townshend was intellectual and Lambert wasn't exactly intellectual but he had the jargon. Between them, they looked at the things the Who did and analysed them and thought up sassy names for them. If the Who smashed up their instruments and used feedback and acted like apes, was that violence? Certainly not: it was auto-destruction. [...] Townshend wasn't like this Mod hero at all [in *My Generation*], of course, but Roger Daltrey was. I mean, Daltrey wasn't stupid but he was no theorizer; he was interested mostly in girls and cars, he wasn't too articulate and Townshend used him like a mouthpiece. In fact, he used all of the Who like that: he *was* the Who. (245–246)

On Dylan, Cohn wrote that "technically he was nothing at all, he played bad guitar and blew bad mouth-harp, he hardly ever sang in tune and his voice was ugly, it came through his nose and whined." Most of all, Cohn found Dylan boring. However, the strange thing was that "even when you didn't like it, it bruised you" (184). Cohn has little of Paul Williams's admiration for the artists he writes about. Above all, Cohn is fun to read. He knows how to make rock history and histories into narratives, to make persons as well as the myths constructed around them come alive. In one of his most bizarre "true stories" (1989:231–254)—reporting on his experiences from a tour with the Who—he unquestionably equals the best of Hunter S. Thompson's writings as regards outrageousness of style and content; in sum, a nerve-wrecking experience.

Cohn's writing was important also because it derived rock's meaning from a larger cultural context, depicting the effects artists had on various kinds of public as well as the differences produced by the ethos of various places, subcultures and social backgrounds. In his writing, he exhibits a sense of place showing forth the varieties of local meanings that rock culture seemed capable of generating already from its beginning. In the U.S., "Southern rock was hard rock,

Northern rock was high-school," with "high-school" identifying not a musical form but an "attitude" (1969b:51). Cohn brought out the differences, not only between London, Manchester and Liverpool, but also between Regent and Carnaby Streets.

The fact that Cohn's book was alternatively titled *Pop* in Britain and *Rock* in the U.S. illustrates that the meaning of these terms was differently conceived and also constantly changing. 1960s pop discourses center around different ideas of stylish "self-invention" and in Britain we see a deliberate turn in 1964–1965, when not so much the American "other" (represented by rock 'n' roll and R & B revival movements) as the uniquely British becomes designated as the "real thing." In this context, "pop" comes to signal something distinctively British. As another influential British writer of this period, George Melly, sums it up, by the end of the decade "popular culture" was "unconscious" or "unselfconscious" whereas "pop came about as the result of a deliberate search for objects, clothes, music, heroes and attitudes which could help to define a stance."[150] Nik Cohn became the spokesman for and interpreter of the new "pop sensibility" of British youth culture, to which old clothing or musical stylistic elements are rendered acceptable only insofar as they are reinvested with a symbolic meaning of the present.[151] The meanings of "pop" draw upon the understandings of an "imagined community" and the stylish innovations to which they refer rather than their conventional referentiality.

With *Pop [Rock] from the Beginning* Cohn goes back in history to redefine what rock is. As it were, he became the first rock history writer. On the other hand, and perhaps more strikingly than with any other critic, his stylistic approach does not fit neatly within a linear history of rock criticism. Rather, his idiosyncratic writings make him an outstanding figure of that history. And even though his reputation as a writer has grown, his style has not become paradigmatic in the sense that there is a school of Cohn followers. However, his texts have certainly influenced a number of writers, among them Simon Frith and Charles Shaar Murray.

150 Melly, George (1966): "What Is British Pop Culture? An Attempt at Definition", quoted from Melly (1970:3). George Melly (b. 1926) was also an influential critic at the *Observer*, the *New Statesman*, *Queen* magazine, and elsewhere during the 1960s. His book *Revolt Into Style* (1970) places him somewhere in between journalism and historical-theoretical reflection. As such, his work also had an impact on popular music scholarship in Britain

151 Hence, the Who had no problems with discarding their Union Jackets in favor of similar styled clothing made up of the flag of Eire, after having received threats by Irish Republicans before a show in Dublin in 1966 ("Who Bomb Threat: IRA Warn 'Don't Wear Union Jackets in Dublin,'" *Music Echo*, May 14, 1966).

Cohn's influence in the field of rock criticism is seminal in the sense that

- he was the first "style" writer, who made the case that critical language had to catch up with the rhythm of rock 'n' roll;

- he was the first writer to look back at history in order to redefine what "rock" and "pop" means, and his narratives represent a first, influential step toward the formation of a rock canon;

- with him for the first time the reception side of the music became the most important; to Cohn, rock is part of a subjective dream world— it exists solely for the sake of the listener, who is situated within an "imagined community" of lonely boys with a subversive attitude;

- his narratives have served as an important influence on the formulation of subcultural and popular culture theory in Britain. Unquestionably, Cohn's texts echo in the work of theorists such as Melly (1970), Hall and Jefferson (1975), Hebdige (1979), Chambers (1985) and subsequent cultural studies scholars. On the other hand, though Cohn's descriptions of teds, mods or rockers seemed both imaginative and fairly accurate, he never indulged in the kind of narration of "youth reality" that these subcultural theorists represented. For Cohn life was always, as Colin MacInnes stated in *Absolute Beginners*, "the best film for sure, if you can see it as film."

Chapter 5

Founding Fathers in the Promised Land (1967–1975)

If the forefathers of rock criticism were crusaders, discovering a new Promised Land, their followers were those who colonized it and won the battle as creators of different distinct positions, evolving within a few years (1967–1972) into a field with its own criteria, discourse and "clergy." Especially in the U.S. a growing number of aspiring journalists, writers and intellectuals found rock criticism an open and exciting arena. Many of them shared the feeling of promise and later of disillusionment, but they still found it important to write about rock, echoing the sentiments expressed by Jon Landau in the title of his compilation of articles *It's Too Late To Stop Now* (1972). Some were around almost as early as Goldstein and Williams, some of them came a couple of years later, and in the years 1967–1972 they established rock criticism as a field claiming considerable autonomy.

This chapter will focus on Robert Christgau, Jon Landau and Greil Marcus, who all started to write about rock around 1966–1967, and Lester Bangs and Dave Marsh, who started in 1969. Some attention will also be given to writers like Ralph Gleason, Ellen Willis and Richard Meltzer who exerted great influence in the early years. A full historical account would need to take many more writers into account, but for our purpose it is more useful to have a closer look at the most distinct positions, those which became the frame of reference for rock writers for decades.

The field of rock criticism was not only defined as regards content in this period, but also in terms of publications and geography. A few new U.S. rock periodicals established themselves as the center of the field and other channels had to relate to the discourse developed there. From these U.S. centers the discourse spread to most Western countries. Within a few years British rock criticism became about as important as the American, whereas elsewhere rock criticism was peripheral in the sense that it related itself to these centers and was not distributed outside of national arenas, even though these national discourses were often highly developed.

In the previous chapter we saw how rock music from the mid-1960s and on was increasingly discussed as something important in the British music journals as well as in some newspapers and other publications on both sides of the Atlantic. A growing number of young rock fans and writers were feeling the need for more coherent treatment of rock. This was especially the case in the U.S. where readership among high school seniors and college students was expanding. A few fanzines and local underground papers started to meet this demand, but their distribution was limited.

Crawdaddy!, founded in 1966, *Rolling Stone*, founded in 1967, and *Creem*, founded in 1969, were innovative publications. All three papers were based on the belief that rock had become the most important cultural form for a new revolting generation. Thus rock needed to be presented and discussed seriously as innovative, in relation to changes in lifestyle and to politics, and on a nationwide scale. In this way the rock magazines staked out a new territory, previously uninhabited, but neighboring other forms of publications that either aimed at narrow taste groups or local scenes, like the fanzines, or wrote about rock without making it a prominent part of their profile. This latter category included:

- *The underground press* that had grown from the days of beatniks and civil rights activism in the early 1960s. The underground papers of the late 1960s revolved around radical politics and alternative lifestyles, and tended to treat rock instrumentally, as a way of getting teenagers "turned on."

- *The newspapers* that had mainly treated rock for news value and rarely with a continuous line in their rock criticism (Nowell 1987).

- Some *weeklies* or *monthlies* that had started regular columns of popular music as an insignificant part of their profiles, although the *Village Voice* columns of Richard Goldstein and Robert Christgau gained greater reputation than their humble status within the paper signified.

Such publications were now drawn into the maelstrom of the new field of rock writing. A typical move to raise their profile in this emerging field was to hire a rock critic with a distinct style or position, but most commonly these critics were recruited from the rock magazines and continued to write for them as well. It was the profile of these magazines and the positions developed by their main writers that drew the contours of the field. Shortly after its start *Rolling Stone (RS)* began to pursue a hegemonic position in the field. Through Jann

Wenner's editorial policy, which combined discipline with unpredictable wildness, and through the voices of Ralph Gleason and Jon Landau, soon to be joined by those of Greil Marcus and a number of other prolific writers, it would immediately beat the more primitive *Crawdaddy!* Less than two years later *RS* received serious competition from *Creem,* a magazine that combined the anarchy of the underground papers with the professionalism and dedication to rock found in the early *RS.* Other publications that did not have rock as a focal theme, but wanted to include it as an important part of contemporary culture and stuff that sold papers, had to adapt their style to these leading rock magazines. Often they recruited their writers from the magazines, like Landau, who was the top music critic of the *Phoenix* and the *Real Paper* as well as with editor of the *RS* review section, Dave Marsh, who was headhunted by *Newsday,* and Greil Marcus, who wrote for several papers.

After short profiles on the main publications in the field we will sketch some defining positions in the early field through profiling five leading critics of the period. As we will see they are all deeply involved in American cultural mythology, and while America had been the promised land of Puritans and other refugees from Europe, these critics entered rock writing at a time when rock was widely seen as the promise of a new generation. It became their task to secularize this promise and write the Declaration of Independence and the Constitution of the new Republic of Rock. Therefore they are the founding fathers of rock criticism.

5.1. The Rock Press 1967–1975

Rolling Stone
Within a year or two of its start in November 1967, *RS*, with its in-depth articles, substantial interviews and reviews, had suceeding in becoming *the* authoritative voice on popular music for most of the Western world.

Jann Wenner has been publisher and editor from the magazine's inception. Over the years, he has withdrawn for long periods from active editing, but major policy decisions have always been his, as well as a legion of detailed instruction. The jazz critic Ralph R. Gleason functioned as Wenner's mentor and was heavily involved in the founding and running of the magazine the first few years. Almost every well-known rock writer has written for *RS* at one time or another.

The mainstream media and probably a part of the readership viewed *RS* as an underground magazine, but in reality it was planned and has always functioned as a commercial venture. Thus the editorial layout has from the beginning been rather conservative, although the advertisements might give another

Table 1: Rolling Stone, *number of reviews, record review editors, and main critics (1967–1970):*[1]

Period	Amount of reviews	Amount of pages	Record editor according to masthead	Central critics
November 9, 1967 - January 20, 1968	3–4	1	none	anonymous
February 10, 1968 - August 24, 1968	5	2	none	Some still anonymous, Robert Greenberg, Robert Christgau (only July 6), Jann Wenner, Jim Miller
September 9, 1968 - March 15, 1969	5–9	2	none	Wenner, Miller, Gene Sculatti, Jon Landau, Tony Glover, Greil Marcus (since November 9), Ed Ward, John Mendelsohn
April 5, 1969 - July 26, 1969	Ca. 10	3	none	Bangs (since April 5), Lenny Kaye, Marcus, Ward, Miller, Mendelsohn, Langdon Winner, Paul Nelson, Paul Williams (only June 14), Glover, John Morthland

1 Criticism as understood in this book is more than reviews, and in the first volumes of *RS* important critical contributions were made in for instance Jon Landau's, Ralph Gleason's and Jann Wenner's columns, and later on in the *RS* interviews. According to Draper (1991:113, 171) Ed Ward was review editor from early 1970 until November 1970, although his name never showed up in the masthead. That would not be the last time the masthead gave inaccurate information about active staff at *RS*.

2 Publishing more reviews of one album became common during this period. The September 6, 1969, issue carried three reviews of Blind Faith's debut and by the end of that year the Kinks's *Arthur* and the Beatles' *Abbey Road* were reviewed twice each.

August 8, 1969 - August 9, 1970	10–20[2]	5	Marcus	Winner, Ward, Marcus, Bangs, Morthland Gleason, Mendelsohn, Peter Guralnick, Kaye, Simon Frith (only March 7)
September 3, 1970 - December 2, 1970	15–20	5	none	Ward, Bangs, Winner, John Lombardi, Chet Flippo, Robert Palmer, Paul Gambaccini, Miller, Mendelsohn, Kaye, R. Serge Denisoff
December 24, 1970 - December 23, 1971	22–28	4–6	Landau	Landau, Kaye, Bangs, Palmer, Mendelsohn, Ward, Denisoff, Gambaccini, Marsh (only January 7), Richard Meltzer, Nick Tosches, Greg Shaw, Jon Cott, Nelson, Flippo, Patti Smith, Jonh Ingham

impression with their arabesques and other art nouveau gimmicks typical of contemporary psychedelic posters.

In 1967 San Francisco became the symbolic center of progressive rock music, and the strong San Francisco bias of *RS* helped it achieve its central position in the field. The competitive advantage of this bias vanished gradually, and in 1977 a move to New York was a logical step to protect the leading position of the magazine. *RS* has had intermittent British editions and a regular Australian one since 1972. The first issue sold 6,000 copies, but soon the magazine became a success and the circulation, according to Draper (1991) rose to 100,000 in 1969, passed 1 million in 1985, and was 1.2 million in 1994 (1 million by subscription).

During the first couple of years the San Francisco bias of Gleason, Wenner and other writers was counterweighted by Jon Landau who wrote from Boston, emphasized black American music and belittled most of the psychedelic music. In the beginning there was no systematic editing of the review section, but from August 1969 Greil Marcus became review editor. The section remained quite anarchistic but Marcus attracted writers who shared the ambition of interpret-

ing rock music in terms of American culture and politics. In 1970 Marcus, in his own words, was fired for giving Bob Dylan the thumbs down, and most of his closest collaborators, such as John Morthland, Langdon Winner and Ed Ward, left with him or shortly after (Draper 1991:170–172). Jon Landau took over, after producing records for about a year. He made the section much more straightforward and demanded shorter reviews that judged the music technically and in light of whether its intentions were realized. Landau reigned over the review section for most of the next five years.

During the early 1970s Wenner's editorial policy changed from an emphasis on rock to more general coverage of the news and culture that interested his generation, the male "baby boomers" born mostly in the late 1940s. The result was several classic news stories (e.g., on Patty Hearst and Charlie Manson) and Hunter S. Thompson's famous railings, among them the original essay-length "Fear and Loathing in Las Vegas." The magazine continued to take a special interest in music, but that also changed into more mainstream coverage by authors like Cameron Crowe and Ben Fong-Torres, while the review section remained a steady guardian of "quality" and "authenticity" under Jon Landau and Dave Marsh throughout the 1970s.

RS is financed by advertising and by subscriptions. During the first years only musical recordings were advertised. This began to change in 1974–1975 with the introduction of advertisements for stereo equipment and liquor. With a successful marketing campaign called "Perception/Reality" directed towards advertisers in 1985 the magazine's image was thoroughly transformed from hippie to yuppie. Today manufacturers of cars, liquor, perfumes and fashion are the leading advertisers. Hardly any record company advertisers are left (the prices are probably too prohibitive). In the 1990s, 50 to 60 percent of the pages consisted of advertising. In the 1980s the star interviews began to focus on movie stars at the expense of rock stars, and the serializing of new novels (e.g., star journalist/novelist Tom Wolfe's *The Bonfire of the Vanities*) was not uncommon. The record reviews remained quite long and well argued, but in the mid-1990s diminished in number (10–20 per issue).

During the first six years only men wrote for and administered *RS*. Women ("chicks") were relegated to menial roles such as secretary or receptionist, but after 1973 several women became editors. Although *RS* employs more women in editorial jobs than most other big music magazines, men still dominate.[3] But

3 The women who broke the ice were Marianne Partridge (copy editor, 1974), her replacement
 Barbara Downey and Harriet Fier (managing editor 1978–1980) (Draper 1991).

then again, women only became more influential when rock became less important for the magazine.

Musically, *RS* has not been attentive to new trends since the 1960s.[4] At that time the magazine was a taste leader, a position it has since lost, although it carried in-depth articles on punk and MTV (both of which the magazine condemned in general). Instead, it has contributed heavily to the canonization of the 1960s legacy: the Beatles/John Lennon, the Rolling Stones, and Bob Dylan—and not least itself through numerous spin-off books containing articles, interviews and reviews "from the pages of *Rolling Stone.*"

Creem

> Unlike *RS*, which is a bastion of San Francisco counterculture rock-as-art orthodoxy, Creem is committed to a pop aesthetic. It speaks to fans that consciously value rock as an expression of urban teenage culture.
> —Ellen Willis in the *New Yorker*[5]

One of the many rock magazines to surface in the wake of *RS* was *Creem*, founded in Detroit in February 1969. During its first months it was no more than a local underground paper, peddling politics and local musicians and advertising for the record store of owner Barry Kramer. After a few months the first editor left. The remaining writers established a collective of which 19-year-old college dropout Dave Marsh soon became the de facto leader. Together with Kramer and Deday LaRene, a 25-year-old law school graduate, Marsh shaped a sharp and witty magazine. The Detroit roots were not abandoned, as special attention was given to hometown acts such as the MC5, the Stooges, Mitch Ryder and the Motown scene. However at the same time these roots were shaped into a sensibility based on the popular music of the Motor City that provided a specific perspective on music and lifestyle. The *Creem* writers were anchored in the radical community that had been the soil of the White Panther Party, and they were committed to rock as a lifestyle and living it in the headquarters of *Creem*: "*Creem* was an ongoing argument that happened to produce a magazine once a month" (Dave Marsh, personal interview, November 22, 1999).

In form and style *Creem* was open to experiments. After Greil Marcus was kicked out of *RS* in 1970, *Creem* distinguished itself as a magazine that was

4 Talking Heads, for example, were not featured on the cover until 1987.
5 Quoted from DeRogatis (2000:75).

ready to print lengthy pieces if they were worthwhile, whereas *RS* was not printing lengthy reviews or ravings about rock any more. Marsh and LaRene wrote some long, engaged pieces, but a new standard was set when an eight-page-long Stooges review by Lester Bangs appeared in November and December 1970, the first piece that exposed his enormous talent. He continued to write for *Creem* and by the end of 1971 he had moved from southern California to replace Deday LaRene as the de facto coeditor with Dave Marsh. The common commitment of Bangs and Marsh to the wilder side of rock, as well as the huge differences between their personalities furnished *Creem* with a creative force for more than two years.

> As editor I was guided by the idea of inspired amateurism, encouraging and guiding kids to write. Lester's contribution, beyond being the best writer we had, was his capability of really throwing it open. Lester was a much less rigid person than me. Lester was running things that he violently disagreed with, and he would really like to run things that I violently disagreed with. But what we had in common was this sense of nurturing people, resulting in issues that conveyed the sense of openness, of possibility and diversity, who wanted to do this work, and I think that was…amazing to some people. Not only were we open for them, but we would help out, basically if we liked you, if we could stand your personality we would encourage you. (ibid.)

While *RS* was becoming a general magazine with a special interest in music, *Creem* presented itself as "America's Only Rock 'n' Roll Magazine," and the best known rock writers, such as Robert Christgau, Greil Marcus, Richard Meltzer and Nick Tosches, often contributed, side by side with Detroit kids and newcomers from New York, like Lenny Kaye and Patti Smith. The contributors also wrote about books, films and occasionally community matters of vital importance for the Detroit counterculture that was the magazine's original core readership. During the years of Marsh and Bangs *Creem* reported that its circulation rose to over 200,000 copies each month (*RS* always sold considerably more). *Creem* was read all over the U.S. and to some extent overseas, winning a reputation out of proportion to its circulation—the new generation of British writers, for instance, looked to *Creem* rather than *RS* for inspiration. From about 1972 British writers like Nick Kent and Simon Frith often contributed, and the British periodicals *NME* and *Let It Rock* printed a few articles by Lester Bangs.

The genre taste of *Creem* writers was broad and diversified. For instance the pop aesthetics of *Creem* made the magazine more receptive than *RS* to many

British bands. The Who and the Faces were early heroes and later Bangs raved about glam rock and heavy rock, from Bowie to Slade, Kiss and Deep Purple.

Dave Marsh left *Creem* in 1973 and Lester Bangs in 1976. Its golden age was over, although a bunch of Lester Bangs's disciples continued the magazine into the 1990s.

Other Important Channels of Rock Criticism

With *RS* and *Creem* the centers of rock criticism were in San Francisco and Detroit at the end of the 1960s and the beginning of the 1970s. New York had, of course, a large concentration of "new intellectuals" willing to read and write rock criticism but no magnetic forum appeared. In 1966–1968 the "Pop Eye" column of Richard Goldstein in the *Village Voice* was the center of attention; Robert Christgau wrote a column in *Esquire* from 1967 through 1969 and Ellen Willis had a strong platform in the *New Yorker. Crawdaddy!* moved to New York in early 1967, but lost its importance as *RS* took the lead in 1968. In October 1967 *Cheetah* was launched as a periodical digging intellectually into popular culture, but it lasted only nine issues. By 1968 Christgau replaced Richard Goldstein as rock columnist at the *Village Voice* and became the leading critic in the area. During 1972–1974 Christgau wrote for the Long Island–based, suburban daily *Newsday* and after him Dave Marsh kept the column as a stronghold of rock criticism for a year before moving to *RS*. Christgau returned to the *Village Voice* in 1974, this time as a music editor. With rock given greater and more core space he could gather contributions from respected critics like Paul Nelson, Ellen Willis and well known *RS* and *Creem* writers; the *Voice* published Lester Bangs frequently after he left *Creem* in 1976. By the mid-1970s the *Voice* thrived on its closeness to the CBGB scene and Christgau groomed a new generation that wanted to turn punk and new wave into words and thought.

The fourth center of criticism was in Boston. *Crawdaddy!* was published during most of 1966 but then nothing much happened until a small student paper was relaunched and rechristened the *Phoenix,* "Metropolitan Boston's Weekly Journal of News, Opinion, and the Arts," in early 1970. It was styled as a more traditional version of the underground papers, giving priority to political material, reviewing the local art scene and running features about alternative lifestyles in the countryside. It was often said (cf. Marsh 1979) that it resembled the *Voice,* but its layout was slicker, if conservative, and rock was an integral part of the image. Rock often provided the cover "hook" and was substantiated by thorough reports and reviews. The trump card was hiring Jon Landau as top music critic, returning him to criticism after a year in record production. The *Phoenix* had an unmistakable smell of campus and was a very visible part of the

student/hippie scene in Boston with longhaired street hawkers selling the paper in the streets (Goodman 1997). In 1972 it was bought by its competitor, *Boston After Dark*, and renamed the *Boston Phoenix*. The staff of the *Phoenix* responded by forming their own antibusiness business, the *Real Paper*. They had the credibility and furthermore managed to enlist the main rock music authority not only in Boston but the entire U.S., Jon Landau. Landau provided a regular column, "Loose Ends," and mediated the hiring of Dave Marsh as music editor, although Marsh couldn't stand staying in Cambridge more than six months. The *Real Paper* continued the line of the *Phoenix*, becoming a commercial success with a circulation of 50,000. It was here that Jon Landau published the most famous single piece of rock writing in May 1974, the one that identified Bruce Springsteen as rock 'n' roll's future.

In the late 1960s, underground papers like the *East Village Voice* in New York and *Distant Drummer* in Philadelphia contributed to the rock discussion, as did high school papers, college journals and the various fanzines dedicated to special genres or artists, Clearly secondary, generally modeling their writing on that of the leading rock magazines, they became a breeding ground for new writers. The dailies were no trendsetters either, but from the early 1970s widely distributed and rather conservative newspapers like the *New York Times* and *Los Angeles Times* employed regular critics that were a respected part of the field.

By the early 1970s the field of rock writing was populated by publishers, editors at different levels, staff writers and both professional and occasional freelancers. In a sense the most powerful individual in the field was *RS* publisher and editor Jann Wenner, since he hired and fired writers for the most prestigious publication and sometimes passed strict editorial orders. Yet his power was limited as eminent writers could find jobs elsewhere and *RS* had no hegemonic position after *Creem*, the *Phoenix*, the *Village Voice* and various other publications became fixtures of the scene. Music editors and review editors contributed more steadily to the shaping of criticism profiles, especially Jon Landau through his long tenure at *RS*, Greil Marcus through his shorter tenure but longer-lasting authority, Dave Marsh and Lester Bangs as editors of *Creem* and, finally, Robert Christgau as music editor of the *Village Voice* from 1974. Incidentally these five editors were also the star critics of the period, only temporarily challenged by colleagues such as Ellen Willis, Richard Melzer, Nick Tosches, Ed Ward, Langdon Winner, John Morthland and Paul Nelson, and they have had a lasting influence.

5.2. The First Dean of Rock Critics Lays Down the Basic Rules: Jon Landau

> We tell ourselves we are a counter culture. And yet are we really so different from the culture against which we rebel?
>
> —Jon Landau[6]

For most of the period 1967–1975 there was no question who had most authority as a rock critic. Jon Landau (b. 1946) was chief music critic of *Crawdaddy!* (1966–1967), of *RS* (1967–1969), of the *Phoenix* (1970–1972) and the *Real Paper* (1972–1975), and he was review editor of *RS* for most of the period from 1970 through 1975. From the beginning he presented his interpretations and evaluations with an aura of authority, which was reinforced by his insights into record production and the music industry, but unlike many of his best colleagues his basic interest was not in writing per se, but in the messages he delivered. He left rock writing in 1975 to become producer and manager for Bruce Springsteen. Understandably he is less referred to than those of his contemporaries who stayed in the rock writing business. But in the early days, he was the giant.

Landau inherited a strong social commitment as well as a broad musical interest from his well-off Jewish family, living in Brooklyn and Queens until moving to Lexington, Massachusetts, in 1960. With this background it was natural to play radical folk music in the early 1960s and to go electric shortly after Dylan. This was in 1965 and Landau had enrolled at the Jewish-dominated Brandeis University. Landau emphasizes that he has a strong and positive attitude towards his Jewish roots. At Brandeis Landau became somewhat involved in radical politics, but to his regret American students were at that time turning from activism to an inner search through drugs and rock music. Landau was never given to drug-induced mysticism, and he held the view that rock should be political in the sense of a cultural revolution. Although social commitment was positive, rock musicians should not try to be prophets but concentrate on making good body music.

A chronic intestinal disease forced Landau to stop playing and studying in 1966 and he took some time off to work as a record shop assistant. Here he met the editor of the new rock paper *Crawdaddy!*, Paul Williams, and told him that he would be able to write much better criticism. Landau instantly became the main critic of the journal. When Ralph Gleason and Wenner, sharing a creative

6 *Phoenix*, October 13, 1970:14.

vision and a lot more money than Williams, launched a competitor, *RS*, they headhunted Landau to write a regular column with his own full page each issue, which he did for a year and a half while finishing his bachelor's degree at Brandeis. However Landau wanted to become a more active player in the field of rock and became a record producer for a year in 1969–1970. His first attempts were not a great success. So in 1970 he returned to rock writing, in the *Phoenix, RS* and the *Real Paper*. In 1975 Landau again left criticism for record producing, this time for good.

Already in *Crawdaddy!*, Landau speaks with authority and hands out judgments without hesitation:

> There are specific musical shortcomings with this group's approach to their material that has resulted in this musically embarrassing album. The way I hear it this shortcoming is the failure of the individuals in the group to subordinate their individual techniques and styles to some higher musical goal, namely some kind of unified aesthetic expression of *what they feel*. ("On The Blues Project's Projections," *Crawdaddy!* 8, March 1967)

Landau's review of *Between the Buttons* by the Rolling Stones was a landmark in rock writing.[7] In this review Landau sweeps elegantly through the history of the Stones, pointing with authority to the moves that had made them great and passing technical judgments on details:

> Charlie in the past has been somewhat hit or miss. [...] He has had a tendency towards sloppiness, like on "I'm Free" from December's Children but that's completely gone here. [...] The close-miked snare and hi-hat fit what's happening perfectly. The dry, un- or lightly -echoed thing he [producer Oldham] is working with Watts gives the overall sound tremendous bite, which is really central to this album. [...] The songs on Buttons [...] don't all confirm my judgment that the group is moving in new directions lyrically. [...] And its not the Beatle thing either [...] there aren't any triple-tracked, speeded up, back-up vocal tracks that sound like they couldn't really be sung by human beings here. [...] The Stones make you feel their presence in a way that is so immediate, so essential, so relevant, that one can't turn his mind away from what they're doing. (*Crawdaddy!* 9, May 1967)

Writing in *Crawdaddy!* at the age of 20, Landau was already convincing. His style is extremely self-confident, but it is sufficiently supported by arguments,

7 Dave Marsh still remembers it as the piece that opened the doors of rock criticism for the 17-year-old wannabe (personal interview, November 22, 1999).

examples and sharp evaluations to avoid being boisterous. When Landau moved to *RS* he sharpened his profile, not least through choosing the topics of his one-page column carefully, hereby constructing an elaborate canon, stressing black soul and blues and the holy trinity of the Beatles, the Stones and Dylan. Landau never constrained himself when judging the quality of rock, but he would some-times change his mind when artists issued new records. He started to write about rock as a missionary, preaching rock 'n' roll salvation, but especially after he returned to writing in 1970 another side of him took over: the connoisseur who knows the music and the music business from the inside and has the authority of a judge, weighing his arguments and formulating his verdict as an absolute and indisputable truth.

During the first year of *RS*, Landau's one-page articles obviously carried more weight than shorter reviews or articles, and at the same time Landau distinguished himself in an elegant way from the general editorial policy. Jann Wenner, Ralph Gleason and many of their writers had a heavy San Francisco bias. For them a new era in rock music had begun with Jefferson Airplane's *Takes Off* (or perhaps with Buffalo Springfield's "For What It's Worth") in late 1966. They tended to see the Beatles (with *Sgt. Pepper*), Jimi Hendrix and Pink Floyd as more or less gifted disciples of the San Franciscans, but the rest had not yet seen the light or were aesthetically repulsive like the Velvet Underground. Landau on the other hand was not only placed on the East Coast, in Boston, but he was always skeptical about the San Franciscan gospel. Especially Gleason announced the birth of new rock aesthetics, close to the aesthetics of avant-garde jazz, while Landau stressed that rock aesthetics really had their foundations in 1950s body music. The tension between these two main poles in the first *RS* issues undoubtedly made the maga-zine more exciting than a univocal gospel song would have been.[8]

After one year off to produce rock music, Landau went back to writing in 1970 with "more reflection, detachment and a mellower approach" (Landau 1972:18), although his basic criteria remained unchanged. He felt that rock had become less important, but still meaningful, which was expressed in the title *It's Too Late To Stop Now* that he used for his "comeback" essay in 1970 and for his collection of pieces in 1972. In the book Landau makes a point about his having

8 Some examples of this tension from *RS* in the first half of 1968: Landau writes off the Doors, while both an anonymous reviewer and Jerry Hopkins praise them. Landau's critical attitude towards Cream is balanced by Wenner himself emphasizing the positive in a review of *Wheels of Fire*. Landau attacks the producer Felix Pappalardi, but a few issues later a whole article is devoted to his productions as some of the most exciting developments in rock. Gleason proclaims that rock musicians are the shamans of our times, and Landau replies that musicians are not prophets.

started writing about rock with messianic aims, but gradually feeling his enthusiasm fade. Two years later, in his most famous column ever ("Loose Ends," *Real Paper*, May 22, 1974), Landau emphasized even more strongly that between 1966 and 1974 he had became more and more disenchanted with rock.

Although his commitment went up and down, Landau's basic taste was rather consistent. His deepest affection was reserved for black soul singers, as expressed in a comparison between John Fogerty and Aretha Franklin:

> Fogerty is a stylist who knows how to use a limited vocal tool with reasonable intelligence. Aretha Franklin is an artist with a voice that is in itself overwhelming to listen to and a knowledge of the art of the singing that knows no bounds. (*Phoenix*, December 15, 1970:12)

Landau was far more critical of contemporary white bands than most other critics of this period and unreservedly dismissed a band as hip as the Doors. He demanded clear aesthetic objectives and technical precision—for instance, he loved the Stones when they played their own music in a scruffy rhythm 'n' blues style. His writings from the late 1960s about Cream can serve as a good example of his approach, emphasis and idiosyncrasies.

In the August 1967 issue of *Crawdaddy!* Landau reviewed the "new" white British blues bands Blues Breakers, Spencer Davis Group and Cream. He praises Clapton's guitar playing with the Blues Breakers, but finds Cream still searching for their own style. In the first issue of *RS* (November 9, 1967) Landau devoted his page to a discussion of the Jimi Hendrix Experience and Cream. Focusing on the absence of rhythm guitar in both groups, his main point is that Hendrix can afford it but Cream needs it. A few months later he puts *Disraeli Gears* down by calling the LP a "bummer combining poor singing with some horrible melodies, awful production by Felix Pappalardi and academic, totally detached instrumental work" (*RS*, February 23, 1968:18). A few weeks later he modifies this bombastic statement, by commenting that even Cream have problems in the studio (*RS*, April 27, 1968:18). In the next issue he tried to set the record straight, devoting his page to a concert review of Cream. He states that they are not creating anything new in their improvisations but first and foremost copy American bluesmen without always knowing what they are doing. However, there are not "more than a handful of American bands that can come within miles of Cream." The conclusion is that "Cream live, as on record, are clearly in a transitional style [...] warming up" (*RS*, May 15, 1968). Especially Clapton is accredited with a talent that has not fully developed yet. Clapton himself was

shocked by this review. "And it was true...I immediately decided that this was the end of the band" (Robert Palmer, *RS* interview; quoted from Schumacher 1995). Then the final verdict of Landau came in his state-of-the-art article:

> Cream was not merely a blues band—at their best they combined that musical form with rock in an expert and exciting way. At their worst, they indulged in a narcissistic display of technical virtuosity. Among other things they institutionalized rock "jams" and long cuts, and they may well have pulled it off better than anyone who has tried them since.[9]

For Landau copying black blues with technical virtuosity is not enough when there is no clear artistic vision and the melodies are poor. But as time goes on Landau learns to appreciate the innovative elements of some white blues-rock bands, like Cream, and hit even harder on bands like Led Zeppelin who "offer us only greed, bravado and blatant insincerity [...] in order to pick up a paycheck" (*Phoenix*, September 19, 1970:31).

Another characteristic of Landau's approach is how ready he is to declare whether music is arranged and produced in the right or wrong manner. No other rock critic at that time had been so daring in telling groups they had chosen the wrong producer or described in detail where the production went wrong. This self-confidence is based on his own understanding of a credibility consisting of four elements and their internal relations.

Landau's academic training helped to establish his credibility, but he does not emphasize it himself, and as concrete tools for rock criticism he points only to a few courses in art history (Landau 1972:192–199). For him this is rudimentary training, which, just as musical education, only becomes important when coupled with the really important experience: that of a fan and a rock musician. Already at the age of 23 the disenchantment of age provided him with a problem but also a challenge: to develop "a more mellow approach" (Landau 1972:18) based on his earlier experience of having been able to relate strongly to certain music. But privileged access is ensured not least by Landau's experience as a rock musi-

9 *RS*, December 2, 1970; quoted from Landau 1972: 26. Whiteley (1992:15) carried out a musicological analysis of the music of Cream, finding "innovation, eg the incorporation of psychedelic coding, fuzz tone, wah-wah pedal and reverb in Clapton's guitar playing, blues/jazz, blues/classical, blues/Indean fusions, the overlay of different styles of melody lines and lyrics which relate to contemporary themes." Michelsen (1993) cites Landau's concert review as an example of a musically nuanced discussion of rock from this period, although he does not find Landau's analysis too sophisticated.

cian, which enables him to depict what is going on in the studio and on stage as well as to explain the music in terms that can be understood by people with musical experience, although not necessarily with musical training. It is important for his credibility that he did not stop his career because of failure but because of poor health. Throughout Landau's career as a critic these credentials and this elaborate hierarchy within its elements remained stable in his profile. He managed to ride the heavy tide of his time while at the same time staying independent and critical, which must not only be taken as the result of combined empathy and distance, but also of a sharp insight into the music and the 1960s movements.

Additional aspects of Landau's approach can be exemplified by his interpretation of Dylan's "All Along the Watchtower," written in an extended review of the long-awaited release of *John Wesley Harding*:

> Rather than see the song as something to be interpreted, I tend to see it as an evocation of a mood, a mood created primarily by the way Dylan sings his words. Suppose he sang "There must be some way out of here" softly, in 3/4 time, Supposing he was laughing while he sang it. That would change the meaning, such as there may be, drastically. But now suppose he scatted in place of using words, and that he did the scatting precisely as he sings the words. You'd probably respond quite similarly, except your response would be less specific due to the lack of words to focus on. That is, I think that the line "There must be some way out of here" is a great line to sing in the tone of voice Dylan uses, not the other way round. […] It's just that I think it more natural to respond first to the music and then to the words when one is listening to a song and I think that is in fact what most people probably do. (*Crawdaddy!* May 16, 1968)

Here Landau uses a substitutional approach to highlight meaning in music.[10] It involves a likely presumption of how rock is usually listened to (sounds before words), though Landau does not discuss the influence of different cultural settings on the reception as his focus is as always on the work. Perhaps his "imagined readers" are his peers, his own generation of (white) males with a certain amount of education, musical training and practice, as he never bothers to explain his own musical terminology or to reflect on barriers for understanding music his way. His style is not to raise questions or admit own insecurity of interpretation in the manner of Paul Williams, but only to point out that this is his evaluations, writing "I think," "to my ears" or "the way I hear it."

10 Musicologists like Philip Tagg and Johan Fornäs would later walk the same path in a more systematic way.

Addressing the question of rock and art in the summer of 1968, Landau attacks the notion that rock has changed drastically from "the honky-tonk atmosphere of rock and roll" to a "valid art form." For Landau rock is only authentic as a resurrection or extension of the spirit of the early rock 'n' roll. The Stones in particular, "more than the Beatles or anyone else, modernized as they interpreted" from the first album and until they tried to be arty with *Their Satanic Majesties Request*. Groups like the Doors are "posturing and attitudinizing. [...] The Stones have the authenticity, while the Doors wind up playing music that, to these ears, sounds as close to rock as professional wrestling is to sports" (*RS*, July 1968; quoted from Landau 1972:133).

> The only thing I would insist on is that rock functions at its best when it does not seek to over-generalize, preach, or tell people what to do or think. It is at its best when it is used to explore the experience of the musician and the listener, when it seeks to entertain as well as provoke, when it realizes that rock is not primarily poetry or art, but something much more direct and immediate than either. Rock and roll has to be *body music*, before it can be head music, or it will wind up being neither. Rock and roll may be the new music but rock musicians are not the new prophets. (1972:134)

In this piece, and elsewhere, Landau is arguing that rock is a specific art form whose one leg is named "entertainment" and the other "provocation." To study and interpret this art form Landau follows in the footsteps of film critics who for more than a decade had searched for an auteur behind the technology and cooperative efforts of mass produced art (cf. p. 40):

> [T]he concern has always been with the search for the author in rock music, the search for the source behind the music, the search for continuity in all of the musician/artist's work. [...] To me the criterion for art in rock is the capacity of the musician to create a personal, almost private, universe and to express it fully. A point of view can be delineated through a combination of means. In some cases the vision is created through instruments alone in a way that can never be completely defined and never should be. In others the lyrics and music provide alternate or ultimately joint ways of expressing the same accessible ideas and feelings—as in the music of Bob Dylan. (1972:14–15)

Although Landau agrees with fellow critics that rock is based on interaction between artists and audience, for him this interaction is not qualitatively different from the case of Shakespeare, Dickens and other artists who had to survive commercially (*Real Paper*, May 9, 1973:6).

There are not many American groups that can squeeze themselves through the needle's eye of Landau's standards, although the Beach Boys, Byrds and Creedence Clearwater Revival are finally accepted. For Landau rock 'n' roll is created in the 1950s mainly by white people, as a reinterpretation and rearrangement of mostly black musical elements. In the 1960s there are two main lines of descent, one being mainly British (the Beatles, the Rolling Stones, etc.), the other black blues and soul, responding in a creative way to the whitening of black music. In 1966–1968 Landau devotes most of his space in magazines to promoting black music, especially Aretha Franklin, Sam and Dave, Otis Redding, the Temptations and B.B. King. However, he does not hesitate to tell these artists that they could do better, especially production-wise.

Although a little discordant within this schema, Dylan is always listed as one of the greatest. The example above is from one of a number of careful studies Landau makes of him. Comparing his comprehensive view of Dylan with another favorite, the Stones, reveals an important aspect of Landau's aesthetic standards.

Repeatedly Landau names *Between the Buttons* as the best album of the Rolling Stones but criticizes *Beggars Banquet*, *Let It Bleed* and *Sticky Fingers* for being "too controlled and manipulative" and "detached." This can be seen as a personal and quite justifiable preference, an insistence on authenticity and a provocation against conventional wisdom on the Stones. But it can also be seen as a projection of Landau's personal development.

In 1967 Jon Landau was personally committed to rock and found *Between the Buttons* fabulous. By 1969 he had become disillusioned and received everything negatively. There was a neat conjuncture between this personal development and the artistic development of Dylan. When Landau started to write about rock, Dylan had quit posing as a folk musician and a prophet and sought his expression in rock music, fitting Landau's standards. Landau's increasing disenchantment happened at the same time as Dylan was, in the view of most critics, hitting the absolute bottom in his career with *Self Portrait* (and even *New Morning*, see, e.g., Landau in the *Phoenix*, November 2, 1970:25). The Stones on the other hand were undergoing their second artistic growth at the same time as Landau was becoming more and more negative.

Landau is a better interpreter of Dylan than of the Stones, not only because of personal development. He also shares cultural references with Dylan, which enables him to contextualize and interpret him in a sensitive and illuminating way. For Landau the Stones were not primarily a group that had developed their music within a local context in England, but one that had presented the herit-

age of American 1950s rock and roll to American rock audiences in the 1960s. In his state-of-the-art article Landau writes:

> So many of the most popular groups of the late Sixties came from England because in that country they could remain shielded from American audiences until they were well prepared. American groups had to make their debuts and mistakes in front of the audience that counted most. (*RS*, December 2, 1970; quoted from Landau 1972:23)

Before commenting on this passage, it should be mentioned that British rock groups have never doubted that their own audiences were the most critical ones and that conquering the American market was a matter of the right marketing strategy. In light of this, Landau's remarks either express subtle irony, usually not to be found in his writing, or sheer U.S.-centric ignorance. The latter possibility is more likely, given Landau's reception of many other British artists, such as the Yardbirds, Cream, Pink Floyd and David Bowie and that nothing he has written implies that he ever considered whether anybody could be making rock music in other countries. Landau was central in establishing geographical and ethnic balance in American rock discourse, but he contributed also to its U.S.-centrism.[11]

In this section the credentials of Landau have been identified as an elaborate hierarchy of musical training, academic training, a history of dedicated fan-attitude to rock and, most importantly, experience as a musician and producer. He moves within a set of clear and consistent aesthetic standards: conventional art standards of expressive individuality and originality, and what he perceives as the specific qualities of rock, emphasizing its 1950s roots and an appeal to the body. In addition some tacit axioms have been identified as poorly reflected egocentrism and ethnocentrism. His influence as a rock critic can be explained by the fact that he understood better than any of his contemporaries how to combine empathy and distance into strong insights into the making of the music. Through most of his reviews and articles he is listening as a producer: what are the potentials, what could be done better, and so forth. Landau's early pieces in *Crawdaddy!* and *RS* in 1966–1969 were perhaps the strongest contributions to raising the standard of rock criticism, while his writings in 1970–1975 rather

11 An amusing symptom of this U.S.-centrism is that Landau, when considering the recordings of British groups, comments only on the versions of LPs released in the U.S., often musing on the intricate relations and sequencing between the individual tracks, even when these U.S. releases have been reshuffled from their original versions due to the commercial rationale of the releasing company and not the artistic choice of the musicians.

appeared as authoritative, insider orthodoxy, inviting attacks from up-and-coming writers eager to reinvent rock criticism in light of the music of the 1970s.

Landau certainly wanted to shape the world of rock music, not only by convincing people of his standards or taste, but also by direct intervention. Dave Marsh, a true disciple of Landau, has remarked:

> Landau knew how to wield his influence. He had been instrumental in getting the J. Geils Band signed to Atlantic Records, and his review of Maria Muldaur's "Midnight at the Oasis" had been a key factor in convincing Warner Bros. Records to back the song, which eventually became a major hit. (Marsh 1979:84)

As mentioned, Landau's first attempts to put his standards into practice did not fare well, and he hesitated trying again. In the spring of 1974, though, Landau was again moved by a rock artist. He called Bruce Springsteen's second album, *The Wild, The Innocent and the E Street Shuffle*, "the most under-rated album so far this year" (*Real Paper*, April 10, 1974) and after witnessing Springsteen live, Landau wrote a column that instantly became the most famous and most quoted piece in the history of rock criticism. It started: "I'm twenty-seven today, feeling old, listening to my records and remembering that things were different a decade ago." Landau went on to describe how the thrill had gone during his years as musician, critic and producer.

> But tonight, there is someone I can write of the way I used to write, without reservations of any kind. Last Thursday at Harvard Square Theatre, I saw my rock and roll past flash before my eyes. And I saw something rise. I saw rock and roll future and its name is Bruce Springsteen. (*Real Paper*, May 22, 1974; quoted from Marsh 1979:86)

As Dave Marsh (1979:90) points out, "It would be ingenuous to suggest that Landau had not anticipated the effect of his words," but the consequences for Landau must have been bigger than he could foresee. Less than a year later Landau found himself producing Springsteen, and the appraisal of his production of *Born to Run* launched Landau's second career as a producer and manager of Springsteen, Jackson Browne and other artists. It is not within the scope of this book to review these productions, even though they can be seen as the realization of the standards Landau had set in his writing. In the words of Langdon Winner from 1979:

> Now, rock and roll is (or at least has become) an extremely conventional music. Performers who observe its stylistic traditions most faithfully—Bruce Springsteen

is the most obvious example at present—are the ones likely to win the largest following of fans and critics. (Marcus 1979/1996:62)

Perhaps Landau's famous words can be rephrased: "I saw the future of rock and roll business, and its name is Jon Landau."

5.3. Taste Inc.: Robert Christgau, the Dean of New York Rock Critics

> It seems to me that from 1974 when I began to edit the music section of *Village Voice* to some time in the early 1980s we were the only game in town. We were the people to do the best work. I used *RS* critics, I used *Creem* critics, I used people who came in off the streets. [...] We were the kings. As far as I was concerned, we were better than anybody else. We could publish anybody and make them do better work.
>
> —Robert Christgau[12]

When defining his prime, Christgau thus emphasizes his function as editor. As a carefully chosen indicator of his ability as editor, Christgau takes pride in being the only editor ever to wield any influence on Lester Bangs's writing style, and though the two never became close, Bangs "often praised Christgau's editing."[13] More generally, Christgau defines his "grand coup" at the *Village Voice* as synthesizing two traditions, the *RS* tradition of intellectually rigorous auteurism (the position of Jon Landau) and the *Creem* gonzo, writer-centric tradition of the literary bohemian (the position of Lester Bangs).

Christgau has continued to edit the music section of *Village Voice* and he has groomed many of the strongest writers of the 1980s and the 1990s. His own pieces have carried much authority in the field since the early days at the *Village Voice* in the late 1960s and into the 21st century, and they have been anthologized twice (1973, 1998). He has functioned as an always visible landmark in taste through his "Consumer Guides," which he has published regularly since 1969 and gathered in books by decade. His authority is illustrated by the fact that he is the only rock critic who has been honored with a Festschrift, *Don't Stop 'til You Get Enough. Essays in Honor of Robert Christgau* (Carsons et al. 2002).

As Christgau stresses in personal interviews, the choice of the humble consumer guide format was part a declaration directed against the snobs of elite culture, part

12 Personal interview, May 22, 1998.
13 DeRogatis (2000:137); also Robert Christgau, personal interview, May 22, 1998.

the outcome of his belief in the possibility of "intelligent consumption." The move is very characteristic of Christgau's opinionated, self-conscious, antielitist stance.

Robert Christgau (b. 1943), brought up by lower-middle-class parents in Queens, New York, was the first member of his family to receive a university degree. He started out in the mid-1960s as a wannabe writer, and he still thinks of himself as primarily a writer. None of his attempts at fiction were successful, but captured by the idea of New Journalism he wrote a piece on a girl who died from a macrobiotic diet that made its way into Tom Wolfe's classic anthology (Wolfe and Johnson 1973/1990). Before that, however, he had a realization that guided him for years to come, that of the confluence of pop art with pop music, signaling a democratization of culture (see p. 63–64).

Christgau is not comfortable with the highbrow connotations of "criticism," preferring "amateur sociology," "journalism" or just "writing." He accepts the term only because he is convinced that rock criticism is qualitatively different from academic literary criticism (1973:7). To Christgau popular art aesthetics surpass high art through "a vitality of both integrity and outreach…[dealing] with common realities and fantasies in forms that provided immediate pleasure" (3).

Christgau's position has always had clear political implications. He describes himself in the mid-1960s as the average college-educated bohemian in Greenwich Village, although an "oddball," always criticizing the one he loves. Popular culture was on the one hand a medium to turn the average youngster on to the values and lifestyle of left wing bohemians (59). On the other hand he "saw pop as class warfare in which paying customers thumbed their noses at cultural panjandrums" (1998:3), and he was not the only new intellectual to site his strongest identity in his background among the common people.

Unlike many of his underground friends, Christgau never let his political orientation dominate his aesthetic judgments, and he stresses repeatedly that even the best message fails if it does not meet the aesthetic demands of rock 'n' roll. Thus Christgau (1990:7) always tries to balance "two decisive general criteria, importance and quality." In 1990 he defines importance as cultural impact, subcultural acclaim, from the writers and readers of rock criticism, and past performance. Through the years he has offered different explanations of his quality criteria, but in the end it is a question whether Christgau likes the record or not, whether it provides "notable satisfaction" (1981:7), turning him on with the first listening, and whether it can stand repeated playing. Christgau sees no problem with such subjective criteria. It is obviously his opinion that good rock criticism is a question of incorporated taste that derives from social origins and experience but can only become illuminating for others through disciplined work.

Christgau seems to believe that trained listeners like himself have embodied the standards of rock, yet he also finds a reflexive awareness of one's point of departure important. This is expressed in an article about *Sgt. Pepper* from 1967: "In matters of interpretation, the important thing is not whether you're wrong or right, but whether you are faithful to your own peculiar stance in the world" (1973:46).

Christgau often appears more self-reflexive than his colleagues. Thus he repeatedly points to systematic shortcomings that burden him as a white male: his inability to identify in an immediate way with music of, for instance, black and female artists, even though he tries. Christgau's 1973 review of the female-dominated band the Joy of Cooking leaves the impression of a sympathizer with feminism incapable of applying his usual critical standards. In his collections of articles he omits most pieces he has written about black music because he is not satisfied with them. He has a tendency to refer to the authenticity of black music in a clichéd manner, although he qualifies his view in a review of Chuck Berry:

[H]is simplicity and vulgarity are defensible in the snootiest high-art terms. His case doesn't rest on such defences, however. It would be perverse to argue that his songs are in themselves as rich as Remembrance of Things Past. Their richness is a function of their active relationship with an audience—a complex relationship that shifts for every perceiver every time a song enters a new context, club or album or radio or mass sing-along. Proust wrote about a dying subculture from a cork-lined room. Berry helped give life to a subculture, and both he and it change every time they confront each other.[14]

Christgau stresses that although Berry possessed a strong element of blues, he was not an outstanding bluesman. His genius consisted in understanding what the public wanted and delivering it with love. He and Elvis Presley and perhaps a few other top artists "came near to bridging the gap" between white and black music and audiences (1973:35).

At the same time most white rock 'n' roll was shamelessly exploiting R & B and country and western "augmented by some primitive electronics and infused with enough pap, especially in the lyrics, to make it palatable to white urban teenagers [...] danceable and sexual" (ibid.). This fusion rhymed with

14 Christgau (1973:10). Retrospectively Christgau (1998:5–6) refers to this article as one of the best from his early days.

the white working-class lifestyle that was Christgau's own point of departure in his "baseball-and-sodapop past in Queens" (3).

The gap between these two separate tracks of rock and roll was finally bridged with the Beatles and the Rolling Stones, an achievement made possible by their distance from the social realities creating this gap. Unlike many of his contemporary critics Christgau welcomed the British moment of artifice from the start, by underlining the Beatles element of "light irony of pop art" (2). Bob Dylan becomes the third in the "canon" through his incorporation of pop art and other avant-garde elements into rock.

For Christgau it is not sufficient to refuse to understand rock through the standards of high art. At the same time as he underlines the pop art connections with rock music he stresses a difference—in favor of rock music: "For me, as for most of my early co-theorists, pop was also reactive—to the insularity and elitism of radical avant-gardism" (3).

From the beginning Christgau not only positioned himself in a provocative way against such isolationism but also against the dominating anticommercialism of the counterculture. This is evidenced in an article written in June 1968 when most of the counterculture was expecting the end of capitalism in the wake of the Parisian May revolt: "I believe commercial strictures are good for pop, forcing artists to concentrate on their audiences instead of themselves" (65).

Coming from the earth-colored beatnik scene Christgau welcomed the colorful, mod-influenced clothes of the hippies and the integration of pop into their music, as a healthy counterweight to the bohemian culture of the "true self." But later on he criticized the growing insularity of the hippies, who on the one hand proclaimed "us against them" and on the other nurtured their "own kind of snobbery directed not just at the high aesthetes who missed the point but at the yahoos who didn't apprehend the ironies of their own culture consumption" (6).

Here Christgau identifies precisely the same mechanisms of distinction as Bourdieu is describing. Any "new" cultural field establishes its own cultural practices by marking off an inner circle from the newcomers or the followers of fashion. The lesson learnt by Christgau is formulated thus in 1973:

> Rejecting the elitism built into both modes of self-preservation [i.e., the ruling culture and the counterculture] I melded the communitarian rhetoric of the counterculture and the populist possibilities of pop into a sort of improvised democratic radicalism that functioned more as a sensibility than a theory. (ibid.)

Not only does Christgau clearly state that the standards of criticism cannot be defined but must be embodied; he also takes an early stand in the controversies just emerging between the positions of communitarianism and liberalism, seeing himself as a radical communitarian.

It is only logical for Christgau to find "the silly auteurism of Jon Landau" insufficient (personal interview, May 22, 1998). Christgau primarily emphasizes the reciprocity between the musical products and the audience:

> [I]t's the nexus I write about. Of course popular music is a collectively produced "cultural practice." (1998:6)

Secondly, to Christgau the most important "works" even in the late 1960s are not albums but singles (a view later supported by Dave Marsh, issuing his *1001 Greatest Singles* consumer guide). Christgau does not, like Landau, imagine himself in the studio; neither is the concert the ideal listening situation for him.[15] Christgau's ideal scene is hearing single songs on AM radio. During the 1960s he is straight about it, arguing that AM radio disseminates the message of rock music to broad audiences, like the pirate radios in England in the mid-1960s. "My choice for our very own Liverpool is Los Angeles. L.A. has the best rock radio in the country" (1973:39; written in June 1967). However, in the 1970s, his support for the cause of AM radio becomes an eccentricity, as when he opens a think piece titled "All My Friends Call Me a Fool" with the words: "Sometimes I feel silly carrying the torch for AM radio" (259).

This last comment may suggest that Christgau at times indulges in populist posing, making a fictional character out of himself: "How will this oddball bohemian of Lower East Side, with his vulgar Queens roots react in a given situation?" But it also signals a strategy, by which he escapes labeling through varying his media. He explains his shift from the *Village Voice* to the Long Island newspaper *Newsday* as a wish to break away from readers who are too similar to him and participate in spreading the message to the suburbs. He adopts a modest pose and mocks Jon Landau at the same time by presenting himself as the "Dean of the Long Island Critics" (1973: 2), but later he becomes more boister-

15 Christgau, a fervent concertgoer, emphasizes that some concerts are important as events and concerts in general are significant as meetings between artists and audience. He prefers to write about concerts only as a way to point to such significance, for instance in a concert review of the Grateful Dead (*Village Voice*, May 9, 1977) and in a *Newsday* report on a shopping mall venue in Long Island in 1972, where ex-rock star Country Joe MacDonald played solo with an acoustic guitar (reprinted in 1973:254).

ous and accepts the titles "Dean of the New York critics" and later "Dean of American rock critics," thus casting himself as an heir to Landau's throne.

Because Christgau so readily admits that his writings are to a considerable degree based on his highly subjective perception and evaluation, his U.S.-centrism is much less of a problem than Landau's. He is not very illuminating on the Beatles; his solid pieces on the Rolling Stones concentrate on their meaning for American youth, and he does not dwell on many other non-American artists. It makes an odd impression when he tries to treat Jethro Tull in a serious way with no visible awareness of their strong references to English musical and general history. The pop art element of the Beatles and the Who fits well into his own background in New York in the early 1960s, but he cannot appreciate its development into the mannerisms of David Bowie.

Christgau is always occupied with the quality of writing. Sometimes he writes entertaining bits, for instance about traveling and listening to music together with other people, sometimes the records he is reviewing get lost in a cloud of insubstantial verbosity, for instance, the several pages on the Beatles (1973:229–246). He writes retrospectively (8) that some of his earlier writings were too occupied with the form of the column and the necessity of coming up with wiseass comments.

Christgau's piece on the Eagles for *Newsday* in 1972 (265–269) may serve as an example of the style and qualities of his approach in the early days, combining subjectivity with convincing arguments. Christgau starts his article in a positive tone:

> The Eagles […] are the tightest and most accomplished rock band to emerge since Neil Young's Crazy Horse. […] These guys can execute. Not only do they all sing and compose, which is nothing new—they're good at it […] Another thing that interests me about the Eagles is that I hate them.

For the rest of the article Christgau explains this surprising last statement, mostly by pointing to an alleged insincerity. For the Eagles the eagle is a symbol of a free bird not hurting anybody, not a particularly well-chosen comparison according to Christgau, who points out that eagles fly about searching for prey. The Eagles present a vision of "California dreaming" as a purely spiritual thing, when the Beach Boys ten years earlier "reminded us that happiness and material things are far from unconnected."

> It's no accident, either, that the Eagles' hip country music excises precisely what is deepest and most gripping about country music—its adult working-class pain,

its paradoxically rigid ethics—and leaves sixteen tracks of bluegrass-sounding good feelin'.

Substantiating an expression that opened the discussion—"Listening to the Eagles has left me feeling alienated from things I used to love"—Christgau has no problem summing up: "Brilliant stuff—but false."

This piece shows that Christgau's pop sensibility does not rule out a demand for authenticity. His reflection on the late 1960s line of demarkation between psychedelic rock on the one hand and soul and blues on the other, also indicates a yearning for a reconciliation between these strategies:

> The problem is that as poetry, musical complexity, and psychedelic basso-pro-fundity come into the music, its original values—simplicity, directness, charm—are often obscured or returned to the black performers, who tend to embrace them so self-consciously that they smother. So as always, there is a lot of good in rock and quite a bit of bad, and I am simply hooked. (1973:36)

Although Christgau's version of new journalism draws much more attention to the writer than Tom Wolfe would have advocated, he is really too straight to deliver gonzo journalism. As an editor Christgau had to hire the madman Lester Bangs to do full-fledged gonzo. But already from 1967 Christgau's writings can be seen as his attempt to find a synthesis between the gonzo approach and Landau's attempt to apply an expressive aesthetic to rock criticism.

That Christgau's approach remains basically unchanged through the years is exemplified by an excerpt that was published in identical words in 1980 and 1998:

> Only popular culture could have rendered art accessible—in the excitement and inspiration (and self-congratulation) of its perception and the self-reali-zation (or fantasy) of its creation—not just to well-raised well-offs but to the broad range of less statusy war babies who in fact made the hippie movement the relatively cross-class phenomenon it was. And for all these kids, popular culture meant rock and roll, the art form created by and for their hedonistic consumption.[16]

16 Christgau (1998:77; also published in *The Rolling Stone Illustrated history of Rock*, 1980). The topic is the Rolling Stones (and Christgau continues, after the cited sentences: "In turn, rock and roll meant the Rolling Stones.") Christgau's earlier pieces also carry the message that the Stones epitomize rock and roll as mass bohemianism (Christgau, 1973:228).

Christgau's (and his contemporaries') demand for authenticity went on trial when confronted with the art rock and glam rock artists like the Velvet Underground, Iggy Pop, New York Dolls, David Bowie and Mott the Hoople. At first Christgau tended to reclaim as many of these acts as possible in terms of recognition rather than as something new and qualitatively different. Thus he gave Velvet Underground good grades in his early "Consumer Guides" but evaded all substantial comments, while the Stooges in 1969 received not only a good grade but were called "Stupid-rock at its best—the side of the Velvet Underground that never developed" (1973:92). From the beginning Christgau declared his love for the New York Dolls, but did not want to see them as a glitter band but as "the best hard-rock band since the Rolling Stones" (305). As for David Bowie, Christgau is preoccupied with his image and calls him "an art scene outsider…trying to ride a massive hype into superstardom" (286–288). On the other hand Mott the Hoople, whose first single hit was written by Bowie, are considered real rockers:

> Mott the Hoople enters the battle for the soul of English working-class adolescents, capturing their angry confusion but trying to point beyond it, too. That sort of transcendence is what art-rock really ought to be about. (290)

Christgau's taste has gradually broadened. He not only learned to appreciate the glam and glitter rockers on their own terms (cf. his piece on the New York Dolls in Marcus 1979/1996). He was also into "'accessible' 'Downtown' 'classical' items, relevant (note fudge-word) jazz, and hard-edged or crossover-prone country" (Christgau 1990:6), although his taste was still discriminating. Christgau has kept his senses open for new mainstream as well as cult phenomena. He called the 1970s the decade "when the music had come into its own: only after countercultural upheaval could individual musicians buck rationalization's conformist tide to create oeuvres and ones-shots of spunk and substance in the belly of the pop beast" (1981). The 1980s were the decade when only megaplatinum stars really counted, but they delivered quality material and actually gave more space to alternative and subversive marginal acts than had the permissive 1970s (1990). In the 1990s however Christgau's tolerance showed its limits more often, as for instance when he denounced rap star Tupac Shakur for his message of violence, which led Christgau's long-time friend Dave Marsh to stop talking to him (Dave Marsh, personal interview, November 22, 1999).

No rock critic has had as long and stable impact on the field as Christgau, whose "taste as habitus" has been consistent and adaptable at the same time for

almost four decades. The emphasis in this profile has been on portraying this habitus. It should be added that a woman fellow critic contributed to its formation. Between 1966 and 1969 Christgau had a relationship with Ellen Willis, who also became a rock writer during these years, and they influenced each other strongly, sharing a taste for and insight into the links between pop art and popular music. Christgau refers to her writings on Bob Dylan as especially impressive and confesses that "I received my own sexism sensitivity training from a militant feminist who is almost as fervent about rock as I am" (*Village Voice*, June 11, 1970:55). Willis, on her side, profiled Christgau in an account of her feminist awakening:

> He checks out on the obvious things: respect for my work, absence of domestic servant hangups and Don Juanism, etc. But he definitely prefers to be the leader in any situation, whether it involves men (a concomitant of male dominance is competition among males) or women; he is the kind of person who when he's going somewhere with a group, walks two steps ahead and chooses the route. (Goldstein (ed.) 1969:121)

5.4. On a Mystery Train Through the History of America and Art: Greil Marcus

Greil Marcus (b. 1945) was a great authority in rock writing already in the late 1960s, through his *RS* articles and as the editor of a widely read book (Marcus (ed.) 1969). Since then he has not contributed continuously as a magazine critic, but has on the other hand established himself as an authority within criticism and academic rock studies with magazine columns and essays and with his books (Marcus 1975/1991, 1990/1997, 1993, 1995, 1997).

In 1968 Marcus was a Berkeley graduate student in American political thought with good career prospects in the university world and a great interest in rock music. These two sides were occasionally combined in reviews that Marcus sent to *RS*. In retrospect he describes his initial motive as the urge to express the revelation he experienced in the rock music of the mid-1960s; at the same time his early pieces were distinguished from other reviews through their extensive references to broad cultural and political questions.

In 1969 Marcus became the first review editor of *RS* and functioned as a sort of ideological guru for most of the writers (Draper 1991:165). As editor he improved the quality of writing in the section, and groomed two promising writers, Lester Bangs and Ed Ward. The latter would in early 1970 take over as review editor from Marcus, who continued to publish long articles. It was one of

these articles, a four-page review of Bob Dylan's *Self-Portrait* that led to Marcus's departure from *RS*, not because it was long and boring, but because Marcus found fault with Dylan's latest work, which was blasphemy to Jann Wenner. Some of the concluding remarks of this article can serve as a key to Marcus's approach:

> Dylan's songs can serve as metaphors, enriching our lives, giving us random insight into the myths we carry and the present we live, intensifying what we've known and leading us toward what we never looked for, while at the same time enforcing an emotional strength upon those perceptions by the power of the music that moves with his words. (*RS*, July 23, 1970:15)

This approach was also expressed clearly in the book that Marcus edited shortly before he became review editor of *RS* (Marcus (ed.) 1969), in which he encourages a "look at the myths and depths of rock" (15) and emphasizes the role of rock in shaping the consciousness of the generation growing up in America:

> [B]ecause of the way songs are heard, with an intensity that one provides for himself, they become part of one's mind, one's thought and subconscious, and they shape one's mental patterns. People sense this: there is a conscious effort by the members of the generation I'm talking about to preserve and heighten the experiences of rock 'n' roll, to intensify the connection between the individual and his music, between one's group of friends and the music they share. (17)

In the following years Marcus contributed to this project of "intensifying" as a freelance writer for several publications and as a university teacher, highly respected but not as visible as the other founding fathers. That changed overnight when he published his book *Mystery Train* in 1975. The book was immediately received with enthusiasm; it has remained almost constantly in print and by many colleagues it is regarded as the most important book ever written about rock.[17]

Before *Mystery Train* the only serious books on rock were anthologies, compilations of articles and rock histories (Belz, 1969; Gillett, 1970). Peter Guralnick dug deeper than most other writers, by writing serious profiles of blues musi-

17 Mazullo (1997) documents "overwhelming support" and "admiration" in reviews and the book's subsequent impact on the writing of rock history in the late 1970s. Despite many strong points, Mazullo mistakenly focuses on what he sees as *Mystery Train*'s influence on canon formation and rock history writing. As shown in this section, the strength of Marcus's contribution lies rather in his exemplary approach of rooting rock in general cultural history and not in his idiosyncratic choice of artists and historical lines.

cians and early rock 'n' rollers, suggesting a historical progression, while writers like Landau and Christgau had emphasized rock as something new that should be interpreted in a sociocultural context—though without going extensively into that context. Marcus combined these approaches but aimed at going further:

> [T]his is a book about rock 'n' roll—some of it—and America. It is not a history, or a purely musical analysis, or a set of personality profiles. It is an attempt to broaden the context in which the music is heard; to deal with rock 'n' roll not as youth culture, or counterculture, but simply as American culture. (Marcus 1975/1991:4)

Marcus is clearly addressing an enlightened American public, assuming a number of writers are common knowledge, part of a shared heritage. In the introduction he endows his project with a strong pathos by comparing his book to history books on the American Civil War written during World War II. With this parallel Marcus postulates that for American identity the situation in 1972–1974 is just as important as World War II. The Vietnam War is dragging to an end, the Watergate scandal is emerging and the president of the U.S. has to stand naked.

Marcus argues that the urgent need to redefine American identity should not least be fulfilled through inscribing the rebellious rock music in a genuine American heritage—perhaps the darker and less illuminated aspects of it, but nevertheless aspects already touched upon and treated by established writers, such as Twain, Fitzgerald, Melville, Chandler and Fiedler. Hereby he places himself within a critical American tradition, reinforced by carefully chosen references to movies by directors like Altman and von Sternberg and to the film critic Pauline Kael, whom Marcus constantly refers to as a pivotal influence:

> My influences were Pauline Kael, more than anybody else, D.H. Lawrence's studies of classic American literature, Leslie Fiedler and other people. They were people who made me think if I could only write with the engagement, the commitment and with the excitement of these people and with the sense, that the key to everything might lie in a single movie, or a single book, a line from a book or a scene from a movie—if I could write with the same intensity then I would feel more alive than I ever had before. (personal interview, April 17, 2004)

By demonstrating that rock is firmly rooted in American culture of the past and the present, revitalizing and reinterpreting some of its central themes, Marcus is at the same time legitimizing rock as an important contribution to American culture and making it a part of the national heritage. Like most of the other

prominent American critics he is somewhat bothered by the importance of British rock bands.[18] At the same time as he thanks artists like Clapton and the Rolling Stones for introducing important blues artists to a broad American public, he stresses that British acts such as these—and not least the Beatles— lived in an imagined America (1975/1991:97). In *Mystery Train* the contributions of non-American artists are toned down and seen from an exclusively American perspective; he does not point to any relations between rock and cultural heritages other than the American.

Marcus does not carry out any systematic analysis of music, lyrics or performance; instead he offers a subjective and highly intuitive interpretation:

> The process of criticism is to me fundamentally mysterious. Often I cannot remember, or even exactly reconstruct, how I came to produce certain arguments—but that, I think, is a result of attempting to trust the artifact, the object of my scrutiny. I take it on faith (until proven wrong, or until I run into my own limits) that a historical event or a cultural artifact that has sparked the enthusiasm, discomfort, or confusion of the critic will, if pressed hard enough, or merely in certain uncertain ways, give up untold and nearly infinite secrets. (Marcus 1995:6)

His interpretations refer most extensively to the lyrics, but they are more profoundly based on the mood he experiences when listening and in the broader associations to widely diverse elements of the cultural context that surface after repeated listening—and often after quite a long time. Most commonly, Marcus constructs one main narrative as a frame for a given body of work, a story that is developed in an intuitive way from years of listening.[19] In the case of the Band it is the story of the worried man: he is a wanderer who senses the American mystery and betrayal, tells his stories from the shadows, most often in the company of outcasts, even the devil:

18 Landau and Christgau have already been discussed from this perspective. Peter Guralnick goes even farther reducing English rock to a mirror for American audiences. In the first chapter *of Feel Like Going Home* (1971/1981) he describes his own road from early rock 'n' roll and back to the blues, including a recollection of his stay in England in 1963 and the role of English Rock bands. For Guralnick the crucial role of the Rolling Stones consists of introducing blues and soul to white American public.

19 "I ought to note that I am setting the story down—or, if you like, making it up—simply as I hear it, without much regard for song sequence, cross-checked lyrics, or other formalities" (Marcus 1975/1991:46).

> [...] this is a remarkable figure: the Band's recreation of an American original, the democratic man—trapped, against his better judgment, in a hilarious and scarified recreation of a very old American idea: this is a joint-stock world. A joint-stock world is open to devils and angels alike; all barriers are betrayals, and the man who sees only himself sees nothing at all. (51)

This narrative is only partly constructed from the lyrics and no less through Marcus's vision of the Band's music, combining all American music without imitating, "made in a particularly American spirit: loud, crude, uncivilized" (210).

> The song creates, out of words and music, a big, open, undeniable image of what the country could sound like at its best, of what it could feel like. [...] You couldn't ask for a more perfect statement of the conviction that America is blessed, or of the lingering suspicion that it is cursed. When the two ideas come together—in a story, a voice, or a group—all things seem possible. (53)

The flip side of the coin is always close at hand, as illuminated through the stories of Robert Johnson and Sly Stone. They, too, had inherited the settlers' view of America as the promise to fulfill a man's dreams and the Puritans' firm belief that a failure to realize this dream meant that you are in the company of the devil. Johnson lives this imagery out. In a world without salvation he "walked his road like a failed, orphaned Puritan, looking for women and a good night" (21–22). One of the most persistent stories about Johnson is that he sold his soul to the devil for the mastery of his music and of women; through a reading of his songs Marcus argues that Johnson rather viewed his own actions as evidence that his soul belonged to the devil.

Sly Stone lives out a related myth. For almost a century blues singers and rock and rollers have been singing about Staggerlee, the ruthless gambler who later became the survivor of the black ghetto or the ultimate gangster. Staggerlee is the guy who goes to hell and takes over. Around 1967–1970 Sly seemed to incarnate this image without its dark side. He was only the winner. Then

> The images of mastery, style, and triumph set forth earlier in Sly's career reversed themselves; his old politics had turned into death, his exuberance into dope, and his old music into a soundtrack for a world that didn't exist. As an artist Sly used those facts to reverse the great myth itself. [...] The role is all too real. It was forced on Chuck Berry, who never wanted it, and he paid for it in prison; Hendrix resisted, but in the public mind, the role enclosed him anyway. (78)

Even though Marcus's interpretation is subjective, the subject stays mostly in the background and steps only forward in a discreet manner, always at a safe distance from his own main points. When he tries to "convey the impact" (80) of the wave of music that in the early 1970s responded to the crisis of the counterculture and of the fight for racial equality, his narrative mixes personal and general emotions and the reader is left wondering whether it was Marcus himself who pulled the car off the road totally absorbed by the Temptations' "Papa Was a Rolling Stone." The penetrating interpretation of the Band (39–64) refers only to their records, concerts and facts about their career until the end, when Marcus adds new shades to the interpretation with references to conversations with Robbie Robertson and his wife in Woodstock. The concerts he tells us about are never the great concerts, except for the last concert of the Sex Pistols, which, ironically enough, triggered Marcus's deep interest in punk (1990/1997). These side stories consolidate Marcus's credibility in a subtle way. The author presents himself not only with a thorough knowledge and engagement in American history but also by reflected commitment to rock 'n' roll, never suggesting that he is emphasizing an event because he was there, but letting the reader know that he has had his moments of ecstasy and his moments of exchanging the truth with the rock gods.

Marcus's writing style places him between the rock critic as consumer guide and the academic rock writer, and within the tradition of public enlightenment:

> Everything I write is an attempt to engage the reader, to capture somebody's attention, to draw them into a discussion or a fancy of a sort. I try very hard not to use references. [...] There are ways to make things clear without lecturing or explaining. You fit the identification of somebody you might be referring to or a situation you might be trying to talk about into the narrative rather than saying: "Now we are going to discuss so and so, and this is why this person is important [...]." You don't do it that way. You find a way of not leaving the reader out of the story, without making the reader feel he/she is somebody who has to be told something. You make the reader feel that he knows what's going on. (personal interview, April 17, 2004)

In a broad sense Marcus shares a vision of rock similar to those of other leading rock writers, such as Landau, Christgau and Guralnick. Unlike many of his colleagues in American studies he avoids the trap of basing his interpretations mainly on the lyrics. For him there is no doubt about the primacy of the music as even "words are sounds we can feel before they are statements to understand" (quoted from Frith 1981:14). Like the other founding fathers he sees the rock 'n'

roll of the 1950s as the basis of everything. The singers of that era "sang as if they knew they were destined to survive not only a few weeks on the charts but to make history; [...] they delivered a new version of America with their music" (1975/1991:4). The role of the British musicians was to give this music back to a new generation of American youngsters and to illuminate the black part of this heritage.

Marcus differs from his colleagues not only in his emphasis on roots and myths but also in how he approaches the bonds between rock and youth and its potential respectability. Christgau never forgot to affirm teenagers as the most important part of the rock audience; Landau repeatedly expressed a fear of losing the feeling for rock when growing old (i.e., older than 25); and Guralnick could not stand the thought of rock becoming respectable (1971/1981:35). For Marcus, on the contrary, rock was not only becoming the music for most age groups, but the time was also ripe for rock to claim a certain critical respectability as a part of the surrounding culture. More precisely, of *American* culture, partly because rock ought to be conceived as an American art form and partly because it fits better into American culture than other comparable cultures. In order to sustain the last argument Marcus has to borrow from Leslie Fiedler a disputable distinction between the historical consciousness of Europeans versus that of Americans:

> [T]o be an American (unlike being English or French or whatever) is precisely to imagine a destiny rather than to inherit one; since we have always been, insofar as we are Americans at all, inhabitants of myth rather than history. (5)[20]

As a generalization this is of course untenable, as all national inheritance can be conceived as myths that are constantly being (re)invented. But Marcus has strong points, not least illuminated by the fact that so many rock musicians and rock fans outside the U.S. choose to develop their artistic world and identity as some kind of an "imagined America."[21] For Marcus this proved methodologically useful, not least in tracing the roots of Sly Stone and the Band. But Marcus stretches his point too far. For him Robbie Robertson's musical vision—that the land makes the music (1975/1991:42)—stems from the American myth pronounced by Jefferson "that, in America, virtue must be found in the land" (138).

20 Marcus (1975/1991:5) is citing Leslie Fiedler, "Cross the Border, Close the Gap."
21 The subject of Europeans as "imaginary Americans" has for instance been treated by Berkaak and Ruud (1994).

What Marcus leaves out is that this myth is not specifically American but deeply embedded in every agricultural society, given nationalist forms, for instance, in the German *Blut und Boden* mythology and in the ideological foundations of the Finnish Center Party, the mythical idea of *Maahenki*—the spirit that grows out of the special relation between the farmer and his land.[22] However, another aspect of Marcus's Americanism is more worthy of consideration. For him the relation between the individual and the community takes on a specific form and acquires a specific cultural meaning in the U.S. In Marcus's words:

> In the work of each performer there is an attempt to create oneself, to make a new man out of what is inherited and what is imagined; each individual attempt implies an ideal community, never easy to define, where the new man would be at home, where his work could communicate easily and deeply, where the members of that ideal community would speak as clearly to the artist as he does to them. [...] The tension between community and self-reliance [...] make[s] rock 'n' roll at its best a democratic art, at least in the American meaning of the word democracy [...] the creed of every man and woman for themselves, and thus the loneliness of separation, and thus the yearning for harmony, and for community. (1975/1991:6)

On the one hand Marcus is here formulating the humanist-Marxist position of practice, held by many critical scholars and easily merged with concepts of authenticity and the aesthetics of the Frankfurt school. But he also claims that there is an American version of this position focusing on the possible strain between the individual and the community. His fellow critics Christgau and Marsh share his concern for this issue although their views on it are not always compatible. Within the social sciences and philosophy this concern has fuelled the debate between liberalism and communitarianism for more than 20 years. From this perspective Marcus can be seen as trying to resolve this contradiction in a leftist way. He values community highly but rejects conservative communitarians who take for granted inherited values, whereas Marcus affirms hidden values. Along with radical liberals he stresses individuality as a precondition for community,

22 Historians and sociologists have often pointed out (see Marx 1845/1932), that embryonic social relations and culture, which have been restrained in their land of origin, can blossom in colonies and new settlements, North America being the prime example. During the centuries of emigration from Europe to North America not only capitalism but also the vision of the independent farmer was fettered by the old society and lived strongly in the dreams of emigrants.

but at the same time he maintains that community is a precondition for the expression of individuality. Again Marcus's position is not far from the young Karl Marx and his vision of society where "the free development of each is the precondition for the free development of all" (*Communist Manifesto*, end of part II).

With *Mystery Train*, Marcus graduated to the ranks of highly esteemed general cultural critics. For more than a decade he was often more preoccupied with books and films than with rock (Marcus, 1995). However, he edited important books on rock, the anthology *Stranded* and the anthology on Lester Bangs's writings (both treated elsewhere in this account), and remained an authoritative voice in the rock field. Often he would strike against the 'pop myths' of the entertainment industry, for instance as presented in the movie *American Graffiti* (1995:126), but he became somewhat detached from the dominant trends in rock music. The musicians he had chosen for subjects in *Mystery Train* either died, quit or sank into oblivion; he did not like much of what was happening and unlike fellow critics such as Christgau, Bangs, Kent and Murray, he did not respond immediately to punk music. On the other hand, Marcus was perhaps more deeply touched by it, indeed so much so that he started digging into the meaning and history of punk. Starting in early 1978 much of his writing revolved around punk for more than a decade (Marcus, 1993), and in 1990 he came up with a book that has become one of the most widely read books on the roots of punk. Wrestling with the meaning of punk Marcus renewed his commitment to rock, still combined with an urge to seek deep cultural roots; the result was a series of widely read books published during the 1990s.

In *Lipstick Traces* Marcus follows a similar general idea as in *Mystery Train*: of rock music as a resurrection of earlier cultural substreams that have been marginalized. Where *Mystery Train* traces the roots of the Band and Elvis Presley to American folk culture, *Lipstick Traces* focuses on the heritage of the 20th-century European avant-garde:

> In my account of what McLaren and Reid made of the SI's (Situationist International) old art project—by 1975, dead letters sent from a mythical time—Johnny Rotten appears as a mouthpiece; I prefer to think of him as a medium. As he stood on the stage, opened his mouth, and fixed his eyes on the crowd, various people who had never met, some who had met but who had never been properly introduced, some who had never heard of some of the others, as Johnny Rotten had heard of almost none of them, began to talk to each other, and the noise they made was what one heard. An unknown tradition of old pronouncements, poems, and events, a secret history of ancient wishes and defeats, came to bear on Johnny Rotten's voice—and because this tradition

lacked both cultural sanction and political legitimacy, because this history was comprised of only unfinished, unsatisfied stories, it carried a tremendous force. (1990/1997:440–441)

Marcus freely admits that he is not the first one to point to the link from dada to punk,[23] but his account is surely the most extensive and no doubt enlightening especially for Americans, to whom, as to Marcus himself, "dada was barely a word [... and] I'd never heard of the Situationist International" (19).

While it is astonishing for Europeans to learn that an intellectual so deeply engaged in the youth revolt of the late 1960s as Marcus was could miss the Situationist link of May 1968, it is equally enlightening to read about the roots of the Basement Tapes of Bob Dylan and the Band in *The Invisible Republic* (1997). Once again Marcus is digging up hidden culture, suggesting spiritual ancestors for the strange world of the tapes. Most interesting for a European reader is his account of the burgeoning folk and blues scene of the 1920s that largely disappeared, at least from record publishing, through the recession of the 1930s. With his usual myth-making powers Marcus goes on to draw a picture of the people's community in the America of the 18th and 19th centuries as an "invisible republic," existing on a day-to-day level as a counterpart to the official federal republic. This general narrative is a further elaboration of his reading of the Band from 1975, and in the meantime Marcus had explored related forms of 'secret history', but he needed the distance of several decades to fully open his mind for such a reading of Bob Dylan.[24]

Marcus's method is association, frequently loose and sometimes very idiosyncratic, but often illuminating and as a rule inspiring. His method has not changed much from his first long *RS* reviews of Bob Dylan, but his writing style has become much more disciplined. His long links are, of course, far-fetched. They can be seen as working on the level of suggestion and call for critical read-

23 "In the early days of London punk, one could hardly find an article on the topic without the word 'dada' in it: punk was 'like dada,' everybody said, though nobody said why, let alone what that was supposed to be" (Marcus 1990/1997:19). Marcus makes no reference to the "classic" text that made this connection a central element of interpreting punk, Dick Hebdige's *Subculture. The Meaning of Style*: "The radical aesthetic practices of Dada and Surrealism— dream work, collage, 'ready mades' etc.—are certainly relevant here. They are the classic modes of 'anarchic' discourse" (1979:105).

24 Bob Dylan has in his autobiography (2004:34–35) expressed his appreciation of this interpretation and it may have supported Dylan's own presentation of how he internalizes the folk heritage into his own subjectivity.

ing. For instance, even though we find it fascinating that "a secret history of ancient wishes and defeats came to bear on Johnny Rotten's voice," is the heritage of the dadaists, Situationists, and a mad 17th-century preacher that by coincidence bore a name similar to John Lydon's the most important background to understand punk? How about the more recent wishes and defeats of Johnny's own generation and its "parent culture"?

Marcus may provide convincing arguments for the proposition that the Basement Tapes are rooted in the American folk tradition in a far more nuanced and authentic way than Dylan's protest songs of the early 1960s, which matched the invented tradition of Pete Seeger and the folk movement. The reader is again left wondering whether Dylan's deep intuitive insight into this obscure heritage only surfaced as short blisses of revelation in his career and in which senses it has served as a primary resource for his work at large and for American rock more generally. Raising such questions is perhaps Marcus's main point:

> I did not have a last word on anyone. I did not intend to. The whole point was to start a discussion, not to finish it. (personal interview, April 17, 2004)

A critical reader would prefer that Marcus inject his intuitive method more often with critical reflection on his own perspective and biases. The problem is not so much Marcus's idiosyncracies about single artists and choice of historical lines to be examined; it is more grave on the level of cultural politics. A critical examination of what it means to be American has been a red thread through his writing. In *Mystery Train* this question was accentuated by the national identity crisis in the wake of the Watergate scandal. Since 9/11 American national identity has been going through a no less critical phase, and how does Marcus's reading of rock address this crisis? The insistence on hidden histories like the Invisible Republic implies insights into America as being more than its elites, but, more than any other U.S.-centered rock critic, Marcus should be asked how a U.S. centered view on the development of rock contributes to the understanding of America's political and military role in the world community.

Marcus is not the only writer to connect rock criticism and wider cultural and political discourse, but he has mastered both arenas simultaneously better than any competitor. He has had tremendous influence in terms of raising the standards of rock writing and probably made the greatest contribution of any rock critic to making rock and rock criticism respectable.

5.5. Hit Man and Radical: Dave Marsh

While Landau, Christgau, Marcus and a handful of other college graduates were staking out the territory of rock criticism in the rock enclave of the public sphere, the next generation was writing about rock even more personally in a frantic identity search in school papers all over the U.S. Some of the more ambitious members of this generation made their way into national magazines before the 1960s were over. Dave Marsh (b. 1950) won his original reputation at *Creem* from 1969 through 1973. For six months he was the music editor of the *Real Paper* in Boston, and then he replaced Bob Christgau as music writer for *Newsday* on Long Island. At the end of 1975 he moved further up the ladder by taking over Landau's post as review editor of *RS*. Along with this influential and prestigious post he worked for years on his first book *Born to Run* (1979), which became one of the most widely read and inspiring books on rock. It simultaneously canonized Bruce Springsteen as a rock 'n' roll saint and Marsh as a writer. He not only anticipated that the popular appeal of Springsteen was about to explode, but his growing disappointment with the mainstream development of popular music seemed to match well with the general sentiments of rock 'n' roll aficionados. After editing a couple of *Rolling Stone Record Guides* Marsh left *RS* in 1980 but strengthened his individual profile through a string of books (1983, 1987, 1989) and his own "aggressive newsletter, *Rock 'n' Roll Confidential* [that] seemed to spend half its time beating *Rolling Stone* to the punch on industry news and the other half attacking Marsh's former employer" (Draper, 1991:459). By 1985 his publisher called him "America's best-known rock writer" in the subtitle to a collection of his shorter pieces.

Marsh was writing for the Wayne State University paper *South End* during what would turn out to be his only year at the university, 1968–1969, when he became involved with the White Panther Party, its charismatic chairman, John Sinclair, and its house band, the MC5. The party supported the Black Panther program, but was better known for the slogan "rock 'n' roll, dope and fucking in the streets." Sinclair had been the center of a small beatnik community, but was now gathering a bigger following among young hippies. The new bohemian generation of the Motor City was more political than the Californian beautiful people or the New York heads. They were influenced by the militant socialist tradition of their hometown, adding the Sinclair dictum "total assault on the culture." From March 1, 1969, *Creem* was a part of the Detroit scene as a rock 'n' roll paper dedicated to "help build a more cohesive community" (editorial, *Creem* 1:1, March 1969). It was not directly associated with the White Panther Party, but from July that link was established through Dave

Marsh, who soon became the de facto editor of the paper, which at the same time went national and became the most serious competitor to *RS* for the title of *the* rock magazine of the U.S.

Dave Marsh established himself from the beginning as a bold writer. Mostly he wrote about performers that he loved, saving most of his aggressive outbursts for the system and the exploiters, but he was merciless when reviewing acts that he found pretentious and purposeless.[25]

The stable core of Marsh's taste is the music that served as revelation in his youth. It started with the Motown sound of his hometown, which became the magic key to casting off the racism of his white working-class youth without losing its strong emphasis on community and to breaking free from his authoritarian father to develop new sensibilities:

> Smokey Robinson [...] was putting his finger firmly upon a crucial feeling of vulnerability and longing. It's hard to think of two emotions that a fourteen-year old might feel more deeply (well, there's lust...), and yet in my hometown expressing them was all but absolutely forbidden to men. (Marsh 1985:xxiv)

From Motown Marsh developed his tastes towards soul in general, R & B and several jazz genres; through the years he has become more and more interested in gospel. Marsh naturally embraced early rock 'n' rollers like Little Richard, Chuck Berry and Elvis Presley. He welcomed the British Invasion, especially groups like the Who and the Rolling Stones who not only emphasized their respect for black American R & B and soul but added arrogance and an aggressive attitude that Marsh could identify with. When white Detroit begot its own Motor City Rock with the MC5 and Iggy Pop and the Stooges the identification became total. These groups became Marsh's ticket to rock journalism and especially through the MC5 "one could begin to construct an aesthetic and perhaps even a program that proposed how rock culture fit into society as something more than a diversion" (Marsh 1985:205).

During 1968–1969 the MC5 became a cult band for radical hippies in Detroit, combining an aggressive rock sensibility reminiscent of the Who with a hipster/avant-garde sensibility influenced by John Sinclair. Dave Marsh was one

25 See his record review column covering Al Kooper, Mike Bloomfield et al. (*Creem*, May 2, 1969) or the book review column covering Mike Jahn's book about the Doors ("fails totally") and the collection *Rock and Roll Will Stand*, edited by Marcus ("pointless [...] purposeless [...] series of pretty undistinguished writings about rock music") (*Creem*, November 2, 1970:28–29).

of the youngsters hypnotized by the performances of MC5 and his command of the written word made him a spokesman of the community. In 1985, Dave Marsh recalls his original focus as

> at first instinctively and later more consciously, on rock music as a form of culture for the uncultured, and particularly as a means of expression for those to whom more rigorously credentialed channels are denied. As one consequence, the audience and the performer are almost always linked in my writing, through their changing relationships to the ideals and ideas that the music expresses and represents. (ix)

No other major rock critic has more consequently stuck to this "underdogs" and "anti" aesthetics, and Marsh has remained true to the left-wing ideals of his youth. However, rock was never to serve the revolution, rock *was* revolution:

> [T]he Five were the one band that attempted to let its music carry an explicitly and implicitly political, even revolutionary (as they interpret it) message. [...] [However], the Five's political premise would seem to be musical, in the first place, not rhetorical. They weren't talking revolution, they were making it. [...] On the other hand, I don't think rock 'n' roll can define our ideology for us, either. [...] I mean do you really see David Crosby and Paul Kantner as the leaders of the future? Do you want them to be?[26]

Marsh's emphasis on the relation between artist and audience has made him a keen reader of the roots and resonance of rock performers. He excels in the art of sociological imagination (C. W. Mills) which designates the ability to interpret the individual experience of the artist (most remarkably Springsteen) or of the fan (most remarkably the London mods) in a social context. However, such readings have become more and more difficult in a world of individualization and detachment of performers from any specific communities. It can be seen as a result of such processes that Marsh himself experiences "an increasing conviction that, while rock acquires important dimensions of its meaning through social interaction and through its use by the audience for specific purposes, the

26 *Creem*, December 1971:38–42, reprinted in Marsh (1985) with some changes, mostly cosmetic. However there are interesting new passages, e.g., a sentence explaining the political vision of Marsh and the MC5 in the late 1960s in more poignant words than Marsh could find in 1971: "They planned, as the sixties children that they were, to revolutionize the spirit of their listeners as well" (1985:209).

music is a self-sufficient mode of expression, [...] one of the most interesting and valuable post-war popular arts, and one that is (for all its British influence and attraction) at best uniquely American" (1985:ix).

Thus Marsh moves closer to Landau's insistence on rock as "oeuvres," though he draws an important distinction regarding the Romantic vision of "the poetic individual creating in solitude [that virtually has] no place in rock and roll" (1989:xiii). In Marsh's opinion the best works of James Brown, Bob Dylan and David Bowie are the product of intense collaborations.

Marsh's position also resembles that of Greil Marcus by emphasizing the deep American roots of rock but, again, there is an important difference. Marcus tends to seek roots in the world of Puritan immigrants from Europe, while for Marsh rock is black. It "is not mostly anything other than black-rooted popular (mainly vocal) music made in the late twentieth century" (xv). Although this definition is broad enough to include Marsh's favorite aversions like the Greatful Dead and Emerson, Lake and Palmer, what matters to him is how you locate the heart of rock. Here Marsh attacks conventional wisdom about 1950s rock being revived by the British Invasion and then superseded by psychedelia, soft rock and later by diversification. Marsh constructs an alternative picture of "Rock and Soul," a fruitful interplay between black church-based music and crossover rock. Soul, Motown, girl groups and doo-wop of the early 1960s are no less central to this concept than 1950s and 1960s rock and Marsh sees a vanishing interaction between the black and white world as a main problem of rock in the late 1980s (ii). In this respect Marsh picks up the torch of Landau's writing in the late 1960s, and he does it in a way similar to Christgau's—everything being ultimately rooted in personal experience. Marsh's own experience was origi-nally of rock in Detroit in the early 1960s, and he has continued to maintain devotion as a precondition for his writing. At the same time as he stresses objec-tivity as factual accuracy he is skeptical of objectivist approaches:

> Semiotics, the New Criticism and other formalist approaches have never had much appeal to me, not because I don't recognize their validity in describing certain creative structures but because they emphasize those structural ques-tions without much consideration of content. And that simply doesn't jibe with my experience of culture, especially popular culture. (1985:xxiii)

In sum, Marsh's position can be seen as a synthesis of other critics' positions, especially of Landau's insistence on the rock-soul interaction and Christgau's reflexive use of personal experience. He develops these elements—and others—

in a very personal way and, increasingly, he has taken on the task of reminding the audience of rock's early radical promise. Furthermore, Marsh shared with Lester Bangs the ambition to develop a writing style of criticism that reflected the subject matter, although he readily admits that Bangs surpassed him in this respect (27). He also points to another aspect that he shares with Bangs:

> What makes me different from other rock critics, except Lester, is that I am a storyteller. My best reviews tend to be about things where I can feel there is a story inside the record that I can help teasing out. An example is my review of James Brown Live at the Apollo. In order to get the story of that record I had to listen to it for three days. What I then heard was that James is basically taking you through a love affair, from the beginning of the album to the end and this show is very carefully edited. (personal interview, November 22, 1999)

Marsh's storytelling abilities are wide-ranging. Already his first pieces, like the portraits of Mitch Ryder and Iggy Pop, convey life stories different from the usual career stories of aspiring artists.[27] The reader is confronted with strong and seductive dramatic narratives of individuals desperately trying to break the fetters of convention, poverty, racial segregation and the music industry. This narrative—later perfected in *Born to Run*—is the story of the proletarian boy using rock 'n' roll to "get out of the this place." Marsh loves to tell other stories as well, but he clearly feels closest to the tales of those who refuse to accept their ascribed status as underdogs.

From the beginning Marsh won great respect for his well-written prose, for a consistent and well-explained taste, reasonable judgments and for a flair for editing. Gradually his reputation came to stress a "talent for invective" (1985:135). In his first years as a critic, Marsh, like most of his contemporaries, wrote almost exclusively about the music he loved, but gradually he also found space for harsh attacks. There is an interesting move on his part from originally praising the Doors to calling them "the most overrated group in rock history" (137). In 1969 Marsh proclaims the Stones as the greatest, but in 1985 he states that they "were never my favorite rock band…important to me primarily for their few great hit singles" (100). New heights are reached by the pejoratives reserved for Cher, Peter Frampton, Linda Ronstadt and other stars of the late 1970s and 1980s. Marsh also calls Eric Clapton's "Wonderful Tonight" "tailored humbuggery" (49) and Rod

27 "The Teenage Dreams of Billy Levise," *Creem* 1969, reprinted in Marsh (1985); "The Incredible Story of Iggy & The Stooges," *Creem*, spring 1970:1, 29–33.

Stewart's "Do Ya Think I'm Sexy" "a song so sleazy that even his staunchest supporters (like me) gave up on him" (46). "Toto grows more popular every day, but then, cockroaches are supposed to outlast the human race" (140).

Marsh's development can be seen as symptomatic for his generation: he reads rock culture more and more as a betrayal of its original promise, although single performers still keep the flag waving. Throughout most of the 1980s Marsh figured as a devoted guardian of the social promise of rock; he was always ready to lambaste commercial exploitation and humbuggery. On the other hand, he kept mostly silent when his 1987 book *Glory Days* came under attack for lack of distance from Bruce Springsteen's and Jon Landau's commercial interests (Goodman 1997). When heavy metal and later rap met hard criticism from moral guardians, Marsh stepped forward as a fervent defender of the freedom of speech, a popular lecturer and debater.

In the 1990s Marsh slowed down to write and edit *For the Record*, a series of smaller documentary books comprising an oral history of rock, as well as a few articles. The best of these articles, for instance one on Kurt Cobain's death, demonstrate that he has lost nothing of his feeling for rock and for writing. What has happened is mainly that there are fewer and fewer acts he can write about "without reservations of any kind" (Landau in his famous "Loose Ends" column on Springsteen—which was edited by Marsh).

5.6. The Holy Madman of Rock Criticism: Lester Bangs

> Sitting around, underaged, narcissistic, masochistic, deep in gloom cuz we *could* have a real cool time but I'm not right, whether from dope or day drudgery or just plain neurotic do-nothing misanthropy, can't get through ("You don't know me / Little Doll / And I don't know you…")—ah well, wait awhile, maybe some fine rosy-fleshed little doll with real eyes will come along and marry you and then you'll get some. Until then, though, it shore ain't no fun, so swagger with your buddies, brag, leer at passing legs, whack your doodle at home at night and dope out with the gang, grass, speed, reds, Romilar, who cares, some frat bull's gonna buy us beer, and after that you go home and stare at the wall all cold and stupid inside and think, what the fuck, what the fuck. I hate myself. Same damn thing last year, this year, on and on till I'm an old fart if I live that long. Shit. Think I'll rape my wank-fantasy cunt dog-style tonight.
>
> —Lester Bangs[28]

28 "OF POP AND PIES AND FUN. A Program For Mass Liberation in the Form of a Stooges Review Or, *Who's the Fool?*" *Creem*, November/December 1970.

Lester Bangs has been for 30 years the greatest legend of rock criticism and in many ways its most influential writer. His works have been published widely, there is an extensive literature on his contributions, a fan biography has been written about him and a mainstream movie featured him as a guru character. He did not earn this status by staging himself as a serious critic in the manner of Landau, Marcus and Christgau, but through radiating a deep commitment to the rock experience, expressed in entertaining pieces sometimes of high literary value. He started his writing career in *RS* in 1969 as a committed kid, either loving or loathing the records he reviewed. From early on he displayed a taste that was at the same time broad and selective, his topics ranging from avant-garde jazz to mainstream rock to marginal trash. Gradually his vision became consistent and open at the same time and his tastes obviously matched those of the hard-core rock fans. He was famous for expressing total disrespect for all authorities, also within the rock congregation, and for being able to write both ears off the devil.

Lester Bangs was born in Southern California in 1948 and raised by his single mother, a Jehovah's Witness. He wrote for *RS* from 1969, soon also for *Creem* and other papers. In 1973 he moved to Detroit to become a staff member/de facto editor of *Creem*. In 1976 he went to New York to become a freelancer, contributing mainly to the *Village Voice*. There was a growing demand for his work in both the underground and the more established press, both in the U.S. and in Europe (the first collection of his writing was published in West Germany). After fighting with alcoholism and drug dependency for some years, he died from an accidental overdose in 1982.

Bangs came to a scene that already had established canons and internal hierarchies. The first reviews and articles that surfaced in *RS* did not deviate much from other writings. What stands out is that they were better written than the average and showed less respect for rock icons. During his first year at *RS* Bangs wrote an obituary of Jack Kerouac, using the opportunity to claim his own roots in the early spirit of the Beat Generation, but distancing himself from "the affected zombielike 'cool' stance which came to predominate later" (*RS*, December 13, 1969:28). He frequently turned to avant-garde jazz as a reference in his rock writings, especially in order to welcome free-floating aesthetics, and wrote a few articles directly on the genre. Unlike his Anglo-American centered colleagues Bangs was sensitive to rock music from other countries and displayed a special liking for Nordic, German and Dutch bands, which he saw as refreshing innovators in a stagnating rock world dominated by U.S. and British metropoles. Bangs's taste was also wide enough to celebrate Dusty Springfield.

Bangs's pieces at *RS* show that he is no more at ease with the rock canon of his colleagues than with the prevailing standards of writing. To a certain degree he could adopt the aesthetic standards of Landau, who became review editor at *RS* not long after Bang's arrival. In his own way he insists on authenticity understood as individual expression rooted in a community; he does not care about the conventions of rock but is more concerned about artistic honesty. Being a trained and keen listener, with some musical aspirations and experience, Bangs is confident enough to comment on the handling of instruments and music production. He certainly demands social relevance, and he is also capable of seeing the music in an often unexpected cultural context, following the example of Greil Marcus, his first editor. But bubbling under all these pieces is a discontent with the growing slickness of rock.

At *Creem* Bangs found the liberty to develop his style through long articles in which he weaved his reviews into stories and reflections on rock music, life in the U.S. and whatever came into his mind. Until then Bangs, like most rock critics, had obeyed the general standards of art criticism, bending them a little to incorporate excitement and rebelliousness. It was fairly common in the field to employ some New Journalism approaches, for instance using fiction to fill the vacuums of a report, and word machines like Greil Marcus allowed themselves to make endless associations to American life and cultural works. Richard Meltzer allowed himself to mix heavy cultural theory with hip statements and banal observations, and other forms of experiments popped up in the columns of rock magazines. But it was Bangs who became the master expressing the uncontrollable spirit of rock in his writing.

To a large degree his strategy resembled Hunter S. Thompson's gonzo journalism. At this time Hunter S. Thompson had experimented for a decade with transforming the beatnik attitude into journalistic writings, reporting from the subcultures of beatniks, student rebels, hippies and Hell's Angels and from the U.S. backyard in Latin America. Gradually he developed a personal style where the reporter increasingly inhabited the center of the narrative, usually in a lousy condition, drunk or sick with dysentery. The escapades of this half-crazy journalist start to move the story, unveiling straight society through its reactions to his mad behavior. Hunter's gonzo journalism escalated into marathon articles in *RS*.[29] Thompson defines gonzo in the following way:

29 For instance "Freak Power in the Rockies" (1970), "Fear and Loathing in Las Vegas" (1972) and "Fear and Loathing on the Campaign Trail" (1973), the first one frequently anthologized, the two latter turned into books.

It is a style of "reporting" based on William Faulkner's idea that the best fiction is far more true than any kind of journalism. [...] True gonzo reporting needs the talents of a master journalist, the eye of an artist/photographer and the heavy balls of an actor. Because the writer must be a participant in the scene, while he's writing it—or at least taping it, or even sketching it. Or all three. Probably the closest analogy to the ideal would be a film director/producer who writes his own scripts, does his own camera work and somehow manages to film himself in action, as the protagonist or at least a main character. (1980:114–115)

While "Dr." Thompson was defining gonzo journalism and flocks of journalists were copying him, most often with terrible results, Bangs developed a similar approach in rock writing. This meant, for instance, that interviews were never polite microphone-holding jobs; for Bangs assaulted the interviewees, twisted their words and confused them, while simultaneously "filming himself in action." The reviews became self-reflexive. Of course, rock writers had for a long time written how records had thrilled them, how they had pulled their car off the road to hear a new song and how they had messed up a date through their obsession with a new record. But Bangs ridiculed all such attempts to glorify the critic as the sensitive and committed listener. Bangs links his own strongest rock experiences with "feeling like dirt and not having no fun "cause you're a fucked up adolescent, horny but neurotic, sitting around bored and lonesome and unable to communicate with yourself or anybody else."[30] Bangs casts the ideal rock fan as such a sexually frustrated and fucked up teenage boy and he never hesitates to place himself as this central character, gradually growing up to become a sexually frustrated and fucked-up man.

> [I]n Detroit I thought absolutely nothing of going to parties with people like David Ruffin and Bobby Womack where I'd get drunk, maul the women, and improvise blues songs along the lines of "sho' wish ah wuzz a nigger..." and of course they all laughed. It took years before I realized what an asshole I'd been. ("The White Noise Supremacists," *Village Voice*, April 30, 1979)

But just as Thompson uses the drugged journalist to mirror a crazy world, Bangs's fucked-up teenager is a key to the sickness of his times. Lester Bangs's version of rock as a promise is that the holy madmen—the shamans—are the only ones able to cure the sickness:

30 "OF POP ..." *Creem*, November/December 1970. See also "James Taylor Marked for Death," *Who Put the Bomp*, winter/spring 1971; reprinted in Bangs (1988).

The Stooges also carry a strong element of sickness in their music, a crazed quaking uncertainty, an errant foolishness that effectively mirrors the absurdity and desperation of the times, but I believe that they also carry a strong element of the cure, a post-derangement sanity. And I also believe that their music is as important as the product of any rock group working today, although you better never call it art or you may wind up with a deluxe pie in the face.[31]

This vision of "post-derangement sanity" sometimes takes the form of a classical aesthetic notion, as shaped by, for example, Adorno:

[I]n an age of pervasive artistic negativism, we have in [Captain Beefheart] a new-old man refusing to discard the heart and humanity and essential innocence that Western culture has at least pretended to cultivate for three thousand years and which our electrified, relativistic generation seems all too willing to scrap as irrelevant sentimental bullshit. (*Creem*, March 1971:76)

Bangs abstained from discussing politics, except on such a cultural and humanistic level. Though he never participated in the leftism of his colleagues at *Creem*, he was deeply moralistic and several times wrote against racism, the nihilism and self-destruction of rock culture and other social maladies *in spe*. His political commitment was fully embedded in his aesthetics, which always stressed the relevance of the music for its community. As Steve Jones (1992:104) puts it: "For Lester Bangs, authenticity was tied to fandom." The necessity of respect for the fan—a position that was beginning to emerge in his *RS* writings, for example, his criticism of Frank Zappa for his cynical attitude towards his audience (December 24, 1970)— was clearly fundamental in Bangs's view: "Most rock stars have their audiences so cowed it's nauseating" ("OF POP...," *Creem*, November/December 1970).

Bangs's approach can be clarified by a comparison with other rock writers. While Peter Guralnick is preoccupied with the roots of Elvis Presley in the life of poor southerners and Greil Marcus emphasizes how Elvis carries deep-rooted myths of American culture, Lester Bangs is more interested in the contemporary meaning of rock. In the eyes of Bangs, Elvis

could be seen not only as a phenomenon that exploded in the fifties to help shape the psychic jailbreak of the sixties but also ultimately as a perfect cul-

31 "OF POP ..." *Creem*, November/December 1970. See also a witty application of the notion of shamans in: "Bring Your Mother To The Gas Chamber. Are Black Sabbath really the new Shamans?" *Creem*, June 1972.

tural expression of what the Nixon years were all about. (*Village Voice*, August 29, 1977)

Describing his teenage life, Bangs paints himself as a loner, reading beatnik literature and listening to avant-garde jazz, until he found some pals and together they developed a liking for raunchy R & B–based rock. These tastes were lasting and much of his favorite music combined spiritual search with bodily excitement. He walks in the footsteps of Landau, Christgau and Marcus legitimizing rock through its noble history, but in his own way by stressing "the traditions of two decades of beautifully bopping manic, simplistic jive" ("Of Pop…"). For Bangs the lifeline of rock stretches from early rock to the aggressive R & B of the Yardbirds and the Who, with an important input from free jazz channeled through the Velvet Underground and into punk/new wave ("A Reasonable Guide to Horrible Noise," *Village Voice*, September 30, 1981). The Rolling Stones are perhaps the ideal, but at the time Bangs starts to write about music, he feels that they already have delivered their message. The most important groups of the early 1970s were the Stooges and the New York Dolls and Lou Reed remained *numero uno* throughout the decade. In his writings Bangs liked to make references to the history of rock, not to giants like Dylan and the Stones, whom he deeply respected, but to obscure and forgotten acts, often garage bands of the mid-1960s. Perhaps the best example is the article "James Taylor Marked for Death," where the bulk of the long article dwells on the Yardbirds, Troggs and Count Five, establishing a perspective that allows him to slaughter James Taylor in a few sentences. This article is probably the strongest support that the Troggs ever received, and Bangs's gonzo, fan-based perspective unfolds in an interpretation whose main social reference is not the life situation of British bricklayers but American teenagers.

Bangs had a taste not only for noisy music—he wrote extensive and sensitive pieces on Brian Eno's ambient innovations throughout the 1970s. In addition to obscure rock bands and jazz, he considered many groups on the margins of genre and even ventured to write on classical music. When asked to write about the record he would take with him to desert island, he chose *Astral Weeks* by Van Morrison—a choice that surprised many of his followers, hough Bangs had been writing warm and thoughtful pieces on Van the Man from the beginning of his writing career. The artists Bangs loved to hate included James Taylor, John Denver and the rest of the singer-songwriters except for Joni Mitchell. Among rock groups he despised Grand Funk and Mountain, his favorite aversion being Jethro Tull—"uptight, pretentious and haughty" (review of *Songs from the Wood, Stereo Review*, 1988).

Bangs was able to match his messages with his writing style in various ways. His teenage frustrations exploded in his texts on 1960s garage bands. Some pieces on avant-garde artists resembled improvisations, and he treated popular acts like Slade and Black Sabbath with simple and entertaining prose that took these acts more seriously than most other contemporary writers did. He also found Alice Cooper as entertaining as a cheap old horror movie:

> A good case could be made that Alice is just dally-dabbling in the Deep, and that his actual involvement with what he's putting forward (and not just the obvious sexual elements) is most likely about as demoniacally driven as Jim Morrison's must have been late in the years when ol" *bota*belly would come lurching on to sing "Celebration of the Lizard" to an opera house full of bigeyed pubies. ("Alice Cooper All American," *Creem*, January 1972:20)

Bangs's frequent returns to Lou Reed are no light entertainment but rather a thrilling if painful identity quest. At one level they are the story of a man finding his hero, finding out that the hero does not like him, earning his respect by verbal fights using every intellectual and dirty trick conceivable, but feeling betrayed in the end. First and foremost, though, Bangs's obsession with Reed is a struggle with his double—his own inner demons. Lou is smart and popular, while Lester is sloppy and lonely. But what Lou is for rock, Lester is for rock writing:

> Lou Reed is my own hero principally because he stands for all the most fucked up things that I could ever possibly conceive of. [...] Getting off vicariously on various forms of deviant experience compensated somehow for the emptiness of our own drearily "normal" lives. [...] And what may be even more important is that he had the good sense (or maybe just brain rot, hard to tell) to realize that the whole concept of sleaze, "decadence," degeneracy, was a joke, and turned himself into a clown, the Pit into a puddle. (*Creem*, March 1975; quoted from Bangs 1988:171–172)

Bangs increasingly felt like a clown in his later years at *Creem*. But as usual, rock 'n' roll saved his soul. Although it took some time for him to appreciate the CBGB scene in New York he gradually understood that it was "new-old" in the same positive way as Captain Beefheart had been. And beyond that, it was also the realization of his vision of rock, of this strange unity of raw power and derangement, of sincerity and fakery. Until then Bangs's love for the garage bands of the mid-1960s, punks as he had sometimes lovingly called them, had largely been seen as a symptom of his eccentricity, but now the Ramones and the Brit-

ish punk bands took off from exactly those bands. Bangs's heroes like the Stooges, the New York Dolls and Reed became the heroes of a new generation.

In Patti Smith Bangs heard all his favorite voices—"the Shangri-Las and other early Sixties girl groups, as well as Jim Morrison, Lotte Lenya, Anisette of Savage Rose, Velvet Underground, beatniks and Arabs." References are also made to the Stooges and Bo Diddley; ultimately, "[w]ith her wealth of promise and the most incandescent flights and stillnesses of this album she joins the ranks of people like Miles Davis, Charles Mingus or the Dylan of 'Sad Eyed Lady'…" (*Creem*, February 1976).

Gradually, as the glory of punk faded away, so did Lester Bangs. His self-reflexivity became more and more self-critical. The thrill of rock had dwindled and he was moving over to other types of writing, perhaps the Great American Novel, when a premature death shattered his plans—ones that probably would have developed into something quite different from what he had originally conceived.

Drugs and alcohol killed Bangs and drugs and alcohol had been an integral part of his life and image from the beginning of his career. This part of his image was always Janus-faced. His celebration of hedonism was coupled with a disappointment over the defeat of the counterculture; in the beginning of the 1970s "life politics" contained no positive option except for "keeping the party going." Nobody was keener on keeping the party going through the 1970s—but the reader does not always want to join the party.[32] Basically Bangs's politics of ecstasy were hooked up with a belief in the thrill of being united with other person(s) in a bodily and aesthetic experience. Sometimes drugs could help but more often he refers to drugs as killers of pain, boredom and, ultimately, of life.[33]

There is no doubt that the writings of Hunter Thompson and Lester Bangs can be read as the products of heavy drug users, and their writing styles contain

32 See, for instance, Bangs's writings on Lou Reed (1988:165–201).

33 It is not that important how drugs helped Bangs make it through the night, but whether they shaped his aesthetic vision. Richard Wilmot (1985) has discussed how drugs can help the users to achieve distance, objectivity and control over their experiences. The intoxicated person often shifts between deep empathy and a cool remove. By changing these perspectives repeatedly, new observations and new discoveries are made. The ability of changing perspectives is generally seen as a central competence of the modern person and is now systematically developed in scientific training, but already the Romantic artists, using the media of intuition and confusion of the senses instead of systematic methods, knew that drugs can give such a sensation in unexpected ways. In fact, exploration of these media has been a part of the intellectual strategy of, among others, Sigmund Freud, Walter Benjamin (Reeh 1988) and undoubtedly of several other scientists who do not wish to admit it.

valuable documentation about the chaotic road to discovery through intoxication. Each has a tendency to start a story or a theme and then through an intuitive association slip into ravings about his own experiences, traumas and phobias. Self-accusations and outbursts of masochism alternate with desperate attempts to protect the ego, not least frequent excursions to shoot at anyone in sight. Such revelations of the author's chaotic inner life are undoubtedly clinically valuable, but Bangs and Thompson are also readable for the general public because of their entertainment value. The reader is always left in doubt about whether one is being led into a real confession or a devious trap. Often the thread of the story seems forever gone and the reader gets the sneaking suspicion that the text was finished during a blackout and will never survive the daylight. Then suddenly the stories of drunken nights and mad behavior are swept aside and the reader realizes that they have been leading to a point or a punch line, and either the A-, B-, or C-story of the article is back on the track. The aforementioned piece on James Taylor is a prime example—Bangs introduces the villain, but uses most of the first thousand words of the article to rave about an obscure group (the Count Five) and the next thousand to weave the Troggs into his own sexual fantasies; then suddenly James Taylor pops up again and the previous meanderings acquire an entirely new meaning. Thompson often deals with his favorite target, Richard M. Nixon, in an analogous fashion.

Lester Bangs is the only rock critic to be fixed as part of the star firmament of rock. Of course he is the only major rock critic who is dead, but his writing ability, eccentricity and vulnerability provided him with star qualities that turned him into a myth while he lived, and as the years have passed his fan culture has only grown stronger. Two anthologies of his work have been issued (Bangs 1988, Morthland 2003), a Web site has been dedicated to him for years, he was the first rock critic to have his biography written,[34] and he is the model for the guru character in the first movie based on rock journalism, Cameron Crowe's *Almost Famous* (2000). His own musical adventures range, according to the few who have bought and played these records, from "embarrassing" to "interesting," but he received his minutes of fame playing the typewriter on the stage with the J. Geils Band:

34 DeRogatis (2000) is a fan biography with some of the best qualities of the genre (love and well-documented details) and some of the typical fallacies (lack of distance and perspective). Interestingly, he starts out by disagreeing with Robert Christgau, that "[Bangs's] critical ideas were not the strength, it was the language that was the strength" (xvi), but fails to examine or highlight these critical ideas—a task that hopefully is carried out here.

and when the encore came and I heard my name I strutted up and onto the boards, Smith-Corona in my hand, no trace of stage fright. I set the machine down and clenched my hands over my head like a boxer, the better to bask in the adoration of the mawsome throng, two of whom applauded, one of whom was Leslie Brown, whose desk sits to the right of mine. [...] So I commenced to yell at the roadies just like a true superstar "Plug the sonofabitch in! Let's get down!"

They did so, setting it on a bench at stage right for me, and I kneeled down and with a consummate sense of theatre took my sunglasses out of my jacket pocket and put them on. Then I held up one of the two sheets of lined notebook paper I'd brought along, just for the crowd to ogle, and slipped it in the machine. I looked over at the band, who were waiting for this cue, and J. Geils cued me right back—brother! Slap me five!—as we broke into the opening bars of "Give It to Me."

[...] I started trying to play on the beat, grinning and nodding at the rest of the group who grinned and nodded back as the peanut galleries gawked, hawked and kfweed. The writing was coming out great too: "VDKHEOQSNCHSHNELXIEN (+&h-SXN+ (E@JN?." I heard one of the roadies, kneeling a few feet to my right, laconically drawl: "Yer doin' great, man." Vengeful bastard. ("My Night of Ecstasy with the J. Geils Band," *Creem*, August 1974; quoted from Bangs 1988:144–145)

5.7. Other Voices of the Late 1960s

The five writers nominated here as the founding fathers are to be considered as *primi inter pares* among a larger group that constructed the field of rock criticism in the U.S. Some of the predecessors of the early 1960s kept on playing an important role throughout the decade and even beyond. Al Aranowics kept the flag of beatnik bohemianism waving through the 1960s, reinforcing his credibility with personal friendships with the stars while sticking to folk authenticity aesthetics, until he became too marginal in his writing and behavior and was squeezed out of the field in the early 1970s. Paul Nelson also came from the folk circuit but managed to make the jump into new times and remained an important critic for decades. Richard Goldstein played an important role as the main rock critic of the *Voice* until 1968, but when he gathered his pieces into a book a few years later, Marcus found his "hip" approach superficial compared to Nik Cohn's and Jon Landau's (*Creem*, October 1972:52). In San Francisco Ralph Gleason became even more committed to the new rock than he had been to avant-garde jazz. He became a father figure not only to Jann Wenner personally but to *RS* staff generally; his regular column in *RS* was given high status and so were his books. Gleason drew on his perspective on avant-garde jazz, whereby good rock was seen as "holy art" where the shaman musicians expressed true humanity in a society that was one-dimensional in most ways. For Gleason rock

became far more important than avant-garde jazz as it was the music of a new generation and attached to the sociocultural movement of the hippies. However, gradually Gleason became isolated at *RS* with his narrow hippie focus, and after confrontations with *RS* cofounder Jann Wenner he withdrew from *RS* in 1973. He died in 1975, hailed as an important innovator in the field of rock writing.

Jann Wenner, editor of *RS*, also started out as a warrior for the cause of acid rock. As an editor, however, he made room for those with other tastes, not least Landau. He was crucial for the canonizing of Landau, Marcus and Marsh as rock critics by signing them on as review editors at *RS* and he played a significant role in constructing Bangs's reputation as the master of irreverence, by firing him from *RS* for lack of respect. In the mid-1980s he completed "the long strange trip" of *RS* by changing it into a yuppie magazine.

RS fostered many solid writers from the start, and although they all left sooner or later after a clash with Jann Wenner, their time at *RS* gave them credentials for many years to come. Jim Miller and Langdon Winner both became professors of political science without forgetting their roots in rock criticism, with Winner attending to the far-out edge of technological innovations and Miller engaging in cultural critiques. Early on Peter Guralnick became more interested in the history of blues than in reviewing the actual scene, and although he returned from time to time to reviewing, his greatest contributions are his books on the history of blues and soul, together with his standard biography of Elvis Presley (1994, 1999). Ed Ward, Greg Shaw, John Morthland and Nick Tosches, who all spent time at *RS*, also rank among the best rock writers, though each has withdrawn from the scene for long periods. Ben Fong-Torres is a prime example of the type of rock writer who avoided rock criticism but contributed to the discourse with enlightening journalism. Many of these above-mentioned writers were also part of the *Creem* staff for a period. Most of the core staff of *Creem*, however, moved into new areas after the original adrenalin rush at *Creem*, like Deday LaRene who became a criminal defense attorney.

Richard Meltzer was and is in a league of his own. In the late 1960s he was one of the linchpins at *Crawdaddy!*, *RS* and *Creem;* later he wrote for the *Village Voice*, *Spin* and other publications.

> In the fall of '66 I embarked on a simple mission: to expand the palette—the text—of philosophy as dealt at American institutes of higher et cetera by slipping massive references to rock-roll, psychedelic drugs, pop art, biker films, and other contempo-cultural wigouts into term papers, classroom discussions, and

the Q&As which followed lectures by celebrity academics. ("Vinyl Reckoning," *San Diego Weekly*, January 28, 1999:30)

Meltzer was expelled from Yale, but found in the rock magazines a place where his attitude was tolerated and where he could excel in throwing bits of heavy cultural theory into hip textual flows about popular records that he liked or (as the saying goes) had not even heard. He was one of the first critics to gather his pieces into a "dadaist" book, *Aesthetics of Rock* (1970), which was presented as a doctoral thesis. In these years Meltzer was one of the bestknown rock writers, but in the late 1970s he felt pressed out of the field, especially by Christgau and Marcus. "These bozos found my rockwriting 'politically incorrect,'" he writes ("Vinyl Reckoning"). He has, however, kept a certain status as an outsider as regards the circle of founding fathers, popular enough to get his "rock aesthetics" republished and powerful enough to upset the more established writers, such as Dave Marsh:

> I don't like Richard Meltzer. Period. I don't like him personally and I don't like his work. I always thought it was silly. The notion that Richard Melzer has something big to say, well I don't get it. He has only contempt for the music. You can divide the content of the book, *Aesthetics of Rock*, into three categories: it's either wrong, irrelevant or obvious. And it's unreadable.[35]

In the early years of rock criticism Ellen Willis was one of the most influential writers. Although she did not stick with it long enough to count among its parents, she clearly put her mark on the field. Her ambitions and talents were geared to a broader arena of general cultural criticism. Willis started to write about rock for the *New Yorker* in 1967 and soon after she was one of the writers who tried (and almost succeeded) to start a New York rock magazine with *Cheetah*. During the 1970s she wrote extensively for *RS*, the *Village Voice* and a number of other papers, but in the 1980s she gradually moved on to teach journalism.

Willis is a cultural critic of great capacity. Her rock connection has given her feminist position a strong flavor of humor and hedonism, which is also found in her criticism of the male-dominated rock scene. Already in the late 1960s she

35 Dave Marsh, personal interview, November 22, 1999. This is not a revised evaluation by Marsh as he already in 1970 commented: "The psychedelic obfustacation which Richard Meltzer used to pour, like a bizarre concoction of mescaline syrup, over his unsuspecting readers in the days of Crawdaddy" (*Creem*, no date, 2/11:29).

wrote profound think pieces on rock without limiting herself to a narrow aesthetic position. This is demonstrated in her consideration of Bob Dylan during the 1967–1968 period, in which she is able to recognize his changing masks as both part of an artistic struggle and "the stigmata of an authentic middle-class adolescence" (Willis 1981/1992:5) and how he "was really at cross-purposes with the hippies. They were trying to embody pop sensibility in a folk culture. He was trying to comprehend pop culture with—at bottom—a folk sensibility" (19). Without mentioning the Basement Tapes, which were not yet in circulation, these last remarks really foreshadow the analysis of the tapes that Greil Marcus was not ready to deliver until 1997.

Apparently, this essay earned Ellen Willis enormous respect from her colleagues. Robert Christgau even states that it changed "my whole perception of the relation between art and persona" (1973:viii). Willis surely has a deep understanding of folk culture, but she is no less receptive to the pop art influence in rock, both in the English variants of the Beatles and the Who and in the New York variant of the Velvet Underground. The tools that she uses are to a large degree based on literary and film criticism, but she smoothly explains music and never fails to see the unity of music and words as the key to the great songs of Dylan, the Who and others. However, the basic approach is to read music as a subversive cultural product—she just understands better than many of her contemporaries that subversion can have many faces—and she writes less about music when this quality has become blurred. In a reflexive and self-ironic introduction to the 1992 reprint of her anthology she admits that she always felt drawn towards absolutism, which culminated with her failed conversion to Judaism in the mid-1980s.

In the 1970s Willis spearheaded a feminist critique of the male world of rock—without rejecting its hedonism—and already when she was a part of the counterculture, she was more sober about the subversive potentials of the rock scene.

> It may be that those of us who still have some faith in collective action are simply indulging an insane optimism. Nevertheless, it is clear to me that if we want to survive the seventies, we should learn to draw strength from something more solid than a culture that in a few years may be just a memory: "remember hair down to your shoulders? Remember Janis Joplin? Remember *grass*, man? Wow, those years were really, uh, *far out*." (review of *Easy Rider*, *Village Voice*, December 1969; quoted from Willis 1981/1992:60)

Lisa Robinson broke new ground as "rock's premiere style and personality reporter" in the early 1970s with her "Eleganza" column in *Creem* (McDonnell 1995:6). Her method of packing cultural and critical comments into stylish gossip, with an emphasis on rock as glamour,[36] did not give her high status in the early 1970s but turned out to be one of the strands building up to the criticism of the 1980s.

These writers—and undoubtedly some more—would be included in a fuller and nuanced account of the U.S. rock critic field in its making, but the main lines can be drawn from the positions of the five founding fathers.

5.8. Young Men with a Vocation: Shaping a New Field and Inventing Positions

When rock criticism emerged as an embryonic field in the U.S. in 1966–1968, rock was automatically and without much discussion seen as an expression of American counterculture. Many rock writers could agree with the CIA that rock was a mind-altering drug turning youth against the Vietnam War and established American values and toward alternative, anticapitalistic lifestyles. In the beginning the founding fathers of rock criticism were not far removed from such positions, but through daily encounters with the music for years they liberated the interpretation of rock from its narrow links with the political movement and came to regard it broadly:

– as *counter* in the double sense of social resistance and artistic negation,

– as *culture*, combining deep roots in cultural history, avant-garde art and the mass form of popular culture,

– and as uniquely *American*—the only context that could produce such a combination.

Rock writing was from the beginning an arena for young writers to establish public images or profiles, whether they understood themselves as journalists, writers, academics, players in the field of popular music or something else. These profiles evolved into positions, each writer making an effort to show that he or she had a taste of his or her own. There were no self-evident criteria dictating the quality of taste, such as degrees from the right university or the right family,

36 See "The New York Dolls In L.A. Looking for A Kiss In Parking Lot Babylon," *Creem*, November 1973:42–45, 76–78.

but the mechanisms of the field turned self-presentations of writers into arguments for privileged access and understanding. Landau pointed elegantly to his mixture of music experience, academic training and the understanding of working conditions in the industry (the question arises whether there is a connection between his emphasis on his Jewish roots and his claim to mediate between black music and a white audience). Christgau emphasized a somewhat different mixture: a proletarian background, enough academic training to be able to see through that bullshit, a pop art sensibility and a way with words. Marsh departed from his hometown music of Motown and the MC5 and gained credibility from his working-class background in at least three ways: a direct understanding of country music, a love for soul music as rebellion against his racist father and an ability to become a man of words in spite of his proletarian upbringing and limited education. Marcus has two strong spots, a deep historical knowledge of American culture and thought and a keen insight into contemporary music, and he manages to present the combination of these two elements as the key to understanding rock. Bangs, finally, established a very different authority from the other critics, elevating adolescent frustrations into romantic beat poetry.

These shifting approaches may be looked at broadly as *quests for identity,* whose aim was understanding the cultural processes that the writers were participating in. They shared the optimism and the vision of pioneers convinced that not only was rock a "legitimate" art form, but one that voiced the contemporary cultural situation much better than any other. They were also conscious of "inventing" rock criticism and put great efforts into defining the best way to do it. All of them saw writing on rock as a necessary part of the rock culture as a whole—they all felt a need to improve the quality of the music (and the writing), win recognition for rock, save newcomers from too many trials and, what is most important in the beginning, help the rock community to grow. Adapting aesthetic criteria from other fields in varying degrees, they all think that an important part of their job is to distinguish good rock music from bad rock music. Their ideal of rock combines quality with popular appeal, they all attack "undeserved" popularity without mercy, and all of them lend strong support to some acts that never really made it.

As we have seen, these critics entered the profession due to a variety of personal motives. No one set out deliberately on a career as a rock critic or to make rock criticism respectable. Rather, rock mattered greatly to them personally. It was a brand new thing that they were eager to explain to others less enlightened, and their excitement often made the writers blind to the institutionalizing and incorporating mechanisms of the culture they were participating in. Even if

they did not intend to legitimate rock or to demarcate a rock field, the logic of cultural fields made them do just that.

The brand new thing had partly to be explained by drawing on old paradigms, set in motion by the turbulent 1960s. Folk, jazz and film criticism came in handy, and the students and dropouts grabbed elements of literary theory, classical aesthetics, philosophy, sociology and whatever they had studied. One of the liberating experiences of early rock criticism, as expressed by Marcus and Meltzer and welcomed by numerous students who wrote about rock in college papers, was the possibility of playing with theories without the censorship of academia.

Rock was regarded as a strong force crossing and tearing down racial and cultural boundaries. A common motif in rock criticism was the unfolding of its autonomy and the refusal to countenance rock as a mere instrument for leftist politics. The critics all stressed the personal rock experience as liberating in itself and explored various ways of expressing that gut feeling. Marcus spoke of rock shaping new mental patterns of his generation, Christgau, Bangs and Marsh referred to individual emotional revelations triggered by songs on the radio. Many writers referred to special relations between artist and audience within rock, but for Landau and several other writers the new consisted rather in the body aspect of rock, in its beat and sounds, as opposed to previous forms of art—also popular art. So the discussion went on, partly in think pieces discussing the state of rock criticism with regular intervals, partly in single reviews trying new angles.

The founding fathers agreed to an astonishing extent on their evaluation of rock history and its canon.[37] For all of them the basic energy and fundamental aesthetic standards of rock originated in the 1950s and were synthesized and further molded by the Beatles, the Stones and Dylan—the holy trinity in these critics' worldview. In general, the founding fathers all took pride in avoiding hype and jumping on bandwagons; they demanded a longer-range perspective and kept their heads cool while their hearts stayed warm. In these ways, all five founding fathers succeeded in establishing authority for themselves as the "clergy" of a new cultural field.

37 The positions of the founding fathers have often been mystified as the years have passed, not least by young up-and-coming writers attacking their orthodoxy, Burchill and Parsons (1978) being a prime example. These heterodox writers attack the early rock critics for idealizing psychedelic music as the music that made it worthwhile to write about, a position that should be attributed to Ralph Gleason and to a certain degree to Jann Wenner and a few other *RS* writers, but certainly not to the founding fathers.

This would of course not have been possible without the existence of a specially demarcated public sphere that came into being with the rock magazines *Crawdaddy!*, *RS* and *Creem* and the surrounding alternative weeklies, general-interest periodicals and dailies gradually molding their rock writing after the specialty press. In due course these magazines learned to introduce their writers as men and women of weighty words, and rock criticism soon began to win some status outside the world of rock fandom.[38] The increasing recognition of rock as a subject for serious meditation is confirmed by the introduction of courses on the topic at American universities from the late 1960s onward and, above all, by coverage of rock alongside the art columns in respectable dailies and periodicals.

Aside from Landau, who proceeded strategically from the beginning in 1966 with the aim of establishing rock writing as a respectable part of the critical field, the other founding fathers were at first primarily driven by their personal experiences with rock, the transformative effect the music had had on them and a felt need to communicate and explain such experiences to their peers. As Landau carefully nurtured and wielded his influence on the rock field in the early 1970s, his fellow critics became more conscious of the power they could possess, a process that culminated in Marcus's deliberate and successful attempt with *Mystery Train* in 1975 to establish rock as essential American culture. At that time the leading critics had, from different points of departure, developed distinct positions through different answers to a few basic questions:

– *The question of the political meaning and social importance of rock* was at the heart of rock criticism in the beginning, but changed radically between the late 1960s and the early 1970s. In the beginning sophisticated rock criticism distinguished itself from much countercultural rhetoric by comprehending rock as subversive in itself and not simply an instrument for subversive politics. Landau and Christgau repeatedly argue that political social meaning must not overshadow artistic

38 The importance of the rock critics and magazines in these early days is partly to be explained by the music industry's spotty understanding of the rock audience. Although the industry was not always pleased with the rock magazines, it often had to rely on them as a way to reach this audience and had to accept them as consumer guides. Although relations between industry, magazines and critics were not always "clean" (Draper 1991, Goodman 1997), criticism gained dignity from a principled independence and irreverence, sustained by the continuous feedback from the rock community.

quality. As demonstrated in their reviews of Joan Baez, Phil Ochs and John Lennon's *Some Time in New York City*, they both prefer a silly but good song/performance to a politically correct but unoriginal or pretentious song/performance. To Landau artistic quality seems to be separable from the political content, while Christgau tries to see them as a unity. Landau seems to lean towards the leftist politics of the 1950s and early 1960s, arguing that good music can be used for good political purposes, while Christgau contends that the politics inherent in good rock are more important. They both are preoccupied in a critical and reflected way with the relation between rock, the social movements of the 1960s and the counterculture.

Marcus starts from a similar place, but his method of looking for a broad context becomes a way of redefining the social and political meaning of rock. Instead of seeing rock as something new, connected to the social situation of the 1950s and 1960s, he establishes a longer perspective, placing rock in a critical cultural tradition going back to the 19th century. He thereby attempts to save the social implications of rock for more complicated times and to move the discussion from the more and more marginalized counterculture to the center of the American society. In the meantime, Bangs and Marsh hurtled into the field each with his own radicalized approach—for both of them rock 'n' roll is revolution. While for Bangs there is no revolution beside the cultural, Marsh started writing in a militantly radical milieu. Although he soon stopped looking for revolution around the corner and discerned less and less promise in rock, he has remained true to his guns, seeing rock as music of and for the people and commenting on the scene from a clear radical position. There is a certain difference between cohorts here, as Landau, Christgau and Marcus cast themselves as leaders working at making rock fit for the drawing room as socially important art, while Bangs and Marsh cast themselves as rank-and-file members of the rock community, keeping the fire of revolt alive.

– *The question of "auteurism."* Landau adapted the auteur perspective of film criticism to rock music, as a matter of forming a coherent aesthetic vision and being able to express it in the specific production settings of rock music. Christgau, on the other hand, sees auteurism as a malplaced criterion of high art; he argues for the specificity of rock as a revolt against the insularity of high art, a revolt based on the

interaction between audience and creator mediated by mass communication and the commodity form. Bangs emphasizes the reception from the perspective of the teenage fan. Marsh moves between these positions, asserting work and performance as a narrative. Marcus places the artist differently against his cultural background, stressing the lines from silenced cultural expression.

– *The question of a specific rock aesthetic* is accentuated by all these critics in different ways as well as to different degrees. Landau has the most rigid definition since he not only stresses artistic self-expression but also demands a respect for orthodoxy: original rock, body music that entertains and provokes. Landau's vision was later incarnated by Bruce Springsteen's "show that would tell the whole history of rock" by a "complete artistic persona" singing classical rock, framing it with witty stories and delivering it with gestures of innocence and toughness (Marsh 1979:91, 86). Marsh has a similar vision, but subversion and African-American roots are far more fundamental for him, and he does not want to legitimate rock in terms of high art. Bangs was to take that stand even further and perhaps his position can be formulated as a paradox: resenting classical notions of aesthetics while putting them to use in his writing. Christgau combines an "underdog" position with a sensibility that draws on pop art. He opposes Landau's idea of clearly defined criteria for such aesthetics and replaces it with a notion of critics *embodying* aesthetic taste. For Marcus rock aesthetics work in more or less unconscious ways as a collective conscience and revive long forgotten and shared dreams better than other art forms.

– *The question of authenticity.* Individual expression comes in early as a correction to folk authenticity. Landau regards rock authenticity as the expression of individuals or groups, but related to traditions, roots and the audience. Although Christgau and Willis oppose Landau with an emphasis on ironic distance and artifice, the latter are seen as artistic tools, and they too demand a basic authenticity provided by individuals situated within a social nexus. For Marcus authenticity is both a question of reflexivity and of an artistic opening up for unconsciousness to become a medium for collective memory. Marsh casts a light on the alienating effects of the industry, seeing artists as succumbing and

struggling within these structures, while Bangs always carried to excess
the demand for artistic honesty, giving a poignant definition in 1977:

> The point is that, like Richard Hell says, rock 'n' roll is an arena in which you
> recreate yourself, and all this blathering about authenticity is just a bunch of
> crap. The Clash are authentic because their music carries such brutal conviction,
> not because they're Noble Savages. (*New Musical Express* December 10, 1977;
> quoted from Bangs 1988:227)

Although all these writers adhere to a paradigm of authenticity, their attempts
to illuminate authenticity within popular culture not only contain important
individual variations but are far too sophisticated to be written off as the "ro-
mantic primitivism" of an authenticity cult (Middleton 1990:168).

– *The question of rock as American culture* occupied the founding fathers
 to different degrees. Part of the canon formation and construction of
 tradition was to emphasize the specific American roots in music linked
 to race segregation and divisions of classes and between south and north.
 The importance of non-American music was measured in terms of an
 "invasion" and its meaning for American audiences. The justified em-
 phasis on the American context often turns into narrow-sightedness,
 one that can produce unintentionally amusing results as when musical
 compilations, designed for the American marketplace, are studied as
 oeuvres (Landau), but that is more subtle when puritanism and the
 ideology of the land are examined as cultural patterns specific to the
 U.S. (Marcus). This original unreflexive attitude was for decades repro-
 duced in rock studies, for instance when Simon Frith (1981:3–4) stated
 that "rock is an American music" or Grossberg (1992:201) echoed that
 "rock is 'about' growing up in the U.S. (at least that is the only context I
 am talking about)." However, some rock critics tried to overcome this
 narrowness, for instance when Marsh dug into the specific British roots
 of the Who (Marsh 1983). Lester Bangs was from the very beginning
 exceptionally receptive to music coming from outside the American
 metropoles, whether it was Austin, Texas, or Seattle or European coun-
 tries. His reviews of rock from non-English-speaking countries displayed
 an unusual openness towards the acculturation of rock, but it is symp-
 tomatic that it is not this side of Bangs that has been canonized (Bangs
 1988, DeRogatis 2000). Christgau tries from the start to be reflexive and

confesses that U.S.-centrism is at the same time an asset and a limitation. The ambivalent consequences of the American cultural insularity for rock criticism are epitomized by the difference between the strong contextualization of the American studies of Greil Marcus and his far more erratic *Lipstick Traces*. The real problem of rock studies may very well be the lack of exploration of these limits in studies by non-American rock writers, whose worldview may be centered not solely on the U.S. but on American and British language, culture and intellectual tradition (Gudmundsson 1999).[39]

– Although the efforts of the founding fathers, seen in terms of cultural practices, work to legitimate the rock field, criticism appears to the subjects themselves as a *vocation*. Their message is a gospel, although a very worldly one, and they seem to like to see themselves as chosen to execute it. But they preach in very different ways, placing themselves differently in their texts and using different strategies to establish their credibility. Landau establishes it by means of a professional, objectivist stance, judging technical details, arrangements and any part of the total "work" in an authoritative way, supporting his authority by referring to his own history as a musician, to his education and to his experience as a long-time aficionado. Bangs is his opposite, staging himself as a sort of fool, presenting total earnestness as the (very fallible) fan. Christgau takes an intermediary position that tries to combine the cool and knowing head of Landau with the warm heart and witty pen of Bangs. He speaks as a man of good taste, though underlining his subjectivity and fallibility. Christgau also tries to reproduce some of the music's anarchy in the spirit of new journalism, a method that Marsh also tried, but of which Bangs became the master. Christgau and Marsh hint at special privileges provided by their proletarian background, especially Marsh. At the other end of the specter, Marcus stages himself as a man who effortlessly combines being a rock fan and an academic scholar.

These five founding fathers were central in demarcating the discourse of a fraction of new intellectuals (see p. 34–35). They embarked on a journey without a firm destination in a period of great social and cultural upheaval and one of the

39 Recent explorations in this direction can be found in the contributions of Simon Frith, Robert Christgau and Jason Toynbee in Weisbard (2004).

biggest waves of upward economic mobility in recent history; they became a clergy of a new legitimable cultural field, giving it the trademark of a simultaneous insistence on artistic importance and popularity.

If, arguably, Landau was the pivotal agent in establishing a relatively autonomous rock criticism, supported by Marcus, Christgau and others, Bangs and Marsh were crucial to revitalizing the butt-kicking moment when criticism was becoming dangerously serious. Credibility with the rock audience was the main asset of the critics, but gradually recognition came from academia and publicists. After the *Village Voice* made the music pages, headed by Christgau, into one of its main sections in 1974 and Greil Marcus's *Mystery Train* was published in 1975, rock criticism had moved close to the centers of cultural discussion in America.

Chapter 6

British Brats
(1972–1978)

6.1. The *NME* Connection

By 1967 British pop escapism was no longer felt to be adequate to the new mood of optimism, geared to cultural and political change. "The 'summer of love' of 1967," writes Iain Chambers (1985:97), "seemed to have unleashed the promise of a transnational counter-culture—an electronic 'global village.'" American psychedelia, New Journalism and rock criticism started feeding into the British scene. Pop became rock (art rock, progressive rock), and for a few years London could boast a flowering underground culture, mirrored and supported by a number of new magazines. Spearheaded by *IT* and *Oz*, followed by *Frendz* and *Cream*, the British underground press was, like its American counterpart, passionately devoted to provocation, alternative living and "revolution" in a broad sense. Some of its favored topics were sexual liberation, drugs, the Vietnam war, Black Power and police brutality (Neville 1971:122–123). Being a vital part of the movement, music was also extensively covered, if seldom in detail. The predominant view was, as Jeff Nuttall observes in *Bomb Culture* (1968), functional: popular music that crossed the borders between high and low culture and art and everyday life was commonly considered to contribute to the development of a new subversive sensibility.

Though *Oz* and *IT* could boast print runs of 20,000 and 50,000, respectively in 1968 (Frith and Horne 1987:52), the British underground remained small and exclusive in comparison with American counterculture. Nevertheless it provided a missing link between indigenous pop writing, American rock criticism and what was to become 1970s rock journalism. *Melody Maker* gradually picked up on progressive rock from 1967, selling itself as "the thinking fan's paper" by 1970. This move was followed by the launching of a new weekly, *Sounds*, specially designed to cover progressive rock. But the process was not accomplished until 1972 when *New Musical Express* joined its predecessors after having recruited a host of new writers from the then decaying underground press. Setting out to construct a new, initiated rock community on the basis of what they had brought with them, *NME* writers such as Nick Kent and Charles Shaar

Murray soon were established as the major critics of the decade. There were indeed others who were much read (like Richard Williams in *MM*) and other strands of criticism (like that represented by the politically and academically inclined *Let It Rock*), but none with the same impact. In Kent and Murray, Lester Bangs's carnival of words joins forces with the bluntness of Nik Cohn on what is basically a countercultural platform. With this approach, which synthesizes most of the strands outlined in the preceding chapters and sets the standards for later generations, British criticism is brought onto a level with its American counterpart. Though transatlantic communication was rather sparse, it also seems that a transatlantic "clergy" of critics whose shared standards and dialects form a hegemonic discourse had taken shape by 1972–1973. For a period, lasting till the advent of punk in 1976, rock criticism appears as a young, *transnational* field.

The Irreverent Inkie: NME *in the 1970s*
New Musical Express was constructed as a weekly aimed at teenagers in 1952, the same year as it launched the first singles chart in Britain. At that time few alternative sources of information were available, and news was star reports, chart entrances and the like. "We give the kids what they want. We write about their current idols," stated editor Alan Smith.[1] As late as 1965, this concept brought *NME*'s circulation to a peak of 307,000.[2] But then it started falling, and the paper had to acknowledge the inadequacy of its pop image to the needs of the new rock audience. By 1972 circulation was down to 148,000, lower than that of *MM*. This crisis was dealt with by the recruitment of the underground writers mentioned above. "Their immediate effect," comments Simon Frith (1981:172),

> was on the paper's style rather than on its content; their writing was hip and knowledgeable, their cynicism about the rock business was up-front. By 1973 the effects of these new attitudes on the paper were obvious even to its most casual readers: on one hand, the *NME* had developed a calculated eccentricity in its layout and subheads and picture captions—the paper knocked itself in a zany way derived from the American rock magazine *Creem*; on the other hand, music coverage was beginning to stretch beyond the latest chart sensations into a critical vision of rock and its history that went beyond sales figures. The underground argument that rock was only one part of youth culture was expressed in the extension of coverage to nonmusical matters—film and science fiction and comics and drugs. By 1974 *NME* was back to 200,000 sales.

1 Quoted in Frith (1981:167).
2 All information on circulation comes from the annual issues of *Benn's Press Directory*.

From the viewpoint of rock criticism, the mid- to late 1970s were *NME*'s heyday. Not only was it competently edited by the enterprising Nick Logan, who was recruited from *Sounds* in 1973 and left to project *Smash Hits* and then *The Face* in 1978. First and foremost *NME* deserved its reputation as "a writers' paper" (Spencer 1991:x). Most of the cream of British rock journalists (and the token American) contributed more or less regularly: Nick Kent, Charles Shaar Murray, Ian MacDonald, Roy Carr, Tony Tyler, Mick Farren, Lisa Robinson, Paul Morley, Ian Penman, Julie Burchill and Tony Parsons. So did photographer Pennie Smith. It is telling that Lester Bangs ran a column for a number of years. "As in rock itself," comments Logan's successor, Neil Spencer, "the USA was the aspirational role model; everyone had their copy of Tom Wolfe's *New Journalism* collection, and US writers like Lester Bangs were avidly read" (ibid.).

A 1973 issue (April 28) picked at random shows a design that was to remain largely the same during the period. It holds 52 pages, fronted by a Slade photo and advertisements for Jethro Tull, the Stones, and Joan Baez. The framework consists of a "News Desk," British and U.S. charts, a three-page album and a one-page singles section, a gossip column called "Thrills," readers' correspondence ("Gasbag") and classifieds. The feature article is a Nick Kent interview with Lou Reed in Detroit, seconded by a page in a series called "This Is America," a Joan Baez exclusive on Vietnam, a two-page Roxy Music feature, Roy Carr on Charlie Watts and Linda Solomon on McCartney, a T-Rex overview by Charles Shaar Murray, a consumer's guide to "Common Market Rock," two pages on "Black and British" and "Jazz," and more. The amount of verbiage is rather overwhelming. It must be recalled that there was still little coverage of pop on British TV and in the quality press, and that a new rival weekly, *Sounds*, had appeared on the scene in 1970. These circumstances made the papers copy-hungry. Yet it is remarkable that the *NME* staff, week after week, could turn out 40 to 80 tabloid pages in which journalistic text occupied far more space than pictures or ads (which used to be music related) and more often than not maintained good quality.

Such an output required a literate and passionate readership as well as hardworking hacks, and there had to be occasions when readers felt left behind.[3]

3 For instance, when editors let readers dump on writers in *NME*, December 27, 1975, Nick Kent was told he was too highbrow and had to face questions like "Why read so much into it?" Conflicts were to increase some years later, when journalists had begun to acquaint themselves with semiotic theory. The angry reactions to a 1979 Ian Penman article on Throbbing Gristle that we will return to were a starting point.

This risk was not diminished by the music industry's then lavish treatment of rock journalists, including free records, concert tickets, meals, drinks, drugs, sex and trips to America. Some critics became stars, on par with the artists, and behaved accordingly. At company launches, writes Dylan Jones (1997:5–6), "[j]ournalists would regularly pick fights with each other, steal each other's drugs, and abuse any rock star who came within spitting distance." In that context, the much boasted "irreverence" of *NME* makes sense as a mode whereby critics were able to maintain their independence in the eyes of the informed reader; such an attitude had been cultivated before by writers like Nik Cohn and Lester Bangs. Simon Frith (1981:172) notes that the paper tended towards "a sociological response to rock, valuing music for its effects on an audience rather than for its creators' intentions or skills." It seems likely that the success of writers like Kent and Murray had more to do with their skill in making readers participate in the scene than with the brilliance of their analytic faculties.

In terms of taste and standards, *NME* remained largely consistent through the decade. Like its readership, which it confronted in annual polls, the staff was predominantly young and male.[4] This was mirrored in a predilection for American roots and urban rock, British lads' rock and arty innovators. While Abba and disco found little sympathy, the paper after some hesitation willingly embraced punk. Murray and Kent were so busy breaking New York CBGB groups like the Ramones, Patti Smith and Television that readers began to wonder why British critics had to cross the Atlantic in search of new cult acts, when they already had access to the Sex Pistols and Ian Dury (*NME*, July 17, 1976:46). It was up to Neil Spencer to draw attention to the Pistols in an influential review of their appearance at the Marquee titled "Don't Look over Your Shoulder, but the Sex Pistols Are Coming" (*NME*, February 21,1976). "From a manager's point of view, it contained everything required: there was a picture, an arresting caption, and best of all, it did not mention the headliners, the Hot Rods," comments Jon Savage (1991:151–152). The finish of the piece was perfect, too, quoting the group stating they weren't into music, but into chaos (ironically a claim first made by the "hippie" Jim Morrison). However, this initial lead was lost as *NME*, unlike its competitors, could not boast an "insider" correspondent until Julie Burchill and Tony Parsons were recruited half a year later.

4 According to Frith and Horne (1987:78), *NME*'s readers are recognizable as "lower-middle-class, young, predominantly male, suburban, self-educated, would-be-cultured, self-defined musical connoisseurs."

In the early 1980s, *NME* began to lose terrain to its new competitors *Smash Hits*, the lifestyle bibles and the glossies. Commentators argued that its time was over.[5] In "The Meaning of Bile," a 1984 article reprinted in Heylin (1992:106–116) that dwells on a number of questions indicative of a turning point, critic Barney Hoskyns rises to the defense of his paper. On the one hand, Hoskyns refuses to think that all the public wants is consumer guidance, on the other, he criticizes the inherent elitism of *The Face*. Instead he speaks up for a pluralist approach, which leaves room for an advanced, textually and culturally oriented criticism of the kind that had become part of *NME's* profile at the time through the writings of Paul Morley, Ian Penman and Hoskyns himself.

For a number of years *NME* was associated with the indie scene, living off its reputation and continuing the cult of the star critic in the shape of, above all, Paul Morley. However, by 1990 the paper's circulation was down to around 100,000, where it has remained. This drop affected the myth of its independence by prompting owner IPC Magazines to intervene on several occasions in order to increase circulation.[6] Today *NME* seems to have come full circle. Once again a service organ, a patchwork of news, gossip and consumer guidance, it offers little of interest in terms of rock criticism.

A Keithchord Split My Skull: Charles Shaar Murray
Charles Shaar Murray (born in London in 1951) first appeared in print in *Oz* in 1970. He was one of the team of gifted writers who entered *NME* in 1972 in connection with the music weeklies' co-option of young blood from the underground press. When he left in 1981 to go freelance, he was an assistant editor. In the last 20 years he has produced a number of books, among which are an award-winning study of his hero Jimi Hendrix, *Crosstown Traffic* (1989), and a John Lee Hooker biography, *Boogie Man* (1999). His 1991 collection of articles, *Shots from the Hip* (a bow to Nik Cohn's story *I'm Still the Greatest Says Johnny Angelo*), is the main source for the present profile.

The concluding article, "Parting Shots," stages the author as a literate pop fan. After finding out, like so many of his contemporaries, at the age of nine that he "was really an urban American teenager," Murray had two "revelations": the blues and Dylan. The horrible discovery that the blues originated in slavery

5 Among these was Mick Jagger, who said in a Paul Morley interview (*NME*, February 28, 1982:32), "For all its bollocks, its writing on the wall, all this adolescent posing, it is an old-fashioned out of date institution, which we don't even need."
6 *The Guinness Encyclopedia of Popular Music* (1995:3018).

taught him something about the interconnectedness of history, politics, culture and entertainment. From Dylan he learned that pop could discuss "the interaction between people and events" in terms that were at the same time "simple, passionate and poetic." As a teenager Murray devoured James Baldwin, Norman Mailer and Tom Wolfe: Wolfe's "chameleonic assumption of the inner voices of his subjects," Mailer's "apocalyptic language," "a perfect vocabulary for describing concert audiences," Baldwin's "virtuoso assimilation of both literary and street language." He also enjoyed reading Lester Bangs and Greil Marcus, and Hunter S. Thompson was the one who convinced him of the value of speed—"in all senses." Additionally fuelled by his discovery of Hendrix, Murray became a "would-be psychedelic revolutionary" in the late 1960s, got in contact with *Oz Schoolkids' Issue*, swapped guitar playing for typewriting, and started doing the things he had spent his adolescence reading about, as he puts it.

Murray's critical platform at the time he joined *NME* comes out as a characteristic attempt at an intermediary aesthetic, which gives sheer pleasure due credit but subordinates it to a (basically folkish) concept of musical "truth." Pop has to be exciting, but it can also yield more than a quick one. "Sooner or later" it is bound to have "some politics: though not all the time."

> Where pop [...] parts company with "light entertainment" is that the music does not (should not) pretend that everything is super. The world in which we live collapses apace and the best of our music faces up to this, either explicitly—by singing about it—or implicitly, by dancing in a manner that suggests that one dances in the knowledge that dancing is not everything. (1991:336)

Murray is well aware that visual style, trivial as it may seem, makes a difference, because pop deals with reinventing identity as well as asserting it. Most of all, however, he thinks pop was and is about the teens and twenties—a commonplace tenet among critics, which involves the notion of a fall from grace at age 30. In Murray's case punk was found healthy—his portrait of the Sex Pistols (202–219) for once has the lads appear quite sensible—since it could be regarded as an "authentic" revitalization of the scene in a way long called for by the *NME* staff. But its aftermath, "a combined museum and shopping mall," was no longer able to "substitute for literature, or folk wisdom, or political discourse." Despite revised expectations, Murray says he still finds pop worth listening to and writing about.

Shots covers a variety of critical genres, styles and topics. Some (mostly early) articles deal with social issues such as censorship, drugs and musician-related

violence; others (mostly late) take up forms of popular culture beside music—film, comics, science fiction. There are passing references to high culture almost throughout, but the closest Murray gets to its representatives is an interview with Kurt Vonnegut. Lengthy pieces are devoted to stars in the main tradition (McCartney, the Stones, Springsteen, Tina Turner), glam rockers (Bolan, Bowie, Alice Cooper), punk acts (the Pistols, the Ramones), reggae artists (Marley, Black Uhuru) and personalities such as Bob Geldof and producer Guy Stevens, but the performer who gets most space in one single article is Muddy Waters. Murray has a soft spot for the blues, which includes those cross-Atlantic messengers, particularly Hendrix, who brought it up to date. Never is he more passionate than when he gets down to the issue of the blues legacy and its exploitation by whitey. He approves of Springsteen as a good white R & B act, flawed by ambitions to make *important* records but finally redeemed by the artist's capacity of telling the truth (117, 122, 388). "Truth" is a keyword to Murray, and it resides with the lowly. Thus there is a positive connection between "the blues (black ghetto music from the USA), punk (white ghetto music from the UK/USA) and reggae (black ghetto music from JA)" (241). It is no surprise that he cannot fully embrace glam despite serious efforts at grasping the stardom of Bowie and especially Bolan—a 21-year-old reporter visiting a strange tribe of 14-year-old fans (13–22). More pretentious acts only provoke his bile. Thus Murray takes an active part in the burial of progressive rock and dismisses the fake rebel yell of Billy Idol in a few poisonous words (394): "Mad Max's underwear, Elvis's sneer, Eddie Cochran's vowels, Iggy Pop's jacket. At least he invented his own haircut." But "the most dishonest form of rock music extant" (1992:611) is heavy metal.

As mentioned above, Murray was one of the first British journalists to report from the CBGB scene in New York. In 1975 he also reviewed Patti Smith's debut album *Horses*. For some reason "Weird Scenes Inside Gasoline Alley" was not reprinted in *Shots*, but it is available in a section of Colin Heylin's 1992 anthology *The Penguin Book of Rock'n'Roll Writing* headlined "I Saw the Future of Rock'n'Roll …" The review is a skillful piece of persuasive rhetoric. Opening with the assessment "First albums this good are pretty damn few and far between," it goes on to refute imagined objections to Smith as "[f]oreign, female but not stereotypically attractive, and f'Chrissakes, a poetess," before it comes down to characterizing the album as "some kind of definitive essay on the American night as a state of mind," comparing Smith to Jim Morrison, Lou Reed and Dylan. This statement is then supported by comments on each song.

The review shows that Murray's standards are also informed by high art criteria such as originality and transgression. Not that he regards Smith as first

and foremost a poet; on the contrary, his point of departure is the music rather than the lyrics, and the review abounds in attempts at translating its marks by a kind of juxtapositions—"teeth-grinding methedrine piano," "JA Dylan vocal," etc.—destined to become commonplace in later criticism. Nor does the author's conviction that *Horses* is an important achievement produce pompous prose. Organized according to the principle of "one idea—one paragraph," easygoing, spiced with argot, appeals to the reader and irreverent references (Jim Morrison becomes "Jimbo" just as other shots introduce "Elton Schmelton" and "Spruce Stringbean"), the piece successfully establishes an atmosphere reminiscent of Lester Bangs's playful familiarity.

This is no coincidence, of course. In matters of style, Murray is a British incarnation of Bangs. Like the American, Murray does well also when he plays it straight, digressing on the history of the blues, dissecting "Punk ten years after" or dwelling on Alice Cooper in order to spell out the difference between being into tastelessness (rejecting taste hierarchies) and being into bad taste (revolting against good taste). Arguably, though, he is first and foremost a reporter who has wit, a knack for visual detail and an extraordinary ear for carnivalesque language. At its best his prose successfully reproduces the excitement of a musical event—"a Keithchord comes scything out of the speakers and slices the top of my head off" (156)—or is geared to vivid characterization: the voice of a worn-out Randy Newman "has blisters on its feet" (89), while Joey Ramone "resembles one of those old-fashioned street-lamps which curl and droop as if the weight of the lamp itself was to heavy to bear" (323). Intensity is heightened by puns, allusions and neologisms like "Sabs conna-sewer" (Black Sabbath fan), "O Sting, where is thy depth?" and "interestocide." Above all, Murray brings out what Bakhtin (1981) calls the inherently "heteroglot," dialogical character of language by means of mimicry. Not only do approximations of musicians' idiolects abound; Murray's own lingo is a mélange of the respectable, the hip and the vernacular.

But carnivalism does not stop at exciting language. It also involves a perspective on musical events that turns them slightly out of joint and exposes the narcissist desires of the ubiquitous "I." Thus "Elton John—the Short Hello" is an interview disguised as hard-boiled American pulp fiction, while the Rolling Stones concert review "Too Rolled to Stone" flows into a pot dream, where the author hangs out with the musicians only to find himself expelled by Jagger and ripped off for his last smoke by Richards. Next morning, though, he receives an apologetic letter from Richards. Again, the piece brings to mind Lester Bangs pursuing his artist double, Lou Reed.

As a writer Murray belongs in the vanguard of 1970s critics, while his standards are essentially those of the 1960s counterculture. Nevertheless, their scope also contributes to his achievement, making *Shots* a true lesson in how to listen to different acts from Black Sabbath—"The bastards weren't loud enough!" (142)—to Buffy Saint-Marie—"Did you know that the first American to be killed in the Revolutionary War was half-Indian and half black?" (148).

The Critic as Star: Nick Kent

> It's a bit amatuer [*sic*] at the moment but it is the first go isn't it, I mean we can't be Nick Kents over night can we.
> —Mark P, editor of *Sniffin' Glue*[7]

In many respects Nick Kent's career parallels that of Charles Shaar Murray. Born in London in 1951, Kent started writing for the underground magazine *Frendz* as a 19-year-old student of English literature and was recruited by *NME* late in 1972. There he soon acquired something approaching star status. He did not disappear from the paper's lineup of contributors until the mid-1980s, but in practice he was working freelance as early as 1975. In the 1980s he did some writing for *The Face* and moved to France. He went on to do television work, write for magazines and dailies such as *Mojo* and the *Guardian* and publish a novel called *Zonked*. He is the author of *The Dark Stuff* (1994), a best-of-selection spanning some 20 years of rock writing. A new, 2002 edition contains additional articles on, among others, Johnny Cash and Eminem.

Of course, there are differences as well. Kent took his musician's career further, having a brief fling performing with the Sex Pistols and even recording a single with a group called the Subterraneans, named after a Jack Kerouac novel.[8] On the whole, he "didn't just write about rock stars...he lived in their shadow," as the back cover of *Dark Stuff* states. Kent's reputation as a "legend" draws heavily on this image of somebody living through all the myths of rock 'n' roll, including 15 years of drug addiction (Jones 1997:6). The stories about him are legion and seldom as innocent as this impression:

> Towards the end of 1986, Nick was dining with his friends David Bowie and Iggy Pop in a little Chinese restaurant in Gerard Street, in Soho. Confronted with a

7 *Sniffin' Glue* 1, 1976.
8 Salewicz, Chris [1981]: "The Almost Legendary Nick Kent Story," *NME*, January 10:14.

triumvirate of pop icons, the confused, if star-struck waitress approached the man who most looked like a rock star for his autograph. Bowie and Iggy were shocked. Nick was flattered.[9]

Luckily, Kent's contribution does not stop at the adoption of a marketable image. His preferences, of course, seem fairly narrow. *Dark Stuff* exclusively deals with male artists, all white with the sole exception of Miles Davis. "Loud music made by self-destructive white boys was what I wanted to write about," Kent says. "The Stones, the Stooges, the New York Dolls. I wasn't interested in temperance, I was devoured by rock'n'roll. I wasn't interested in Lord Byron, as I was hanging out with the Byron of the Seventies, Keith Richards. I wanted to speak up for the counter-culture—this was life in the extreme" (quoted in Jones 1997:3). The mention of Lord Byron's name, which keeps popping up in the collection,[10] is hardly a coincidence. Kent does not share Murray's taste for roots authenticity; his standards are artier. What occupies him is, precisely, the romantic-bohemian myth of the artist as transgressor. Like Robert Christgau he thinks that rock music is made by people, but unlike the American, he is obsessed by its costs rather than by its blessings.

The twenty-something revised artist/group profiles collected in *Dark Stuff* mould themselves into as many tales of losers and survivors, heroes and villains. Kent's universe is less a political than a moral one. It brings to mind a melodramatic literary tradition, extending from works by authors such as Dickens and Balzac to Céline's *Journey to the End of Night,* sharing with this tradition a growing tendency to let evil get the upper hand of good.[11] Evil, to Kent, is above all heroin.[12] And the human menagerie of *Dark Stuff* conveys nasty im-

9 Jones (1997:9). Of course, having Iggy Pop write a foreword to *Dark Stuff* contributes to the author's credibility. Here Pop describes Kent as follows: "An unlikely, ungainly figure, well over six feet tall, unsteadily negotiating the sidewalks of London and LA like a great palsied mantis, dressed in the same tattered black-leather and velvet guitar-slinger garb regardless of season or the passing of time, hospital-thin, with a perpetually dripping bright red nose caused by an equally perpetual drug shortage, all brought to life by a wrist-weaving, head-flung-back Keith Richards effect, and an abiding interest in all dirt."

10 For instance, Shane McGowan is characterized as a mix of "the Byronic with the moronic" (214).

11 On melodrama, cf. Brooks (1976/1995). At times Céline also seems present at a stylistic level, for instance in the representation of one of Mick Jagger's idiolects (Kent 1994:145): "'Who's dead this week then?' he sneered finally. 'Roy Orbison? Hard to tell these days, innit! Pop stars! They're droppin' like flies! Droppin' all over the place, mate!'"

12 "I take a very moral stance against heroin in something close to the Biblical understanding of the word," says Kent in Salewicz (1981:14). "I just think that it's something completely *evil.*"

pressions of decay (Brian Wilson, Syd Barrett, Shane McGowan), callousness (Jagger and Richards, Guns N' Roses), meanness (Jerry Lee Lewis, Sid Vicious) and stupidity (the mindless drug romanticism of the Happy Mondays and Stone Roses), but it also includes tributes to those who made it through the night, like Iggy Pop, Neil Young and Miles Davis. In the end the moral of the tale boils down to the explicit demand that even though "the world is a strange and ruthless place" (153), rock stars should be able to take some responsibility for their actions. Some portraits, notably that of Jerry Lee, are memorable for vivid detail rather than for knocking over well-established images. Others plunge deeper. For instance, Kent succeeds in making the role of misogyny as a primary motivator of Iggy Pop quite comprehensible (if not excusable).

The impact of the book derives to a large extent from the fact that Kent is a gifted storyteller, who knows his New Journalism lesson by heart. The introductory 74-page-piece on Brian Wilson, the tour de force of the collection, is instructive in this respect. It is well researched and so smoothly edited that you have to consult the brief "Sources and Acknowledgements" section to find out that the most interesting and coherent comments Wilson makes on his music are actually borrowed from another interview, made by a French colleague of Kent's. It also moves forward scene by scene and introduces some heavily symbolic impressions of Wilson's home. Above all, the story makes conspicuous use of a third-person point of view. It opens in medias res, penetrating Paul McCartney's mind as he and his wife Linda are on their way to pay Wilson a friendly visit, but in the end of the scene the focus shifts on to their host. Petrified at the prospect of seeing the couple, Wilson is caught "praying with all his might that the tiny atoms of his body would somehow break down, so that he could simply evaporate into the smog-strained air surrounding him" (3).

Suggestive as it is, fictionalization unavoidably raises some epistemological or even moral problems, especially when it becomes a little too obvious. Take a piece admired by fellow critics,[13] Kent's settling of accounts with his one-time assailant Sid Vicious, which goes a long way to show that Sid was scum—a reckless, dirty-fighting, self-absorbed dimwit (and certainly a lousy musician as well, though the obituary fails to mention that part of his achievement). Again, a third-person point of view is resorted to as the opening scene explores the "bomb site" of Sid's twisted mind. The text then turns to melodrama in order to "explain" his disturbance as condemnation. Having suggested that the year of Sid's birth, 1958, was a bad omen, Kent introduces some conjectures on his child-

13 E.g., Jones (1997:11), who thinks it is "surely one of the greatest pieces ever written on punk."

hood and adolescence. "Our little prince," he concludes, "was given two [options in life]: he could stare at the wall, or he could throw himself against it. He chose the latter, time and again" (181). The end, Sid having OD'd on "the deadly powder," confirms the moral order of melodrama in a climactic mix of sensational detail with cynical reflection:

> A mere seven hours after expiring Nancy Spungen was already *smelling* of death. It takes up to forty-eight hours before the putrefying odour commences in the corpses of the old. At the age of twenty both had wasted themselves beyond belief. Let them rot. (187)

Kent becomes all the more convincing when he sticks to the first-person narrative as in "Twilight in Babylon: The Rolling Stones after the Sixties," a piece belonging in a subgenre that Heylin christens "On the road again." The author's commission by the Rolling Stones office to document the group's 1973 European tour here provides the starting point for some of the most penetrating observations on the art of survival in the collection. They even display a rare dash of dark humor, for instance when Richards is depicted looking out the window of his country house at some crows, mourning the disappearance of a drug stash of his: "The story clearly saddened him greatly, and I could see by the way he coldly eyed those crows he felt the ugly black birds might actually have masterminded the heist" (139).

However, *Dark Stuff,* being precisely that, is not the whole truth about Kent. An examination of his contributions to the *NME* allows a much more variegated picture to emerge. If it is true that Kent favored the interview, it is also true that he wrote in almost any other genre. The scope of subjects varies, too. There is more on black music than in the book; a few women artists pass by, and the white males extend from Captain Beefheart to the Bee Gees, from Sweet to Steely Dan. Above all, it becomes clear that Kent's taste is by no means restricted to the arty; like Murray, he is also attracted by good, solid fun. In an early article (*NME*, July 7, 1973) he goes so far as to appoint Slade "easily the most important British band of the 70's [...] far more so than all the Bowies, Bolans and Roxies." For, as he contends in another piece, "rock'n'roll, by its very nature, demands a genuine commitment to its two basic qualities—energy and raunch" (*NME*, June 16, 1973). These qualities missing, it does not matter if the act happens to be Pink Floyd, whose 1974 Wembley concert leaves Kent "infuriated." Addressing the band members ("O.K., boys, now this is really going to hurt"), he scolds Floyd for producing "a pallid excuse for creative music," dan-

gerously close to something one could expect to find in Orwell's 1984 (*NME*, November 23, 1974). But even more than boring old farts Kent dislikes posing. "Style is not an end in itself. Style is a means of purveying substance," he declares on the threshold of the Style Age (Salewicz 1981:37). This is why his attitude to punk, and the Sex Pistols in particular, wavers; it also explains why he welcomes the Clash, but condemns the Stranglers. It is characteristic of Kent's powerful position that poor Steve Harley, a born poser, asks the critic at the end of another interview not to put him down: "I just want to win. That's all" (*NME*, November 2, 1974). Finally, given Kent's bohemian fallacy, he takes amazingly good care arguing his case when he wants to make a point. Not seldom does he come up with a balanced judgment where one would have expected the hatchet—for instance when, quoting Jon Landau, he casts Elton John as "the best M.O.R. music around" (*NME*, October 30, 1976:31).

As Salewicz (1981:14) points out, in matters of style, Kent has earned a reputation for writing a florid, slightly circumstantial, often syntactically complex prose. In a recent interview Kent states that in fact he strived to distance himself from New Journalism and cultivate "an eccentric, English style of writing" (Sørensen 2003), which is an apt characterization. Like Murray's, his is a "heteroglot" style that plays with archaisms and unexpected juxtapositions. "Lo, the psychotic squirming sense of paranoid that oozeth forth from Harley at being reminded of this particular cri-de-coeur […]," it may say, or "Well fuck'em, say I" (*NME*, November 2, 1974; *NME*, May 15, 1982. There is something coquettish about a Kent text, the writer sideways glancing at himself in the act of penning it out, appearing as "Yours Truly" or even, once in a while, in the third person.[14] Kent is as much into the creation of a familiar atmosphere as Murray. "So long, arsehole" (*NME*, May 15, 1982) is his farewell to the master that taught him the trade, Lester Bangs. But his rhetoric may also strike a magisterial note, as witnessed by a review of Television's 1977 *Marquee Moon*, printed next to Murray's eulogy of Patti Smith in Heylin (1992:234–239). Its composition roughly follows the same pattern as Murray's piece: assessment, general arguments, musician credits, song-by-song commentary, repetition of assessment (though there's no attempt at an overarching interpretation here). Opening in an incantatory, alliterative, Bangsian word-salad style Kent casts the record as a "cocksure magical statement […] to cold cock all the crapola and all-purpose wheatchaff mix'n'match, to set the whole schmear straight." To the author the

14 See, for instance, Kent's account of the circumstances around Sid Vicious's assault on him, *NME*, March 19, 1977.

originality of this "24-carat inspired work of pure genius" compares to that of such "true-blue heavies" as Hendrix, Barrett and Dylan, because the album is as sophisticated as it is passionate, the band's vision being "centred within their music" and not in attitude and rhetoric. "Vision" is a keyword in the high art expressive æsthetic that guides the review, and as it turns out, the genius who possesses it is Tom Verlaine, while other members are given rather lame individual credits. The title track, "a typically surreal Verlaine ghost story," is the one that most enthuses the author, breeding a mixture of formal and impressionist analysis that describes how its "strident two-chord construction" evolves into "a breath-takingly beautiful" progression, "which acts as a motif/climax for the narrative, as the song ends with a majestic chord pattern."

Through his lifestyle as much as his writings, Nick Kent contributed perhaps more than any other critic to the propagation of vital rock myths. His strength as a writer lies mainly in narration, that is, in recording and making sense of artists' lives. As an arbiter of taste he has been rightly acknowledged for his independence. A prominent part of his achievement involves drawing attention to unrecognized or forgotten heroes such as his beloved Iggy Pop.

6.2. Punk: A Moment of Transition

As the 1970s rolled on, the critical platform laid by the founding fathers was increasingly put to the test by artists exploring pop artifice in different ways. In Britain this process starts with glam rock, reaches an uneasy equilibrium with punk, and culminates with the triumph of heterodoxy epitomized by New Pop. It brings about a temporary split of the fresh, transnational field of rock criticism as well as a restructuring of national field positions.

As pointed out earlier, the fact that rock is of American origin has produced a rather ambiguous attitude to "authenticity" in Britain. This was, on the whole, advantageous to punk, and so was the fact that counterculture never became such a big deal in Britain as it was in the U.S. Further, there are important national differences in the writing, mediation and consumption of rock criticism. We have seen that to Simon Frith, American rock writers tend to write, and be received as, American culture critics, while their British colleagues rather represent themselves as pop fans, belonging in a cult world. Also, readers are not only younger but more dependent on the specialist press in Britain. This means that (1) the British rock press becomes more susceptible to fads and therefore in greater need of teenage insiders, which increases the turnover of writers; (2) a subjective form of criticism is encouraged in Britain, that is, a journalism that spawns a stylish, cynic, witty prose and strong judgments, while in the U.S. the

tradition of serious journalism and "proper reportage" is stronger; and (3) star critics are produced but at the cost of little legitimacy outside the field and comparatively poor payment. In all, these differences make for turbulence on the British side and continuity on the American side.

Having originated in New York's art school–inspired underground in 1975, punk became the next big thing in Britain the following year and was then fed back again to the U.S. As Gendron (2002:227–247) has shown, on its emergence in the U.S. the music could draw on an already existing "counteraesthetic" discourse. This discourse was fabricated in the early 1970s by "dissident" rock critics writing for *Creem* (Bangs, Marsh) and the fanzine *Who Put the Bomp* (editor Greg Shaw). Bangs, Marsh and Shaw applied the label "punk" in a retro way to a garage strand found in 1960s rock, which was epitomized by a band like the Troggs and characterized by "assaultiveness, minimalism, rank amateurishness" (236). They regarded "punk" as a kind of (male white) *teen* music, which was identified as the essence of rock. Nevertheless, the music's cherished values also had a great deal in common with virtues traditionally celebrated by avant-garde circles, and as punk discourse reached New York, it was easily applied to contemporary acts appearing at more or less arty scenes, such as the Mercer Arts Center, CBGB, Max's Kansas City and the Mudd Club. On this journey "promotional leadership" passed over, first to Alan Betrock's fanzine *New York Rocker* and then to the *Village Voice* (292). Gendron goes into detail to show how "punk" with its pop overtones had to battle a number of classier labels such as "underground," "new wave" and "no wave." One of his points should be particularly stressed: that the New York avant-garde and the discourse on it were by and large apolitical in clear contradistinction to their British correspondents. Not until the media had assimilated New York punk into the British model of social and political controversy was punk brought to the attention of a wider U.S. audience.

Before punk, British subcultures were analyzed by the Birmingham Centre for Contemporary Cultural Studies as cultural formations through which young working-class males could negotiate conflicts between postwar modernization and their parental culture. But, as Dick Hebdige was the first to observe in his *Subculture: The Meaning of Style* (1979), punk, for all its class rhetoric, communicated a difference *dislocated* from the parents' culture. Insofar as it was informed partly by black ethnicity mediated by reggae and ska, and partly by art theory, punk difference recalled that of the mods. But in 1975, in an England struck by recession, Swinging London was far away. Instead punks picked up on the feelings of decline that were in the air and cast them in millenarian and Situationist discourse, invoking the Antichrist, anarchy, boredom and nihilism

(cf. Marcus 1989 and Savage 1991). Further, rock was no more an open territory in the mid-1970s. Punk's answer to the colonization of rock by the previous "dinosaur" generation of musicians and the music industry became conscious "unlearning": a return to pure rock 'n' roll and the propagation of a DIY aesthetic. Indeed, British punk rock may be seen as a crossroads, where a modernist aesthetic, intent on making it new, results in a postmodern celebration of rock's basic barbarism. Put differently, punk rock was an attempt "to keep in play [both] bohemian ideas of authenticity and Pop art ideals of artifice" (Frith and Horne 1987:124). The former strand, drawing on well-established conventions of rebelliousness, gave rise to a left-wing, realist/populist street politics; the latter, claiming that "the music was about itself now" (Frith 1981:162), questioned precisely that stance in favor of an avant-garde, experimental fifth column politics of deconstructing the pop process. This contradiction pervades punk criticism as well, until the second strategy finally comes out victorious— but that takes a few years. Before 1980 there is no resolution of the struggle between the old and the new.

Punk received extreme coverage in the British media. And in a way, "punk and the music press were made for each other," as Neil Spencer (1991:xi) put it. Banned from both venues and airplay, punk was dependent on print exposure, while its intricacies provided the music weeklies with a raison d'être, explaining them to a broader audience. Arguably, this exposure contributed to shorten its life. But it did make the punks visible, and in many ways attractive, to agents in other fields. The "realist" left won sympathy in Labour circles, not least through initiatives such as Rock Against Racism. And the avant-garde punks of Throbbing Gristle, Cabaret Voltaire and Gang of Four crossed over to youth occupied with similar aesthetic problems from the standpoint of high culture. Taken as a whole, punk's image of complex *and* heartfelt opposition most likely increased the legitimacy of the rock field in the eyes of observers situated in other cultural fields.

Among other things, punk meant a dramatic increase in the market for rock journalism, in the shape of fanzines as well as in the established press. This massive influx of a new breed of critics changed admission criteria and shook the founding fathers' authority. Things happened fast in Britain; in the U.S., the process was considerably slower. But the effects were similar. Robert Christgau:

> It seems to me that from '74 when I began to edit the [*Village Voice* music] section to some time in the early 80s we were the only game in town. I used *Rolling Stone* critics, I used *Creem* critics, I used people who came in off the streets. We were the kings.
> UL: What happened in the 80s then?

RC: What really happens is punk. And it takes time to develop…. But by the early eighties there's lots of alternative media springing up all over the place, and gradually dailies are catching on, this is something they *got* to cover. And while most of these people are no good, some of them are very good indeed or at least good company. […] Every college newspaper had its rock critic. […] There was a magazine called *Nadine* which you probably never heard of. *Nadine* produced Rob Sheffield who was the music critic for *Details* for a long time and is now a chief writer of *Rolling Stone*. It produced Joe Levy, who is now the music editor of *Rolling Stone*, it produced a whole bunch of black critics. […] A tremendous number of good critics came out of the *Boston Phoenix*. And the Los Angeles papers also produced their share, although fewer. Most of them ended up at the *Times*. (personal interview, May 22, 1998)

Young people with no more merits than some writing talent and subcultural credibility now were the ones who *knew*. Some of them were women. Among the British weeklies, *MM* used the resident female, Caroline Coon; *Sounds* recruited Jon Ingham as punk correspondent; and after advertising for "two hip young gunslingers" *NME* got hold of Julie Burchill, age 17, and Tony Parsons, 21, in the autumn of 1976 (Savage 1991:252).

Some recruits (Paul Morley is the best example) dabbled with new styles of writing and new theoretical impulses (Situationism, pop art, semiotics). Some also came to occupy leading positions towards the end of the decade. But even though punk journalism tended to push the *style* of its forerunners into mannerism and parody, it did not abandon their basic *standards*, contained in what we have referred to as authenticity discourses. That explains the schizophrenic impact of Burchill and Parsons's oedipal revolt, the book *The Boy Looked at Johnny* (1978), which we will briefly discuss. The challenge lay in understanding punk's undermining of the oppositions between "authentic" and "artificial," art and commerce, content and style. If established critics ran the risk of familiarizing and so reducing the complexity of the scene, identifying the CBGB underground as a return to the roots of rock, the Pistols as the new Stones, the Clash as dole-queue rock, Patti Smith and Elvis Costello as rock poets, the freshmen often seemed locked up in the very generation-bound fan perspective that was their admission ticket to the field.

On the whole, field positions do not change much until the punk explosion is over. As pointed out, the reconstruction of the field took even longer in the U.S. A look at Greil Marcus's 1979 anthology *Stranded: Rock and Roll for a Desert Island* (reissued in 1996) seems to confirm this picture. It contains but a handful of critics who are willing to question the field's doxa. Still, *Stranded* is evi-

dence of a breach in the positions taken by established U.S. critics at the end of the 1970s. It is less valuable from the point of view of canon formation, though Marcus's own contribution, the discography "Treasure Island," certainly is an attempt at recording the highlights of rock history. The reason is the vagueness inherent in the task. As Marcus points out in his preface (1996:xv), the fictive situation outlined in the subtitle meant you were not necessarily supposed to choose *great* music, neither subjectively nor objectively.

Of the contributors, five are women, none black, which Robert Christgau takes to mirror the state of things at the time fairly well in his foreword to the 1996 issue. A couple of essays deal with new wave acts (Christgau's on the New York Dolls, Tom Carson's on the Ramones), but most look back beyond the 1970s. It is hard not to regard this as telling, even though only Ed Ward (249–251) explicitly regrets what he registers as the rock scene's escalating self-consciousness and pretentiousness, for which criticism is held at least partly responsible.

However, some major contributors (Carson, Christgau, Simon Frith, Ellen Willis) clearly prefer "modernist" artifice, irony and self-consciousness to "romantic" authenticity (cf. Keightley 2002), and so cause a breach in the ranks. Among these Willis offers the most interesting reading. Her piece "Velvet Underground" focuses on the avant-garde tradition that connects the Velvet Underground with punk and new wave. Faced with the dissolution of the counter-cultural community as well as the nihilism of new wave Bohemia, the author speaks up for a kind of third path, represented by the Velvets. To Willis, the group were the first consciously small-scale producers of rock music ("anti-art art made by anti-elite elitists") and as such the forerunners of "alternative" music. But in contrast to contemporary rock musicians, who seem "not only to accept their minority status as given but even to revel in it"—"an enormous contradiction," Willis thinks, "for real rock'n'roll almost by definition aspires to convert the world" (Marcus 1979/1996:77, 74)—the Velvets' arty use of a mass cultural form rejects both nihilism and the easy optimism of the counterculture.

What Willis's essay captures is the shocking new insight that Gendron (2002:260) calls "the idea of a permanent underground." To Gendron, the most important achievement of "the new wave" is that it laid the foundation for "what would become institutionally and aesthetically a separate avant-garde sector within the pop music field itself," bringing about a split between critical and mass audience acclaim (324). Before punk

> it had been an almost universal assumption of rock criticism that whatever was
> well received by critics tended also to sell well, not because criticism determined

sales, but because critics, committed to the idea of rock as a democratic art, could not imagine liking a brand of rock that was not potentially liked by the general rock public. (277)

This is not to say there had not been conflict between small-scale and large-scale production before the advent of punk—or, for that matter, the Velvet Underground. On the contrary we have consistently argued that such tensions were part and parcel of the attempts to launch rock as both "serious" business *and* mass culture. Willis makes abundantly clear that the news was the *conscious* investment in exclusivity by American new wave artists. This seems largely to have been an American problem. Since the myth of rock as a democratic art was more settled here, the low sales of contemporary critics' favorites and their relegation to the category of "alternative" became hard to accept. In the British scene, recuperation difficulties are rather reflected in debates (originally initiated by glam rock) about which artists were "posers" and which were not.

However, the seeds sown by punk were not to mature until the early 1980s. In rock criticism, the punk era therefore appears as a period of transition.

Coda: The Boy Looked at Johnny

Jon Savage (1991:331) has observed that "[t]he music press hires young writers because of their exploitable enthusiasm but [...] places intense pressure on those writers to make their names [by] finding new groups to praise, or ripping apart selected targets." The *NME* "gunslingers" Burchill and Parsons were to favor the latter of these strategies. Burchill was to make a career out of stylish, anti-intellectual bitchiness, extending via 1980s fashion magazines like *The Face* and *Arena* to the Tory quality press and her own *Modern Review,* linking punk's DIY aesthetics to Thatcherite enterprising.[15] In 1978 the couple jointly published a conscious provocation directed at legitimate taste, a short cult book called *The Boy Looked at Johnny: The Obituary of Rock and Roll.*[16] Entering journalism "from school and night-shift," as the back cover has it, the authors cockily introduce themselves as "the only unbiased rock writers in the world," and hence called upon to tell the truth. In practice, *Johnny* is an "alternative" master narration,

15 As pointed out by Kallioniemi (1998:284).
16 The main title is a quotation from Patti Smith's "Horses"—"The boy looked at Johnny/Johnny wanted to run/But the movie kept running as planned"—reprinted in one of the introductory pages. Later writings include Burchill's *Love It or Shove It* (1985), *Damaged Gods: Cults and Heroes Reappraised* (1987) and Parsons's *Dispatches from the Front Line of Popular Culture* (1995).

containing a negligible amount of musical analysis compensated for by the usual bit of juicy anecdote and a whole lot of scathing, vitriolic abuse, rumored to have provided the authors with life-threats. A sample:

> In fact, the only saving grace of a Ramones gig was that if you popped out for a quick puke at the mezzanine celebration of a nation which invented the bomb to wipe out human life while leaving real estate intact, such was the austerity of the show that you stood a fair chance of missing it altogether! (65)

The prevailing figure of the book is that of a fall, which by 1978 seems definite—rock is "dead." As the 1960s were "a decade of iron-lung dinosaurs washing their hands [sic] of the blood of teen idealism" (17), so "the life-blood of punk was finally contaminated into an industry by slumming, exploiting middle-class leeches" (78). Under these circumstances, it is certainly better to burn than to fade away in the ranks of the enemy: the music industry, the philistine critics, the fame-and-fortune-hunting posers, the conservative public opinion. This point is made with a considerable amount of cynicism by the very first line of the book: "Bob Dylan broke his neck—close, but no cigar" (17). Small wonder the pantheon of Burchill and Parsons is sparsely populated: only the 1950s innovators (e.g., Chuck Berry), the young dead of the 1960s, Roxy Music's first two albums, Jonathan Richman's, Blondie's and Patti Smith's record debuts, Suzie Quatro, Poly Styrene, Joan Jett, Tom Robinson, the Sex Pistols and speed (amphetamine) make the grade. The Pistols, and especially Johnny Rotten, stands out as the true heroes of the story, credited with the remarkable achievement of having single-handedly instigated the punk movement (78). Rotten's abject looks and reckless attitude, the ban on some of his lyrics and the assaults on his person all work to confirm the notion of an authentic youth rebel. Indeed, most of the book's standards boil down to a couple of familiar tenets: (1) truth rests with the lowly—working-class youth, blacks, women (the book is an impressively early instance of militant feminism in British rock journalism); and (2) rock should be on their side, that is, politically subversive. In national terms this means that whereas the British new wave stands for "underprivilege and class discrimination," American groups are into "selfish fantasies of individual reality" (59).

Thus, in a way, *Johnny* illustrates the continuity pointed out earlier. It is still "authenticity" that counts, even down to a point where it becomes a caricature. Yet the book's fervent anticommercial, anti-American, anti–middle class, antimacho, antiracist and anti-hippie diatribes leave the reader divided. Is it deeply felt youthful disillusionment or a big con?

The source of this uncertainty is that the *style* of the book successfully communicates the very artifice inherent in punk that it explicitly brands as "posing." Any literal reading is contradicted by the book's artful tabloid prose. Hardboiled, mannered and relentless, it excels in the carnival of words, adding to the witticisms of forerunners like Charles Shaar Murray a nasty, ironic slant. Burchill and Parsons's favorite mannerism is an almost compulsive rhyming, which invests any statement with a devastating finality. For instance, "The Americans think it is punky to be a junkie" (59), Pistols guitarist Steve Jones advances from "fatzero to axe-hero" (31), and Malcolm McLaren's first meeting with Johnny Rotten is visualized as "Mal licked lascivious lips when he clocked the likely lad" (32).

Now, in the case of punk it seems possible to talk of "carnivalism" in terms of a tradition and not in a merely metaphorical way. To begin with, excessive abuse is an essential ingredient of carnivalism as well as of punk. And in both cases it's ambiguous: just as punk "gobbing" redefined spitting as an act of affection, abuse turns into praise in the tradition of grotesque realism examined by Bakhtin. Further, Mikita Hoy (1992:774) has observed that the form of carnivalesque degradation described by Bakhtin as "the human body series" was also celebrated by punks: "vomiting (the food series), wearing dust-bin liners held together with safety-pins (the human clothing series), 'getting pissed' to 'destroy' (the drink and drunkenness series), fucking forever (sexual series), sporting 'Sid Lives' T-shirts (death series)." Also, the punk, like the medieval fool, is granted the right *not* to understand but stay "vacant"; act life as a comedy, rip off masks and rage at others (772). The Sex Pistols mocked, parodied, turned upside down anything sacred—the queen, the political system, the multinational corporations, the Holocaust, the rock canon, the hippie worship of the head. Finally, the borders between artists and their audience were often blurred in a carnivalesque way at punk concerts, making all those present contributors.

There are, of course, a number of problems connected with the application of the carnival concept to modern popular culture. Crucial among these is the difference in worldviews. To Bakhtin, grotesque realism involves a popular perspective on the world, which conceives of all things as parts of one giant, metamorphosing body, hybrid and outgrowing all limits. From this angle degradation means insisting on the physical and obscene aspects of any object, thereby bringing it down to an earth that is always busy with procreation. It is because the old world constantly gives birth to a new one that carnivalesque abuse is ambiguous and its laughter good-humoured. In Bakhtin's view, modern abusive language tends towards pure negation, irony and sarcasm, since bodies have gradually become individualized after carnival was stigmatized and lost its pro-

creative moment (Bakhtin 1968, chap. 1). This dilution of popular culture from early modernity and on is compatible with the civilizing processes described by Elias and Foucault. However, Bakhtin commentators like Stallybrass and White (1986) have argued that a great many carnival practices never were wiped out but rather displaced on to other, symbolic domains—including but not limiting itself to modern popular culture. The routes of these displacements are in need of more thorough investigation, but it seems untenable to deny that carnival was brought to bear on punk to a large extent via high culture: the avant-garde legacy of Situationism, dada and Romantic Bohemia.[17]

The point of this digression is that *Johnny* may be read, not only against a background of journalistic carnivalism, but more specifically as an attempt at translating the carnivalesque ethos of punk into prose. In part it is the language, which mirrors the joy of iconoclastic impulse, finding an outlet in verbal abuse; but it is also the universe it depicts, which appears as a *negation* of the ever dying-begetting world of grotesque realism. Thus modern society stands trial for having stymied the generational shift, leaving the young weighed down by the old that refuse to die:

> Flower-power music papers like *Sounds*; hairdressers like *Schumi*; old actresses like Jenny Runacre; old hacks like Lester Bangs; old groupies like Marianne Faithfull; old fashion magazines like *Ritz*; old DJs like John Peel; old film directors like Derek Jarman; old haberdashers like Malcolm McLaren [...] all would have done well to heed the advice [...]: "SIT DOWN, MAN, YOU'RE A BLOODY TRAGEDY." (Burchill and Parsons 1978:93–94)

17 Marcus (1989) points the way, though not explicitly discussing carnival, while Docker (1994) is an example of the purist ambition to celebrate diverse forms of mass culture as postmodern "carnivalism" while exempting the avant-garde legacy altogether.

Chapter 7

Style It Takes
Criticism and New Pop
(1978–1985)

7.1. The Social and Cultural Background of Late 20th Century Rock Criticism

Individualization, Reflexivity, Makability

During the 1970s the economic, social, and cultural life in Western countries was characterized by crises, which, however, did not shake their foundations. In the 1980s increasing economic and social inequality was coupled with the marginalization of conflicts on all levels. The 1990s took off as a decade of globalization, but little by little attention turned towards social solidarity. As a long-term social change cutting through these trends a radical reconstruction of working life, class structure, gender, and ethnic relations, as well as the life course of individuals, gradually became visible.

The 1970s shattered the social democratic and social liberal visions of the 1960s as economic growth became destabilized and the state expenditure in Western countries grew beyond all predictions. Consequently, the egalitarianism of the 1960s appeared as problematic and an obstacle to economic growth. The radical visions of the 1960s suffered an even deeper crisis as 'liberation' turned into dead end streets like drug abuse or dull commune life and when the economic crisis of the 1970s did not radicalize the working class. The only grand visions that survived the disillusionment of the 1970s were those of a revived liberalism, linking individual rights and freedom to a market liberalization directed against the evil forces of state control and socialism. The Thatcher regime in the UK and the Reagan administration in the U.S. fronted this liberal revolution, but market liberalization became a global mantra. There were radical versions not only in the UK and the U.S. but also, for instance, in New Zealand and more moderate versions in the Nordic countries and on most of the European continent. In South East Asia market liberalization took place within politically authoritarian systems, while in Eastern Europe it rose off the ruins of Soviet totalitarianism. When the dust of the revolution settled in the 1990s, its

protagonists boasted of a revitalized capitalist economy and the fall of the Soviet system, but more and more criticism was leveled against the increasing inequalities and the emergence of new forms of poverty within prosperity as well as the alarming growth of unequal distribution between the North and the South.

Underneath the neo-liberal revolution a radical restructuring of the economy and working life was taking place. Concentration of capital accelerated with transnational corporations becoming stronger than ever. At the same time people in the middle strata of technical intelligence, commerce, communication and care had grown fast as a consequence of economic and educational development since the 1960s. Some of these became employees of transnational corporations or their allies in demanding privatization of state activities, while others defended their status as public officials. These conflicts within the middle strata overshadowed great social transformations, not least the transformation of the living conditions of the working class and of the pathways from childhood to adulthood.

In most Western countries industrialization had reached its peak in the 1950s in terms of proportion of employment. For the following decades, a balance in expansion and a growing productivity in industry meant occupational stability, while new employment was to be found in private and public service. Since the 1970s, this trend has intensified, so that the traditional industries have offered few new jobs whereas there has been tremendous growth within commerce and service sectors, and in a few new branches of industry such as information technology and telecommunications. The social class of industrial workers is still big, but not growing, and it is increasingly split between those who have a secure position on the labor market—through their qualifications rather than through strong unions—and the growing segment of people who do not.

Transition to adulthood has changed no less dramatically for children of the working class. Firstly, the youth labor market has collapsed. Young people could go directly from compulsory education, at the age of 15 or 16, and into working life, where they could develop a relatively stable position without further formal education. Since the 1980s this has been impossible in most Western countries, most clearly in the UK, where this pathway used to be more common. Secondly, this means that young people are pressed to stay in education until the age of 20 without the educational system being able to change into mass education. Thirdly, the educational system has expanded first and foremost by providing general academic education for still more students and finding new paths of further education at an intermediary level between traditional, vocational training and university education. Fourthly, within industry several flexible paths of training and competence have emerged, most systematically in

countries with strong traditions of co-operation within working life. Fifthly, a new labor market for young people has emerged, dominated by part-time jobs, short contracts, and other flexible forms of employment. Other landmarks concerning the transition to adulthood, such as the age of marriage and childbearing, have become more differentiated. The demarcation lines between young people in transition, singles, and divorcees are unclear, and this also affects the lifestyles of married couples. These tendencies, which not only indicate a change in the transition to adulthood but also a general destabilization of the life trajectory, make the youth phase less distinct than before.

The detraditionalization and detachment from self-evident social bonds, described in chapter three as cultural release, has continued and circumscribes not only the life conditions of young people but the population as a whole. This has resulted in fundamental changes in orientation and personality development, conceptualized by theoreticians like Thomas Ziehe, Ulrich Beck and Anthony Giddens in terms of individualization, reflexivity and makability. As Ulrich Beck has pointed out, *individualization* not only means that identity is increasingly experienced as individual uniqueness, instead of being related to origins of place, class, profession, family etc. It also implies that the "individual himself or herself becomes the reproduction unit of the social in the lifeworld" (Beck 1986/1992:90) and what is 'social' is defined through decisions by individuals who are more deeply socialized than the generations preceding them.

Reflexivity means that individual action can no longer be self-evident but involves constant self-confrontation. While British scholars like Giddens and Lash often tend to equate this with reflection, German scholars like Ziehe and Beck stress that reflexivity can take many other forms and become a more or less unconscious part of the habitus. While British scholars discuss reflexivity as individual competence, Beck, especially, emphasizes that the demand for reflexivity has become a collective issue in the age of a risk society, where collectives are confronted with the destructive tendencies of modernization. Bjerrum Nielsen & Rudberg (1994) have pointed out that individualization is a new and more general phase in personality development, which at the onset of modernity was limited to upper class men, but has spread to most segments of society and thereby acquired a new meaning. On the other hand, they argue, reflexivity is a traditional female quality that has now crossed the gender borders as a demand. They also point out that reflexivity and individualization come together in the third cultural tendency identified by Thomas Ziehe (1989): *makability*, understood as the growing expectation that each individual can form his or her own life as a flexible project.

The social and cultural tendencies described above have been expressed in different ways in intellectual discourse, and the 1980s gave birth to the declaration of post-modernity as a new era. The ongoing erosion of traditions and of self-evident collectives, the seeming death of grand theories, ideals and evolutionism, the reshuffling of cultural hierarchies, the increasing role of media representations in everyday life, etc., could be fit nicely together in postmodernism as "the grand tale to end all grand tales." But like its predecessors, this new tale has come to ignore the complexity of cultural change. For instance, as indicated in chapter three, reshuffling cultural hierarchies does not equal an abolition of hierarchies. The idea of a break from "modernity" to "postmodernity" echoes earlier notions of a break from "traditional society" to "modern society"—in both cases with too much emphasis on the break.

Rock criticism of the late 1960s and the 1970s reflected not least that large segments of the lower classes were entering new middle strata, forming new lifestyles and cultural expressions. This development continued in the 1980s, especially with more female participation in education and in middle strata occupations, and with growing attention given to non-whites. The working class heritage of white upwardly mobile boys that was so central to many subcultures, rock styles, and rock critics means something quite different today, and it is not thematized as clearly as it was earlier. In the 1960s and 1970s it meant negotiation of social and cultural class antagonisms within a new personal situation shared by large groups; in the 1980s it consisted of hedonistic consumerism—being able to afford style. The yuppies worked hard, consumed fast and flaunted an exaggerated style, like a Mod who had traveled further up the social ladder and cut the last cords of collective solidarity. Generally, this negotiation has become less contentious since working-class consumer culture is not so alien to the middle class as it used to be and new generations are less antagonistic to middle-class values than they were before.

By the 1980s, the consumption of mass culture had become a perfectly legitimate part of the lifestyle of large middle-class strata, which were generally at the profiting end of the growing inequalities in life standards and opportunities. For a while, the losers in the new polarization were split by gender, ethnicity and class, as expressed in segmented forms of mass culture, such as heavy metal, rap, and various forms of light pop. Within the field of popular music, some agents pursued the old strategy of strengthening their autonomy through alliances with such underprivileged groups, while most explored the new life possibilities through trying on new poses, being ironic, ontologizing, etc. (i.e., ascribing deep essential meaning to symbols and practices that appear tempo-

rary and artificial to most people (Ziehe 1989)). In terms of class politics the field was not polarized but diversified.

The music industry has gathered much experience after it was taken by surprise in the 1960s. 1980s marketing strategies became far more developed and based on an improved sensitivity towards the market. Independent entrepreneurs and small collectives were allowed to look after musical experiments, and in the rare cases when these became profitable, companies with advanced distribution systems were ready to buy in. On the threshold of the 1990s, the industry no longer had to rely on the music press as had often been the case in the late 1960s and 1970s: there were other ways. Rock musicians and entrepreneurs became far more reflexive as well and have increasingly been able to mediate their image without the help of independent writers. Greater coverage of popular music in all kinds of mass media, radio, newspapers and television meant a widening of the discourse but a relative weakening of its autonomy. Rock critics, once at the forefront of the growing strata of "new intellectuals," were being reduced to a less significant intellectual segment of the larger strata of new middle class in the course of the 1980s. These changes meant that new strategies had to be invented for rock criticism to survive.

Beyond Punk

Within punk several sets of values competed and mixed. For a while old rock orthodoxies were celebrated while old rock groups were rejected, avant-garde musical sounds and planning procedures (mainly chance) were incorporated into the music together with reggae and dub, and "subversive" avant-garde strategies were used to market punk as pop. But by the early 1980s, the "subversive" pop trend came out victorious in England, and it was to remap the field, leaving old notions of authenticity behind and redistributing the pop-rock markers. This shift in values may be described as *the* major turning point in the development of the field of rock criticism, resulting in a heightened reflexivity on the part of the critics and an even more intensive celebration of the consumer on the part of most magazines through the following decades.

Most important in the long run were a few new English magazines. New Pop was not only a new style of music that you could buy, it also offered a whole new way to 'live': a new range of objects to buy and new ways to behave in public. These new ways were explained to prospective consumers by the new lifestyle magazines appearing around 1980, *The Face* being the one to relate music and other style objects most successfully. *The Face*'s then unique mix of editorial copy, pictures and adverts that had to be studied in detail to find out which was

which, was to have a decisive influence on the magazine industry in general. Today, the large music magazines carry adverts for a wide range of products either connected to youth (especially clothing) or to grown-up men (cars, beer, liquor), often taking up more than half the magazine's pages. You have to look hard for editorial copy, posited as you are first and foremost as a consumer looking for a certain style to fit your "personal" subjectivity.

Pop became interesting to the critics because it was conceived of as balancing on the sharp edge between eroticism and commodification. The erotic aspect contained references to the body, to desire, to problems of gender, to being-looked-at, to excitement in every sense, while the commodity aspect represented capitalist calculation and power in its most unadorned form. In between these was fame, glitter, spotlights—in short, the star. The investigation of the machinations of pop in this sense became crucial for the critics. The intention was to focus on the erotic aspects and let them erode the capitalistic aspects. Inspiration was taken from avant-garde art, and after a rather crude beginning, interpretation of avant-garde strategies became more refined as postmodern theory filtered into pop criticism. As this tendency became settled after the mid-80s, new positions with links to the academy emerged at the autonomous pole of the field. The result was that the field became polarized. Most magazines and their rather anonymous writers further explored the commercial pole while a few individuals explored the autonomous pole, expecting the readers to be quite well-read.

The positive values ascribed to some pop (real girlie pop stuff like Duran Duran and Wham! was still out) were closely connected to gender benders like Boy George, Marc Almond of Soft Cell, and Frankie Goes to Hollywood. Of course, the girls liked these too, but the thing was that a more reflexive reading applied to such stars made sense to adults. The stars' "subversiveness" could be explained in terms and *bon mots* borrowed from several avant-garde traditions. However, the lasting effect of this inspiration was not a subversion of the media but the acceptance that both pop and rock were actually part of commodity culture and that applying one genre label or other was not a main criterion for judging between good and bad music.

The critics' admiration for pop stars from Boy George and Madonna to the latest R&B singers can best be expressed as "admiration" and maybe the best term for the music is "pop" (also within quotation marks). There was a need for distance which called for an increased self-reflexiveness. Not only is it necessary for critics to judge the music, but they also have to position themselves in relation to it. The suspicion that this is only pop, not "pop," is always present. Furthermore, what role are the critics called upon to play—the fan's, the publicist's,

the neutral consumer guide's, or the culture critic's? It was impossible to know what was really real and what was mere posing, with regard to both musicians and critics. But the question lingered on, often in the guise of a notion of meta-authenticity beyond authenticity and linked to habits of consumption rather than qualities specific to the music—to questions regarding the consuming subject rather than the musical object.

Distance is closely connected to irony. As the subject took on the appearance of a construction, value ascriptions in a traditional sense became irrelevant—at least in the mainstream. Because of the continuous distance between subject and object, any emotional relation was irrelevant. But it could very well be mimed, and camp irony was a good instrument for that. The camp objects originally represented an investment of deep affection, and this affection could be performed as a small ironic play. Temporarily, anything could be accredited with value as it did not matter in the end.[1] The reemergence of 1960s easy listening and the 1990s continuations of it is one indicator of this postmodern pop sensibility whose breakthrough was facilitated by the sampling technique and the continued access to old recordings. It became possible to compose (or rather, edit), playing directly on the listeners' associations to the older musics.

Whereas New Pop had stressed the commercial pole, alternative rock, indie, rap, and techno were conceived of as underground in the latter part of the 1980s, until questions like "alternative to what?" and "what's above the underground, then?" arose. The stance against the mainstream was evident, but with few exceptions the music could only muster negation, not any real aesthetic, social, or political alternatives. In America the new genres opened up for alliances with critics other than white males as women and African Americans taking up critics' pens were becoming less unusual. (Nowadays it is hard to find a national magazine where they are not represented. Especially the rise of rap magazines has made this possible.)

The last 25 years have witnessed a steady growth in the international magazine market, and this goes for music magazines as well. Their circulation has risen and the number of magazines exploded. The market has become more finely segmented, with each magazine seeking out its own small niche, resulting

1 Lawrence Grossberg mentions four such strategies of temporary affective investments based on remnants from the authenticity paradigm: ironic (lack of distinction between investments), sentimental (short, but intense investments), hyperreal (refusal of affective investments), and grotesque (investment in the negative) inauthenticity (1992:224–34). We have commented on this in chapter two, note 22.

in an almost confusing diversification. *Smash Hits* and *The Face* had defined new positions within the field; so did *Spin* and *Q* in the late 1980s and *Mojo* and *Uncut* in the 1990s. Within six to seven years after *Q*'s appearance every main genre and every age group had its own music magazine. In America, *Rolling Stone* stood alone until the mid-80s, but the competition was not a very serious threat as there was space enough for everybody.

Also, rock criticism became normal subject matter in other places than music magazines, and nowadays both men's and women's magazines regularly print articles on rock. In this way, rock has entered into the area of general interest. More importantly, the quality dailies have recruited former music press writers as rock critics in residence. Their pieces are printed in the culture pages and in the Sunday supplements among the art, classical music, and book reviews, indicating rock's acceptance within the general cultural field.

With the positions established by the early 1990s the field of rock criticism seems to have become relatively stable. New agents have come and gone but no new distinct positions have appeared.

7.2. Into the Pop Process

"Style" was the cry of the early 1980s. But what did it mean? The homological analyses produced by the British Birmingham school during the 1970s made countercultural and subcultural styles appear as externalizations of shared values, opposing those of an alleged mainstream. The signs were taken to point in one and the same direction: there was a core. However, the successive aestheticization of everyday life has done its best to undermine such assumptions. By 1980 the mainstream–subculture opposition already felt dated. The lesson of glam had been that everybody could be Somebody, if not a star, by dressing up, and Bowie's children, the New Romantics and their fans, took it literally. This meant two things in particular. First, that identity was individual and makable. Second, that there need not be any specific expressive relationship between sign and referent, between the surface and the subject's inner world. Liberated from the tyranny of content, style became an intertextual play, whereby the postmodern subject *constructed* itself as such. Music lost its privileged place in youth culture; it was reduced to part of various assemblages of signs, and sold as lifestyle to a fleeting plurality of taste publics.

The drastic boldness and the brashness of Thatcherism's "live and let live" ideology put its mark on popular music as well. The entrepreneurism of the pop world was as if made to measure, and pop music came to celebrate conservative values, flaunting consumerism and blurring the boundaries between

pop and rock. For many, rock became not only pop, but New Pop, a celebration of image, surface, and new electronically created sounds coupled with musical quotations or samples from exotic cultures. As usual, the focus was on the young white middle class, but this time more on their conspicuous consumption and rampant egotism than on their thoughts and beliefs. Looking back in 1985, critic Jon Savage in the article "The Toytown Nihilists" christened the first half of the decade "The Age of Style over Content," an interpretation that has stuck ever since (*The Face*, December 1985:90). Among other things he criticized the media and their adoration of the celebrity for just being a negation of "unemployment's anonymity," connecting the worship of celebrities with the New Right:

> [...] celebrity is an ideological fool's gold, marking the successful colonization by the New Right of so many intimate areas of thought and motivations. As the parallel moral panic over AIDS attests, the New Right works through fear, envy, frustration and blind alleys of belief; many similar impulses lie behind our current celebrity culture. ("The Sour Smell of Celebrity," *The Face*, December 1985:121)

The diagnosis style over content also led Savage to discuss the difference between nihilism and negation. He saw the original punk negation as liberating because the no implied alternatives, just like the focus on style at the beginning of the 1980s. But by 1985 style had become empty and nihilistic, the no just meaning "I don't care." To Savage, an important reason for the vacuity of the style generation was the extreme expansion of electronic and printed media in the early 1980s, smearing celebrities over front pages and television screens without worrying what style meant. "The 'real' sickness of our age," he concluded, "is a disease of perception, which concentrates on endless consumption, personal vampirism and a debilitating lack of content" ("The Toytown Nihilists," *The Face*, December 1985:90).

Media politics and the accompanying notions of pop's and rock's inherent criticism of the political system was a central element to both punk and postpunk critical discourse. As already suggested, two strands of punk existed: a populist one, connected with the politics of the street and expressing itself in the traditional political discourse of criticism of all things establishment; and a highbrow, connected with the politics of avant-garde art and using theories of destabilization. Dave Laing distinguishes between those musicians who carried on with the substance of punk, i.e. tried to sound like the early punk bands, and those who carried on the spirit, i.e. tried to undermine the norms of rock music and the industry. He continues:

Substance versus Spirit corresponded to the tension between realist and avant-garde stances. [...] From 1978, musicians coming from a punk background went either the realist/populist or the avant-garde/experimental route. And the collapse of the old punk unity was increasingly underlined by a New Pop music which proceeded from the premise that punk no longer mattered, or that pop exponents could thankfully ignore punk (1985:108–109).

The music press followed all three routes closely: the realist and avant-garde ones mainly up until the first years of the 1980s, the New Pop route particularly after 1980, culminating with the Frankie Goes to Hollywood frenzy of 1984. To begin with, critics and musicians placed the music industry and the media as central adversaries in a cultural struggle. Many critics took upon themselves a role similar to McLaren's self-understanding as an industry insider who subverts the industry norms and expectations. After all, as critics they were employed by magazines owned by large publishing houses. The discussion of this double position sometimes became plain silly as when critic Paul Morley and Mick Jagger bickered about who had sold out the most, *NME* or the Rolling Stones ("Not Fade away (And Radiate)," *NME*, June 28, 1980:31–34). Pop musicians (and writers) with less intellectual aspirations took up the style but ditched the theories.

After the gradual demise of British punk during 1978, a whole lot of new bands (whether post-punk, New Wave, New Pop, or New Romantics) were ready to take over. At the same time the large group of journalists hired when punk began to happen in late 1976, continued to write for a broadened market. Hardly any new critics were allowed to enter the field on the cusp of New Pop. Just as the class of '76 had helped to form the discourse on punk, they were ready to assist at creating a new discourse for the new music, and just like the musicians, they took off from certain areas of the existing punk discourse. They had marveled at McLaren's scams, and the question of how to advance them became pertinent. Burchill & Parsons chose the realist way out: bile. To most other critics around 1980 the answer lay in the style, understood as both looks and as writing style.

A few new magazines that were soon christened "style bibles" went for the look. They were the products of young designers educated at art schools, and nothing—not even words and texts—could stop them from implementing their design manuals. The results were impressive from a visual point of view. The glittery surfaces and the fashion pictures projected the message that being in style—dressing the right way and talking about the right topics—was what counted. These magazines were to influence all later music magazine production and to place rock discourse within a postmodern paradigm.

As mentioned, punk carried both artificial and authentic aspects, but it was the strategy of artifice married to mainstream pop that won the day. Critics, too, jumped on the bandwagon and covered the New Pop musicians, either by miming the gossip and true stories of the 1950s or by trying to develop an appropriate new style of writing. Nearly every British journalist played along, making posing the point of the articles. The excitement of the new was in the air. The markers of the high/low split within popular music were redistributed as the top of the charts became legitimate subject matter for the inkies. Pop, for a while, seemed more important than "underground" or "alternative" rock, and a broad selection of magazine buyers accentuated this notion by making the teen mag *Smash Hits* the best-selling English music magazine ever.

Normally, the artifice of New Pop is seen as the direct opposite of notions of authenticity a decade earlier. But to the critics there was more to it than just jumping into the maelstrom of the pop process. To them, punk had undermined the dichotomy between authenticity and artificiality, but both notions lingered on, intertwined as they have always been in British pop. Artificiality was at the center, but only because the conceptions of rock authenticity had clearly become obsolete. This allowed for a subjectivist position where the personal experience of transcending everyday life through the force of music became regarded as a series of transitory moments of "real", "authentic" subjectivity. The difference was— compared to earlier notions of authenticity—that it was not any longer connected to the same musical conventions and the same collective experience.

In order to make sense of what was happening, the critics tried to develop new ways of writing, inspired by avant-garde techniques, which included oblique references to poststructuralist theory. Behind these efforts still lay an attempt to disclose authentic modes of being. But instead of finding them in "serious" rock they tried to define them in playful pop by attributing to pop a critical-emancipatory function within a reality created and determined by the mass media. In this way, it was possible to differentiate the authenticity-artifice dichotomy and explain the artificiality paradigm as an attempt to define a postmodern subject different from the classical bourgeois subject—a fleeting subjectivity that can be realized in free play, i.e., by changing roles, costumes, ideas, perspectives, etc. Ultimately, the project failed as some critics got trapped in the pop process and produced nothing but style without content while others dropped the whole project of seeing pop as a way forward. The last category survived within the field and went to work for magazines like *Q*.

Nevertheless, the attempt had great repercussions as the criticism that dealt with New Pop turned the field's basic values upside down and created several

new positions within it. First, the style bibles were to have a decisive influence on design, and it has been accepted ever since that rock is a commodity and that music and visual styles are integral. Furthermore, their notions of style were to influence 1990s consumer culture at an international level as can be seen in the present obsession with brand names and the general focus on physical health and lifestyle. Second, "the age of style" paved the way for a greater acceptance of pop and the charts. American *Spin*'s first cover featured Madonna, and she could be found once again at the beginning of the 1990s on a *Q* cover at the same time as Michael Jackson graced *The Wire*'s cover. All this was less because the journalists admired the music and more because they admired the ability of such stars to control the media beast and avoid being eaten up like Frankie Goes to Hollywood. Third, New Pop criticism opened up a critic's position that was theoretically well-informed and sometimes verged on general cultural criticism. This reinforcement of the autonomous part of the field was supported by the quality dailies, which began to hire full time rock critics at the beginning of the 1980s and have not only kept them, but even allowed them more space.

As suggested above, New Pop critics took their inspiration from the avant-garde. David Bowie had already drawn on that source for years when Malcolm McLaren picked it up and used it in a more radical way, and the writers took it from there.[2] Most of the writing styles stem from the historical avant-garde (cut-up, collage, stream-of-consciousness), and some of the chaotic interview situations are reminiscent of happenings (literally: anything might happen). The journalists' often provocative stance and their rather vague political agenda draw on the shock aesthetics of Dada and Situationism, and the small talk interviews could be from Andy Warhol's diaries or early *Interview* interviews. Basic journalist virtues like objective reporting and passing along information were played down and relieved the critic of adopting the classic fan stance. A few critics took to semiotic lingo and interspersed their textual experiments with sheer nonsense—underlining the cut-up character by using different discourses in the same text. The "I" of the journalist became central to the interviews, often at the expense of the "you," the pop star. In a few instances the star quality was even transferred to the journalist as he was the one to curb the stars in arguments and make them look ridiculous. In short, reporting became wildly subjective, sometimes just a narcissistic trip.

2 At this time, to *NME* Bowie was the elder statesman of pop. See for example the monumental seven-page interview by Angus McKinnon ("The Future Isn't What It Used to Be," *NME*, September 13, 1980).

7.3. The Standards of Postmodern Pop Sensibility
Boredom and Transcendence

For the English pop state of mind it is imperative not to be boring nor to become bored. From ecstatic girls, Cliff Richard, and Nik Cohn onwards this has been crucial for the audience, the musicians, and for the critics. While the audience was freed from problems of having fun, the critics, upon whom the burden of naming and describing fun and excitement lay, have used many different literary and philosophical strategies to discuss and solve this problem. To the sociologist, fun is a duality:

> The commercial music world is [...] organized around particular sorts of musical events—events (such as promotional concerts and discos) which offer a kind of routinized transcendence, which sell "fun." Fun is an escape from the daily grind (which is what makes it pleasurable) but is, on the other hand, integrated with its rhythms—the rhythms of work and play, production and consumption. (Frith 1996:41–42)

Rock critics have mainly been interested in the routinized transcendence, part of the job being to de-routinize it, to escape boredom. Boredom is avoided by constant change, first and foremost by the performers and their music, but the audience too must change dress style, find new clubs, etc. What is new is good as long as it is at the same time exciting in some way. To Nik Cohn (1969/1996), for example, the rush and excitement of the metropolis as mirrored in the music was *the* pop experience. On the other hand, he also points towards more permanent, if confusing, conditions without direction: chaos, anarchy, drowning. In fact two slightly different criteria for good music are active in Cohn's writing. One is the rush of continuing novelty, the other is energetic stasis.

These two qualities have been fundamental to rock criticism ever since, implicitly or explicitly. Whereas the aspects of constant change are fairly obvious, the condition without direction—the transcendent moment—is more complex. In some ways the moments are the opposite of change because they freeze time and thereby obstruct change. On the other hand, the moments will invariably cease and new ones are needed to repel boredom. Capturing the moments and the excitement of the moments in words is one of the prime obligations of the punk and post-punk critics. They invested the moment with authenticity, understood as the glimpse of a "real" reality that could perhaps be changed for the better, and contrasted it with the central punk notion of boredom. Strategies differed:

For the moment: only a moment. What was that? It. For the moment. Be bored with that, brats, and be bored with life. The fleeting moment; the kaleidoscopic light of changing environment and circumstance and perception and … what was that? Depeche Mode are absolutely on the brink of 'a'—rather than the—next moment. So absolute, so arbitrary. (Morley 1986:69)

[…] the highlight is the flat-out rocker, 'Moving'. As Brett Anderson and Bernard Butler spin, bump and grind, their bangs tossing from side to side in counterpoint, the Grand shimmers in pure white light. Time is frozen in an everlasting present. (Savage 1996:341)

Morley leans towards a stream-of-consciousness babble, giving the impression of a thousand simultaneous things happening. He chooses the anonymous "it" to designate whatever he is after and thereby accepts it as something that discursive language is barred from. As he prefers *a* next moment to *the* next moment—the present is privileged over constant change. Savage uses a totally different literary strategy by objectively describing what he sees and summing it up in the last sentence which stands out because of its literary pathos. These moments, whether formulated as a rudimentary it or as an everlasting present, are what matters to both critics. But as the detailed discussion of the two critics below will show, their transcendental moments are not the same. Morley's is the narcissistic longing for the oceanic feeling, Savage's the academic's longing for the romantic notion of another world. Another point where they diverge is that chasing the moment is far more important to Morley than to Savage. With Morley the chase is even at the heart of his interview style, making him perhaps the essential New Pop critic, whereas a rationally based critique is most important to Savage.

Such transcendence is pop's *raison d'être* and a central element in rock criticism.[3] It is the window towards other worlds, whether netherworlds of the subject, alternative social worlds, or just the instant when you become aware of yourself. Sometimes it even represents a glimpse of the 'real' reality hidden behind the everyday surface. Earlier generations of critics took it more or less for granted that good music conveyed transcendence, but to punk critics reacting against prog rock and post-punk critics dealing with pop, how to capture the transcendent moment became imperative. The often mentioned loss of authenticity is described thus by Iain Chambers:

3 Cf. Aronowitz' discussion of Greil Marcus and the attempt to escape time (1993:196–197) and the Marcus article itself (1969).

Face masks and fashion costumes, surrounded by drum machines and programmed synthesisers, replaced links to the 'street' and its associated 'authenticity' with a refusal to consider that there need necessarily exist a moment of 'authenticity' at all. The logic of 'origins', the subsequent explanations and romantic attachment that flow from them, is ignored. Musical and cultural styles ripped out of their contexts, stripped of their initial referents, circulate in such a manner that they represent nothing other than their own transitory presence. (1985:199)

Chambers, writing a year or two before Savage's negative style over content article (cf. pp. 227), saw the liberating possibilities in this loss as a negation of institutional authority that made possible a parallel reality beyond everyday life. What Chambers describes is the simulacra aspect of the postmodern condition. But while he is right in observing a loss of historical perspective and street authenticity in the media versions of youth culture (although it might be only a partial loss), he is not quite right in defining it as a loss of authenticity as such. Only certain aspects of authenticity disappear with the loss of historical origin. Chambers himself places concepts like the refusal and possibilities at the center of his book. They are not part of a narrow historical understanding but still part of the Hegelian and Marxian master narrative about the teleology of history. Instead of looking back at origins, the refusal points towards the future—not formulating *the* utopian condition as Hegel and Marx did, but such a condition understood in a more modern sense as the continuous evolution towards a goal that will always change.

Savage, on the other hand, has admirably captured the opposition between classic authenticity and postmodern artificiality paradigms, also referring to other well-worn and related oppositions like art/commerce and rock/pop, as they were articulated in British pop culture during the 1980s:

In England, pop culture has a simultaneous function of exploitation and expression: exploitation as the product of an industry at the sharp end of the new conditions of capitalism, expression by virtue of its position—which has occurred by default—as the main area of activity in our society which freely admits voices of both youth and change. The tension between these two contradictory functions has provided the space within which new signs and new attitudes can break through; it also, depending on which function is in the ascendant, explains pop culture's vacillation to date between empty reaction and charged visions of possible futures. In this the way which popular culture communicates is as important as what it communicates: at worst this means a culture of style

over content, at best a visionary flash—the secular equivalent of a miracle which can transform people's lives. ("Tainted Love," *MM*, February 21, 1987:38)

Each generation of critics has had its own ways of formulating the dilemma and drawing the crucial dividing line between two poles. Savage formulates the opposition as that between industry exploitation and musicians' free speech. And the point is, he regards it as fruitful for innovative moves. The autonomous pole within the cultural field is hardly present as an ideal; rather it is the *tension* inherent in pop culture that is celebrated. Especially in the first half of the 1980s this tension was indispensable and led to far-reaching explorations of the heterogeneous pole.

Art(ificial) ideals?

Most of the time, leading critics stuck to a concept of art that stemmed from the historical avant-garde, whose ideal was a dissolution of the dichotomy between life and art by making art an integral part of everyday life. The avant-garde notions were handed down to them through—among other things—advertising, British and American Pop art, leftist actionism, art school teachers, and the application of these sources to pop and punk. The impact of the Situationist International was particularly strong. It was yet another avant-garde movement in the tradition begun by the Futurists with their 1909 manifesto, and it can be seen as a partial continuation of the Surrealist movement which faded away after the war. The Situationist International was founded in 1957 and it was the last international avant-garde movement, being dissolved in 1972. In contrast to the older movements, it was not launched by a manifesto. Instead, its views and definition of central concepts were presented in the journal *Internationale Situationniste*, published in 1958–69. According to Peter Wollen the most significant terms were "*Urbanisme unitaire* (integrated city-creation, unitary urbanism), psycho-geography, play as free and creative activity, *dérive* (drift) and *détournement* (diversion, semantic shift)." The aims of the artists involved were to

> break down the divisions between individual art-forms, to create *situations*, constructed encounters and creatively lived moments in specific urban settings, instances of a critically transformed everyday life. They were to produce settings for situations and experimental models of possible modes of transformation of the city, as well as agitate and polemicize against the sterility and oppression of the actual environment and ruling economic and political system. (1989:70)

By 1962, following the hallowed traditions of the avant-garde, the Situationist International split into two: the artists and the revolutionaries led by Guy Debord who fused the above mentioned concepts with Marxist theory. Based on, among others, the works of Georg Lukács and Henri Lefebvre, Debord in his book *Society of the Spectacle* (1967/1970) theorized the increasing fragmentation of everyday life and the false unifying power exercised by the spectacle. The result was a critique of modern society and mass culture along the lines of Western Marxism. The spectacle is the overarching and totalizing principle of society; it is the glue that keeps it together and shuts everything else out; it is the social relations between people propagated through pictures (§4). Debord stresses sight as the primary organizing factor within modern society, and television is an obvious target for his critique. The alienating conditions of everyday life are continually stressed and the goal is to place free play at its deroutinized center. One of the main strategies for obtaining this was the previously mentioned *détournement*, here explained by Sadie Plant:

> The closest English translation of *détournement* lies somewhere between 'diver-sion' and 'subversion'. It is a turning around and a reclamation of lost meaning: a way of putting the stasis of the spectacle in motion. It is plagiaristic, because its materials are those which already appear within the spectacle, and subversive, since its tactics are those of the 'reversal of perspective', a challenge to meaning aimed at the context in which it arises. (1992:86)

This description is echoed in several discussions of punk and it could almost read like a program for the reflexive aspects of New Pop. Subversion was indeed intended, but not of the political sort. The aim was rather to draw the carpet out from under the reader's received notions by artistic means without suggest-ing new notions and to make this gesture in the full light of day.

Wollen states that the Paris May '68 revolt "was the zenith of SI activity and success, but also the beginning of its decline" (1989:71). The first French student uprising (Strasbourg 1966) took its lead from Situationist theory, and in May '68 most slogans were created or inspired by Situationists. The stu-dents' and the May '68 uprisings brought elements of Situationist theory and praxis into popular culture, and they were to be applied to punk nearly a decade later. As the designer of the Sex Pistols' visuals Jamie Reid states: "I wasn't so much attracted to the Situationist theory as to how they approached media and politics. The slogans, for instance, were so much better than the texts. They were very immediate, very direct and quite classless" (1987:38).

One consequence of the continuous exclusions made by the Paris Situationists was that similar groups evolved in several countries. In England one such loose grouping, King Mob, published a magazine in 1968–70 where French high Marxist theory was fused with both English and American pop sensibilities, in this way also preparing for the appearance of such ideas in rock criticism. A different and more indirect route of Situationist-like ideas was the shared theoretical foundations of the Situationists and 1970s cultural studies. Iain Chambers' notions of the ruptures in everyday life rests partly on Henri Lefèbvre (and Walter Benjamin) while Dick Hebdige, among other things, celebrates the *détournements* of Jean Genet. Later on, the avant-garde legacy spurred Greil Marcus to write a whole book on the prehistory of punk, focusing on the avant-garde (1990/1997).

It is much easier for rock critics and musicians to relate to such a concept of art than one which is ultimately bound to a European canon beginning with Palestrina, da Vinci, and Dante, because the avant-garde concept of art contains a critique of the doctrine of the autonomy of art. In some ways the historical avant-garde's problematization of the whole notion of art and its institutions sits well with rock music. But there is one basic difference: the avant-garde tries to break out from the confines of art while rock tries to break in from the outside. The avant-garde is exclusive; it works as small-scale production for the few, while rock is populistic and belongs in the overcrowded media. Nevertheless, there has been a mutual inspiration resulting in a blurring of the divide between pop and postmodern art and theory.

For a time though, avant-garde strategies were only mimed. For example, *The Face* carried a column called Disinformation for a couple of years. None of the intentions behind it mattered as exaggerated glamour, celebrity, shiny commodities, etc. became ends in themselves. But within this rule a few voices were still affected by the avant-garde dilemma between authenticity and artificiality, and in extreme cases traditional high art discourse popped up, showing it was not quite dead within rock criticism after all.

Articles and reviews of Joy Division and Ian Curtis are good examples of this. Here, the highest praise possible is called for, and the only words available are those belonging to traditional high art discourse. In a 1979 review of the debut album *Unknown Pleasures* Jon Savage lauds the record in terms normally reserved for Shakespeare and other "transhistorical" artists. "Joy Division's vision" is a result of a specific time and place (decaying, postindustrial Manchester in 1979) but at the same time the group "makes the specific general, the particular a paradigm" (1996:93). In a concert review Paul Morley extols the

group's performance in terms reminiscent of Baudelaire: "Division's music is genuinely violent, and it's the violence of beauty rooted in beastly desire, the violence of breakdown, inhibition, failure, fatalism [...]" ("Joy Division, University of London" (concert review), *NME*, February 16, 1980:55).

If reviews were positive, the shock caused by Ian Curtis's suicide in May 1980 craved canonization. In his three page obituary (written with Adrian Thrills), Morley feels called upon to discuss what the very best of rock music is (as opposed to merely good rock and crap rock):

> The very best rock music is created by individuals and musicians obsessive and eloquent enough to inspect and judge destinies and systems with artistic totality and sometimes tragic necessity; music with laws of its own, a drama of its own. The face of rock music is changed by those who introduce to the language new tones, new tunes and new visions. [...] The very best of rock music is art, and that is nothing to be ashamed of. [...] Whether it's Jimi Hendrix or Joy Division it suggests infinity and confronts squalor. In direct opposition to the impersonal exploitation of the rock structure it miraculously comes from, it cares for the inner person. It is rarely straightforward intelligence and wit that produces the very best of rock music. It is dreams, naivety, aspirations, intuition, exuberance ... there are dreams that shout for a better world and a deeper understanding. These are the dreams of the very best rock music. Joy Division make art. The prejudice that hangs around the word 'art' puts people off, makes them think of the untouchable, the unreachable and the unrealistic. Joy Division put reality into rock. Yet for all the intensity and violence of their images, the music never relinquishes a classic accessibility; rhythm, melody, atmosphere are awesomely sophisticated. Joy Division make art. Joy Division make the very best rock music. ("Don't Walk Away in Silence," *NME*, June 14, 1980:38)

Morley uses no avant-garde references in the article apart from, perhaps, a single Rimbaud reference, "this current season in hell." Instead, in his "tribute to the man and the group", he finds it necessary to invoke the classical markers of art of the highest rank such as "created by individuals," "artistic totality," "tragic necessity," "music has laws of its own," "suggests infinity." Such words have been used to explain the music of Beethoven for a century and a half. Furthermore, in his claim that Joy Division produces art (as in Rembrandt, not as in Warhol) he argues that genuine subjectivity and intuition are essential, that opposition and longing for a better place is an integral part of art, that the group brings the rules of classicism to the fore (accessible, yet sophisticated), and that "the very best of rock music" contains a *promesse du bonheur*.

It seems that when the object becomes worthy enough the critic takes refuge in a venerable, idealist aesthetic discourse far removed from the ordinary. Hidden behind the day-to-day cleverness lies the romantic idea of music as a separate world which in a few instances can enter the real world and influence it ("Joy Division put reality into rock"). Where seriousness and pathos are needed, a traditional high art discourse reveals itself as the yardstick that actually matters. It runs like a subterranean river through New Pop criticism, only surfacing when the problem about what the critics are actually doing in the middle of the pop process becomes pertinent—which is seldom.

The Interview as Happening (The Musicians' Nightmare)
Situationist strategies flourished in New Pop interviews as they often have a strong tinge of happening to them—Paul Morley's being the best examples. Neither he nor the interviewee seems to know where it is at, and at times his preparations are said to consist of getting tipsy or even downright drunk. His questions are confrontational, and the write-up often turns into a malicious put-down of the musician in question. In this way he continues the carnivalesque tradition within rock criticism by translating Burchill into interview format. Morley describes his technique thus:

> [...] the best interviews don't come from planning. You have to trip over the first question. Once you've tripped up, the next problem is to ease out into a kind of vacuum where the only thing that matters in the world are the words of the conversation, the strange pressure between the two of you that is somehow summoned up, the belief that you are digging right into the truth of the person's private vision. [...] what I preferred to do when asking questions was begin with something casual but provocative that would push out the interview into the strange, revealing areas I was always despairing towards. (1986:4, 51)

This is vaguely reminiscent of Hunter S. Thompson's method: jump into it, cause a stir, and write about it. At the same time, this being 1980s media, it is theatre—and theatre in a very artful way. Basically, each player knows his part, the interview is just a slight variation of the fixed position journalist vs. pop star. Morley tries to explode the situation with questions that are either banal or reflect his basic doubts about whether pop matters at all. His aesthetic program could read like this:

> Hearsay: A new generation of performance artists has arrived. They use existing situations to actually affect society from the inside, to subliminally infiltrate popular culture aware of their perception as art but realizing their redundancy. (Gen-

esis P. Orrige & Peter Christopherson: "Annihilating Society," *Studio International,* June/July 1976, quoted from Savage 1991:244)

This is the legacy of the Situationists as formulated by two Throbbing Gristle members and this is what Morley tried to do by poking around in the middle of pop trying to stir it up: to affect it from the inside. The techniques used for furthering this idea of subversion are to cast the reporter as a star by accentuating that he is the master of the interview—sometimes even *the* central person—and not a microphone holder for the pop star; to openly criticize all aspects of the media and point out the role of his articles and of himself within the pop process; to experiment with different styles of writing by using avant-garde strategies like cut-up, stream-of-consciousness, and collage; and to draw attention to the fact that most pop interviews consist of babble or chatter (as in the title of Morley's 1986 anthology *Ask: The Chatter of Pop*). Only in connection with the best music or in the best interview situations does the chatter turn into talk.

Often, the contextualization (the intro) takes up quite a lot of space and here Morley is radically present, either because he describes his state of mind or his surroundings in detail or because he feels a need to place the group in question within a wider context (the future of rock, for example). In an interview with Wham! Morley demonstrates an interview strategy which turns the event into a screw-ball comedy. Traditional topics like an introduction to the group, historical perspectives or discussions of their records, music, or tours are left out. The interview's entertainment value is high. Obviously, Morley does not like Wham! but always avoids stating his own position explicitly:

> [Morley:] How can you feel in any way satisfied or inspired being a prime part of the current charty gay abandon, all this flimsy jingly sing-along? George/Andrew (in touching harmony): That's what pop music is all about! [Morley:] What, a sing-along? A: That's what makes pop songs popular, because everyone can sing along with them. There's nothing wrong with that. G: What fucking right have you got to say that we should sing something that is socially important? [Morley:] I haven't said that, don't insult me! ("Enjoy What You Do? Idealist Speculation Versus the Passive Objects," *Blitz,* October 1983:35)

Not surprisingly, the result is that the parties do not meet in conversation, and the animosity on both sides is clear. After quite a few exchanges of this sort the two musicians get the point. They change strategy and try to ridicule the critic, mainly by laughing at him: "Wham! chuckled—scoffed, even!—at me quite a lot during my gracefully uneven abuse of the docile, shameless efficiency that is

their entertainment. I, in return, blushed—I'm not beyond blushing, it's one of my greatest weapons" (37). This is entertaining, but hardly revealing in the sense that the reader is presented with something new. And this is the problem with Morley's pop interviews: they are little more than narcissist shows. Other journalists took up the strategy of confrontation and self-promotion (normally with less panache than Morley) and it became probably the most significant stylistic trait in New Pop journalism.

Early Theory
Around 1970 a paradigmatic shift began in the humanities. It affected the social sciences and found its way into rock criticism, too. Diverse as they were, the new signals were labeled "theory," which designated "works that succeed in challenging and reorienting thinking in fields other than those to which they ostensibly belong" (Culler 1988:15). More precisely, "theory" came to refer to the successive breakthrough of structuralism and poststructuralism. It seems reasonable to use literary studies as a model, because the shift is often referred to as the effect of a linguistic turn. Above all, it represented the breakthrough of the thinking of Swiss linguist Ferdinand de Saussure. His dream was to found a science of signs (semiology or semiotics). He proposed that a language works with signs, which in turn consist of sound images (signifiers) and mental concepts (signifieds). Of particular importance was that Saussure regarded the relation between the signifier and the signified as arbitrary—that is, as a matter of convention—and held that meaning is a consequence of a sign's difference from other signs. In other words, he focused on the relations between signs, not on their relations to external referents.

If Saussure separated the sign from the referent, poststructuralism went further and divided, as Terry Eagleton (1983) remarks, the signifier from the signified. This step meant that the object under scrutiny was no more a *work*: "a closed entity, equipped with definite meanings which it is the critic's task to decipher," but a *text*, "irreducibly plural, an endless play of signifiers which can never be finally nailed down to a single center, essence or meaning" (Eagleton 1983:128, 138, drawing on a distinction borrowed from Barthes). The individual text thus opens up to other texts, "intertexts" (a term authorized by Julia Kristeva), and in the end, to a world pervaded by language from its beginnings. Therefore one must "deconstruct" the way language informs thinking, for instance by questioning binary oppositions; this was the project of Jacques Derrida and his numerous American followers. But to rock critics, particularly those with academic ambitions, other French thinkers turned out more influential. Among them were

Jean Baudrillard with his vision of postmodernity as an endless succession of representations without originals (simulacra), Gilles Deleuze and Félix Guattari, whose view of desire as a flow prior to all representation is echoed in some present-day writing on electronic music, and, above all, the ubiquitous Roland Barthes, who could "be applied to anything" (*Spin* editor Richard Gehr, personal interview, June 23, 1999).

In particular, two interconnected facets of Barthes' thinking should be foregrounded here. The first of these has to do with the concept of pleasure. Eagleton has pointed out that in contrast to "meaning", "pleasure is hardly ever mentioned in universities" (1983:181). But the poststructuralist Barthes consistently celebrated hedonist play just as rock critics celebrate fun. Not only does he claim that meaning is created by the reader; since texts are already de-centered, the reader is also entitled to cruise the text for pleasure—an image that was to return in Dick Hebdige's critical view of *The Face* (1988)—without caring about unity or coherence. However, Barthes is more of an aristocrat than a populist libertine. *The Pleasure of the Text* (1973/1990) introduces a distinction between two modes of pleasure, which seems to reproduce the high-low divide. On one hand, there is "mere" *plaisir*, on the other the ecstatic loss of self and meaning experienced in *jouissance* (the terms derive from Lacan and seem to be his reformulation of the classic opposition between the beautiful and the sublime). Whereas *jouissance* is taken to unsettle the reader's assumptions and tastes, *plaisir* rests on their being confirmed. The former "brings to a crisis his relations with the language" (14) by means of excess or disruption; the latter remains safely within the limits of discourse. It seems that Barthes connects *jouissance* with avant-garde texts.

This brings to the fore a second facet, which deals with the notion of a non-discursive meaning. In the early 1970s, Barthes was very occupied by the question of *signifiance*—that is, a meaning beyond that of communication, representation, or expression. The often referred to essay "The Grain of the Voice" (1972/1977) is a prime example of this interest. As indicated by the title, it proposes to illuminate musical timbre, a problem familiar to but largely untheorized by rock critics at the time. Some singers, Barthes argues, have a grain to their voice, while others do not, and this goes for popular music, too (Barthes 1972/1977:182). Those who have not got it fail to go beyond interpretation, which means that they cannot sway us to *jouissance*. If a singing voice is to effect *jouissance*, it must bring to mind "the materiality of the body speaking its mother tongue" (182), which is what a Russian church bass does, seemingly without recourse to any symbolic register.

Less than a decade later, theory crept into rock criticism as well. *NME*'s Ian Penman (1959-) began to write for the magazine in 1977. Up until 1985, when he turned free lance, he became an increasingly central critic for that magazine, and he was probably the one to refer most extensively to theory around 1980. Below is an example of his writing taken from the opening of a Throbbing Gristle review:

> Structuralists believe that what we signify is a function of how we signify it. Simply, all we can say is determined by what we can assess or measure with our faculties or instruments. Thus, finally, we don't know what it is we are talking about—all we know is that our faculties or instruments are, and of what they are capable. This particular—dubious?—form of interpretation might lend itself well to a critique of the New Wave and the reactions, assumptions, and manipulations provoked by and present in it. Numerous outlets for information and criticism—from McLaren's cunning Situationalism [*sic*], through the national/music press distorted from various concurrent (social) phenomena into one image-fixated sensation, to the point where post-'revolutionary' popular entertainers (Boomtown Rats, Stranglers, Clash, Banshees, Devoto, etc.) can get on unquestioned using hollow and ill-reasoned self-justification and speculation as to the nature of their position in rock, and rock's position in a (wider) social context—become the basis for a new establishment ("P. Orrigde Bowls a Grisly Throb—P. Enman Ducks" (review of a Throbbing Gristle album), *NME*, January 13, 1979:28).

Even when one reads this in a positive frame of mind, it is hard to make sense of it. Apparently, Penman does not quite master either his theory or his prose (he has subsequently become much better at both). Nevertheless, it is a good example of the early "theoretization" in *NME*, where strange words popped up in more or less likely circumstances. The following week, the review drew a lot of criticism from readers. The main line was that Penman's text was intellectual bullshit/verbal diarrhea, but one reader (David Toop, actually) also complained about Penman's *reductio ad absurdum* of structuralism ("Heads Down, No-Nonsense, Neo-Structuralist Bag" (readers' letters column), *NME*, January 27, 1979:46). Earlier, pop had been the object of academic historians and sociologists, but here it is suggested that it could profit from being subjected to more prestigious theory. Academics had been thinking along those lines for some time, but now the claim was being made from the other side of the fence.

The use of French high theory joins forces with Morley's use of Situationist strategies in Penman's pop writing. It is used more as small ruptures in the text

than as a fully academic and argumentative instrument. Sometimes references are used to create *bon mots* as in an article about Heaven 17 called "Travels Through Desire and Demand" where he writes: "It's true, I think, floating into Ultrateque [a club]—*one only desires as a function of the machine wherein one is contained*" (*NME*, October 17, 1981:34, italics in the original). The sentence is a one-liner, it is not really explained or discussed in the following. Only when Penman refrained from verbal posing after the mid-80s but still stuck to thinking along the same lines did he succeed in writing intellectually stimulating articles. As we will see in chapter 8, this line of critical enquiry was taken up by new agents in the latter part of the 1980s with considerably more success than Penman could muster in the beginning of the decade.

7.4. Music Magazines in the Early 1980s: New Agents and Growing Competition

The rise of the style bibles in the early 1980s signaled a decisive rupture within the field with regard to definitions of what a magazine was. No longer was criticism only printed in broad-sheet format, no longer was a weekly news round-up necessary, no more pictures of sweaty musicians, no longer were readers' fingers smeared by the print. Instead, the style bibles used glossy four-color printing, chose a smaller format and slowed down the frequency of critical output by going monthly (and you looked nicer when reading it—and cleaner afterwards). The whole visualization of criticism changed, not only in layout, but also in the use of stylized pictures taken at photo sessions and often looking like the photos in the adverts. For the first time fashion and music were brought together on a regular basis in rock magazines (although the second issue of *Rolling Stone* had carried a two-page spread on hippie fashion), and it signaled a totally different take on rock. Apart from the inkies, *Rolling Stone* and all later major music magazines have followed this trend, using pictures and typing as an integral part of the design. In these monthlies, music is only part of a larger agenda—that of stylishness applied to all things in life including the magazines themselves. The magazine has become the important point, less so the content, partly because the article texts became shorter due to more and larger pictures.

Punk and New Wave had not produced any new national magazines. Instead, *MM*, *NME*, and *Sounds* were instrumental in forming and popularizing the punk/post-punk/new wave discourse. Their positions as taste leaders within the field were not challenged as they adapted to new currents. Fanzines were the new agents in the field, but none of them survived for long and none of them

were bought by commercial publishing companies. Instead, their editors were often recruited by the inkies (e.g., Savage, Morley, Adrian Thrills).[4]

As New Pop musicians won the post-punk race to become *the* new music, all magazines flocked around them. Some were rather critical towards the new phenomenon, but nevertheless they wrote about it. Not since the mid-60s had the consensus about 'what's happening' been so outspoken, and everybody from pre-teen magazines to *The Face* joined in. Commercially, *Smash Hits* (1978-) took off, leaving everybody far behind, cresting in 1988 with a circulation of nearly 800,000, and becoming the best-selling British music magazine ever. Its writing on New Pop corresponded well with the music. It was star coverage, gossip, and centerfolds for teenagers' walls. An older music audience was offered an ironic fandom by buying the magazine, but above all, a way of attaining the music's and the television images' innocent lightness, a lightness that was specific to the early 1980s (cf. Toynbee 1993). What had begun as a political gesture in the late 1970s thus ended up in an embrace of commercialism as style. The task of the journalists was no more to criticize (in our sense of the word), but to glamorize.

In 1977 punk had filled the front pages and editorials of most English media. It was interpreted either as simply outrageous or as a telling sign of what Great Britain had come to. By the early 1980s pop stars took over the front pages once again and stayed there among other celebrities. This time the musicians—Wham!, Duran Duran, Boy George—were really nice. In fact they questioned aspects of traditional male sexuality by feminizing themselves (either just hinted at by using heavy make-up or blatantly by cross-dressing). But as long as they were young, good looking, stayed away from drugs, not explicit about sex (whichever kind) and made happy up-beat pop, everything was alright.

To promote these images the new stars needed the tabloids, and the tabloids, trying to reach the young readers, needed the new stars. John Blake of *The Sun* (later, *Daily Mirror*) became the leading tabloid music journalist. Publicly he was reviled by everybody in the music business, but with his access to millions

4	Only Mark P.'s (Perry's) *Sniffin' Glue* (July 1976-August 1977) gained some posthumous reknown. One of punk's most famous quotes, 'Here's one chord, here's another, now go and form a band', is often attributed to *Sniffin' Glue*, but none of the issues contain that expression. Actually, Mark P.'s only invitation to D.I.Y. concerns magazines: "All you kids out there who read 'SG', don't get satisfied with what *we* write. Go out and start your own fanzines or send reviews to the established papers. Let's really get on their nerves, flood the market with punk-writing!" (P., Mark 1976: "Mark P. Pisses on the Lot of 'Em" (editorial), *Sniffin' Glue*, November 1976:2). All issues of *Sniffin' Glue* are now available in a facsimile edition (Perry 2000).

of readers he was the most sought-after journalist by the stars and their publicity departments.[5] From the perspective of the field of rock criticism a new and extreme position was formed at the heteronomous end of the field, one without any consecrating power whatsoever—but with immense power in commercial terms.

Music television, one of the major media developments affecting popular music, came about in the early 1980s. The glossy pictures of well-groomed and fancifully dressed stars came alive and their music was brought into a still closer association with advertisement aesthetics. In America, MTV was broadcast in 1981, and New Pop was tailor-made for this situation because of its obsession with looks and its steady flow of promotional clips. Thus, it became the first British style to conquer the American market since the so-called British Invasion in the 1960s. The video became yet another, rather cheap marketing tool that changed the face of pop. In Europe the video show *Music Box* began in 1982 as a program on Sky Channel. MTV Europe only began to broadcast in 1987. Music television has often been interpreted as the postmodern phenomenon *par excellence*, but Andrew Goodwin has convincingly argued that the music lends order to the video despite the pictures' apparent lack of coherence and that channels like MTV quickly reverted to old-fashioned television formats, chopping up the continuous flow of videos and ordering them into regular programs (1993:96, 131–155).

Even though the style bibles, teen mags, and tabloids took up space in the field, there was room enough throughout the decade for the old magazines as the market kept on growing. *NME* kept the flag flying, but thanks to the new agents the balance shifted somewhat as the inkies lost some of their role as arbiters of taste. Since the early 1960s, and as the result of a merger, IPC (International Publishing Corporation) has been one of the largest companies in the English magazine business, and it has dominated the music magazine market with the titles *NME* and *MM*. In the 1980s serious competition arrived with EMAP (East Midland Allied Press) first in the teen (*Smash Hits*) and then in the rock market (*Q*). It would not be far off the mark to say that the 1980s belonged to the fortnightly *Smash Hits* and the 1990s to the monthly men's music magazine *Q*.

The American field remained more stable with *Rolling Stone* being more interested in movie than in rock stars. A few attempts at launching local papers

5 For further information about pop and the tabloids, see Paolo Hewitt: "Blake's Progress" (interview with John Blake), *NME*, November 19, 1985:21, 38, and Sam Taylor: "The Filth and the Fury," *Q*, January 1996:80–87.

on a national level came about, but without any long term success. *Trouser Press* (1974-84), presenting itself as "America's only British rock magazine," reported on British punk and post-punk and carried a few articles on the American scene as well. It started out as a fanzine, went national and glossy in the early 1980s, had a circulation of 60,000 at its peak, but finally had to close down. According to founder and editor Ira Robbins, *Trouser Press* folded because

> By 1984, with the onset of MTV and the evident failure of alternative music to penetrate the mainstream, except on a sporadic basis, the record industry lost interest in print advertising. We weren't having much fun, other media were poaching our turf covering the same bands faster and more colorfully. Most of all, the audience for our taste in music and independent brand of intelligent rock journalism was on the wane. So much for foresight. Still, we got to read our own laudatory obit [...] in *Rolling Stone* (www.trouserpress.com/faq.html, October 7, 1998).

Robbins's explanation for the closure reflects media changes in the US, and they are basically the same as in Britain: dailies recruiting rock critics, more rock on TV. *Trouser Press* was essentially still writing in the old fan mag style: enthusiasm, partiality, and lots of information. Only in 1985 did *Spin* manage to establish itself on a national level.

The Face: "Takeaway Immortality"
The process of a subject construction in intertextual play can be followed in the birth and development of the style bibles—magazines like *The Face*, *i-D*, *Arena*, or *Blitz*. To begin with, the most influential of them, *The Face*, called itself "The Independent Rock Monthly," which became "Rock's Final Frontier" and then "The World's Best Dressed Magazine." It was started by Nick Logan in 1980 on private savings and a mortgage on his flat, and its staff was easily contained in a taxi, as legend has it (Hebdige 1988:157). Initially a great number of the regular contributors came from the *NME*, among them Tony Parsons, Julie Burchill, who ran a column for several years, and photographers Pennie Smith and Anton Corbijn. For the most part, though, *The Face* was to live off freelance work. And did so quite well, being voted "Magazine of the Year" in 1983 and selling 80,000 copies within five years after its start (*The Face*, May 1985:110–111). Above all, the field position that *The Face* created for itself drew on a new concept of the relation between text and image, which privileged the latter. Looks were to be decisive. To that end, the magazine was printed on glossy paper in the "continental" 30,1 x 25,3 cm format. Ever since its first issue, observes Dick Hebdige,

The Face has always been a totally designed environment: an integrated package of graphic, typographic and photographic (dis)information laid out in such a way as to facilitate the restless passage of what Benjamin called the 'distracted gaze' of the urban consumer [...] It is first and foremost a text to be 'cruised' [...] The 'reader' s/he is invited to wander through this environment picking up whatever s/he finds attractive, useful or appealing. (1988:162)

Early issues convey the impression of a stylish yet substantial rock mag. No. 1, May 1980, reports from Lloyd Johnson's mod shop, shows some street fashion and concludes with a Paul Smith jeans ad. The rest of the content is music- (and film-) related. The very few ads are cast so as to melt into the overall design; there are artist photos by Anton Corbijn, and a hilarious gonzo interview with John Lydon by Kevin Fitzgerald, perhaps the best indication that *The Face* was bent on continuing the irreverence tradition from *NME*. Frith and Horne think that the magazine's "early juxtapositions of discourse were exciting" and praise it for showing "how pop style works" (1987:151). Hoy (1992) likewise foregrounds its heteroglottal discourse, regarding the all-pervasive irony and parody as a popular cultural descendant of the classical fool's violation of linguistic laws. Quoting and analyzing a review of the film *Rosalie Goes Shopping* in the January 1990 issue, Hoy writes:

"A comic fantasy about the consumer credit trap and the personal computer, it stars Marianne Sagebrecht as a German housewife … determined to live life the shop-till- you-drop postmodern American way. Hubbie Brad Davis's wages can't even pay the interest on all those afternoons at the mall, so she starts double-dealing with a vast deck of credit cards and number-crunching on her personal computer. Trouble is, her crimes don't feel wrong. *Rosalie* ends up nearly saying something about the hyperconformist consumer and the double standards of the debt economy. Pity about the soundtrack, though."

Here the dialogue consists of a fusion of British middle-class colloquialisms ("Hubbie") and ellipsis ("Pity about …"), fairly respectable economic textbook language ("the consumer credit trap", "the double standards of the debt economy"), the language of nontabloid, ostensibly apolitical British journalism ("A comic fantasy, it stars Marianne Sagebrecht as a German housewife"), tabloid language ("shop-till-you-drop"), American language—or, at least, the Americanisms commonly used by British journalists ("Trouble is …", "number-crunching"), and a parody of current social and literary discourse ("postmodern American way", "the hyperconformist consumer"). (1992:768–769)

To Hoy, popular cultural texts like *The Face* "recognize the emptiness of society, the plasticity of consumerism and [...] resolve that there is nothing left to do but celebrate that very vacancy, to go shopping" (776). Thus an artificial world is constructed, "an eternal chronotope of youth [...], youth idyll with its magic costumes and accoutrements" (779). Hoy's postmodernist analysis observes that the referent recedes in favor of linguistic play, but this is celebrated more as an instance of ephemeral carnivalism.

Hebdige (1988), writing from a modernist position, puts forward a very different, critical account of *The Face* as a monument of postmodernism. He is aware of its mod, Pop art and Situationist roots and credits the magazine with having become synonymous with contemporariness and being responsible for the emergence of a particular 1980s sensibility. But to him *The Face* flattens out the world. Like Hoy, Hebdige (159) argues that time and space dissolve into the eternal present, the now of the images. But to him this means that because there is no history, there is no contradiction—just random clashes and equally random conjunctions of semantic particles (images and words). Fashion and politics, trivia and high theory are treated as equally important and served in atomized units of information. The rhetoric of advertising—"the witty one-liner, the keyword, the aphorism, the extractable (i.e., quotable) image" (172)—penetrates everything. Statements favor indirectness. "Where opinions are expressed they occur in hyperbole so that a question is raised how seriously they are meant to be taken" (170). There's nothing to be revealed under the surface, nothing to analyze. "The pleasure-seeking bricoleur replaces the truth-and-justice-seeking rational subject of the Enlightenment" (166).

This controversy is emblematic of the restructuring of the field brought about by the style bibles, which ushered criticism into postmodernism. It also pops up in the pages of *The Face* itself. At the peak of the magazine's celebration of success in general and its own in particular in 1985, Jon Savage in a couple of columns declares that the "Age of Style" is over and turns against the "Celebrity Culture." He argues that just as punk's liberating negation mutated into nihilism, so has the equally liberating assertion of the supremacy of style become a dead end, "the preferred solution to our profound social and spiritual problems [being] not solidarity (or community in its widest sense) but selfhood, and a particular kind of selfhood at that: a takeaway immortality" ("The Sour Smell of Celebrity," *The Face*, October 1985:121). Such criticism, however, did little to change the magazine's course. By 1985 *The Face* had already become a lifestyle monthly, packed with posh adverts, consumer guidance and features on any subject, including pop music—until its closure in 2004 by the new owners, EMAP.

7.5. The Critics

After 1980 critics already working within the field created new writers' positions by adopting the new values and new writing styles. Among them Paul Morley (1957-) was most conspicuous in carving out a new field position, moving away from a traditional authenticity towards a position as a self-indulgent and provocative journalist star—about as far away from the fan perspective as you can get. Ian Penman (1959-) took up a similar position, and many others tried to emulate the two. Their position was marked by the mix of avant-garde writing strategies and pop subject matter sprinkled with French "theory." Another position was formed by, among others, Jon Savage (1953-). In the late 1970s he had used some experimental writing techniques, but his early 1980s' curiosity about pop was communicated in a more traditional way, the analyses often being based upon aspects of cultural history.

Morley and Penman came to write for *NME* just after school. Morley began his career as a pre-punk fanzine writer, then published his own glossy fanzine, and in 1976 he began to write for *NME*, reporting from Manchester. Two years later he moved to London to work for *NME* on a regular basis. Savage had graduated from Cambridge in 1975 and began training as a lawyer while publishing a fanzine, before being recruited by *Sounds* in April 1977. Simon Frith (1946-) had a full academic background and held a university post when he made his mark in the early 1980s.

To all young critics in the early 1980s punk had been an epiphany. In a *The Face* article from 1981 Savage describes his experience in this way:

> At the time, punk rock wasn't just music or going to the right clubs or wearing the right clothes (which is not to say that these matters were not absorbing or important). It was or *seemed* more: an all-in critique of, an all-out attack on, things as they were and things as they were going to be. Apocalypse now. Serious stuff; playing with, and stoking up, real fire. For a brief time energy replaced 'reality' and anything seemed possible. When the inevitable slackening off happened throughout the second half of 1977, the consequent disillusionment and cynicism was profound, and still affect us today. Idealism turned into the careerism that was always lurking and that was that—Chaos into Cash. (1996:126, italics in the original)

The musical and cultural upheavals caused by these events—both the instant high and the come-down—have shaped that generation's frame of reference ever since. Not as nostalgia, but as the realization of a moment where the order of things was not totally predetermined, and unforeseen possibilities could sud-

denly crop up. To Savage (and to many others) such a sense of possibilities—of freedom—has been hard to find ever since, though the androgynous aspects of Soft Cell and Boy George could for a short time function as subversive. The media sees to it that it happens only momentarily, if at all.

Media Eccentric: Paul Morley

Paul Morley combined McLaren's media play with New Journalism, taking *NME*'s humorous and confrontational style to its logical conclusion. His gonzo writing made him the new star of the *NME* staff, the successor of Nick Kent. Morley's style—negative and talkative—was to be one of the most influential in British 1980s' pop writing, although very few of his imitators were able to manage it. He has published the anthology *Ask: The Chatter of Pop* (1986) and more recently an overview of the punk scene (1997), a semi-autobiography (2000), and a reflection on pop (2003).

Morley mentions, among others, Lester Bangs, Richard Meltzer, and Nik Cohn as great rock critics, and especially the Americans seem to inspire his quest for the disruptive, negative or sublime moment (1986:6).[6] Musically, the American "alternative" rock tradition beginning with Captain Beefheart and The Velvet Underground and continued by British groups around 1976/77 is his musical reference point. Even in the late 1980s he names Patti Smith's *Horses* as his favorite album ("Wilde Child," interview with Morrisey, *Blitz*, April 1988:50). Musical adversaries are mainstream acts like Wham!, Dire Straits, Sade and Billy Joel but also groups like Killing Joke, who still insisted on the punk spirit of '77, and explicitly political groups like The Pop Group. Around 1980 his assignments slowly changed from musicians he respected (experimental post-punk groups) to musicians he could not stand (old rock and New Pop stars). His claim to fame rests primarily on these interviews.

Whereas McLaren could take upon himself and perform well the role of the villain (in rock terms: businessman, manipulator), Morley is still searching for moments of authentic being in the heart of the media. In this way, his role as consummate media jester becomes flawed. The constant tension between the two that he wishes to attain does not really work out because Morley the star

6 In an interview he singles out Meltzer: "There was an American guy called Richard Meltzer, who wrote in the late sixties, and he was influenced by outside of rock music, the kind of Lévi-Strauss anthropological way of looking at things, signs and symbols and that kind of thing. He was a huge influence because he broke it down into the pure absurdity of what you were doing." (Morley quoted in Tim Hulse: "Prententious? Moi?" (interview), *Blitz*, April 1983:33)

writer and star abuser/amuser takes over. In true 1980s fashion, his style and journalist's celebrity overshadows what content there might be, making him appear a modern British media eccentric who revels in his own name on the front page and feels free to spew his bile over all and sundry.

Morley (like Savage, cf. p. 252f) assumes that authenticity can be found in the old dichotomy between a dampening industry ("the standardization of product") and the pop moment, where anger, enthusiasm or other extreme feelings are flashed. Good pop is praised as the moment when the cracks in the wall can be sensed and it is possible to pose questions and become genuinely excited:

> [...] rock's subtle, enormous influence [...] can create an interest, fascination and identification with the liveliest aspects of one's time and place. [...] What we need is illumination and action, rather than melodious consolation. [...] what should concern the buttery liberals of rock is not hand-outs and self-reliefs but to find ways, through vigour, pertinence, and excitement, to charge up its captive audience, to forge self-belief, and determination so that we can more and more question our masters, the masters that make the muck that is apparently to be cleared away overnight with paper money. (1986:11)

The rhetoric is quite close to that of Orridge's and Christopherson's Situationism-derived manifesto quoted above. Another aspect is the pop moment where all things rational disappear. Boredom is its exact opposite. Morley's description of the ideal interview situation as a vacuum where only the now matters (quoted above) is an example of this incandescent moment.

In 1983 Morley—following the path of McLaren—changed sides and became involved as publicity manager for the record company ZTT, among other things casting himself as a member of The Art of Noise, taking care of publicity. He became just as popular as an interviewee as he had been as an interviewer. His greatest success in economic terms was Frankie Goes to Hollywood, one of the best orchestrated media campaigns ever. Contrary to both Oldham's and McLaren's campaigns, chaos did not seem to be part of this. The clever high theory references on the record cover, the planned obscenity of song lyrics and videos, the many different mixes, the T-shirts carrying messages with "Frankie say ...," the cleverly produced and danceable pop music—all was well planned, and it took the records right to the top of the charts. But his politics of opening up the charts for the unsuspected did not work. As soon as Frankie reached the top, they became just another pop group—according to Morley himself:

Finally, nothing actually changes. The same barriers exist, probably a little firmer. It's been a bit of fun for a few people, an irritation for others. The group becomes just another group in the charts, in the magazines, and the industry finds a way to squeeze all the juice and delight that we tried to press into the record. ("Who Bridges the Gap Between the Record Executive and the Genious? Me," *NME*, February 18, 1984:25)

One of the sure signs of a powerful position within the field is the right to name new genres. In the introduction to *Ask* Morley claims to have invented the term New Pop only to see it used on the wrong music (Culture Club, Duran Duran, etc.) (1986:128). He did indeed write about New Pop as far back as 1979 in *The New York Rocker* (reprinted in Heylin 1992:199–205), but he used it as a tag for almost all post-punk British music from PIL to Tom Robinson Band to Blondie, not in the sense that it was meant—and stuck—by 1982. For a few years Morley— "The father-figure of negative journalism" (Trevor Horn)—was the star of the British music press. He was just as outrageous as his subjects and he was clever, yet not clever enough, as he came to realize, to subvert the pop process. His ideals were high and he was a good writer, but his brand of insider activism ended up as just another cog in the entertainment wheel.

Humanism vs. Media: Jon Savage

Jon Savage is a politically engaged critic who often refers to recent cultural history to contextualize his subjects. He started out from a fan position documenting punk (mainly reviews and interviews), but after 1980 his main object of criticism became the media, especially what he saw as their commodification of culture. Sexual politics, often from a homosexual or feminist perspective, was another central theme and his criticism became more and more firmly based on an intellectual left wing stance. Since the middle 1980s he has also written about traditional power politics, stating that "[...] a sequence of disturbing events—the Falklands War, the miners' strike, the onset of AIDS—pricked my pop bubble. Politics entered the equation" (1996:10). Savage was inspired by McLaren's idea of exposing the hypocrisy of the media and the claim that style, for a short time, can go against the grain of consumer culture. He put these ideas into an explicitly political frame, losing the confrontational politics but gaining in academic reflection. Sometimes his critique approaches that of 1950s' culture critics when he focuses on culture as a commodity, but he is self-reflexive enough to realize his own position as a pawn in the game, and knows very well that commodities may harbor unseen possibilities and turn reality into

energy, as he wrote of punk. In this way, Savage has moved on from being a punk music critic and acquired the status of a general commentator on popular culture with close relations to the academy; but he has also moved from an intense involvement in punk music to a more detached position at the margins of musical life.

In 1980 Savage began a seven-year association with *The Face*. As a freelance journalist he has contributed to a host of British and American magazines of a more "serious" bent. He stopped being a full-time journalist in 1989 in order to write books, of which the biographies of the Kinks (1984) and the Sex Pistols (1991) are widely known. About a quarter of his articles are published in *Time Travel. Pop, Media and Sexuality, 1976–96* (1996), which the present profile is mainly based on. Savage has also worked in television, both as a researcher and as a program host.

In his early live reviews the key positive words are energy, tension, atmosphere, realness, and audience/performer interaction. The values of pop as opposed to rock (that is, "authentic" music) are cardinal. It is notable that Savage hardly mentions any American bands before Beastie Boys, REM, and Nirvana, and these he relates to British punk. Neither are "authentic" stadium rock bands like U2, Simple Minds or Big Country mentioned in the book. The central stars/groups are Boy George/Culture Club and Morrisey/Smiths, all gender benders. Among the newer ones are Björk and Tricky.

The right wing manipulations of the press comprise the topic of a large article, "The Secret Public" (*Touch Ritual*, 1985/1986, reprinted in Savage (1996:183–190). Among other things he criticizes the press coverage of the Handsworth riots for privatizing a general and social problem and the coverage of AIDS for creating a panic instead of giving actual information. He concludes that the media "may well be the most critical political, social and spiritual question of the late twentieth century" and that one way of reacting is through *refusal*, because "refusal, whether social, logical or linguistic, can yet unleash a sense of possibility and of purpose to transform the world" (189–190). This refusal is not far removed from Hebdige's description of refusal in *Subculture. The Meaning of Style*:

> […] it ends in the construction of a style, in a gesture of defiance or contempt, in a smile or a sneer. It signals a Refusal. I would like to think that this Refusal is worth making, that these gestures have a meaning, that the smiles and sneers have some subversive value. […] (1979:3)

The politics of Savage and Hebdige are in many ways parallel, and both refer to the Marcusian notion of "The great Refusal." The differences lie mainly in the choice of genre: journalism and academic texts. In his analysis of media texts Savage gets close to academic traditions of reflexivity, but he avoids the academic jargon. In the article, "The Age of Plunder" from the January 1983 issue of *The Face* (reprinted in Savage 1996:143–149) the liberal use of historical references in contemporary music is criticized as unreflected nostalgia for a past that has not existed. The solution, surprising when suggested by a pop writer, is that

> [a] proper study of the past can reveal, however, desires and spirits not at all in accordance with Mrs Thatcher's mealy-mouthed ideology as it spreads like scum to fill every available surface, and it is up to us to address ourselves to them. (149)

Savage does not invoke the concept of postmodernism in order to explain the phenomenon as a "free play of signifiers" or another such cliché. Instead, he prefers to turn towards established humanist thought. Savage's historical bent has gradually come to the fore since the mid-80s, first and foremost in his chronicling of The Sex Pistols, *England's Dreaming: Sex Pistols and Punk Rock* (1991), but also in his other books and in articles like "Blank Generation: Beavis and Butt-Head" printed in the summer 1995 issue of *Frieze* (reprinted in Savage 1996:395–404), a short history of stupidity in popular culture from punk to the present day. The Pistols chronicle takes up 600 pages and documents the group in very great detail through interviews with everybody who had had just the slightest relation to the group. (It even mentions the birth year of McLaren's grandmother.) It is investigative journalism at its best and by its comprehensiveness it nearly meets academic criteria—only the footnotes are missing. This normally very opinionated author is almost invisible in the text. He sums up the chapters and points to important events, but often he lets the interviewees do the interpreting.

Stylistically, Savage's turning from punk critic to cultural commentator can be seen as a move away from being enmeshed in a culture, living it, documenting it, being very partial to the music, and experimenting textually according to its criteria, towards a magisterial I, a classical subject passing aesthetic judgments and expressing political opinions. Savage shoulders authority without losing his subjective stance. Judging from the articles collected in *Time Travel*, personal comment prompted by a new CD is his preferred genre. Likewise, concert and CD reviews since 1980 are used as stepping stones for a wider perspective.

This authority and the magazines Savage publishes in give credence to the music he writes about. He does not in any way try to legitimize the pop he

writes about by taking in arguments about or just referring to high art. He writes within popular culture, and its positive moments are postulated as legitimate, it is "flashy, trashy, trivial, mythic" (Savage 1996:87–89), and only indirectly legitimized by the inherent aspects of the refusal and historical self-reflexiveness. And 1990s pop still contains the dream of utopia: "The fact that pop can embody the future makes it one of the few places in modern communications which transcends cynicism and populism to offer hope, joy and love" (Kureshi and Savage 1995:xxxiii).

Today Savage is among the most respected critics in the field. His book on the Sex Pistols is a classic and one colleague refers to him as a Joy Division scholar as well. Compared to his 1980s high-profile colleagues Savage has focused more on subject matter and less on writing style and his own person. He can be seen as a source of inspiration for the 1990s more objective critics who only report and make themselves as inconspicuous as possible in a style that Ben Thompson has named "reverse gonzo" (1998:12).

The Sociologist as Critic: Simon Frith

> My starting point is that what is possible for us as consumers [...] is a result of decisions made in production, made by musicians, entrepreneurs and corporate bureaucrats, made according to governments' and lawyers' rulings, in response to technological opportunities. The key to "creative consumption" remains an understanding of those decisions, the constraints under which they are made, and the ideologies that account for them. Such understanding depends on both industrial research and the intelligence revealed in single songs. (Frith 1988:6–7)

There are few rock writers so far who have been able to successfully combine an academic career with journalism. The two careers are seldom "good for each other: rock writing is not considered suitable for inclusion in an academic curriculum vitæ; and [a word like] 'sociology' is a term of abuse among rock critics," notes Simon Frith (1981/1983:4). Being one of the pioneers of rock criticism as well as a professor in film and media studies at the University of Sterling, Frith should know better than most other people what he is talking about. The introductory quotation characterizes his position. Frith thinks of himself as a sociological critic, whose task it is to remind textually oriented practitioners of cultural studies of the material foundations of the rock world.

In the mid-60s Frith read Nik Cohn, who made him "think about pop music" (1981/1983:277). After graduation in Oxford in 1967 he spent two formative

years in Berkeley and returned to Britain convinced that rock was "inextricably linked" with politics and pleasure—a conviction that has lasted (4). During his critic's career, Frith has had a long-standing column on Britpop in the *Village Voice* and periodical engagements with the *Sunday Times* and the *Observer*. Most of the time, though, he has been freelancing, appearing almost everywhere from *MM* to *Creem* to *Marxism Today*. As noted earlier, he was also included in Greil Marcus' 1979 anthology *Stranded,* playing the part of its "token Englishman" (Marcus 1979/1996:301).

In the 1970s Frith the scholar liked to use his insider position to expose rock fan mythology by means of sociological methods. The most obvious outcome was a seminal book, *The Sociology of Rock* (1978), revised as *Sound Effects. Youth, Leisure, and the Politics of Rock 'n' Roll* (1st edition 1981). The core of its argument is that rock, for better or worse, is neither high art nor folk music but mass culture: "a mass-produced music that carries a critique of its own means of production [and] a mass-consumed music that constructs its own 'authentic' audience" (11), two contradictions that the book proceeds to explain. The article "Rock and Sexuality," produced in collaboration with Angela McRobbie and printed in *Screen Education* the same year, caused debate and also drew attention to Frith.[7]

Several factors—the rise of cultural studies, new fads in rock and rock criticism, intense concert-going—brought about a reversal of the academic/critic relationship in the 1980s. "As a fan," Frith comments, "I was amazed by academic theorists' cavalier way with social facts, while as an academic I enjoyed upsetting readers' consumer common sense with wild subjective theory" (1988:3). This new orientation was mirrored in a collection of criticism and short academic pieces, *Music for Pleasure* (1988), to which we will return. Its critical focus on 1980s phenomena is the reason why we have chosen to treat Frith here.

The end of the 1980s marked something of a boom in Frith's academic writing. One notable result was the 1987 pioneering study of rock's art school connection, *Art into Pop*, written with Howard Horne. In brief, it claims that what British musicians have added to rock is above all a self-conscious attitude, which they acquired in art schools, where the divisions between high and low culture were regularly crossed. Another collaboration, this time with Andrew Goodwin, resulted in the 500-page anthology *On Record. Rock, Pop, and the Written Word* (1990). This is only a small selection from his extensive production; Frith has written on a great variety of subjects and decisively influenced academic

7 The article is available in Frith & Goodwin (1990), which also includes the self-criticism originally voiced in Frith (1988) as "Confessions of a Rock Critic."

discourse on popular music. Lately he has taken a particular interest in the neglected area of value judgments, which informs his latest book *Performing Rites. On the Value of Popular Music* (1996). In the author's own words, it's all about "taking popular discrimination seriously" (16) and trying to span the bridge between the fan and the academic. The critic's task is to *orchestrate* "a collusion between selected musicians and an equally select part of the public" (67) in order to define a kind of ideal musical experience.

In matters of taste, Frith's position is very clear: "I'd take pop artifice over rock naturalism any day" (1988:91). His favorite act is the Pet Shop Boys (1996:6-8). This illuminates his celebration of the Stones as "funny" and "clever" in *Stranded*. As suggested before, in Frith's case such a postmodern(ist) reading seems as much a matter of habitus as a response to the Zeitgeist. To Frith, all music is fundamentally impure, and Britpop, being an acculturated suburban version of African American music, has always been aware that authenticity is a *code*. Musicians work with conventions; nothing comes naturally (1988:4). At the same time, Frith's taste is for the "unpopular popular," which involves the belief

> that the 'difficult' appeals through the traces it carries of another world in which it would be 'easy'. The utopian impulse, the negation of everyday life, the aesthetic impulse that Adorno recognized in high art, must be part of low art too. (1996:20)

Music for Pleasure starts with a variation on a recurring 1980s theme: "I'm now quite sure that the rock era is over." The tradition from Presley to the Pistols is judged as a by-way in 20th century popular music, now made obsolete by technology and capital. However, the author doesn't feel any regrets: "there is something essentially tedious these days about that 4:4 beat and the hoarse (mostly male) cries for freedom," and perhaps other forms of mass-produced music "don't work in the way we thought, either" (1). The instability of this post-punk world of scattered "taste markets," where nothing seems truer than anything else (5), has left its imprint on the collection's criticism pieces: "Two years ago I wrote that 'British pop is more interesting, more exciting, more adventurous than it's ever been'. Today [1984] I'm convinced that it has rarely been so trite and dull" (1988:192).

The main themes of the book—the impact of technology, aspects of social class, musical conventions—should be familiar to a Frith reader. Of the academic pieces, most deal with media history, the chief exception being "Why Do Songs Have Words?" The drift of this important article is anti both written poetry and realist reading approaches. Enlarging upon tenets introduced in *The Sociology of Rock* the author stresses that rock lyrics are meant to be sung and

therefore come closer to plays than to poems, and that their primary reference is common speech, to which the best lyricists, like Smokey Robinson, bring a kind of *Verfremdung.*

The journalism deals with a variety of subjects: contemporary pop acts (New Romantics being exposed as teeny-boppers in disguise), rock and gender, film music, college audiences, the death of John Lennon, cartoonist Ray Lowry, etc. When the starting point is a concert or a record, Frith soon departs from it in order to discuss some problem of a more general character. This means that there is rather little sensuous detail, no interviews and a great deal of reflection. In short, the academic and the journalistic contributions tend to differ mainly in length and the number of footnotes used. An illustrative example is the 8-page dissection of Springsteen's "authenticity rock," "The Real Thing—Bruce Springsteen," prompted by the success of the CD box *Live* 1975–1985. It points to the contradictions of the artist's image—a millionaire who dresses like a worker, a 37-year-old teenager, a superstar-as-friend, etc.—and argues that what makes Springsteen transcend them all is "his art, his ability to articulate the *right* idea of reality" (97). This involves the use of conventions drawn from a number of sources: among others, American populist anti-capitalism, realist story-telling, the sounds of classic rock, soul's public display of energy, and the performance of male bonding. To Frith, the view of Springsteen as the voice of the American people is subverted by the fact that the line between democratic populism and market populism is dangerously thin. He thinks "Live," like all monuments, "celebrates (and mourns) the dead, in this case the idea of authenticity itself" (101).

Such analyses constitute criticism in the best sense of the word, and if one is tempted to cast Frith as first and foremost a scholar, this is also to pass judgment on the bulk of rock criticism. Contrary to most of his colleagues Frith never sets style before communication. He is well read, an acute observer and a mobile thinker. The price that he has had to pay is a (perhaps unavoidable) distance to lived experience as epitomized by the likes of Nick Kent.

Chapter 8

Academic Leanings
and Consumer Guides
(1986–2004)

8.1. A Wealth of Positions

After the relative unity of New Pop, both the music and the criticism field split up once again. In criticism a plurality of voices or positions appeared, some continuing the "*Face*-ification,'" others returning to the underground, still others taking up political agendas like racism and feminism and a few reaching for a "rock-(or whatever)-as-modern-art" position. In different degrees they all had to adapt to the growing aesthetization and concomitant commodification of distracted quotidian life. Although the excesses of New Pop criticism were tempered, the agents had learned an important lesson: that aesthetics can be applied to other things than rock, in this case pop, and that the authentic and the artificial were not in fact separable, which resulted in vague notions of "meta-authenticity." "The age of style" had also left its mark as distancing, posing and ironizing for their own sake lingered on and solidified in the 1990s as a cool pop sensibility. Smart trendsetters could apply the aesthetic gaze to any kitsch; an interesting example of this is the reemergence of easy listening in the 1990s. In the mainstream Mike Flowers had a hit giving Oasis's "Wonderwall" the kitsch treatment, while *The Wire* published several articles in which original easy listening was interpreted and discussed in detail.[1] The trend even fostered a book-length history of the genre published by a *Wire*-related company (Lanza 1995). In general, the status of kitsch was for some time removed from easy listening, and very different kinds of assessments appeared, stretching from "yet another piece of fun" enjoyed at a safe, ironic distance to taking it seriously as a historical expression of how to deal with the climate of the cold war.

1 For example, Ken Hollings wrote that "[n]either Les Baxter nor Martin Denny were under any illusions about how 'authentic' their music was. It was about introducing something atonal and foreign into their harmonies, turning noise into 'sound,' redefining the space between Us and Them. Denny called it 'showmanship'" ("Apocalypse Hawaiian Style," *The Wire*, July 1998:45).

With the most notable new agents of 1986 turning away from the top of the pops there was a restructuring of the field. Pop became mainly the area of *Smash Hits,* whose circulation topped at nearly 800,000 as late as 1988, but fell to half that figure only two years later. Some agents, like the new magazine *Q,* returned to well-tried standards and sought comfort with old rock stars, while others, like the Simon Reynolds clique at *MM,* turned towards the new underground. *NME* "invented" the shambling (indie) bands, who were decidedly unstylish (in *The Face*'s sense) but very aware of style nevertheless, and rap and noise rock followed soon afterwards. Techno was not covered to any great extent by the established music press or any critics until well into the 1990s, according to Reynolds, because it was considered a fad in the 1988 "Summer of Love" (personal interview, June 21, 1999).

With regard to design, *MM* and the new magazines *Q* and *Spin* chose a strategy that contrasted with the those of the style bibles and the teen mags. They picked a stark black/white look with the pictures clearly separated and lots of text, indicating a new moderation and seriousness. In content as well, *Q* adopted a stance different from that of *The Face,* focusing on music, more specifically rock stars from the 1960s and 1970s, and expected the fans to be still interested—and they were. Also, *Q* preferred objective reporting in which the journalist was as invisible as possible. As with *The Face,* the message was the magazine, not the journalists' opinions. In the end *Q* became a consumer magazine rather than a forum for serious criticism, partly because the editors planned the magazine along magazine industry lines and found themselves in a niche that happened to be music—to them a men's hobby alongside sports and cars.

MM, on the other hand, hired a gang of Oxford fanzine writers and gave them ample space for printing lofty essays written in a decidedly academic style. The new *MM* critics drew explicitly on their academic backgrounds, contributing a theorization of rock along the lines of Julia Kristeva, Roland Barthes and other French poststructuralists, then considered de rigeur in progressive humanities departments. The seeds of Penman and Morley blossomed. Later on agents within this field position also took up ethnology as a means for reflecting upon music.

This led to a rapprochement between avant-garde critics and the academy. It even became possible for a few critics to transgress the borders of rock criticism and enter the general cultural field as "serious" cultural commentators. This, of course, added to the amount of legitimacy of the field of rock criticism within the general cultural field. In sum, *Q* and the *MM* clique represent different positions in a field where agents tendentially were to belong *either* at the autono-

mous or the heterogeneous pole, while the middle position, inhabited by the inkies, gradually became less important through the 1990s.

In the U.S. the polarization was not quite as obvious, although the difference between rap and rock magazines is one major dividing line (you find rap articles in rock magazines but not vice versa). Instead of spreading out towards the extreme ends of the field, the middle of the field became diversified to an unprecedented degree as new magazines and African American and female critics (some even both) surfaced at a national level. They took up positions along a vertical line between the field extremes, stretching from consecrated to illegitimate music, from the quest for the important to cruising popular culture for the fun of it. The difference between these two polar attitudes (the first "modernist," the second "postmodernist") is explained by Reynolds:

> There are two big approaches to rock writing in America. One is the abandonment of the idea of pop as subversive, as a change of the world. But they still look for traces of subversion or subversive ideas. So they would analyze Alanis Morissette and her sexual persona. They would look at pop cultural artifacts and read it for signs of the progressive. It's not like punk, where everyone rallies around the bands and the bands try to change the world and threaten the establishment. But it's still a kind of left liberal idealism—looking on the bright side through pop culture and trying to locate things worthy of approvement. The other is where everything is open for your amusement. It's the ironical approach where your gaze flicks across pop culture and finds amusement in this or that. There's no real aesthetic, it is just a sort of omnivorous approach. You're looking for amusement, and people accept the idea of total incoherence. They do not make the same kind of investments, like, in the past you would make an investment in a cultural formation or a band and it would last for a while. Now, people's investments are much more provisional, an ironical mindset; I think it is very fleeting and provisional. (personal interview, June 21, 1999)

The first attitude described by Reynolds is still related to the old authenticity paradigm, albeit toned down. The second has developed from *The Face*'s (and postmodern culture's generally) celebration of surface, resulting in a postmodern pop sensibility in which investments may be changed at the drop of a hat. Provisional and often contradictory investments are held together by an ironic stance that could encompass, say, both Madonna and Nirvana. To such critics value scales and aesthetic judgments have become relative: at one moment the Spice Girls are praised for their pop superficiality and silly images while in the next Jeff Buckley is lauded for his deep insight into the human soul. Actually, both

represent a few minutes of "fun," the promise of a "feeling" that is at the same time precluded due to an ironic distancing.

Just as old music was recycled as samples, old ideas became mixed up with new. In the U.S. politics became part of the equation once again as the Parents' Music Resource Center's crusade took off in 1985. It met a united front from artists and music magazines against any form of censorship. The detailed discussions of AIDS policies in *Spin* and *Rolling Stone* are another example. As in the 1960s, there was once again a common, if less deep-rooted, political cause— a clear example that popular music in the U.S. has closer relations to the political domain than in most European countries, where the politics of popular music are less obvious. This aspect of the American field of rock criticism can be attributed to its roots in the underground press in general and more specifically to the *Village Voice*'s leftist line, to *Rolling Stone*'s music-as-part-of-culture and general interest line and to the politicization of rock in the late 1960s.

The split reception of Nirvana was quite a different matter. To some it was a great new rock group with deep roots in American punk, and it could be explained in the old (sociologically inspired) ways as a clear expression of a new generation, the X'ers. To others, Nirvana had sold out just by releasing *Nevermind* on Geffen Records. To still others, hard rock could not be taken seriously, as anger and lyrical incoherence was not on the agenda that season—it was just old-fashioned (cf. Nehring 1997:79–104). Here we have the coexistence of a multitude of value systems, which is visible even in the present-day record review sections in *Rolling Stone*.

Other Voices, New Agendas

At least from a European perspective, the "great" American magazines have been founded by Anglo-Americans or by Anglo-American-dominated companies, and most journalists are Anglo-American as well. This does not mean that music made by African Americans has been totally neglected, but the space devoted to it has changed quite a lot through the years. During the 1960s many genres normally associated with African Americans were used to construct a prehistory of rock, but after 1970 music associated with African American culture became more and more neglected in critical discourse as it was placed on the wrong side of the great dividing line. In *NME*, for example, in a review of the *Woodstock* film under the heading "Woodstock: Best Film Ever Made," Richard Green was allowed to write blatantly racist remarks like this: "Of the thirteen act featured in this film [...] only one disappoints. Suffice to say it is Sly and the Family Stone who behave like irate chimps whose tea is late arriving, and leave

it at that" (May 23, 1970:12). This process culminated in disco—which was not neglected but widely and actively reviled, for example by the public burning of records (Ward et al. 1986:532). In its early years MTV played next to no videos featuring African Americans; only the success of Michael Jackson and Living Color forced them to change their policy. But it was not until 1989 that music made by African Americans featured regularly in the program *Yo! MTV Raps* (Rose 1994:8).

The U.S. had to wait until the 1980s before rock critics of African American origin manifested themselves, Nelson George and Greg Tate being among the first. Christgau and the *Village Voice* have been instrumental in their joining the ranks of leading critics, and both *Rolling Stone* and *Spin* gave space to African Americans during the 1990s. Among these were Danyel Smith who managed to cross over into editing and served as editor in chief for *Vibe* from 1997 to 1999. Although African Americans have been allowed into the field they have mainly written about the music most closely associated with African American culture—soul, R & B and rap remain their beat. An aspect peculiar to hip-hop criticism is the meeting between journalism and the street ethos that can result in the threat of physical violence. For example *Blaze* editor Jesse Washington was allegedly threatened with a gun by one rapper and beaten up by another on a separate occasion (McLeod 2002). These are not isolated events and they constitute an aspect that other music journalists only very seldom have had to deal with.

Rap's commercial breakthrough—probably the latest major happening within American popular music—came in the mid-1980s, but it was not until around 1990 that national magazines devoted to rap music came about. Until then an Englishman, David Toop (1984/1991/2000), had been rap's main historian. The absence of magazines through the 1970s and 1980s can be explained in many ways. One reason could be that the music is part of an oral culture with few models for written criticism; another, that the music was partially covered by general interest magazines like *Ebony* seeking an African American public. Why then magazines about rap? Tricia Rose (1994:7) suggests that the appearance of *The Source* coincided with rap beginning to cross over to a white audience, but this shift is not visible in the pages. Perhaps rap magazines were politically motivated by a new sense of cultural and musical identity among African Americans created by rappers building on experiences from the 1960s Civil Rights Movement and the Black Panthers.

Today, several national magazines with a large circulation focus on rap music. *The Source* (f. 1988) is the leading and oldest one, having evolved from fanzine to commercial magazine. The others were introduced in the 1990s, first

Vibe (f. 1993), then *Blaze* (1997–1999)[2] and *XXL* (f. 1997), all based in New York. Ironically Vibe Ventures (started by African American entrepreneurs, among them Quincy Jones) bought *Spin* in the mid-1990s. But this does not make any of the rap magazines hesitate to make fun of guitar-based rock's inability to cook up anything new. These magazines and many more have given nonwhites the column space to express their views of their own music. Robert Christgau explains that

> due to the rise of the hip-hop press there is a substantial presence of people of color, especially African Americans. It is the first time ever in American history that black people write about their own music—first time ever. And whatever the limitations, and I think they are numerous, it is an enormously positive de-velopment. (personal interview, April 18, 2004)

Despite its "substantial presence" hip-hop criticism remains a world unto itself. Music criticism to this day is in fact segregated, mainly due to institutional racism, even if the hip-hop press has opened up for nonwhite and nonblack writers like Chinese Americans Jeff Chang and Oliver Wang. As Chang points out in a critique of the series *Da Capo Best Music Writing* (Wolk 2000, Hornby and Schafer 2001, Bresnik and Lethem 2002, Groening and Bresnik 2003, Bresnik and Hart 2004):

> Da Capo's Best Music Writing series demonstrates the old problem that activists of color, feminists, and gay and lesbian activists raged against during the 1980s. A very particular kind of worldview—in this case, one that favors white, male, English-only, New York-approved, rock-centric writers and writing—is passed off as the universal standard of excellence. Once again, this point seems so obvious that I'm embarrassed to write it. ("Return of the White Noise Supremacists: Truth, Lies, Da Capo's Best Music Writing series, and the White Man's Burden." *San Francisco Guardian*, January 7, 2004, http://www.sfbg.com/ 38/15/art_music_white.html)

Even though a few nonwhite critics of non-rock genres have obtained central positions within the field of rock criticism through, among other things, writing for rock magazines, it seems that hip-hop criticism in general constitutes a distinct subfield. Most hip-hop critics do not cross over, and if the content of

2 *Blaze* was a spin-off from *Vibe*. Both are published by the same company as *Spin*, Vibe/Spin Ventures LLC. *Vibe* is first and foremost a lifestyle magazine, splitting copy evenly between fashion and music, while *Blaze* focused on music. Both refer to Hispanic music and culture as well.

the *Da Capo* series can be seen as a contribution to the canonization of critics (as Chang seems to think it can) they do not stand many chances of being included since more than 80 percent of the writers in the first four editions were white males. Instead, a younger generation of writers have chosen to publish books on the best rap albums ever (Wang 2003) and the best of hip-hop journalism (Cepeda 2004). Despite hip-hop criticism's partial autonomy (or exclusion) we have chosen to see it as a part of the field of rock criticism because of shared basic values and because some critics have been able to cross over.

In England, hardly any women have made a lasting career out of rock criticism, whereas in the U.S. at least a few have succeeded in staying in business (e.g., Jaan Uhelszki, Lisa Robinson). In general, more American women critics have appeared in print than their British counterparts. This does not mean that the situation is fine, only that rock criticism is not quite as much a boys' club in the U.S. Evelyn McDonnell claims that "from roughly 1975 to 1985 was a Renaissance period of female rock criticism, a time when talents and philosophies flowered" (1995:13). It may be questioned whether it was indeed a *re*naissance. Although Ellen Willis and a few others had been writing almost since the beginning of rock criticism, it would be more precise to talk about the birth of criticism written by women around the time of punk. McDonnell offers no explanation for this birth apart from feminism in general, but feminism, understood as a theoretical complex, probably influenced the rock world only in a very indirect way. Other explanations might be that rock had lost its status as a focal point for the changes in society, thus making it a less relevant and less high profile topic to write about, and that punk opened up for women taking on other roles than window dressing.

Nevertheless, most women never got to be more than freelancers, and the opening closed again in the mid-1980s when criticism became professionalized. The margins were cut and more unusual or personal ways of writing were discarded. Robert Christgau describes it thus: "the business became increasingly important and straight journalism caught on, so there began to be rock critics at the daily papers. […] It became a profession that people thought they could do. It was, inevitably, professionalized, and the room for that fannishness diminished" (quoted in McDonnell 1995:16). Because many women writers had chosen a subjective and personal angle, they disappeared. Another aspect is that women tend to stop writing about music in their mid-thirties, either to raise families or because music becomes irrelevant to them (Ann Powers, personal interview, April 18, 2004). In the 1990s, however, some women were again writing professionally for the biggest magazines and newspapers and in the process

gaining their male colleagues' respect.[3] At least four nationals have had women editors in chief for extended periods—Susan Hamre at *Request*, Danyel Smith at *Vibe*, Mimi Valdez at *Blaze* and Sia Michel at *Spin*.

McDonnell argues that stylistically, female critics have been more open to experiments, which may well be true for the U.S.. The prime example is Patti Smith's 1970s pieces in which nearly all traditional values of criticism are thrown overboard in favor of personal visions and ramblings, reminiscent of her lyrics (cf. p. 13). But even a more sober critic like Ann Powers brings her personality into the text and sometimes uses quite poetic prose (McDonnell 1995:21). Powers herself points to structural reasons for women writing differently:

> There is not an essentialist difference but there is a structural difference in the position that women hold in rock culture and in culture in general. Women write from a different position than men. They rarely write from the center but from the margins and they get a different view from that place. Women have not been welcome into or chosen not to participate in fan boy culture, although I think it's changing nowadays. (personal interview, April 18, 2004)

New voices have entered the field and they have to some extent broadened the agenda, not changed it. But it is still harder for nonwhite males to obtain a position within the field of rock criticism. The majority of the 3,000 to 4,000 rock critics working in the U.S. are still young white males (Christgau's estimate, personal interview, April 18, 2004).

The Reaction to Punk Politics
Pop and politics have always been strange bedfellows. Despite the political polarization during the right-wing turn in the 1980s, most musicians and critics concentrated solely on music. The magazines, on the other hand, generally endorsed a liberal or left-wing line, and in England all three inkies (*NME, MM, Sounds*) and *The Face* took up a left-wing stance against Thatcherism. For example, *NME* Ian McDonald wrote three consecutive large articles about the realization of Orwell's *1984* in present-day Britain. The political engagement culminated in 1985 when *NME* printed two three-page articles about the miners' strike and put Neil Kinnock, then Labour leader, on the front page as a

3 For example Robert Christgau's: "Ann Powers, who writes for the *New York Times*...I think is actually the best active rock critic in the U.S. right now. Ann is, she's doing magnificent work, magnificent" (personal interview, May 22, 1998).

trailer for a three-page interview.[4] Furthermore, the movement Red Wedge—with roots in 1970s movements like Rock Against Racism and punk's populist strand—was formed with the explicit goal to support Labour in the 1987 general election. Among the musicians in Red Wedge were Billy Bragg (also one of the founders), Paul Weller and the Communards; former *NME* editor Neil Spencer played a central role in the organization.

In this context, rock was considered subversive simply because it supported left-wing causes. But after the mid-1980s a new and somewhat different angle on rock subversiveness appeared, primarily in the pages of *MM*, led by the group of new *MM* critics, Simon Reynolds, David Stubbs, Paul Oldfield and the Studs Brothers. One characteristic of this group was that their articles often carried two bylines. They constituted a new generation of British critics who had not experienced punk firsthand and tried to avoid the large shadow it cast. In two articles Reynolds and Frank Owen trounced punk's populist strand.[5] They grouped together magazines like *NME*, *The Face* and the *New Socialist*, writers like Neil Spencer and Jon Savage, musicians like Paul Weller and Matt Johnson, and the Red Wedge movement as part of the "sinister cult of Social Realist Pop." According to Reynolds and Owen the stance of these socialists was the same as 1950s mass culture critics: they contrast a pop music belonging to a "genuinely popular culture" with a pop music as a product "that corrupts and inhibits." The pop fan is reduced to being a receiver of a singular message, instead of being able to play around with multiple simultaneous meanings. Reynolds and Owen question the picture of punk's "radical reality" and "social concern," maintaining that punk's concerns were taken from media babble, not from social reality, and they contrast the social realist perspective with their own Nik Cohn–inspired views:

> Their aim is to abolish or curtail the fantastical elements of pop (those elements that Nik Cohn referred to as "Superpop...the noise machine...the image, hype and beautiful flash of rock 'n' roll music") in the interests of some spurious

4 McDonald, Ian (1980): "The NME Consumers' Guide to 1984" (parts I–III), *NME*, August 23:29–32, August 30:25–26, 31–32 and September 6:31–34 (all the pages are very wordy and together the three articles would fill a small book); Moore, X. (1985): "Lives on the Line," (parts I and II), *NME*, January 5:20–22 and January 12:6–7, 28; and Hewitt, Paolo (1985): "The Neil Kinnock Interview," *NME*, April 27:12–14.

5 "These Loafers Kill Tories," *MM*, November 8, 1986:20–21 and "Designer Socialism," *MM*, November 15, 1986:31. All quotes in this and the following paragraph are taken from *MM*, November 8, unless otherwise stated.

realism. Fantasy is regarded as some kind of consumerist con. What pop music should be about, goes the argument, is the real world (will the "real" world please stand up, say we). What is ignored here is that pop has always been about fantasies. Pop is not about the narrow reflection of the "reality" of what and where you are, but about who and where you'd rather be.

The crucial word here is "fantasy," which is understood in a very broad and vague sense as possibilities. In the follow-up article Reynolds and Owen suggest that fashion and pop music are intimately connected to an amorphous desire that "is antagonistic to socialism as it is to *all* forms of organization. 'Designer socialism' is an attempt to accommodate desire, but can only succeed by stabilising desire, suppressing its anti-social elements" (*MM*, November 15, 1986:31, italics in the original).

In the article "The Impossible Dream" (*MM*, May 28, 1988:46–47), written two years later, Reynolds and Paul Oldfield return to these topics in a more nuanced way. Their main objective here is a critique of the Situationist legacy in pop. After a short analysis of the May 1968 events and McLaren's various projects, they describe the essence of the Situationist ideology as a liberation of the subjective desire from all constraints, including the commodity and the "spectacle," in order to obtain absolute individual autonomy, ending all power relations. Reynolds and Oldfield argue that, although desire is central to the idea of something else beyond the existing conditions, it is impossible to just liberate it. They thus acknowledge "the moment" (cf. p. 231–32), but argue that it is not reached through creativity and activity, but through passivity:

> Pop Situationism (punk DIY, the new glam's "reinvention of yourself", and the Vermorel's inflammation of mass desire) all assume that people's moments of release are the one where they are active, expressive, desiring agents, creative and self-creating. We'd argue that the supreme moments in a life, when people are most emancipated or transported, are when they are overwhelmed and undermined: the passivity of being ravished or mesmerised. (47)

In contrast to the Situationists' basically optimistic views, Reynolds and Oldfield do not regard these mesmerizations and ravishings as leading to utopia. They only have a carnivalesque function as a break from daily life, where reality can be turned upside down.

With this new generation of critics several basic topics lost their importance: left-wing politics (whether Labour or Socialist Workers' Party); the critique of the music industry and the mass media in general; the interpretation of the

moment as a fleeting glimpse of reality, carrying possibilities for a better life. This marks a separation of a traditional politics from a politics of the body or desire, which before Reynolds and his compatriots were intertwined, partly due to the mix between body and politics found in various European avant-garde traditions from Dada to Situationism, partly to the mix of "art" and commerce. After the mid-1980s, their background in French poststructuralism made the Reynolds clique ignore traditional politics and retreat into private and often destructive bodily desire.

Rock Criticism and the Academics

Generally, musicians, audiences and critics nurture a genuine hostility towards academics, especially sociologists, but also musicologists. As mentioned, Simon Frith was able to cross the border from the academic side, and critics like Ian Penman began to use French poststructuralist terminology, slowly becoming better at it. In *NME* the antiacademic line seemed to be the official one, although more theoretically inclined copy crept into it. Even if theorization became more and more common during the 1980s, it is still suspect to most readers and many critics. An academic writing style is not acceptable to the editors either. At the same time, the academy has slowly changed attitudes:

> The political analysis of popular culture has in the last twenty years undergone a radical overhaul, in which elitist, economistic, reductionist, and pessimistic approaches have been replaced by emphases on relative autonomy, audience resistance, multiplicity of meaning, and a politics of pleasure. These arguments have sharpened our understanding of how ideological reproduction is dispersed throughout the social formation […], and they have usefully pointed up the ways in which culture can be seen as a site of contest, rather than domination. In relation to rock and pop culture, the critique of elitism has been especially important as a way of validating popular musical forms […]. (Goodwin 1993:157)

Andrew Goodwin's brief sketch shows that an academic body of knowledge and a set of relevant analytical tools have emerged. After critics had tried to raise the status of popular culture for years, legitimization went on the agenda for some of the humanities and social sciences. Cultural studies was probably the first academic discipline to have an important influence on pop critics. Early academic/scholarly contributions, like musicologist Wilfrid Mellers's Beatles study (1973), had a limited impact because the music was treated as a classical art object. Dick Hebdige's *Subculture: The Meaning of Style* (1979), on the other hand, became enormously influential both within and outside the academy as

it fused Gramscian politics, Genet's literary modernism, and semiotics in an interpretation of punk and reggae culture. The book is one example of the general turn towards linguistics that took place in the late 1970s and early 1980s (cf. pp. 240–241).

Furthermore, the new video phenomenon made a host of academics from media studies venture into popular music, though their focus normally was on the visual aspects only. The videos were seen as *the* postmodern phenomenon, much in line with Baudrillard's theories of "simulacra." It was this praxis that popular music critics gradually addressed, trying to balance giving in to the experience (the spontaneous "visceral" sensation) with academic knowledge. Together with some academics' refusal of an elitist stance, this made continuous contact between the two fields possible. As Angela McRobbie has noticed, since the mid-1980s more rock critics "have followed a freelance route through the music press, the style glossies and the Sunday newspapers to the *New Statesman*, *ZG* and *Marxism Today*" (1989:xv), thus blurring the line between journalists and academics. Her own anthology, *Zoot Suits and Second Hand Dresses* (1989), is an obvious example as it includes texts from both academics and critics (among the 22 contributors are Penman, Frith, Savage, Reynolds, Oldfield, Stubbs and Marcus).[6]

Frith and Savage (1993) discuss how the two groups became closer on a general level through the 1980s. They deplore that cultural studies have given in to journalism's indiscriminate celebration of popular culture, forgetting in the process a critical stance. Journalism's prestige has risen above the academy's due to a new populism based on constant references to lived experience. By repeatedly referring to popular culture these ideologues articulated common sense, and "[i]n broader cultural terms, the effect has been to elevate the authority of experience (valorized in much feminist and pop writing) over the authority of the intellect, and subtly to change what is meant by knowledge" (112). Instead, Frith and Savage insist on the Frankfurtian notion of the academy as "the culture of the dissatisfied" (115), as the place in which changes for the better can be thought, while they also maintain a critical populist position: "[T]he truly popular describes something remarkable, that work or event or

6 Simon Frith has contributed to this as an anthology editor, e.g., Frith and Goodwin (1990), which includes articles by Reynolds, Marcus, the Vermorels, Sue Garrat and Holly Cruise; and Frith (1988), of whose contributors Frith alone held an academic position at the time. In the U.S. this practice can be seen in, for example, DeCurtis (1992), Kelly and McDonnell (1999) and Weisbard (2004).

performance that transforms people's ways of sensing and being" (116). This indicates that, although the border between journalism and academy has been crossed, it is still contested even though journalists seem to have taken the lead in certain areas of cultural studies, in popular music studies and in popular culture itself.

8.2. The Critics

A Comparison Between the American and British National Fields
Critics from the two countries have always looked upon each other with some suspicion despite mutual influences. In the 1970s Simon Frith reported from England for the *Village Voice* and later for the *New York Rocker*, while Simon Reynolds as a Brit in American exile has written extensively for *Spin*, even holding a post as senior editor for some time in the later 1990s. Lester Bangs was one of the few Americans allowed into the hub of British criticism in 1970s *NME*. Whereas only few American magazines since the 1960s have covered British music extensively (e.g., *Trouser Press*), British magazines would have been unthinkable without comments on American music.

Nevertheless, the differences are conspicuous. In the U.S. new musical genres have not generated new magazines at a national level, the exception being hip-hop. *Spin* is traditionally connected to new wave and indie rock, but those genres only slowly surfaced commercially in the U.S. From the start the magazine covered rock and pop in a broad sense, although it also acknowledged local scenes. In Britain, many magazines seem to have appeared in connection with new musical genres (*Sounds* in connection to progressive rock, *Smash Hits* and *The Face* to New Pop, and *Muzik* and *Mixmag* to dance). *Musician*, *Spin*, *Q* and *Mojo* have all been commercial ventures tapping into the mainstream of rock writing and commenting on new genres as they appear. The sometimes fierce competition in the English market cannot be found at a national level in America. It is extremely hard to enter it because you need to attract national advertisers, but once you are in, advertisers and readers seem to be quite loyal.

On the whole, the "irrational" style and academic interests of British critics have not had any great impact on American writers. For example, the U.S. did not take to punk nationally in the 1970s and thus did not spawn any significant new magazines or writers connected with it. According to Christgau, new writers and local magazines, taking off from American punk, appeared only at the beginning of the 1980s (cf. p. 213). On the question of theorization, Richard Gehr, the first managing editor at *Spin*, comments on the early 1980s:

There were no parallels in the U.S. to the theorization that happened in England in the early and middle eighties. Only in odd corners. The academic influence on criticism in the U.S. pretty much stopped in the mid-sixties, when people like Marcus and Christgau graduated, it's still very fifties, early sixties sort of English criticism. There are two kinds of textual criticism: the deconstructive criticism, that actually took a text and took it apart in and of itself, working at the relationship within the text. And then there's American literary criticism. Deconstruction became institutionalized in the eighties. All the graduate students picked it up and took it to the academy combined with identity politics and multicultural studies, but not to rock criticism. Only identity politics have influenced rock criticism to some degree as people who write about rap music are pretty tuned into that, and Henry Gates Jr. seems to have influenced people who write for *Vibe* and white rock critics who write about rap music. (personal interview, June 23, 1999)

English New Pop was exported to the U.S. thanks to MTV, but the related critical apparatus was not, apart from a few local experiments. The U.S. did not produce any new individual agents carrying the theoretical torch until identity politics turned up in the guise of feminism (it was, among other things, used to discuss Madonna, who since the mid-1980s has taken the New Pop aesthetic to its logical conclusion) and African American studies, which was applied to rap. This is echoed by Ann Powers who notes that only "the late 1980s saw the rise of identity politics on campuses and in activist circles" (2000:34). For a while, the hegemony of the old agents was too strong, and they were not particularly interested in new trends. Sets of criteria for good rock had become stable (roughly, Marcus's more academic and Christgau's more populistic) and the very influential journalistic ethos of good reporting had been established by *Rolling Stone*.[7] It was thus impossible for American writers to adapt to a British writing style. As Gehr formulates it:

> English writers are a lot more argumentative, pedantic, disputational among themselves, a bit more dynamic. They really argue about stuff, they are much more vehement. They can actually have a debate going on about the value of music. The Americans are not as well educated as the British critics. The British usually have a pretty decent classical education and probably have more critical instruments at their disposal. In a way they always seemed a lot more glib and a

7 In an internal *Spin* memo factual inaccuracies are seen as a very serious problem, a failure to "respec[t] our readers' musical intelligence" (internal memo from Bob Guccione Jr. to all editors, February 2, 1986).

lot more facile than their American equivalents, which I thought was a lot more entertaining. You know, criticism as flash. For them criticism seemed to be a performative activity and in America it seemed more reactive, probably because of the history of film criticism and because in England they had three weekly rock magazines for a country of 60 million people, whereas in the U.S. there are zero weeklies for a country of 270 million people. In America there is never any hot critical debate. It is more diffused between the east and the west coast, but there's a lot more going on musically, there's a lot more scenes going on. (personal interview, June 23, 1999)

To Gehr, the fundamental difference is that the climate for public debate on music is better in England because of higher publishing frequency, because British critics are better educated, and because British music criticism is an individual performance rather than a description of events. Important, too, is the fact that the sense of national unity is less important in the U.S. than in Britain. These views are seconded by Simon Reynolds:

In this country [America] rock writing is considered much closer to proper journalism so there is a much greater tradition of objective journalism. People will say to me, thinking that they are praising me: "Well, that story was very well reported." You know, the whole idea of reporting stuff, secondary quotes, a balanced, objective piece—despite this being the country that invented new journalism, Tom Wolfe and that. Whereas in England music journalism is considered a very inferior form of journalism, it has very little legitimacy in English culture. It's very poorly paid, so people there write much more like they do in fanzines. They blurt out their feelings, they're much more passionate and gushing. And Americans hate them, they are always complaining about English magazines, saying: "Ah, they just hype things up. They are so unbalanced. The English press build them up and then they knock them down next year. In England records are either the best thing ever or shit." People just totally abuse them, and you are not allowed to do that here. Here, people are valued for writing in a very measured way. If everything is one out of ten, it's like six, seven, eight. You're not supposed to be too unkind here or too praiseworthy. (personal interview, June 21, 1999)

American writers have stayed with a tradition of good journalism that (with few exceptions) owes more to Marcus and *Rolling Stone* than to Bangs and *Creem*. And it is significant that the most anarchistic of the old school critics, Richard Meltzer, has become neglected, although he is still active.

The differences in writing style, media organization and aesthetics, among other things, make it possible to view British and American criticism as sepa-

rate fields with power structures that do not influence each other. On the other hand, they share a set of basic values as a general frame of reference, be they modifications of the authenticity paradigm established in the late 1960s or the postmodern pop sensibility, which is now at work in both countries. In this way, Anglo-American rock criticism can still be considered a transnational field despite local differences.

Populism Versus "Seriousness"

> The Q Rock Stars Encyclopedia eschews critical opinion in favour of a torrent of factual data: UK and US chart placings, dates, locations, till receipts. Somehow, these facts tell us more about the history of rock 'n' roll than any critical musings ever could: the Buzzcocks signing a record deal the day Elvis Presley died, for example.
> —Mary Kelly[8]

Most would expect such a statement, when coming from a British music critic, to be ironic, but nothing in it suggests such a stance. The quotation conjures up a return to a precritical state of precriticism in which the registration of absurd facts or curious coincidences rules the day. From this perspective the quote appears reactionary and populist. But trainspotting continues to exist as one of the motive forces of rock journalism, and its relationship to such traditional journalistic virtues as "objective" reporting deserves some attention. The factual ideal is succinctly expressed by *Billboard* editor in chief Timothy White:

> Hopefully, the informing principle in all good journalism is that no one, least of all a responsible reporter, should ever try to understand any person too quickly. [...] Facts are details confirmed by diligence, but the truth is a series of connections made that disclose the bolder shape and substance of the business of living. The worthiest goal in entertainment journalism is to be accurate in one's portrait while disappearing behind the process, in order to eliminate the distance between the writer and the subject. (1998:17, 18)

The notions of "disappearing," "distance elimination" and revealing the "truth" about the musicians have become characteristic of a large group of journalists and most magazines, whether British or American. Their primary task is to paint an accurate portrait of the musicians in question by using their own words,

8 "Q Rock Stars Encyclopedia" (review), *Q*, December 1999:180.

not so much to interpret or criticize. White is arguably the most important and respected writer within this "school," partly because of the influential positions he has held,[9] partly because of his highbrow writing style (a flowing language without too many frills, precise descriptions, suggestive contextualizations), partly because he has published several books (1983, 1984, 1990, 1994, 1996, 1998). With regard to content, there is no trace of fandom left in his pieces: they are the observations of a professional reporter. His frame of reference is the history of popular music since sometime in the 19th century, and like Marcus he uses that story as myth:

> Make no mistake about it: only America, the greatest social laboratory in the history of the planet, could have produced a cultural phenomenon as singularly violent, plaintive, reckless, tender, lurid, threatening, heart-wrenching, grotesque, corruptible, and vital as rock and roll. It took a land where every soul had a fairly decent shot at the awesome state of freedom with license to hatch an art form so triumphantly incendiary. (1990:xv)

White sees rock as an integral part of American culture, as an American art form. This view, here stated with some pathos, represents the argument for the institutionalized consecration within the field, and it is comparable to statements like jazz is "America's classical music."

Kelly and White represent two different versions of the populist strand. The first is limiting and condescending in that it just hands out pieces of unrelated information which might be used in everyday conversations between mates or in pub pop quizzes. The amount of such information resembles an act of disinformation. The second continues the tradition of American populism, indicating an "of the people" and a "for the people." In this figure the people, in the best of situations, represent "truth." Behind this sort of populism lies an egalitarian conviction that stresses the equal importance of high and low, a rebellion against authorities legitimating themselves only by reference to tradition, and a will to communicate, often by simplifying somewhat. Many American critics can be characterized as populists, but they adhere to different aspects of populism. White, for example, writes in the grand populist tradition, whereas

9 White (1952–2002) began working as reporter for Associated Press. In 1975 he moved to *Crawdaddy!* and three years later became senior editor at *Rolling Stone*. In 1982 he was sufficiently established within the field to go freelance, only to be appointed editor in chief at *Billboard* in the early 1990s.

critics like Chuck Eddy, Nick Tosches and Joe Carducci focus on the rebellious aspect, often just for the hell of it.

Other critics have come near the top of the hierarchy without pontificating. Jon Pareles, who started at *Rolling Stone*, and Ann Powers (discussed below) have used the institutionalized position of the *New York Times* and their own writing skills to formulate a more opinionated criticism. Pareles's beat is both the music and the industries surrounding it. He has commented intelligently and critically in the style of the seasoned columnist on, for example, new formats, the role and pricing policy of the stadium concert and the festival, the music profile of the 1997 inauguration weekend and music on the Internet. He has also done reviews of and long interviews with celebrated musicians for the *New York Times*, *Musician* and others. His detached writing style (using the conservative *Times* way of referring to people, e.g., Mr. Dylan) and the lack of personal presence (the journalist is seldom mentioned, and if so, in the third person singular) make him in some ways America's answer to Jon Savage—but without the political engagement.

At the other end of the spectrum stand critics like Eddy (discussed below), Tosches and Carducci, who all question the canon from a populist viewpoint. They will go for anything obscure within pop: Eddy, for anything not respected by others; Tosches, for pre-rock 'n' rollers; while Carducci keeps to a bar band aesthetic. They use lots of four-letter words and perform as iconoclasts while paying tribute to Meltzer. Tosches, who started out as a critic in the late 1960s and quickly turned to novels, begins his book *Unsung Heroes of Rock 'n' Roll* like this:

> [L]et's get is straight. Rock 'n' roll is dead. Deader than the eighties. Deader than Liberace. Deader than the papal penis. Dead. Bill Haley, the first white rock 'n' roll star, came, turned to shit, and went all in one fell swoop, by the summer of 1954. In other words, the cycle was already complete, the beast of rock 'n' roll had been tamed for the circus of the masses, by the time Elvis (another dead fuck) came along. (1984/1991:vii)

He is trying his best to be irreverent and entertaining by speed writing and by declaring rock 'n' roll dead before it even began, and his own foreword is followed by one attributed to Samuel Beckett! The rest of the book is an attempt to install a number of R & B musicians in rock history. Carducci's aesthetic is somewhat different, here characterized by Simon Reynolds:

One of the most interesting books in the last few years is the one by Joe Carducci [*Rock & the Pop Narcotic*]. He acts like a major canon rewriter. He has an amazing section at the end where he runs through the history of rock, listing all these minor hard rock and boogie band from the seventies, and he has something intelligent to say about them all, just one or two lines. He drops out Brian Wilson and the Beach Boys from his rock history but celebrates surf rock. He likes them because there's a kind of rhythmic urgency to them that the Beach Boys didn't have. They correspond to the model of a rock band that he has theorized. He is bound up with small bands playing with rhythmic energy, playing gigs constantly so they become a very tight unit. Not like a band where there's a singer and a producer and then hired musicians in the studio constructing a kind of sing-a-long rock which he thinks is a betrayal of what rock is about. So he runs from garage bands and surf bands through heavy metal and and hard punk in the eighties, to grunge. It's an interesting way of rewriting history. (personal interview, June 21, 1999)

Carducci's celebration of "real," guitar-based, sweaty rock constitutes one of the few major, seriously heterodox positions nowadays. In some ways it is connected to the growth of the American college circuit and the college radio format in the early 1980s, a market that also spawned local rock magazines. Here, "alternative rock" was established as the beneficiary of American rock and punk. According to Robert Christgau (cf. p. 213), the critics recruited by the nationals and the serious dailies from these mags became the next generation of American rock critics (e.g., Robert Sheffield and Joe Levy, both at *Rolling Stone*, and Chuck Eddy). Some of the old critics who are still around have their younger colleagues' utmost respect and are credited as active founding fathers. This goes for Marcus because of his wide horizon and his acceptance outside the field, for Christgau because he has kept it up so long within the field and mentored quite a lot of young critics, and for Bangs because he is dead. Of course, they also command respect because they are considered among the best writers. Consequently, the American field has not seen a great many clashes between orthodox and heterodox agents.

Journalists and editors have been moving freely between what we conceive of as different magazine genres and field positions. Nick Logan worked as an editor for *NME*, then *Smash Hits*, then *The Face*. Mark Ellen moved from a journalist's post at *NME* to the editor's chair at *Smash Hits* only to become founding editor of *Q*. This pattern goes for ordinary journalists as well. It is notable that their trajectories take them from the inkies to the glossies. This suggests that just as they discover new bands and build them up, the inkies discover new journalistic talents, build them up and bid them farewell when they search for less hectic jobs at the monthlies. It is also notable that hardly any of these writ-

ers move on to magazines covering, say, African American music or dance. These patterns indicate a way in which music journalists obtain cultural capital working for magazines. The next step is to get out of the magazine treadmill by becoming a freelance writer, first for the same magazines, but hopefully later on for newspapers and the wide range of general interest magazines. In this way critics enter the cultural field where they are allowed to discuss a broad range of topics and maybe even get to write books. Savage and Reynolds are the best examples of critics starting from "the bottom" at fanzines and working their way up through the music press to acquire the status of general cultural critics with a special interest in music and popular culture—and with the "license" to write books. They have been successful to such a degree that they are respected by both music critics tied to their beats and by academics, while Morley is an example of one who tried, but failed to establish himself with his 1997 book on punk. Another way out is to enter the business side of the magazine industry like Mark Ellen, who is now editor in chief at EMAP Metro, and Danyel Smith, who has become editor at large at Time Inc., or to move into the record industry.

The 1990s and 2000s were to privilege an old medium: the book. Both critics and academics wrote books like never before and the field itself became historicized by the many anthologies. Most central critics have published anthologies of their articles, anthologies with contributions from different writers have become quite common, and even reissues of old anthologies can be found. The increase in books on music includes musicians' biographies, overviews of scenes, and encyclopedias. In particular, the rise in academic books on popular music has been astounding when compared to the meagre harvests of the 1970s and 1980s. Some recent critics' books have already obtained the status of classics, for example Ian McDonald's book on the Beatles, *Revolution in the Head* (1994), and David Toop's *Ocean of Sound* (1995). This raises the question of whether rock criticism is moving away from magazines into books, which would mark another phase in the legitimization process.

In order to illuminate some central positions five critics are discussed in detail below. Two of them, Simon Reynolds and David Toop, take up slightly different, heterodox positions at the autonomous pole. This also goes for critics like Kodwo Eshun and Ben Watson. All four have written for *The Wire*, the main institutional agent of that position. The three Americans, Nelson George, Chuck Eddy and Ann Powers, are situated in the middle of the field but placed differently in a high/low perspective. George's main perspective is related to African American politics, Eddy has taken up a populist, more or less ironic position, while Powers has chosen a "serious" one.

Dionysos in the Groves of Academe: Simon Reynolds

Simon Reynolds (b. 1963) began his career writing for the fanzine *Monitor*[10] and moved on to *MM* in 1986 where he stayed for a couple of years as a staff writer. Later on he went freelance, penning pieces for U.S. magazines like the *Village Voice* since 1991, *ArtForum International* (1994–1996) and British magazines like *The Wire* and the *New Statesman*. For some time in the 1990s he held a post as senior editor of the New York-based magazine *Spin* and he reviewed electronica for *MM* between 1993 and 1996. He has written or cowritten three books and presently lives in New York.

In his introduction to *Energy Flash: A Journey through Rave Music and Dance Culture* (1998; U.S. title: *Generation Ecstasy: Into the World of Techno and Rave Culture*), Simon Reynolds describes two conversions. The first—a paragraph from a 1981 Barney Hoskyns review of the Birthday Party in *NME*—set him on the quest for the "Dionysian spirit." Taking off from Hendrix and the Stooges, he sought it in bands like the Pixies, Young Gods, and My Bloody Valentine. After the noise rock heyday of 1987–1988 he continued the quest and took to rave music. But he only "got it 'right' in 1991" in what he describes as a revelation, namely the experience of

> [...] music in its proper context—as a component in a system. It was an entirely different and un-rock way of using music. [...] There was a liberating joy in surrendering to the radical anonymity of the music, in not caring about the names of tracks and artists. The "meaning" of the music pertained to the macro level of the entire culture, and it was much huger than the sum of its parts. (1998:xv)

But long before these epiphanies was punk. "It has changed my life. I wouldn't have got excited about music were it not for punk, particularly the journey that John Lydon made from the Sex Pistols to PIL" (personal interview, June 21, 1999). Reynolds is aware of writing in a tradition as he demonstrates in the introduction to his anthology *Blissed Out: The Raptures of Rock* (1990). *Blissed Out* is really a "tale of that strange Indian Summer of rock" in 1987 when rock was reborn as "Dionysiac" and left both New Pop and Band Aid pop (sometimes called "the

10 *Monitor* evolved out of *Margin*, both edited by a group of Oxford graduates living in Oxford. Reynolds describes *Monitor* thus: "*Monitor* was sort of a journal of pop music, of pop cultural studies. It had some feminist and theoretical elements to it, it was basically moods without music. The initial idea was to do what couldn't get into the music press anymore, think pieces. So we hardly ever did interviews, only towards the end did we do reviews of records. It was all, like, essays, overviews". (personal interview, June 21, 1999)

New Authenticity") behind, and criticism brought old tools up to date by means of poststructuralist theory. It contains a large collection of articles written between 1985 and 1990, most of them edited and pasted together. His strategic move is to set up a mainstream version of rock criticism against a "renegade tradition" including, besides himself, such writers as Cohn and Bangs, Penman and Morley. To the former, content and depth are important and to achieve them, mainstream critics rely on literary criticism, political theory and cultural studies. But the effect is "the fixing of chaotic and inchoate elements in music [...] in a lasting scheme of value" (9). The bliss (English for Barthes's concept of *jouissance*) of the music is thereby transformed into mere pleasure (*plaisir*). The renegades, on the other hand, are convinced that "the power of pop lies not in its meaning but its noise"—"the non-signifying, extra-linguistic elements that defy 'content analysis': the grain of the voice, the materiality of sound, the biological effect of rhythm, the fascination of the star's body" (10). They want to express that experience of loss of meaning in their prose. "We imagined a local seriousness, the serious-as-your-life of the ecstatic moment," Reynolds explains (13). Reynolds's agenda has not changed much in his later writings, although the music in question has.

To Reynolds as to Savage, the gender perspective has always been central. In an early article, "Ladybirds & Start-Rite Kids" (*MM*, September 27, 1986:44–45), which seems also to have contributed to establishing Reynolds's position but wasn't included in *Blissed Out*, he analyzes the (a)sexual dress code of the indie audience. The then current style was secondhand clothing, and he points out that the favored 1950s and 1960s garments conceal the body and negate adulthood. Reynolds interprets the style as a wish to be liberated from sexuality by retaining a childish androgyny and as a "nostalgia for a never-never England." Although Reynolds is attentive to the historical connections and interprets on the basis of these, he concludes:

> What's interesting is the way the indie scene doesn't revive, but *weaves* elements from different eras to create fresh meanings. This is because the future is No Future, the death of the *idea* of the future: there'll be no Next Big Things, just an ever after of pick 'n' mix plundering from the past. No more major waves in fashion, no uniforms to be conformed to exactly—instead, on each of us descends the freedom (or burden?) of being the author of our own identity, making stylistic choices to express not so much our inner selves as our allegiances and our fantasies about who we'd *rather* be. [...] What all this adds up to is an elaborate and stylised *authenticity*, an *innocence* that isn't natural but put on, worked at. Indie-pop's fantasies of innocence are actually a sophisticated response to current reality *and* to pop history. (45; italics in the original)

The article is written in the style of Barthes's *Mythologies* (1957/1993), but the drift is more Baudrillardian: free-floating second order simulacra and the death of history. In a way Reynolds himself punctures this in his writings because of his fine sense of historical references, his interpretations using homology, and—in the long run—by hooking into a long tradition for Western philosophy to create a framework for reflection upon pop.

The gender aspect is expanded in *The Sex Revolts: Gender, Rebellion and Rock 'n' Roll* (1995). Here Reynolds joins forces with cohab Joy Press in a brilliant book, which poses the question of whether or not the savagery with which male artists have tried to fend off female attempts at domestication may be taken as the very essence of rock music. As the authors point out, rock arose in a 1950s climate of misogyny, visible in films like *Rebel Without a Cause*. The first part analyzes a number of archetypal masculine personas from this point of departure, the second is dedicated to its back side, the "oceanic" male rockers who dream of a return to the womb, and the third penetrates female rockers' strategies to make themselves heard. The book is loosely founded on psychoanalytic presumptions but far from the (now dated) poststructuralist jumble that made *Blissed Out* hard to read.

In *Energy Flash*, Reynolds—like Savage in *England's Dreaming*—chooses the role of the chronicler. Through nearly 450 pages the history of rave and techno music is told, based on earlier articles and new interviews. Reynolds is more present as an interpreter than Savage, but their intentions are the same: a definitive history. And *Energy Flash* may well turn out to be that, as it is comprehensive, applies musical and sociological as well as aesthetic instruments and accounts for personal preferences. Reynolds upholds the currently reigning paradigms of social science by using the analytical categories of class, gender and race, and discusses the double-edged sword of technology as well as the culture's drug of choice, ecstasy. As we have demonstrated several times, dichotomies are one of the basic structures that rock critics take as their point of departure. Reynolds is no exception as he contrasts intelligent with hardcore styles (e.g., LTJ Bukem vs. early Rony Size) and from this derives others like head/body, melodic complexity/rhythmic compulsion (158) and gentrification/ghettocentricity (352). These oppositions are then analyzed through the above mentioned lenses. Reynolds clearly prefers the second element of each of these oppositions:

> Jungle's meaning is still made on the dancefloor. At massive volume, knowledge is visceral, something your body understands as it's seduced and ensnared by the

music's paradoxes: the way the breaks combine the rollin' flow and disruptive instability, thereby instilling a contradictory mix of nonchalance and vigilance; the way the bass is at once wombing and menacing. (354)

Reynolds was allowed to write a surprising amount of "state of the union" articles in which he presented his poststructuralist program and applied it to rock music.[11] The articles about the socialist realists and the indie audience were two examples (cf. p. 267), "The Heart of Noise" (*MM*, February 28, 1987:40–41) is a third. It reads like an aesthetic manifesto outlining his antihumanist stance. Some groups use noise but do not realize its possibilities in full because their noise is a reaction to something specific (a reality effect or an antipop gesture). Herein he detects the loathed notion of pop as subversion. Instead, "forget *subversion*. The point is *self-subversion*, overthrowing the power structure in your own head. The enemy is the mind's tendency to systematize, to sew up experience. [...] The goal [is] in OBLIVION" (40; italics and majuscules in the original). Taking off from this bombastic statement, he comments on two ways of using noise: total noise as in Big Black and the Swans or the small noise in the creaks as in the sound-focused voices of Diamanda Galas and Kristin Hersh. Whereas the first strategy leads into a "shell-shocked state of catatonia," he terms the second psychedelic, full of "open spaces and fragility" (41).

The manifesto is a typical avant-garde genre. But instead of reading the avant-garde through Situationism, Reynolds chooses Bataille's radical version of the classical avant-garde. Apart from its bombastic moments, the text is very academic in its choice of words (e.g., abjection) and its clear composition (statement of premise, discussion, conclusion). Reynolds is a heavy user of metaphor and alliteration, for example: "compare its claustrophobic confines and concealed machismo" (41). Sometimes he overburdens his text with it, but at other times it works well as a way to overcome the basic problem of describing music in a logocentric medium. On the question of influences he states that:

I have lots of favorite writers. One of my favorite books is Lautreamont's *Maldoror*. But I don't know if that's an influence. I tend to like quite overripe rich things like Nabokov. But most of the influences are from other rock writers. Ian Pen-

11 That Reynolds and his fellow "brothers in arms" at *MM* were allowed to produce such an amount of theoretical articles suggests that *MM*'s recruitment of new staff in 1986 was intended as a parallel to the change at *NME* in 1972. Also, Reynolds suggests, "*MM* was in a very bad way". (personal interview, June 21, 1999)

man's very sensual, vivid sort of erotic writing, to do with the body, for example. (personal interview, June 21, 1999)

Reynolds ruthlessly interprets by his use of language: it is as if he investigates the music in question by throwing words at it to see if they stick. In his critic's project there is an obvious contradiction between the search for a bliss that exists beyond meaning and his continuous efforts to name it, to describe it in language. This contradiction cannot be resolved, but he surrounds what he is after with many words interacting with each other as much as with the music discussed. In general, Reynolds is present as a very talkative and opinionated "I" in his articles. The interviews are conducted as real discussions although the flow of the interview is often broken in order to contextualize or theorize. Some of the poststructuralist terminology is explained, but nevertheless, a Reynolds reader had better be well read. Thanks to New Pop "theory," Reynolds's habitus was quickly accepted within the field, and very early in his career he established a strong position near the field's autonomous pole. His power is perhaps best exemplified by his ability to coin new genre terms, "post-rock" being probably the most successful ("Shaking the Rock Narcotic," *The Wire*, May 1994:28–35).

It is possible to talk about a Reynolds aesthetic understood as a theory about what good art should be. The center of this is the nexus of bliss-rapture-ec-stasy-oceanic-psychedelic. Basically, the criterion for good music is that the lis-tener/critic is "undone" by it. Just like his ideas about what good music is, Reynolds's ideas about bad music are quite clear. Most often "pop" and "rock" are interchangeable terms, but "mainstream" is the pejorative term of choice, and it contains roughly the same connotations as the late 1960s use of "pop." In this way, Reynolds goes back to the ideals that preceded punk and post-punk experiments with mixing pop/mainstream and rock/avant-garde subversive-ness, which may well be characterized as romantic. What makes Reynolds dif-ferent is his heavy theorizing.

Contrary to his own views in 1990, Reynolds must be described as a critic in a broad tradition of literary criticism. He focuses on music as texts, and inter-pretations of the music are often connected to interpretations of "the state of the union." Reynolds's discussions clearly aspire to be part of high (academic) culture, and they certainly contribute to make rock music look more like an autonomous field. Academics have taken him to their heart, quoting him at length and reviewing his books in academic journals—*Blissed Out*, for exam-ple, was reviewed in the scholarly *Popular Music*. In this way Reynolds (together

with, among others, Savage and Toop) has contributed a few building blocks towards bridging the gap between popular music journalism and the academy.

Explorer of Musical Matter(s): David Toop

> We are, in short, [...] increasingly un-centred, un-moored, living day to day, engaged in an ongoing attempt to cobble together a credible, or at least workable, set of values, ready to shed it and work out another when the situation demands. I find myself enjoying this more, watching us all becoming dilettante perfume blenders, poking inquisitive fingers through a great library of ingredients and seeing which combinations make some sense for us—gathering *experience*—the possibility of making better guesses—without the demand for certainty.
>
> —Brian Eno[12]

This Brian Eno quotation is the point of departure for David Toop's magnum opus *Ocean of Sound: Aether Talk, Ambient Sound and Imaginary Worlds* (1995), and Eno's ambient music and corresponding music theory are central to Toop. The above quotation is a description of the late modern condition if there ever was one, and it spurs Toop on in his research into how sound and music "has come to express this alternately disorienting and inspiring openness," and— alluding to Marshall Berman's study of modernity (1982)—"through which all that is solid melts into aether" (Toop 1995:11).

David Toop (b. 1949) is one of the very few rock critics to have combined a career as a musician and composer with that of a journalist. He went to Hornsey Art College in 1967–1968 and has since worked as a freelance journalist appearing in British publications like *The Wire, The Face, Mixmag*, the *Sunday Times* and *Arena*, and U.S. magazines like *Details, Spin* and *Interview*. He has published several books and a short story. Apart from writing, Toop has worked in television and radio, and as an ethnologist he has made field recordings in, among other places, Amazonia. As a musician he has recorded with, among others, Brian Eno, John Zorn and Prince Far I, and even released some solo albums.

As a critic writing for magazines he normally takes upon himself the role of the traditional journalist, reporting and describing with the intention to get the musician's points across. His own interpretations are secondary, if present at all, and luckily, he seems only to interview those whose music he actually likes. In this way Toop avoids specific aesthetic judgments and it is notable that he

12 Quoted in Toop (1995:11); italics in the original.

only seldom writes reviews. In articles that deal with overviews—either of historical or contemporary scenes—he draws on an encyclopedic knowledge. His first book, *The Rap Attack: African Rap to Global Hip-Hop* (1984; revised as *Rap Attack 2* and *3* in 1991 and 2000, respectively), is a good example of this genealogic perspective as well as of his appetite for contemporary transgressive music. This book has become a classic, not to say the standard work on hip-hop culture.

Toop's writing techniques are quite different in his book *Ocean of Sound* and in his columns for *The Wire* (1995–1997). He often uses a stream-of-consciousness technique in the former. The overall composition of the book is weblike—or as Toop prefers to describe it, "nomadic." There is no clear central argument, rather a free play of associations. Insertions are often short descriptions of places, and they—not the music—are the fixed points in the story. There is no real beginning or end, one idea leads to another and he uses excerpts—sometimes quite large—from interviews to express his own views. The flow of the last chapter goes like this: In medias res (David Lynch's living room)—telephone conversation with Badalamenti—reflection: is it possible to record the voices of the dead—reflection: oceans as a metaphorical image (George III swimming, New Age music as accompaniment to sharks swimming in a tank, the Sony Walkman, musical examples, Beach Boys and the death of Dennis Wilson, floating tanks, John Lilly, Bateson, Toshiharu Ito)—in medias res (Kate Bush serving tea)—Celtic mythology—shamanism. The book ends: "memory: Sitting quietly in never-never land, I am listening to summer fleas hibernating on my small female cat …" (1995:280), which are also the first words on page 1. This way of writing echoes the conditions described in the opening Eno quote; as the book's interviewees often are Toop's musical collaborators, *Ocean of Sound* can be seen as an insider's guide to "open music" (22).

In connection with the publication of a later book, *Exotica: Fabricated Landscapes in a Real World* (1999), the stylistic experiments are taken one step further as he has recorded some of the text in an almost whispering voice and asked some friends to put music to it (*Hot Pants Idol*, Baroni: bar 020, 1999). The result is an eerie sort of ambient music in which textures dominate the words. The book itself is even more personal than its predecessor with its numerous free associations inspired by real travels in foreign places and Western conceptions of the exotic, especially early 1960s easy listening.

"Open music" is Toop's own term for the sounds (rather than music) he discusses. Anything may be listened to as music; there are no boundaries between life and art to Toop. His musical preferences in a narrow sense concern all things nonmainstream, from the more exotic end of easy listening over hard-

core avant-garde (noise, jazz and classical) and rap to world music. Left out is music based on narrative structures (pop, rock and traditional classical music), as it is taken to impose itself upon the listener (1995:10). Besides, musings over already well-known music is not to his liking:

> Over the last 30 years, every vital conundrum of rock has been unravelled, impaled, dredged, reified and counter-reified. So if, as happened recently, a critic such as Dave Marsh tells you why he believes Neil Young is a minor rather than a major artist, you can be forgiven for yawning sideways towards questions of more compelling import, viz: what is the relationship between heavy black eyeliner and the pagan sacrifical rites of the Incas? ("Kitsch of Distinction," *The Wire*, October 1994:40)

This is a quotation from an article praising Re/Search Publications' *Incredibly Strange Music* project, Toop's point being that it is anti-canonic and that the music in question will never win the Mercury Music Prize "and few, if any, will find themselves in the index of the Robert Christgau Important Encyclopedia Of Revered Music Useful For Protecting Your Obsessions Onto Others" (41). Another, more basic, point is that rock has become plain boring. Toop stages himself as led on by his curiosity and a wish to destabilize, where Marsh and Christgau contribute to stabilization. Even if Toop's music of choice could be termed "world music," he does not celebrate it in the naive manner of most Westerners as the latest in authenticity and non-boredom. He stresses the differences in the music and the many lapses in trying to come to terms with it.

Toop does have his own shortlist of central names, only his canonization is much more indirect since the persons qualify as conversation partners, not as objects of praise. Apart from Eno, central musicians include Sun Ra, the Beach Boys, John Cage, Jimi Hendrix, Jon Hassel and Bill Laswell—most of them with cult rather than popular followings. It is also important to name his literary references as they influence his way of writing. He uses Thomas Pynchon, J. G. Ballard, Philip K. Dick and Joris-Karl Huysmans as a build-up in the book's first ten pages, and in the rest of the book there are passing references to a host of modernist authors (Conrad, Burroughs, Poe and Vonnegut, among others).

The "erosion of categories" and the transitory are important and positive notions to Toop. His diagnosis of culture as based on "accelerating communications and cultural confrontations" results in a postulated rootlessness and "search for meaningful rituals" (1995:i–ii). This makes Toop turn to ethnology in order to illuminate basic musical functions. He does not theorize ex-

plicitly but *Ocean of Sound* is informed by anthropological and ethnomusico-logical research (and writers like Jacques Attalli and Canadian composer R. Murray Schafer's influential concept of "soundscape"). This turn corresponds to the turn towards ethnographic methods found in the humanities that hap-pened as a consequence of the deconstruction of canons in a number of disci-plines and has led to a new search for empirical data. The following quote could be his credo:

> In *Dramas, Fields and Metaphors*, anthropologist Victor Turner wrote that "man is both a structural and an anti-structural entity, who *grows* through anti-struc-ture and *conserves* through structure." Open structures which begin as revolutions often deteriorate into master plans designed to encompass the universe and auto-cratically eradicate all anomalous forms of music. So a return to listening, to hear-ing the world, is the most radical structure of all, since it is hard to envisage a master plan emerging out of such an amorphous, uncontrollable method. (257)

Whereas Reynolds crosses over between journalism and the academy, Toop makes a point of constantly crossing between musical sounds. *Ocean of Sound* makes numerous references across main genre boundaries and points to unsus-pected, common denominators. To Toop, the world is actually the *whole* world—no place is too distant to him, no subculture too little known. In one sense this makes high/low terms obsolete: music just exists in different spaces. But at the same time Toop posits himself at the front of a way of music making that con-siders itself to be the avant-garde. Music is interesting to him when it is novel, when it explores uncharted sounds and points towards new possibilities for living. That kind of position is new, insofar as the musicians and the musical material used cross institutional boundaries. But it is still clearly a "high" posi-tion. Toop is the refined connoisseur of fragile music, music that it is very hard to get at (i.e., buy on CD or hear in concert) and music that is relatively unlistenable to most Westerners. However, the utopian dimension of his think-ing is not exactly news.

The question of whether Toop is actually a rock critic or if it would be better to categorize him as an art (music) critic misses the point—he is really a sound critic. He publishes in magazines that belong to the rock and popular culture sphere. But it would be hard to categorize most of the music under discussion as rock (or any other main label), and his writing style changes a great deal depending on the medium. It is either traditional journalism for magazines or a very literary style as in *Ocean of Sound*. These multiple positions make Toop one of the most interesting British music critics of the 1990s.

The African American Dream: Nelson George

Normally, critics with a non-European background remain in the ghetto of magazines concentrating on genres mainly associated with a non-European ethnic group. Only a few have been allowed to cross over into mainstream magazines, the most prominent African Americans being Danyel Smith, Greg Tate and Nelson George. The two latter critics both made the crossing via the *Village Voice* in the early 1980s, and Greg Tate served as music editor for that magazine for some years. We have chosen to profile Nelson George because his production is the broadest, stretching from magazine criticism to books on music and cultural history and novels to film manuscripts and film directing.

George (born in 1957 in New York) grew up in the Brooklyn ghetto of Brownsville and graduated from St. John's University in 1979. The year before, he had his first piece published. He quickly became a sought-after writer and did freelance work for the *Village Voice* and *Musician;* from 1982 through 1989 he served as black music editor at *Billboard,* even though he had been banned as a freelancer from that magazine around 1980 for writing black English (George 1998:29). George's range of topics has widened considerably, slowly changing him from a music critic into a general African American culture critic. Among his six novels, one, *Urban Romance* (1993), has clear autobiographical elements as the main male character is a struggling music journalist. Among his books on music are a quickie biography of Michael Jackson, a history of Motown (1986), histories of African American music culture in the 20th century (1988, 1998), an account of the 1980s from an African American perspective (2004), and one anthology of articles (1992/1994), primarily from the *Voice.* He has also written books on sports, film and television.

George took up journalism just before rap was first recorded, and he has been documenting it ever since. As he noted when celebrating rap's ten-year anniversary, "For me rap was a professional and aesthetic inspiration" (1992/1994:93). But on the other hand, rap is not "his music" as he did not grow up with it. Instead, he considers himself "an affectionate older observer, not quite a peer" (1998:x). Several of George's books are dedicated to Robert Christgau, whom he considers among his primary mentors, who opened the *Voice's* columns for rap early on and whose idea of the importance of the critic's instinct is paramount for George (1988:xv). Other sources of inspiration seem to be older journalists from *Billboard* and the *Amsterdam News.*

George grew up on 1960s soul, and his readers often get the impression that that was when African American music was at its best. It is closely related to some of the values he praises, like the craft of songwriting, vocal expressiveness

and "the secular salvation in love [that] has rarely been better expressed than in this music's sweet passion" (1992/1994:218). Writing about "the death of rhythm and blues," to cite his 1988 book title, he claims that R & B "is just not as gutsy or spirited or tuned into the needs of its core audience as it once was" (xiv). Disco (which "came to represent some ugly amalgam of black and gay music" [181]) is one of the main culprits in this as producers without training in songwriting took over from musicians and installed the new music technology, left out the melody and mechanized the groove. Another clear distinction is that between kids' music (the juvenile attitude contained in "well-produced records with some words thrown on top") and music for grown-ups ("a story in sync with a groove" [ibid.]). This is quite close to a pop/rock distinction, a distinction also echoed in his discussion of video's influence on rap in which he deplores the instant success that can be obtained though videos at the expense of building your audience by partaking in DJ battles, making 12-inches and touring (1998:113).

Together with music African American politics has remained a prominent topic with George, and the two are intertwined in that music is an integral part of African American culture. Never is the music treated as something separate from its context, as can be seen in *The Death of Rhythm & Blues,* in which most of the links in the chain of music dissemination (DJs, radio, independent record companies, local record shops and musicians) are given equal weight in what is a cultural history of African American popular music in the 20th century. The book has become a classic, even contributing to the academic debate. The basic dichotomy for George when analyzing African American culture lies in the political strategies of segregation and assimilation. George demonstrates that the assimilation strategy (in his terms, the crossover) had won the day by the mid-1980s. African American communities have been splintered as the African American middle class has moved out of the cities into the suburbs leaving the poor to take care of themselves—with devastating results. Thus, George argues for a greater amount of self-sufficiency in the African American community since the other strategy has not helped most African Americans.

This perspective recurs in his book on Motown (1986). Basically, George paints a positive portrait of founder and owner Berry Gordy, stressing his roots, his sense of family unity, the need for people to help each other and, not least, his business acumen. Capitalism is fine for George, and Gordy only failed as a major role model when he moved the Motown operation to Hollywood and forgot the Motown community back in Detroit. Russell Simmons is ascribed a role somewhat to similar to Gordy's, being rap's prime record company owner and promoter ("Rappin' with Russell: Eddie Murphying the Flak-Catchers," *Vil-*

lage Voice, 1985; reprinted in 1992/1994:46–58). George's interest in success is quite central to his criticism. If his critic's instinct tells him that a record is good, he often drives the argument home by pointing to its success in the charts. For example, his account of Sean "Puffy" Combs's rise to fame and fortune ends with a mention of the week when Combs had a number 1 single and album and was on the cover of *Rolling Stone*.

Common to most of George's reviews is his comparing musicians with each other. Often the comparison is of a historical nature, for example when he refers to earlier artists from the 1960s or 1970s. History is also used for the introductory paragraphs harking back either to the earlier work of the artist in question or the genre in general, for example in this review:

> Rick James's *Street Songs* reminds me of my favorite period in black pop music, the early 70s, when, as Greil Marcus noted in *Mystery Train*, "social comment" was unusually prominent in black lyrics. Sly's *There's a Riot Going On*, Curtis Mayfield's *Super Fly*, Marvin Gaye's *What's Going On* [...], several Gamble and Huff productions, and a number of other records featured brash, inventive music and lyrics that were streetwise and either overtly or obliquely political. ("Rick James's Ghetto Life" [review], *Village Voice*, 1981; reprinted in 1992/1994:190–192)

After such intros—taking off from a personal memory—George normally goes on to assess several individual songs, commenting on texts, the groove, and vocal performance. His basis for evaluation is once again comparison with other artists. In all these comparisons the writer's voice and preferences are clearly present; he is the one making the musical associations and the music either fulfills or misses his ideals. With regard to language George keeps it simple. He does not become a "B-boy intellectual" (his own description, 1992/1994:7) by referring to complex theories, but by being able to argue a point. His language is often infused with African American expressions (e.g., brothers, sistas, dope, rep, doing serious damage) and often musicians' appearances (hair cut and clothing) are mentioned to show that they follow or set the latest trend.

Following his separatist leanings, George hardly ever mentions rock and other genres associated with Anglo-American culture. When he does, he makes fun of them. Only in the epilogue to *The Death of...* does George surprise by stating that Paul Young, George Michael and Phil Collins have "matched their black contemporaries."

> How? Through a deeper understanding and (dare I say?) love for the currents in black music history. As the 1980s roll into the 1990s, it is clear that black America's

assimilationist obsession is heading it straight towards cultural suicide. The challenge facing black artists, producers, radio programmers, and entrepreneurs of every description is to free themselves from the comforts of crossover, to recapture their racial identity, and to fight for the right to exist on their own terms. (1988:200)

The "music as part of culture and politics" stance of much music criticism by African Americans has its precedent in 1960s rock criticism, but most Anglo-American writers can no longer write from that position. However, African American critics have retained a political position because they still live in a racist society. In one of the few comparisons between African American and Anglo American musicians and audiences George writes:

The black audience's consumerism and restlessness burns out and abandons musical styles, whereas white Americans, in the European tradition of supporting forms and style for the sake of tradition, seem to hold styles dear long after they have ceased to evolve. The most fanatical students of blues history have all been white. These well-intentioned scholars pick through old recordings, interview obscure guitarists, and tramp through the Mississippi Delta with the determination of Egyptologists. Yet with the exception of Eric Clapton and maybe Johnny Winter, no white blues guitarist has produced a body of work in any way comparable to that of the black giants. Blacks create and then move on. Whites document and then recycle. In the history of popular music, these truths are self-evident. (108)

To a large extent, George himself works like these Egyptologists. Not by taking upon himself the positivism gone awry of record collecting, but by interviewing hundreds of obscure musicians in order to create a tradition of music history writing for African Americans to identify with. He documents and points to history in order to identify ideals for a community that does not exist any longer, and when reviewing Anita Baker's *Rapture* he actually lauds it for its mix of contemporary and historical feel, launching the term *retro-nuevo* to name the phenomenon.[13]

The 1980s saw the rise of the two biggest African American stars since Aretha Franklin—Michael Jackson and Prince. George takes an equivocal stand on both.

13 George, Nelson (1986): "Anita Baker: Quiet Storm," *The Village Voice*, reprinted in George (1992/1994:223–225). In (1988:186) George claims to have invented the term *retro-nuevo* in order to describe the "embrace of the past to create passionate, fresh expressions and institutions." He adds, "It doesn't just refer to music."

On the one hand, they betray African American standards (and looks) in the attempt to cross over, on the other, they are the two most important retro-nuevo musicians in the 1980s:

> [Jackson and Prince] ran fast and far from both blackness and conventional images of male sexuality (and their videos got on MTV). Michael Jackson's nose job, often ill-conceived makeup, and artificially curled hair is, in the eyes of many blacks, a denial of his color that constitutes an act of racial treason. Add to that a disquieting androgyny and you have an alarmingly unblack, unmasculine figure as the most popular black man in America. [...] Jackson and Prince were assimilation symbols as powerful as Bill Cosby. [...] Despite the unfortunate impact of the imagery, this dynamic duo proved to be the decade's finest music historians, consistently using techniques that echoed the past as the base for their superstardom. [...] if we look at Jackson and Prince from the perspective of economic self-sufficiency, there is no question that this duo exercise a control over their careers and business that neither James Brown nor Sam Cooke, as ambitious as they were, could have envisioned. (174, 194, 195)

This sums up quite well George's insistence on traditional masculinity, his rather conservative focus on the historical aspects of African American music and his admiration and hope for African American economic independence. To him, music together with sports is the most important way out of the ghetto and the people who manage to escape via that route are to be regarded as role models. The musicians may create wonderful music and lyrics full of passion and history, and that is of course important, but it is their craving for success and respect that matters most to George. His continuing contextualization of the music is, in the end, primarily a political project. In this way, he insists on the positive aspects of the American dream, namely that each man may seek his luck in the pursuit of happiness. And these may be expressed through music. The feeling of loss expressed by, for example, Greil Marcus is far from George's mind as African Americans have little to lose but still much to gain.

Intelligent Dumbness: Chuck Eddy

Chuck Eddy (born in 1960 in the Midwest) went to college and spent some time in the army. He wrote for high school and college magazines where he slowly became interested in music. In 1983 he was invited to write for the *Village Voice*. Since then he has published in all the most read magazines and written two books, *Stairway to Hell* (1991/1998) and *The Accidental Evolution of Rock 'n' Roll* (1997).

Although Chuck Eddy acknowledges Greil Marcus as one of the greatest rock critics and Robert Christgau as an early major influence, he sees himself carrying on the writing tradition of Richard Meltzer.[14] Stylistically, both men's texts are based on loose association. But whereas Meltzer in *The Aesthetics of Rock* (1970) mixes his musical associations with Western philosophy and in this way gives them a high cultural gloss, Eddy's associations are firmly within music, especially lyrics, song and album titles, and covers. His apparently encyclopedic knowledge of popular music from the whole Western hemisphere since the 1920s makes it possible for him to take up a theme and then discuss, say, 20 records that one would not otherwise imagine having anything at all to do with each other. This results in generic categories like "onomatopoeia rock" and "working woman-rock from Sigmund Freud to Simon Frith," both mentioned in *Evolution*. He also stands out from his peers in his knowledge of continental European and Mexican popular music, which makes him less Anglocentric than most other critics. On the surface Eddy's position is the trainspotter's, but it has been consciously chosen in opposition to the wordy "serious" writers.

He deliberately avoids any reference to theory or theorization. Instead he celebrates the record collector's joy in factual trivia, meaningless coincidences and rare records. His sentences are short, often statements without any trace of discussion, and contrary to most American critics he is often very funny, sometimes in the manner of a stand-up comedian. Although it is not immediately apparent, there is some method to Eddy's way of working, namely the idea of generic taxonomy. As an exception to the rule of "no theory" he refers to "French discourse doofus" Michel Foucault's *The Order of Things* to legitimate the "logic" of his own generic categories (1997:4–5).[15]

In the opening part of *Evolution* much of his aesthetics is laid out in short, provocative dictums occurring in the text flow: "I like music that doesn't feel like too much second-guessing went into it"; "This is entertainment made for monetary ends: it's product by definition and better for it, because corporate

14 Eddy refers positively to Marcus in Eddy (1997) and he mentions the Christgau influence in an interview (Wood 1997). Among several Meltzer references is this: "[O]n my desk nearly the entire time I was doing my research…was Richard Meltzer's *The Aesthetics of Rock*, which more than 25 years after its birth increasingly strikes me as the most useful volume written on the topic, if only because almost nobody has done anything with its ideas since—until now, I hope" (Eddy 1997:338).

15 The reference is actually to Foucault's reference to Borges's reference to a certain Chinese encyclopedia that proposes a rather unusual animal taxonomy (Foucault, Michel [1966/1970]: *The Order of Things: An Archaeology of the Human Sciences*. New York: Random Books).

corruption and rock 'n' roll go hand in hand—in fact corruption pretty much *caused* rock 'n' roll"; "Ignorance of aesthetic integrity, of where the 'edge' is, keeps people honest: 'Idealism' limits music more than commercialism does" (1997:11, 12). His main criterion for good music is whether it becomes part of your life and language: "If you went to high school in the '70s, Alice Cooper's 'I'm Eighteen' and 'School's Out' became part of your life and language whether you cared about rock music or not" (13). And he hasn't experienced that since, not even with Nirvana's "Smells Like Teen Spirit."

Behind this lies an intention to play havoc with the canon and with the critical establishment. Central to Eddy's taste is such "low" music as that of Boney M, Slade, Abba, Def Leppard and Mariah Carey. Bob Dylan appears to be one of the few canonical musicians he likes. Most rock groups from the Beatles to Nirvana are not to his taste, and this makes it almost impossible for Eddy to use the critic's position as a consumer guide in any traditional sense.

At the end of *Accidental Evolution*, he states his critic's credo, which is reminiscent of Meltzer's position:

> Nowadays rock criticism tries its damnedest not to raise a ruckus, tries not to be funny or to hurt anybody's feelings. It's not supposed to be messy like the world; it's supposed to be respectable like a grad-school symposium, or the goddam rock of Gibraltar. A great party idea has backslid somehow into a somber institution that I can't imagine luring in any adolescent with half an I.Q. [...] The generation of critics that grew up on college radio never learned how to get pissed off, how to make fun of their idols, how to *complain*. (313; italics in the original)

Raising a ruckus often seems to be Eddy's main ambition. His strategy is quite consistently to laud what he thinks others consider bad taste. Thus he performs and highlights the split between high and low within popular music, siding with "[a]dolescent females [who] have the best pop-music taste in the world, usually" (51).

Eddy makes fun of his idols or his preferences: for instance, Bruce Springsteen is actually to his liking, but in *Evolution* there are several disparaging remarks about him. This is because Eddy sees entertainment as the most important aspect of rock criticism:

> [T]he bottom line is, I want my writing to be *good writing*, okay? And it's, it's like, I just don't know that I have any interesting good things to say about Springsteen. But that doesn't mean that I don't *like* him. I write about stuff—the records I write about are not necessarily my favourite records, but they're the

ones I think will make for the most interesting writing, and I say what, positively or negatively—that doesn't mean I'm lying, but because I write about Debbie Gibson a lot, that doesn't mean that she's my favourite artist, it just means that I think I have a lot of interesting things to say about Debbie Gibson. If I wrote about Springsteen as much as I liked him, I think what I wrote about him would be pretty boring, I don't think I would say that much that people haven't already said. (Wood 1997; italics in the original)

Eddy represents an American populist version of being enmeshed in "the moment." It is definitely not a transcendental category as with most English critics. Rather, it is the pleasurable now, in which the music enters everyday life and induces good feelings without pointing toward something beyond. Compared to Morley, who also tried to fill the court jester's position, Eddy fares better. Morley's grand project became too all-encompassing: he tried to be funny, sarcastic, philosophical, postmodern and self-promoting in his quixotic search for authentic moments. Eddy, on the other hand, has much less belief in pop's redeeming powers: he just insists on the value of the small kicks in everyday life. Compared to other critics discussed in this report, Eddy manages to stay on the fun side of pop. His version of the carnival is to turn received values upside down, but it is questionable if he obtains anything by it, apart from being entertaining. Apparently, to him, pop is, well, just fun. Eddy keeps a straight face defending the eternal, maladjusted teenager in us all. But often it is hard not to interpret his anti-importance stance as postmodernist, ironic distance. His way of arguing resembles the reasoning of a cross teenager, but his aesthetic may just as well serve as an excuse for evaluating positively what he actually considers kitsch. The "war" of the value systems that he acts out actually obliterates both sides. Eddy's criticism may then be seen as a public construction of a subject who comments on how to make your own media personality.

Intellectual and Feminist: Ann Powers

Ann Powers was born in 1964 in Seattle and grew up there. At 20 she went to San Francisco where she held different low-wage jobs (among them record shop assistant) and later came to write and edit for *San Francisco Weekly* while studying for her M.A. in American literature at Berkeley. Receiving this in 1992, she went east to work as a rock critic for the *New York Times* at the invitation of Jon Pareles, only to change to the *Village Voice* four months later for a features editor position. From 1997–2001 she held a post at the *New York Times* while publishing in most of the leading music magazines, including *Vibe*. Since 2001 she

has been a curator at the Experience Music Project in Seattle. Together with another major woman critic, Evelyn McDonnell, she has edited *Rock She Wrote* (1995), a comprehensive collection of criticism by woman writers from the 1960s to the 1990s. Powers has written one book, *Weird Like Us: My Bohemian America* (2000), a survey of bohemianism in the 1980s based on personal recollections.

Among the critics discussed in this chapter, Powers is the most academically accomplished. Her background in literary studies is revealed throughout her work via numerous references to high literature and her arcane knowledge of female medieval saints, often demanding a reader habitus on par with her own. Among her influences she mentions Angela McRobbie, Ellen Willis and early 1980s feminist theory and cultural studies in general; among critics she especially mentions Marcus and Christgau (personal interview, April 18, 2004). But it is her literary frame of reference rather than her theoretical background that makes her an intellectual. Theory is not absent, but her brand of feminism is characterized by a gut response to experiences of antifemale discrimination and an insistence on her own subjectivity. She acknowledges the basic differences between the academic and journalistic:

> The gap between journalistic and theoretical discourses is so great that it almost is like writing in two languages. My biggest challenge was to figure out how to communicate theoretical ideas in a language that could fly at the *New York Times* and the *Village Voice*. It was easier in the *Voice* because as an alternative paper it was related to academia, but it was a great challenge at the *Times*. I was not allowed to use theory straight on. I had to do it in a more subtle way. […] For me perspective was always really important. I was very close emotionally to the music, but I would always try to step back and find another way in. I might look at an artist through the lens of theory, be it queer theory, Marxist theory or whatever. I do not write from the inside, i.e., "I know every B-side they recorded." This kind of expert knowledge is problematic because it excludes people. I wanted to be understood by people who did not know very much about music.[…] Being a woman you start without having privileges which forces you to think of other ways. (personal interview, April 18, 2004)

Powers belongs to that generation of critics who evolved out of the college scene at a time when woman musicians came to the fore:

> I came along with a new generation of women in music. It was the first "year of the woman" in a decade's worth of years of the woman. There was a demand for female critics. In that regard it helped me to be a woman at that time. I'm a very

outspoken feminist and I have had to deal with people being dismissive of my work because of that. I've faced the mental harassment of "she's only got the job because she's a woman." That has happened to several of my colleagues. They too are facing sexism. (personal interview, April 18, 2004)

Powers situates herself within a tradition of women writers beginning with Ellen Willis, admired for her "vision of a feminism grounded in a radical dedication to individual freedoms and a hearty embrace of expressive sexuality" (1995:465). This vision she sees as that of rock criticism in general since it originally adhered to the old feminist slogan "the personal is political." Her chosen epiphany is a girlie classic: listening to Top 40 under the sheets in her bed. She states that it educated her "in the possibilities of my imagination and showed me how to name my still-forming desires. I was its novitiate in the discipline of the daydream" (459). Her childhood attendance of Catholic school probably also influenced Powers—she refers to herself as a novitiate, describes the concert experience as a communion and female saints and mystics often crop up in her texts. Judging from *Weird Like Us*, the 1980s indie music seems to be close to her heart. She describes her job in a record store as the beginning of her "sentimental journey" (160), and she defends the indie scene from the ironic and dequalifying critique aimed at it in the 1990s:

> The indie scene of the 1980s and the 1990s, the very one belittled for adopting boyish clothes and girlie haircuts, is the most upstanding, self-sufficient, and, arguably, mature scene rock has yet produced. [...] Emphasizing the freedom that comes with thinking your own thoughts for the first time, and trying to keep that freshness going as they mature, form communities, and take on obligations, indie rockers strive for a practical version of the 1960s youth ideal [...]. [We] have formed our lives from this haphazard culture of noise and tune and style—the daughters and sons of an ideal that was abandoned by its parents. We are striving to do it proud, and being called losers for trying [...] [T]he bohemians of this generation are in their thirties and early forties, struggling to figure out which aspects of conventional adulthood might be acceptable and which must change. Many have personal styles and pastimes that outsiders would label less than mature, if not downright childish. But they are not children. They are adults of their own making, busy being born. (211)

Powers insists on the need to remain childlike in some ways, especially by retaining the ability to play, to hold on to fantasy in spite of maturity. Her book is by turns a "coming-of-age tale" (35), an explanation of what she considers the

values of the young bohemians—labeled slackers or Generation X'ers by others—and a defense for a lifestyle in which notions of, for example, sexuality, drug taking and work are quite different from American norms. Taking a job at the *New York Times* makes her ponder the eternal alternative question—whether she has sold out. And the answer is a yes and a no in that she considers herself to have crossed that border ever so many times since early youth.

Powers sees the woman critic's role as that of challenging the order of taste hierarchies and pop history (462). She consistently opposes sexism and insists on her own specific, female subjectivity as the point of departure for writing. The "I" is always strongly present in her texts. Her feminism is not dogmatic as she might easily go against the grain and argue the virtues of, say, Guns N' Roses, choosing to focus on the music's liberating effects while ignoring the lyrics' and the performers' obvious misogyny. She uses feminism as a critical tool and it works as part of her habitus. Apart from criticizing the male chauvinistic aspects of rock she stresses the realization of the personal, the private, the creation of "your own style through creative consumerism," of "your own fun in ways that defy money's power to exclude" (2000:157). This echoes Romantic individualism, in which her music aesthetic is anchored as well.

Powers is in no doubt that pop and rock are art. Living her twenties in San Francisco in what she conceives of as a bohemian realm (cf. Powers 2000) and her education has helped sustain this view. In her review of Nine Inch Nails' *Fragile*, Trent Reznor is constructed as the ultimate Romantic (and bohemian?) artist. The music is the private "universalized," folded out into "epic" proportions (a double CD), and Reznor endeavors to give artistic form to his tumultuous inner life. This and an introduction that reads like an abstract of a gothic novel shows that to Powers rock can be comprehended in the same language as traditional art:

> Trent Reznor is obsessed with his own mental architecture projects, a preoccupation that would grow dull as a narcissist's monologue if he weren't so good at universalizing it through sound. *The Fragile* is his epic portrayal of the endless, aimless inner din. Because he's an artist he feels compelled to make sense and beauty of it. Because he is a rock star when he calls himself Nine Inch Nails, he does so with hooks and drama [...] ("Building a Mystery: Trent Reznor's Epic Return" [review], *Spin*, November 1999:179)

This is the ideology of the Romantic artist, pure and simple. Powers clearly values the expressive aspects, linking them to the emotions and to art in an emphatic sense. Experiencing strong emotions transcends the ordinary sense

of time, and music's power can do the same. Once again transcendence is central, but related to a far older aesthetic paradigm than the one referred to by most British critics. As McDonnell has stated, Powers sometimes writes in a distinctly poetic style, and she often refers to literary history. The following quotation is from yet another record review intro:

> "The calm / Cool face of the river / Asked me for a kiss." So begins, and ends, "Suicide's Note" by Langston Hughes. The poem haunts not only in its simplicity but also because it is so arrogantly incomplete. Hughes refuses the explanations people crave in the face of catastrophe, instead offering one so pure it seems like a dark joke. The poem is an answer that says no answers suffice. ("Ron Sexsmith: Whereabouts" [review], *Spin*, August 1999:158)

The point is of course to compare the musician in question to Hughes, but it is a highly unusual opening. In her reviews Powers often prefers such startling openings, musings on a more general problem that is then related to the subject of the piece. Also, many of the reviews focus less than usual on the musician's previous recordings and similar traditional contextualizations. She still refers to a couple of individual songs, but generally she prefers interpretation to description, often closing with a strong statement, for example: "Sexsmith sings, his voice tender as a kiss" (158).

All this is contained in a single review, that of PJ Harvey's *Rid of Me* ("Houses of the Holy," *The Village Voice*, June 1, 1993; reprinted in McDonnell and Powers [1995:326–329]). Here Powers places herself as an "academic" interpreter who regards Harvey as a "transgressive" artist in accordance with a Romantic aesthetic: Harvey risks everything in order to explore the unknown. This kind of respectful, analytical review demands a habitus on the part of the reader that can hardly be expected from the average magazine subscriber. The high level of ambition is stressed by Powers's unusual historical associations and erudite quotations. Theoretically, the text is not that advanced as it consequently considers the work of art as an expression of the subject. The intentions of the subject are constructed as well: Harvey "means to create [...] the sonic equivalent" of the fight to "be sexually whole in a misogynistic and body-fearing society" (328). According to Powers, Harvey accounts how she—like a medieval saint—was taken and stigmatized by a god. At the beginning Powers states that Eros to Harvey is connected with Thanatos and carnal desire with the desire to escape the body, whereupon the second part of the review, roughly half the text, exemplifies this by referring to fragments of lyrics, vocal performance, distor-

tions of "classical" formal conventions and so forth. Two short discussions follow, the first implying that the work cannot be reduced to a feminist rhetoric but "envisions a subject between the sexes" (328), a drag king à la Prince or Little Richard. The second tries to place Harvey in a rock tradition that tries to unite sexuality and spirituality. Powers's own position is sisterly; she wants to put her arms around the disgusted artist. Her words express a closeness ("symbiotic tie," "tight," " skin-tight") that probably would not be articulated in the same way by male critics.

Powers's mix of intellectualism, feminism and romantic aesthetic has earned her much credit (cf. note 3, p. 266). Essentially, her views are those of the traditional art critic, including the overt, subjective (if reasoned) judgment. Compared to the rest of the rock criticism field her position is rather conservative, even if it is quite innovative in that nobody has occupied such a highbrow position with such consequence before. This has enabled her to break into the boys' club and establish herself as one of the prime among peers.

8.3. The Magazine Market in the 1980s and 1990s

A general growth in circulation and a multilevel diversification of fora for rock criticism took place in the 1980s and continued into the 1990s. First, whether style bibles or rock consumer guides, the number of rock monthlies covering rock and pop has increased and worked to diminish the influence of the inkies, the traditional carriers of a more nuanced rock criticism. The growth in overall circulation and in number of magazines is surprising—as is the general anonymity of the criticism. According to Sarah Thornton, in England there was a "seventy-three per cent increase in consumer magazine titles in the 1980s [...]. By the end of the decade, about thirty magazines addressed youth, featured music and style editorial and drew advertising from the record, fashion, beverage and tobacco industries" (1995:151). Thus, the main economic reason for the growth was that youth became accepted advertising targets for capital-intensive industries. Another reason was that the number of readers interested in the mix of music information and advice on accoutrements for displaying an appropriate "lifestyle" steadily increased through the period.

Second, market research and target marketing have become still more sophisticated, and they have segmented the market in at least two ways: according to genre preference and according to age group, thus opening the gates for a flood of targeted music magazines. Through the 1980s and the first half of the 1990s each age group and each main genre (which sometimes also indicates racial segmentation) had at least one specialized magazine. Magazines sticking

to white mainstream rock genres kept the lead and thus still define a field center. Third, the acceptance of rock as general interest material has made writing about rock ubiquitous and made the music an object for articles and reviews in everything from women's magazines to serious dailies and free entertainment guides. It is possible to get a rough idea of income from advertisements from the following table:

Table 3: Official advertising prices for 1 page black/white, 1999, selected American music magazines. Source: anon. (1998–1999):[16]

Magazine	$ per page
Request	$11.665
Rolling Stone	$71.030
The Source	$12.790
Spin	$30.946
Vibe	$36.924

To some extent, the differences between these prices make sense when compared to the circulation figures (see table 4 below)—*Rolling Stone*'s circulation is roughly double that of *Spin*'s. It is more interesting that *The Source*'s rates are only a third of *Vibe*'s as they cover the same genre (rap). The actual ads in the two magazines are somewhat different, *The Source* carrying several in a visual style reminiscent of graffiti while *Vibe*'s are the usual ones found in any other successful magazine. The reason for this difference can probably be found in reader surveys.

The American magazine market has proved more stable than the British. The construction of the field in the late 1960s was so successful and so all-encompassing that nothing has challenged it seriously since, and *Rolling Stone* remains dominant. There are several reasons for its quickly acquired status. Outside rock criticism it became respected in the field of journalism because of the high journalistic standards of its reports on rock, youth culture and general interest topics. Early on the news media accepted *Rolling Stone* as the voice of youth as it was apparently the most serious magazine around; at the same time the music industry accepted its more or less independent status by advertising

16 Note that these prices cover black-and-white ads, but that all ads in the five magazines are in full color. Also, prices are probably negotiable if companies buy several ads in the same or related magazines or in consecutive issues.

in it and sometimes even providing loans (Draper 1991:178–179, 255). Its status as *the* American music magazine has been buttressed by the magazine itself through its unique gift for marketing and canonizing itself through countless anniversary books of interview and review outtakes, histories and encyclopedias, "controlling" the history and canon of rock (Miller 1976/1980/1992, Ward et al. 1986, Pareles and Romanowski 1983/1995/2001). This status has been maintained, even though since the early 1970s the magazine has focused less on music and more on general interest, competing within the broad field of journalism. In 1985 *Rolling Stone* officially declared itself a general interest magazine and was so listed by the Audit Bureau of Circulation (ABC). Thus, formally, it has left the field of rock criticism in favor of the field of journalism, but its presence in the former is still very much felt. Even though *Rolling Stone* lost its cutting edge with regard to music early on, no one has been able to challenge its central position in the field of rock criticism.

The other, still existing, major outlet for rock criticism in the 1960s, the New York–based *Village Voice* weekly, has not changed radically either since the mid-1970s. The magazine continues its vaguely bohemian mix of cultural reporting, news, what's on the town and classified ads, now as a free magazine in the New York area. Some established magazines have chosen other directions than those of *Rolling Stone*. In the 1970s *Creem* went populist and focused on heavy rock, producing a lot of Kiss covers. It waned slowly in the second part of the 1970s, drawing its last breath in 1988. The post-Paul Williams *Crawdaddy!* (1969–1979), on the other hand, became a sort of kid brother to *Rolling Stone*, also bearing on general interest. In the 1980s the established magazines *Circus* (f. 1966) and *Hit Parader* (f. 1942) went heavy metal. The same decade saw the emergence of the most serious contender for *Rolling Stone*'s throne, *Spin* (f. 1985), though it has not reached even half of *Rolling Stone*'s circulation. The idea behind *Spin* was the same as that behind *Rolling Stone* around 1970: that music is central to the understanding of contemporary culture. This view allowed a number of general interest articles, though *Spin* today focuses more on music than *Rolling Stone*, and its music pieces are dedicated to more recent musicians.[17]

17 *Spin*'s success showed that it was possible for a rock magazine to survive on a national level, and *Request* became one of the great successes of the 1990s. A glossy, 60–80 pages monthly, it is "semi-free"—available free in certain record store chains and by subscription at a very low price. Following the Q lead it promises at least 100 short reviews in each issue. Recently *Blender* has joined in at a national level, also promising hundreds of short reviews.

Specialization has been a major trend within the magazine industry during the last 30 years. Although neither *Rolling Stone* nor *Spin* has followed this line, most other music magazines have. Musicians' magazines on a national level is one effect. Of these, *Musician* (1976–1999) took a position between the "real" musicians' magazines and general interest–cum-music magazines. Through the 1980s it was regarded as probably the most serious music magazine. *Musician* was founded by two musicians "for high school and college education audiences" in 1976.[18] When that did not work, they changed the profile to jazz. Interviews with Frank Zappa and Robert Fripp marked a turn to experimental rock. Later, popular rock musicians like Springsteen, Hendrix and the Grateful Dead were foregrounded, but the focus continued to be on the musical aspects, not the paraphernalia of rock stardom. This move made the magazine quite successful, and in 1981 it was bought by Billboard Publishing, which relaunched it as a glossy monthly with contributions from Dave Marsh, Lester Bangs, Robert Fripp and Jon Pareles, among others. Technical aspects were discussed in some columns, but long interviews, their main genre, were conducted in an intelligent way without using much undecipherable jargon. Think pieces could also be found. With regard to genre, it covered both jazz and American and English rock. From 1983 its circulation stabilized just above 100,000 copies, and it stayed there for the rest of the decade. The magazine was killed when the circulation dropped below the 80,000 point in the late 1990s.

Specialization also bred some new heavy metal magazines in the 1980s, while the 1990s have seen the appearance of several successful rap magazines. Central to the last variety is hip-hop culture and African American culture. In this way they carry on the rock magazine tradition begun by *Rolling Stone*; only the audience and the music are different. *The Source*, the most central rap magazine, is discussed below.

Other characteristics of American criticism are that most of it appears in the quality dailies; that the magazines have remained monthlies (apart from the biweekly *Rolling Stone* and the weekly *Village Voice*); and that the field boundaries demarcating general interest magazines are not very clear. The boundaries between the arts and the academic fields seem to be more stable. There are many instances in which art (music)—especially of a more avant-garde bent—has been mixed with rock and a number of books also try to cross the great divide (e.g., Bergman and Horn 1985, Rockwell 1983/1996). But when academics enter the mainstream rock press intending to deal with

18 Baird, Jack (1987): "100 Issues?!" *Musician*, February.

rock music, they are apt to take off their academic robes and put on journal-
istic street wear.

Table 4 shows the circulation figures for American music magazines in the
latter half of 1997. It comprises a broad selection of national music maga-
zines directed at interested laymen and for purposes of comparison, a busi-
ness magazine, a jazz magazine, and two of the most successful musicians'
magazines are listed. Further, a small number of the most successful nonmusic
magazines are included.

*Table 4: Circulation figures for American music and a few nonmusic magazines,
second half of 1997. Source: anon. (1998–1999):*[19]

Magazine	years of publication	frequency	circulation
Music magazines:			
Hit Parader (Magnum)	1942-	monthly	148,697
Musician (BPI)	1976–1999	monthly	71,611*
Option (Super Sonic Media)	1985–1999	monthly	27,000*
Request (Request Media)	1989-	monthly	968,310
Rolling Stone (Wenner Media)	1967-	biweekly	1,256,915
The Source (Source Publications)	1988-	monthly	357,215
Spin (Vibe/Spin Ventures)	1985-	monthly	521,137
Vibe (Vibe/Spin Ventures)	1993-	monthly	532,000
XXL (Harris)	1997-	monthly	175,000*
Other music magazines:			
Billboard (BPI)	1894-	weekly	41,000
Down Beat (Maher)	1934-	monthly	96,487
Guitar Magazine (Miller-Freeman)	1983-	monthly	135,947
Guitar World (Harris)	1980-	monthly	221,357

19 All circulation figures are accounted by the Audit Bureau of Circulation (ABC) and stem
from the second half of 1997. Magazines not stating auditors are marked with an asterisk (*).
Some of the figures seem to be rounded off to the nearest thousand.

For comparison:

Family Circle (Gruner/Jahr) (women's)	1932-	monthly	5,107,000
GQ (men's)	1957-	monthly	721,875
National Geographic (National Geographic Society)	1888-	monthly	9,174,000
Playboy (Playboy Enterprises) (men's)	1953-	monthly	3,150,000
Reader's Digest (RD) (general interest)	1922-	monthly	15,038,708
Seventeen (Primedia) (women's)	1944-	monthly	2,567,613
Time (Time Publications Ventures) (news)	1923-	weekly	4,155,806
TV Guide (United Video Satellite Group)	1953-	weekly	13,171,025

TV guides are among the leaders in the market, followed by women's and men's lifestyle publications. Compared to the British market (see table 5, below) the main difference is that the conservative general interest title, *Reader's Digest*, tops the list followed by *National Geographic*. In the music category, there is one clear leader, with *Vibe* and *Spin* vying for second.

In England, both *NME* and *MM* had changed strategy by the mid-1980s and chose to focus on rock again, first on the so-called shambling bands (heavily promoted by *NME*'s mail order tape C86), later on noise rock. The rock/pop opposition appeared once again in the contrast between, for instance, My Bloody Valentine and Stock, Aitken and Waterman. The dawning of the 1990s saw a reduced circulation for the inkies compared to ten years earlier, and the ailing *Sounds* was buried in 1991. The weekly *Record Mirror* suffered the same fate. The glossies had to face reduced circulation too, and *No. 1* was killed also in 1991. At the end of 2000 *MM* had to finally close after a lengthy struggle to survive (it was absorbed into *NME*), and *Select*, which rode upon the Britpop wave, had to close as well.

By 1986 the time was ripe for monthlies devoted to mainstream rock music, and *Q* was launched in opposition to the smart style bibles and New Pop. The audience was a bit older than the 15–25 cohort of the inkies, and the music covered was likewise of the more established sort. The market was there—not quite young men interested in rock rather than fashion or style—and *Q* was followed by a host of rock monthlies in the 1990s. It is characteristic of these magazines that they are generally positive towards their interview subjects, that they only seldom carry articles about anything other than music and that re-

views take up a lot of space. Furthermore, their point of view is that of the media and the music industry, hardly ever that of the musicians or the public, and the object is to inform the public about new products.

The titles are concentrated in fewer hands. IPC controlled the market in the 1960s and 1970s with *MM* and *NME*, but during the 1980s EMAP Metro slowly took over, since 1993 publishing four magazines dealing with pop and rock from different decades and catering to four different age groups (*Smash Hits*, *Select*, *Q* and *Mojo*) as well as "specialist" magazines like *Kerrang!* and *Mixmag*. IPC has published a few competitors (*Muzik* vs. *Mixmag*, *Vox* vs. *Select*) but without much success. The main goal for EMAP (and other publishing houses) is to make magazines that are entertaining in themselves and can function as consumer guides, primarily with regard to record buying but also to other advertised products. Their other objective is to present target groups that are interesting to prospective advertisers, primarily the music industry, but also manufacturers of men's perfume, cars and beer. In this way most music magazines— like all other commercially based mass media—fulfill an important task for advertisers. The difference between music magazines and other media is only a matter of subject, size and target group.

Whereas the EMAP rock magazines are an example of the segmentation of the market by age, magazines like *Kerrang!* and the independent *Wire* are examples of segmentation by genre. Since the early 1980s one or more magazines covered each genre. In the mid-1960s, the divide between pop and rock—in reader terms between young girls and older boys—gave rise to magazines for each group. As rock diversified, some genres were not covered by the nationals; for example, heavy metal was ignored for several years by both pop- and rock-oriented magazines. At first, fanzines covered the need for information, but a bit later commercially run magazines devoted to the ignominious genre began to appear, *Kerrang!* (f. 1981) being the most popular.

The big publishing houses have gone into this specialized market, but only dance and heavy metal are catered for as they probably are the only genres able to provide a sufficiently high circulation. The way to enter the market has been to buy successful independents, the way *Kerrang!* and *Mixmag* for example have been bought by EMAP. Other genres must rely on independent and more idealistic publishers whose magazines (e.g., *The Wire*, *Echoes*, *Straight No Chaser*) cover genres that do not sell many records but whose fans are dependent on such magazines for information. Magazines in this area have existed for a long time and they constitute a middle group between the mainstream glossies and the fanzines.

The circulation for music magazines reported to the ABC for the second half of 1997 can be seen in table 5. A few successful magazines from other areas have been added for comparison and their ABC category is stated.

Table 5: Circulation figures for British music and a few nonmusic magazines, second half of 1997. Source: ABC (Audit Bureau of Circulation) via the internet (http://www.abc.org.uk/):[20]

Magazine	years of publication	frequency	circulation
Music magazines published by IPC magazines:			
Melody Maker	1926–2000	weekly	42,105
Muzik	1995-	monthly	40,366
New Musical Express	1952-	weekly	100,093
Vox	1990–1997	monthly	55,042
Music magazines published by EMAP magazines:			
Kerrang!	1981-	weekly	41,535
Mixmag	1983/1989-	monthly	92,516
Mojo	1993-	monthly	70,428
Q	1986-	monthly	201,979
Select	1990–2000	monthly	86,474
Smash Hits	1978-	fortnightly	295,061
Music magazines published by small or independent publishing companies:			
Hip Hop Connection (Future Publishing)	1988-	monthly	9,826
Rhythm (Future Publishing)	1985-	monthly	6,580
Metal Hammer (Dennis Publishing)	1986-	monthly	38,448
DJ (Nexus Media)	1991-	weekly	25,948

20 All figures are from the second half of 1997, apart from those of *Smash Hits*, which are from the second half of 1998. Those of *The Wire* are the editor's estimate primo 1999 (personal interview, January 22, 1999).

M8 (Music Ltd,)	1988-	monthly	18,259
The Wire (McNamara Group)	1982-	monthly	ca. 20,000

For comparison:

The Face (Wagadon Ltd,) (men's)	1980–2004	monthly	71,381
What's on TV (IPC)	1991-	weekly	1,765,369
Cosmopolitan (National Magazine Company) (women's)	1972-	monthly	476,288
Take a Break (H, Bauer Publishing) (women's)	1990-	weekly	1,273,820
FHM (EMAP) (men's)	1982-	monthly	751,493
Loaded (IPC) (men's)	1994-	monthly	457,318

The category with the highest circulation has traditionally been television and radio program listings, the second highest, women's magazines. While music magazines can be considered part of a traditional men's magazine market that includes magazines about motoring, angling and other traditionally masculine pastimes, general lifestyle magazines comprised the novel genre of the 1980s while the following decade saw men's lifestyle magazines become an important new category. Compared to these the number and the circulation of music magazines are relatively small. Apart from the teen-oriented *Smash Hits*, *Q* is by far the most successful music magazine, but its circulation is only that of a moderately successful women's magazine. Music magazines are thus a relatively small niche within the magazine industry.

The professionalization of music journalism has made it easier for editors to dictate the kind of copy that they think the readers want. Stories of editors changing the amount of stars given by the critics are numerous and the space given to reviews has dwindled. According to Christgau editors in general have become "less and less literate, less and less wordfriendly, and more interested in illustrations and layout. The *Blender* model with 200 reviews of 120 words are now the norm" (personal interview, April 18, 2004).

Four Music Monthlies
After the mid-1980s the month has become the normal publishing interval in England as well. The first two magazines discussed below focus on rock and

their launch in the mid-1980s was backed by wealthy publishing houses. During the first years of the 1990s the other two have slowly manifested themselves on the market; *The Wire* by insisting on remaining a music connoisseur's magazine and thus keeping the circulation down, *The Source* by developing from a fanzine into a successful national magazine and staying independent. The amount of record reviews differs on the national level. The American magazines carry a relatively small number (10–20), thus functioning as preclusive filters, whereas the English consider it important to review as many records as possible, albeit giving detailed attention to only a few.

Apart from *The Wire*, *The Face*'s line of design in music publications has won the day. In contemporary music magazines with a high circulation the line between editorial and advertisement material is hard to draw, partly because magazines endorse the products, partly because the editorial fashion spreads are placed somewhere in between and partly because advertising aesthetics form the basis for the magazine designs. This underlines their position at the field's heterogeneous end, where consuming the right stuff has become an art in itself. In general then, what *The Face* introduced as a postmodern approach to magazine making has become the norm. But whereas *The Face* in its first years consciously celebrated text cruising, using a large variety of visual and textual layers, its playfulness and excitement has now become an everyday phenomenon used for selling things to the respective target groups. Nevertheless, even in these surroundings, qualified criticism can sometimes still be found.

Music as a Hobby: Q

> It's a fact that music is closer to men's hearts than almost any other subject. Not only is the music industry the UK's third largest source of exports, but its cultural importance inspires trends, discussions, fashion and above all passion. Q's mix of exclusive interviews, factual articles, superb photography and highly influential reviews, presented in our witty and provocative style, has made us one of the dominant forces in the men's magazine market today. The next few pages will demonstrate that Q is an extremely effective way of targeting upmarket men.
>
> —"Q: Music for Life Media Information" (sales material for prospective advertisers)[21]

21 Anon (n.d.), "Q: Music for Life Media Information," p. 3 (received from the Q offices, January 1999).

This is the way *Q* introduced itself to prospective advertisers circa 1998. The text stresses that music is culturally important for men and that *Q*'s primary (male) readers are quite well off. It highlights the magazine's interviews, reviews, presentation of facts and writing style. Lastly, the authors define their position within the field in commercial terms. This is not very surprising, given the target group, but it raises the question of whether this is also editorial policy.

Q was launched in October 1986, not as the first, but as the most successful British monthly about rock music, with a circulation slowly growing to more than 200,000 in roughly ten years. The format is 30 x 23 cm and the design is now glossy all the way through. The magazine is financed by newsstand sales and by advertising that takes up 45–50 percent of the pages.[22] The readership is 74 percent male, 71 percent members of the highest three social classes (A, B, C1) and 58 percent over age 25. The estimated total amount of readers (as opposed to buyers) is 764,000 ("Q Media Information" [n.d.]; their source is NRS, July 1997–June 1998). There are hardly any women involved in editorial decisions or as writers.

Q's initial design was rather conservative using mostly black/white print and a sharp grid system. Original art director Andy Cowles even talked about the original layout as "an anti-fashion statement," thus indicating a position different from the style bibles.[23] During the first years *Q* introduced itself as a "serious" rock magazine. The tone was reverent and the stars were treated with respect in long interviews because of their long careers (the first three cover stories were interviews with Paul McCartney, Rod Stewart and Elton John). As founding editor Mark Ellen explains: "We felt that people had a relationship with certain artists the way you do with a football club: you have good and bad seasons, but you stick by them."[24]

To this day, established stars have been at the top of *Q*'s agenda and the magazine still contributes to the canon of white male rock. Since its inception in 1990, the Q Awards have circled around U2, R.E.M., Blur and Oasis, and the "Lifetime Achievement Award" was given first to Paul McCartney, then Lou

22 To give an idea of the monthly turnover, the following calculation can be made: Advertisement revenue for Q, February 1998, would be in the vicinity of £235,000 when counting the number of advertising pages and comparing them to the rates printed in "Q. Music for Life Media Information." If all copies are sold at cover price it would amount to £540,000. It is not known how much of this sum is returned to Q.

23 O'Brien, Lucy (1996): "We Are Ten," Q, October:61.

24 Ibid.

Reed, Led Zeppelin, Elton John, U2, Eric Clapton, Rod Stewart, the Who and R.E.M. Women, African Americans, and African British are rare receivers of such awards (Massive Attack being the exception). As for the covers, during the magazine's first ten years only 8 percent featured African American musicians while 16 percent featured women. Add to this that Q left it to the inkies to spot new talent and you have a musical profile of the readership—the bearers (and buyers) of the central rock canon.

Only the recurring "Who the Hell..." interviews by Tom Hibbert (some are collected in Hibbert 1994) and the mildly ironic photo captions took up the irreverent stance known from the inkies. Hibbert was the only one allowed to act as a star critic using a Morleyesque interview strategy, while the other critics appear quite anonymous but professional as journalists. Since the mid-1990s the editorial line has changed, settling on a lighter note, probably to make room for EMAP's *Mojo* (f. 1993), which is directed at an older and more "serious" audience—but still fans. Thus Q has moved from a "serious" position in the tradition of earlier monthlies (e.g., *Zig Zag* and *Let It Rock*), where exact and nuanced information was central, towards a "lighter" position highlighting readers' responses and gossip. The magazine has retained its commercial attraction, but lost some of its consecrational power to *Mojo*. It is notable that Q, in contrast to *Mojo*, tends to avoid using well-known older critics (e.g., Jon Savage, Barney Hoskyns).[25]

The numerous album reviews are central to the magazine. They are short and use a star rating system, introduced in Britain by Q. The music reviewed is rock in a broad sense (rock, pop, country, soul, but not techno or rap) and reissues take up a large part of the review space. Interviews normally occur in relation to new releases and they are mainly microphone holding jobs although well written and informative. Historical articles, articles about music politics and think pieces are virtually nonexistent. The first two genres are *Mojo*'s prerogative while the third belongs in *The Wire*.

Q depicts rock music as a serious hobby for males (record collecting and factual knowledge), not as a way of life. Although the music may mean a lot to individual readers, it is presented as part of a life that also includes work, football, television and going to the local pub. The values are quite clear: within

25 During the second half of 2003 Q's circulation had fallen to 161,634 while *Mojo*'s had risen to 104,437 (Audit Bureau of Circulation via the Internet, http://www.abc.org.uk/). In the process *Mojo* has neared Q's former position within the field, while Q has become even more glossy and gossipy.

rather clearly defined borders there is room for old and new pop and rock—and the old stars comprise the pantheon. The magazine's primary functions are to serve hobbyists by bringing to their notice facts they did not know, to point out new products and to entertain. Since almost every sentence in the magazine is related in one way or another to new products, *Q* is the ultimate consumer guide in rock and related product—and a model for countless others.

Overground Underground: Spin

There are many parallels between the early *Spin* (f. 1985) and early *Rolling Stone*. Both were founded and edited by a single and ambitious but inexperienced man with a talent for hiring the right writers and administrators, an erratic editing style and luck. Both magazines had rock music as the primary topic, both became successful quite fast, both had the same format and both had a rarely contributing writer legend on the masthead (Hunter S. Thompson and William Burroughs, respectively). In some ways it looked like a father and son relationship between Jann Wenner and Bob Guccione Jr., and Guccione's intention was "to kick *Rolling Stone*'s ass" (quoted in Draper 1991:459). His real father was the founder of *Penthouse*, a successful, light pornographic men's magazine. He sponsored *Spin* quite extensively as its editorial staff for the first couple of years had their headquarters in the *Penthouse* offices. Besides, it took several years for the magazine to come out of the red.

Among the differences between *Rolling Stone* and *Spin* are that Guccione Jr. sold his shares in the magazine in the first part of the 1990s and left for good in 1997, whereas Wenner has kept his and stayed on (at least in principle). *Spin* has continued to cover rock music extensively, with only one or two nonmusic articles in each issue, and has not mythologized itself by countless spin-off books and greatest hits. *Spin*'s circulation figures have risen steadily ever since its inception to more than 500,000 copies by 1997, whereas *Rolling Stone* stabilized its figures in the 1980s and 1990s at 1.1–1.25 million copies (cf. table 4). At the turn of the century *Spin* presented itself to advertisers like this:

> SPIN concentrates its editorial on trendsetters in the music world and the entertainment personalities who are shaping youth culture. Edited for young adults, SPIN's approach to photography and journalism combines contemporary information with a pervasiveness of fun. (anon. 1998–1999:1031–1032)

The stress on fun—not a word one would think of in connection with *Rolling Stone*—can be found in the gossip and letters columns (for example, you could

write in and pose questions to Elvis in the early 1990s) and in the photo cap-
tions. This can be attributed to Guccione's interest in all things British (even
down to his much-publicized British accent). The early *Spin* layout was similar
to contemporary British magazines (*MM* and *Q*) with its rigid grid, broad black
lines and use of sans serif type for both headlines and text. The Dutch photogra-
pher Anton Corbijn, who was vital for *NME* and *The Face* in the early 1980s, had
a lot of photos published and British bands got more coverage than in most Ameri-
can magazines. Guccione even printed articles by British journalists. Through the
years the full color magazine has grown from 76–100 pages to 160–180 pages, and
the amount of advertising has risen from 18 percent (March 1985) to 54 percent
(April 1999) while primary advertisers have changed from record companies to
shoes, clothing, car, and cigarette producers. Now there is only the occasional
record ad, probably due to the high price of advertising (see table 3). The format
has become smaller since the magazine's inception and is now 27 x 22 cm.

 Spin has the usual departments distributed in the usual way, the only excep-
tion being that record reviews were originally placed right after the gossip and
news columns, a place now taken up by book, television, movie and technology
reviews. Together with 20–30 pages of advertising this gives a long lead-in to the
four to six feature articles that run 5–11 pages. These are mostly interviews with
musicians, sometimes very well researched, but essays can also be found—for
example, Charles Aaron's "What the White Boy Means When He Says Yo" (No-
vember 1998). This piece on white boys' appropriation of hip-hop takes up 11
pages, including 7 pages of closely printed text. Apart from music-related arti-
cles, there are pieces on the usual popular culture illuminati: cartoonists, movie
directors and actors. Political and larger cultural issues have also been taken up.
In the early 1990s each issue carried a sometimes quite long article on AIDS.
The music censorship debate around 1990 was covered extensively and explic-
itly political articles of a left liberal bent frequently appeared. But whereas in
the 1960s there was a sense that you could do something about the issues of the
day (war, racism, etc.), this has changed—in *Spin* and in general. It appears that
contemporary readers are more or less "scared" by the big issues they feel they
can do nothing about (e.g., AIDS, the environment).

 A novel idea, at least at music magazines, was *Spin's* use of guest editors—
for example, the president of the U.S. Amnesty International (November 1991)
and the American technology-futurology guru Jaron Lanier (November 1995).
Spin has also experimented with new article formats, for example by simply
transcribing (and presumably editing) conversations between two stars (for
example Paul Simon and Hank Shocklee in January 1991), or articles pasted

together from interviews with many different persons, obviously inspired by the TV documentary.

The first issue featured Madonna on the cover and ran stories on U2, Fela Kuti, Frankie Goes to Hollywood, Run DMC and Bryan Ferry. This illustrates well the magazine's intention to cover music broadly and to be ahead of *Rolling Stone* with regard to presenting contemporary music. Through the first years, this resulted in a focus on the mainstream and the so-called alternative music. Guccione (credited as editor, design director and publisher) saw to it that the mainstream was represented by doing long, not very well written interviews with, for example, Jon Bon Jovi and John Cougar Mellencamp, both personal friends of his, while a host of good journalists covered other territory. According to Richard Gehr, the original managing editor, there was a certain tension between Guccione and most of the staff because

> [he] was interested in sex, but sex in the larger sense of flash, just like every magazine today. It's the buzz, the fetishism of the hot new commodity. In a way he was good at that, but he made a lot of mistakes, he just hadn't very good taste. He used to brag that *Spin* was a magazine edited by people who didn't listen to music. There was a tension between [him and] people like me who were interested in what we felt to be creative, outrageous, and intellectually stimulating. (personal interview, June 23, 1999)

This tension was—probably unwittingly—expressed by Guccione in an internal memo: "I've been saying in the press that we're an overground underground publication" (internal memo from Bob Guccione Jr., March 19, 1985). Even from the start it carried a column unironically named "Underground." *Spin* saw a music movement to back up with the breakthrough of grunge. Here was what every magazine (and record company) had been looking for since 1977: angry young (white) men coming out of nowhere. In an article from September 1992 Chris Cuffaro outlined recent Seattle music history, nailing down the central topoi of grunge: that it continues the punk legacy (both the Sex Pistols and Black Flag); that it is a generational phenomenon (the disaffected, angry, alienated suburban youth); that it continues the indie spirit (although the bands quickly got signed to majors); and that grunge is really alternative (it might cooperate with "the system," but the bands develop individually). But first and foremost was the violent anger of the bands, interpreted by Cuffaro as a generational response to being left without a future:

The punks, from whose ashes spring most of Seattle bands, insisted that we had no future. Our generation—and I write from the cusp between the baby boom and generation X—is living in that future. We face hopeless, demographic, economic, and ecological imperatives. Our older brothers and sisters have all the good jobs (at least those who haven't been cast from grace by recession and corporate restructuring). The American dream is no longer to start a business and hand it down to your children, but to sell out to a large corporation, or buy into a franchise. And the environment has been so relentlessly savaged that getting a suntan has become almost as much a high-risk statement of personal disregard as engaging in unsafe sex. ("Grunge Makes Good," *Spin*, September 1992:55)

Today, when *Spin* is at its best, it publishes penetrating contemporary rock criticism, but often these articles are hard to find in the maze of advertising. *Spin* posits its readers primarily as consumers, then as intelligent readers. This in contrast to *Q*, which concentrates on the entertainment angle. In addition to being part of different popular music cultures, this can also be explained by different radio, television and advertising traditions. Put simply, American society is even more permeated with advertising and lacks the British ironic mindset.

Obscure Musics: The Wire

[T]he magazine's greatest strength is in the risks we take in bringing the very best non-mainstream music to your attention every month. Unlike the majority of music titles, we don't let advance sales figures dictate the content of your magazine—that's why you'll find non-commercial faces such as John Fahey, Jim O'Rourke or Tony Conrad on our covers and why we are free to fill the magazine with such a diverse and independent selection of music every month.
—*The Wire* subscription flyer, 1999

This is the way *The Wire* presents itself to prospective subscribers. It takes risks, it is nonmainstream and noncommercial and it is independent. All the right buzzwords are there to indicate a position at the autonomous end of the field. *The Wire* (current subtitle: *Adventures in Modern Music*) is a British magazine, published since 1982. Originally a quarterly, it began to appear monthly in 1984. The combined editor-in-chief/publisher is the definitive decision maker at *The Wire*, which has been staff-owned since 2000. According to the publisher's estimate, the circulation at the beginning of 1999 was around 20,000, and he estimates that about 90 percent of the readers are male,

probably within a very wide age range. The annual budget is £5–£6 million and the income sources are advertising (35–40 percent), newsstand sales (35–40 percent) and subscriptions (the rest) (personal interview with editor/publisher Tony Herrington, January 22, 1999). *The Wire* is also involved in releasing CDs and arranging concerts.

In the first part of the 1990s the format changed from A4 to Letter+ (28 x 23 cm). The first copy had 40 pages; today just over 100 pages is normal. The design has slowly changed from being very neutral and text dominated toward "design art," using more and larger pictures in an inventive way. Four-color print was used on roughly half the pages during the latter part of the 1990s. The regular staff is small (six full-time and two part-time employees), but there are a lot of regular contributors, among them a few well known (Reynolds and Toop, the only ones to be named on the front cover). In the late 1990s there was only one regular female contributor (Louise Grey).

The Wire began as a magazine for modern jazz and improvised music but has slowly changed. Featuring Michael Jackson on the cover in the June 1991 issue was an important signal of the transformation taking place. Now, most genres apart from mainstream pop and rock and old classical music are discussed, but the focus is on electronica, breakbeat and experimental music of any genre. The image is distinctly noncommercial and the tone is serious and slightly conceited (editorials often posit the magazine against other more overtly commercial ones). Sometimes experimental music—and consequently also *The Wire*—is even described metaphorically in terms of guerilla warfare against the mainstream in accordance with the allegedly subversive role of earlier rock and the classical avant-garde. The magazine functions as a taste leader pointing out unknown or little known music, sometimes publishing controversial views.

Discussing canon formations in an interview, then editor Tony Herrington clearly stated a dislike for them and described canonization as a project befitting high street retailers and the mainstream music press. Canons, he thought, bar the possibility of new musical revelations. Musicians who are central to the magazine (e.g., Sun Ra) do not belong to a magazine canon but function as anchors or beacons and as definitions of what the magazine is; furthermore, there is plenty of room for newcomers. The only criterion for inclusion in *The Wire* is that the music is "interesting" in some way or another. The music must have some kind of impact and at the best of times be able to "illuminate new models for living."

Interestingly, Herrington thinks his magazine sidesteps the high/low split, while he acknowledges its existence within classical and jazz circles. Instead,

he distinguishes between "music in one go" and music that requires listening to multiple times for full appreciation. It is important to him that *The Wire* is not an intellectual magazine but an intelligent one, with writers well versed in culture. Writing about music is regarded as a specialized craft, as music criticism is a unique genre, an extra and independent layer between the listener and the music. However, in Bourdieu's terms the magazine clearly places itself at the autonomous end of the field. It opposes anything mainstream, especially mainstream magazines, and in its own view it is more related to an international sphere that includes such magazines as Sweden's *Pop Magazine* and Japan's *Marquee* (it has a large group of international subscribers). Although *The Wire*—like all other music magazines—has a healthy distrust of academics and tries to distance itself from them, several articles use an academic vocabulary. This makes it possible to contribute to the charismatic consecration of musicians without going full-scale academic. There is no denying that *The Wire* supports a canon and tries to wield it. Although its lists do not look like any other magazines', as rather obscure music is often featured, it does use "all time greatest" listings.[26]

Reporting on Hip-Hop Culture: The Source

The Source (subtitle: *The Magazine of Hip-Hop Music, Culture and Politics*) is a New York–based independent magazine published since 1988 and "dedicated to true hip-hop" (masthead end). Today it is commonly accepted as the most important magazine on hip-hop. Interestingly, it began life as a xeroxed fanzine edited by two white Harvard students, Jon Schecter and David Mays, of whom the latter is publisher today.

The magazine format is letter and since the early 1990s the print has been glossy all the way through. The amount of pages has risen from around 40 in late 1989 to 220–250 at the end of the century and less than 200 in 2004. In volume 115 (April 1999) 50 percent of the pages were taken up by advertising, not counting "editorial" fashion guides and inserts. The most important products in the advertising are clothing, musical recordings and movies (in that order), and the models featured are mainly African Americans. Much of the advertising reflects American teenagers' curious obsession with shoes. The

26 For example, "The 100 Most Important Records Ever Made," *The Wire*, June 1992; "150 Essential Objects of Musical Desire," *The Wire*, August 1996; and "100 Records That Set the World on Fire," *The Wire*, August 1998. Contrary to most of these lists the entries are not numbered from 1 to 100, they are only listed.

staff contains more females than do British magazines and is composed of members of a range of nonwhite ethnicities. By the second half of 1997 the circulation was around 350,000.[27] In 1994 the annual Source Hip-Hop Music Awards debuted.

The Source contains the usual mix of columns and features covering what is promised in the subtitle: music, culture and politics. The columns include gossip, letters, "Mediawatch" (a report on coverage of rap in other media), small articles about up-and-coming acts and recent news related to African American culture. The features are primarily interviews with rappers, but overviews of scenes (e.g., R & B) and general interest articles (e.g,. reports on Nigeria and Zimbabwe) can be found. Like American music criticism in general, *The Source*, too, is largely parochial: There are general articles about the diaspora, but not any on, for instance, French or Australian rap. As rap is primarily made by African Americans, they of course also appear ethnocentric, but white rap acts like the Beastie Boys, and Eminem are featured as well. In contrast to English magazines and following American custom, there are relatively few record reviews, eight to ten pages worth, which means that most new releases are not mentioned. In each masthead the publisher's credo is printed, here quoted in extenso:

> We at *The Source* take very seriously the challenge of being the only independent voice for the Hip-Hop Nation. We strive hard to bring the reader a complete and unbiased representation of this incredible art form and all that surrounds it. With this in mind, we feel that it is important for our readers to be aware of the nature of our relationships with the rap industry. We engage in business transactions with companies that are part of the rap music industry on two basic levels. Obviously, we accept advertising from such companies. Second, we at times are contracted by record companies to aid in their promotion of their product outside the direct channels of the magazine. With respect to any of our business

27 See table 4. Tricia Rose mentions that according to *The Source* itself its pass-along rate is 1 purchase to every 11–15 readers, much higher than norm in the U.S. (1994:8). Today *The Source* claims to be "the nation's number one selling music magazine with a total audience of approximately nine million readers each month" (2002 MRI 12+). A recent, apparent self-description by the company reads: "The Source empire has expanded to include nationally syndicated The Source Magazine Radio Network, The Source Clothing Company, the platinum-selling Hip-Hop Hits series of compilation CDs, the annual 'The Source Hip-Hop Music Awards,' the award-winning source.com and The Source Youth Foundation" (http://www.viacom.com/press.tin?ixPressRelease=80254124, June 15, 2004).

relationships, we feel that it is our responsibility always to strictly police the integrity of our editorial content. Only in this way can we continue to bring you the clear and unbiased coverage which we hope has won the respect of all of our readers.

Here, *The Source* stresses its independence and its respect for the readers, both important notions in the hip-hop community. At the same time, it comments frankly on its relations to the music industry. Contrary to other 1990s magazines discussed, which either just ignore music industry aspects, report on them without any critical distance or are "against" the industry, *The Source* acknowledges that it is an integral element of the "hip-hop nation." Rap as big business is regrettable, but nevertheless to be accepted, as it is a sign of success, a sign that African Americans can make it out of the "'hood" and become influential within American society. Large record sales are regarded as positive and mentioned frequently. Motown founder Berry Gordy is held up as an important role model—becoming a company owner or an executive is one legitimate way out of the ghetto, being a successful rapper another. By bringing attention to those who make good in these ways, *The Source* counts on creating new positive role models for the African American community.[28]

Politics related to African Americans is an integral part of *The Source*. Editorials always comment on politics, the columnist of "American Politrix" also dwells on recent happenings and the news pages relate the latest atrocities from a racist U.S. An historical perspective is stressed as well, although it only stretches back some 50 years, beginning with the early Civil Rights Movement. A similar perspective is applied to music history. Jazz is avoided, probably because of its lack of street credibility, while the soul tradition from Sam Cooke and Ray Charles onwards is cherished.

The charge of "selling out" is probably the most derogative accusation that can be made in rap. To *The Source*, not selling out means balancing street credibility and success: "To reach the masses while never [...] losing the respect of the underground fans" it says, or "art and business were synonymous to him [the Notorious B.I.G.] from the moment he stepped off the ave. in Bedford-

28 The credo might also function as reminder that the magazine has laid behind it the struggle over editorial control in 1994 between Schecter and Mayes. Mayes, who was responsible for promotion and advertising, wanted an article about a crew that the writers did not like but printed it nevertheless. As a result Schecter and most of the staff left under much controversy. (George 1998:71)

Styvesant and into a recording studio."[29] MC Hammer remains the prime example of selling out, not because of his success, but because his music lacks quality—as discussed in this unsigned record review:

> The music is completely wack, with lazy samples (duh, let's just take the whole thing) and cheesy, pop-oriented production. On the rhythm tip, Hammer's about as creative as a glass of warm milk. His voice is annoying, and the simplicity of his rhymes is a constant source of frustration. ("MC Hammer: *Please Hammer Don't Hurt 'Em*," *The Source*, Summer 1990:40)

What is missing is creativity and complexity, both craftsmanlike aspects of making music. The negative evaluation of "pop-oriented production" is of a more ideological nature and reproduces the age-old pop/rock split.

A typical example of a feature is Dimitry Legér's "Forces of Nature" about Naughty by Nature (*The Source*, April 1995:66–70, 88), which mixes several archetypal scenes, all connected with the group: police harassment, growing up in a very poor neighborhood without fathers, intergroup friendship and dependency, success (platinum sales), control of their music and merchandising line, socializing with female fans. The only thing *not* discussed is their music. The article begins in medias res at the corner of an intersection in East Orange, New Jersey, where a confrontation between MC Treach's posse and the police is taking place. Change of scene: Vinni Brown is showing the reporter around the neighborhood, reminiscing heartbreakingly about his poor childhood as one among seven children and the love he feels for his family. Another change of scene: success has not changed anything, "the three members remain the same three boys," and they are "bringing jobs, the most generous gift you can give to Black communities in perpetual recession, to family and friends" (66). Final change of scene: the group members deal with a group of female fans and their relation to other rap stars at a party. The narrative consists of these four scenes woven together, and the moral of the article is this:

29 Anon. (1997): "Forever the Illest," *The Source*, May:78. Musically this is explained thus: "Nowhere was the duality of Biggie's craft more obvious than on 'One More Chance.' While in its original hardcore incarnation, the song was a hilariously explicit ode to the sex styles of the down and dirty; when remixed for radio, it was miraculously transformed into a dynamic spread-love-the-Brooklyn-way mack-anthem, complete with luscious background vocals from wife Faith Evans. Both versions are masterpieces" (ibid.).

Kay Gee's keen ear for succulent melodies and the brilliant bombast of Treach's flow are the visible parts of Naughty by Nature's success. Vinny Brown is the glue who keeps Naughty by Nature together. [… He] helps them keep their focus as Naughty builds into a sprawling empire that reaches into film, retail merchandising, and, of course, music. Yes they are leveraged with all their ambitious projects, and Naughty by Nature needs to keep selling crates of records to keep moving the chains, to keep the community growing. But the title of the mature new album, *Poverty's Paradise*, suggests that they have learned the true meaning of their success, the true power of the cultural force called hip-hop: it's not where you're at, but where you come from. Take care of yours. (88)

The message of hip-hop thus equals the American Dream: it is possible to become successful without betraying your poor origins. Staying true to the 'hood is the most central criterion of authenticity in hip-hop culture. The means to communicate the message is essentially to focus on the musicians' biographies, and the way Naughty by Nature is presented is the matrix for countless articles in *The Source*.

Rap and Hip-Hop culture have a low status within American society. As most acts are radical in one way or another, much energy is used to defend rap against attacks made from outside the "hip-hop nation." Some acts go for radical politics. This is the easiest radicalism to defend as it is related to American politics, albeit negatively. Another radical strand is gangster rap. *The Source* finds these harder to defend, but they must since such rappers are immensely popular. Articles critical of gangster rap are printed, but the gist is still protective. In one of the five memorial articles about the Notorious B.I.G., the New York gangster rapper who was shot only six months after Tupac Shakur had died from the same cause, editor Selwyn Seyfu Hinds wrote:

The man was a loving father of two, four-year-old Tyanna and newborn Chris Jr.; he was a genuinely nice guy, a successful artist who maintained the ability to give a fuck about Joe regular; and he was a straight up hip-hop head. Indeed, the long relationship between Chris and *The Source* is particularly fitting. We put this magazine together for cats like him, heads who thirst after every bit of information; memorize songs before they're a day old; and live for the simple ecstasy of a beat and a rhyme. Chris was all that, and more. Folks have told me they've never seen anyone hungrier to get on and make a mark. And being on, being successful, didn't make Chris any less of a fan, any less driven. ("The Assassination of Christopher Wallace," *The Source*, May 1997:77)

This demonstrates the most normal way to deal with the gangster rap: stick to biography and let the result work as an excuse for the texts. Another strategy is to explain gangster rap as a normal cultural expression. For example, Ice Cube at the time of *AmeriKKKa's Most Wanted* (1990) is defended by journalist Dan Charnas, who borrows an argument from the famous literary critic Henry Louis Gates Jr., saying that "African American culture is [...] a male ritual of exaggeration. In other words, 'talking shit'" ("A Gangsta's Wold View," *The Source*, Summer 1990:27).

The third radical strand is the blatant misogyny of many rap acts. Here, *The Source* has clearly taken a stand by maintaining that misogyny weakens African American communality. Also, female rappers are welcomed and treated seriously. In general, the magazine's basic strategy is to support cultural ideals specific to African American communities, but there is a wish too, that these ideals be appreciated within American society in general, here expressed by Carlito Rodriguez:

> I can't help but imagine a world in which his [KRS-One's] vision comes true. Farfetched? Hip-hop not misinterpreted as some here today-gone tomorrow flash in the historical pan, but instead, respected and recognized by all other social institutions as a legitimate culture? For Kris, this means the ability not only to express ourselves without so much unsubstantiated criticism, but also to affect social change. "I guarantee you that in my lifetime I will one day sit down to a conversation with a President of this country," he declares. ("A Man for all Seasons" [interview with KRS-One (Kris Parker)], *The Source*, March 1997:100)

The Source refrains from using too much slang, let alone Ebonics. Even white, middle-aged European readers like us can understand the texts as the language is a forthright American English, but well spiced with hip-hop expressions. It is used to stress fundamental values like solidarity and roots (i.e., the ghetto) in African American society, while it denounces the use of narcotics, African American males' lack of family responsibility and misogyny. These values and vices are almost contrary to central elements of the present rock ideology, where family is something you break away from (or at least try to scare by dressing like Marilyn Manson) and the use of narcotics signals success. Only misogyny unites—compare the Prodigy's "Smack My Bitch Up" and NIN's "Fist Fuck" to most gangster rap.

Generically, *The Source* places itself at the nexus of the consumer magazine, the fanzine and the critical magazine. Most of its articles are written because of the launching of new products. But the rappers involved, as spokespersons for what is conceived as *the* community, have a weightier symbolic status than most

rock acts. The critics and the musicians seem to subject themselves to what is politically correct: the magazine's role is to be supportive of a musical genre that is not accepted in WASP America and thus its discourse is in many ways that of a fanzine. Musically, the staff is preaching to the converted, but the values of official Black America are preached as well, and that is probably the magazine's raison d'être. It may be said that *The Source* does not practice music criticism so much as political criticism and education in an emphatic sense.

8.4. The State of the Field Since the Turn of the Century

The years since 1980 have seen a fundamental rupture in the field of rock criticism as well as its subsequent stabilization. The change was caused by British critics' reaction to New Pop, but the new, postmodern values were successively integrated during the course of the 1980s, giving rise to a still growing diversification of possible positions, some of which drew explicitly on "high," poststructuralist theory. Another reason for this diversification is the enormous growth in the number of critics. Today every newspaper and most general interest magazines have their own reviewer. Different generations of critics coexist as well. Among those still active, the American founding fathers Christgau and Marcus are today considered the elder statesmen of rock criticism while Bangs stands as the great, lost genius—criticism's (relatively) young dead. In England, Murray is probably the oldest still active critic and, along with Savage, perhaps the most respected.

The eight critics focused on in the last two chapters mainly draw on politics (especially identity politics), "theory" or populist iconoclasm. Political perspectives are conspicuous in the writings of Jon Savage (left-wing cultural criticism), Nelson George (African American politics and the problems of racism and race relations) and Ann Powers (feminism and the problems of sexism). Theory inspired by discussions in the humanities has put its stamp on Jon Savage (history of the popular), Simon Frith (sociology), Simon Reynolds (postmodern philosophy), David Toop (ethnology) and Ann Powers (academic feminism, identity studies, literary history). These categories of critics stand partly in opposition to the iconoclasts, represented by Paul Morley and Chuck Eddy. The take on pop is different as well. First, the critics actually write about quite different genres, being bound to them by age, gender, race, nationality and educational background. Although some of these writers have been able to change bases (most notably Reynolds from indie to techno), they have been typecast by the institutions within the field. Most of them do not deal with mainstream pop at all. Earlier critics were supposed to be able to deal with a spectrum of

genres, but now that hybridization is the rule, critical specialization has become necessary. Contrary to the consumer guide writers, subjectivity is always present in their texts, but the characters staged vary. In this way a wide range of voices are marketed today, from the "objective" to the subjective, from the dead serious to the "just kidding."

The reactions to New Pop prepared the ground for what must be considered the dominant set of values since the early 1990s: what we have called a new pop sensibility based on the aestheticization of both the act of and the products involved in consumption. The "art" of the dandy has become available to anybody with enough money to spend and enough imagination to invest the objects with specific values. The insight that all music is product and that we are all consumers makes distance and irony central to contemporary pop criticism, as exemplified by Eddy. But this is combined with a search for a genuine subjectivity, whether caught in the glimpse of the transcendent "moment," as Reynolds attempts, or constructed as the artist's or the critic's sustained subjectivity, as in Powers's case. The point is that rock and pop aspects are still active, hardly as supergenres with prescribed aesthetic values, but as possible ways of relating to music. Contemporary critics know that they are in the middle of the pop process and enjoy the opportunities it offers for play and fantasy. But they know as well that there may be something else beneath the role-playing and the posing. In the 1960s and 1970s this would have been considered a paradox, but now it has become the normal state of affairs—it coheres with the evolution from authenticity to meta-authenticity. Due to the pervasiveness of this aesthetic no new critics' positions have emerged for the last decade, even though lots of new critics have gained access to and been accepted within the field.

With the breakdown of the pop/rock split and the exploration of the commercial pole by modern art, the question of whether rock is art has become more or less obsolete. It does not really matter any more since great portions of everyday life have been aestheticized—at least to the middle classes. Rock has acquired some of art's aura, while art has lost some of its lofty position. Rock now has its own history, its own museums (in Cleveland and Seattle), its own discourse on the interrelatedness of the commercial and the authentic (i.e., its own aesthetic rules), whereas art is only beginning to discuss the consequences of its commercialization.

Their theoretically informed habitus has made many critics entering the field after 1985 assume a priori that they were joining in a kind of art discourse. It is important that the comparisons between rock and art no longer focus on, for example, the Beatles and Schubert, but Damien Hirst and Goldie. Angela

McRobbie exemplifies this turn in her short discussion of contemporary British art, fashion and (popular) music. She acknowledges that a hierarchy still exists, but contends that the values of the higher echelons are more akin to those of pop (the example is the hugely successful 1997 exhibition "Sensation" by a group of young British artists including Hirst), and those of drum 'n' bass DJs are woven through with artistic ambitions, concluding that

> [w]e are left with a curious scenario in the "Culture Society," with the breakdown of high and low culture being more apparent than real. Even when fine artists think they are not doing art, the critics, collectors and academics bring their own professional vocabularies to bear on the work and confirm that, yes, it is art. [...] Meanwhile, the drum 'n' bass musicians are producing the most innovative and dynamic aesthetic in music since reggae, but there are so few black scholars, intellectuals and critics who have made their way up through the ranks of the academy or into journalism that there are virtually no voices of representation, never mind debate, except those that come from other, largely hidden, spaces. (1999:18–19)

The values of high and low have been set adrift, not least by theoretically inclined critics and members of the academy, but the positions themselves are still around. The inertia of the institutions sees to that.

While the diversification process is most obvious among the critics (as we have not discussed the thousands of critics doing "criticism" as pure consumer guidance), the polarization process is most obvious in our discussion of the magazines. In the wake of *The Face*, nowadays nearly all music magazines haven taken positions at the commercial pole in that they first and foremost construct their readers as consumers, be they clever forever-youngsters in search of templates for a lifestyle (as *Spin* and *The Face* have done it) or societal mainstays on a steady diet of ready-made magnets for desire (cars, drink and CDs as *Q* and *Mojo* do it). The layout, the copious amount of advertising and the fact that nearly all copy is related to new product contribute to this. But it is still possible to find criticism in an emphatic sense in even the most consumer-oriented magazines if one puts some work into it.

The Wire is an example of a position at the opposite end of the field. With its focus on music belonging in the small-scale production and its insistence on criticism as judgments of taste in a classical sense, its critics infuse their chosen genres with a historical perspective and a semitheoretical horizon. Magazines at the commercial pole tend to stay within the selected national field. Only *The Wire* and *Mojo* seem to keep alive a transnational field by using writers from both sides of the Atlantic and (judging from the letters columns) attracting

readers from most of the Western world. *The Wire* actually covers music from most parts of the globe.

The space between the poles was taken up by the inkies in the 1970s and 1980s, but they are not important today. The monthly magazines tend to choose a position either at one pole or the other, for the middle is left to the daily newspapers, which nowadays produce a surprisingly large amount of criticism. Critics employed at quality dailies like the *New York Times, Los Angeles Times, Times* (London), and the *Guardian* still have more column space than most of their colleagues at the commercial magazines for record and concert reviews (if not interviews). They are expected to write and reflect at the same level as the newspaper's art critics, and their pieces strive to embody the basic journalistic virtue of being news stories. At the same time, because they must address most readers they cannot be too highbrow. Normally, the newspapers take up rather conservative positions by contributing to the consecration of established musicians, and they hardly ever print stories on new acts. Nowadays, the positions between the two poles are less important—and thus contribute to the polarization—as the newspapers cannot create the same buzz and excitement and do not have the same amount of column inches as the inkies used to have in the 1970s and 1980s.

Adding to the stabilization of the field are such institutions as awards groups with which critics have seats (the Q Awards, Rock 'n' Roll Hall of Fame, Source Hip-Hop Music Awards, and Mercury Prize) and the industry-led Grammy Awards. They contribute to canon formation, as do the museums. The Experience Music Project (EMP) and the Rock 'n' Roll Hall of Fame and Museum have become a force within American music because of the involvement in music education at all levels and as hosts for conferences on most aspects of music. For the last couple of years EMP has held three-day conferences where academics and critics debate among each other. Encyclopedias have grown since Lilian Roxon's first effort in 1969. Now they include the journalistic *Guinness*, the latest edition in 8 volumes, and the academically based *Encyclopedia of Popular Music of the World*, planned in 12 volumes. University departments specializing in popular music exist in Liverpool, Manchester and Berlin, and a few academics have reached the rank of professor, even though their home is in popular music.

The acceptance of popular music and its criticism within academe is an important factor in the legitimization of rock. To some extent the academy contributes to the canonization as well, especially in American textbooks for undergraduates, even though other academics try to shy away from it. In the marketplace Robert Christgau is one critic who has constantly tried to open up the canon for new inclusions, while *Rolling Stone* is still defending its old school canon. In gen-

eral, attempts at canonization have become still more ubiquitous, in the process reducing canons to top 100 lists like those of the protagonist's in Nick Hornby's *High Fidelity*. In this way canon formation seems to be deteriorating, and apart from a few 1960s acts, there is a great divergence between U.S. and British lists.

In general, the media development of the last two and a half decades has been one of growth, as regards turnover, the number of magazines, television channels and other outlets and the number of people writing about rock. In the last ten years the Internet has brought about some fundamental changes in the distribution of music, which have affected the conditions for rock criticism as well. Several of the critics mentioned in this chapter have their own weblogs ("blogs") where they offer critical remarks and musings on diverse topics without any editorial intervention. Contrary to magazine writers blog critics have obtained a platform to communicate highly individualized viewpoints directly to interested readers. The Internet has also made possible a historicizing of the field. At rockcritics.com you can find interviews with well-known critics; rocksbackpages.com is an ever-growing library of magazine articles from the last four decades;[30] and robertchristgau.com supplies not only the dean's (nearly) collected works but also an address at which the Festschrift written in his honor can be ordered.

Magazines existing purely electronically are a growing presence; one first-generation netmag, *Addicted to Noise,* published articles by, among others, Marcus and Marsh. Such magazines, like the Internet in general, threaten traditional print criticism as can be seen from the reduced number of pages and advertisements, especially in American magazines. The specialist press has reacted by opening their Web sites, where mags present material related to the latest issue, for example uncut interviews. Also, they have started Internet radio stations (*Kerrang!*, *Smash Hits* and *Q* even have Internet TV stations) in order to use their brand in new ways. Last but not least, the big Internet record "shops" such as Amazon.com invite customers to award stars and write their own product reviews, thus influencing public discourse on rock to an unprecedented degree. In this haze of comments on music some of the Internet shops feature reviews of stocked CDs using some of the high profile critics as editors. In the

30 This trend has also resulted in a curious analogy to the music industry's use of the back catalogue. The IPC-owned *Uncut* publishes a series of magazine format "NME Originals" that contain old *NME* articles about bands that are still of interest to (presumably) nostalgic readers—this time in full color. This book together with Gorman (2001), Jones (ed.) (2002) and Gendron (2002) does, of course, contribute to the trend.

history of rock criticism this seems to be the most dependent criticism yet as the institutional differences between the music press and the industry have been dissolved and the sole reason for its existence is to sell product.

Again, even though consumer magazines blur the border between industry and criticism and the Internet the border between writer and reader, there still seems to be room for "serious" criticism in our sense, although it has become harder and harder to find among the verbal debris coming from all kinds of media.

Chapter 9
Concluding Remarks

9.1. The Field of Rock Criticism

One problem that has guided our investigation from the outset is to what degree and in what sense rock criticism has been established as a cultural *field*, bridging the gap between journalism and popular music.

The existence of a general rock field that includes a clergy of critics has been postulated by, among others, Laermans (1992) and Regev (1994), but on the basis of limited data and with many questions unresolved. Laermans stresses resemblances with other cultural fields, pointing to the reproduction of the high/low distinction within the rock field. Regev is also attentive to some differences, particularly the part that notions of subversion play (or used to play) in rock discourse. Both writers emphasize canon formation as a central legitimation strategy of the agents, both treat the rock field as an international field; and both refer mostly to the late 1960s and the 1970s as the empirical basis for their hypotheses.

Our more persistent exploration of British and American rock criticism supports the general idea of rock as a cultural field. But it also complicates Laermans's and Regev's tentative pictures, above all by demonstrating the possibility of studying criticism in terms of a separate field. Contributing to a new understanding of popular culture, rock criticism has developed its own standards, its own themes to dispute, its own doxa, its own stylistic repertoire and its own criteria for access. It has fostered distinct positions in combat on the understanding of rock and popular culture, bred a clergy capable of setting the agenda for other players and made crucial contributions to the canonization of works and artists.

At the same time, we have found it necessary to address some problems concerning the applicability of Bourdieu to late modern conditions, following two different routes. One was an attempt to open up certain aspects of Bourdieu's *theory*, in particular by confronting it with theories of modernization. This brought about a long-term *time* perspective, which allowed us to regard the late-20th-century legitimation of rock, film, jazz, photo and other forms of "low" culture as symptoms of intensified modernization (rather than a postmodern break with modernization). In accord with this we have outlined the possibility of an alternative, inclusive rather than exclusive view of modern aesthetic thought and practice, according to which elements of the "low" have been successively

incorporated and elevated to "legitimate" culture for a couple of hundred years. The second route concerned a *spatial* problematic, more or less given by the fact that rock criticism, though globally spread, is the child of complex British-American negotiations. In relation to Bourdieu this meant raising *empirical* questions concerning national versus transnational fields.

Discourse on rock has a prehistory in the discourse on popular music and other forms of popular culture. However, until the mid-1960s, no one questioned that popular music was essentially commercial, challenged only by weak and dispersed quests for autonomy coming from jazz, blues or folk music segments. From their different positions, journals like *Billboard, Down Beat, Sing Out!, Melody Maker* and *New Musical Express* agreed on this construction. A new discursive formation began to appear in 1964–1965 with high cultural appraisal of the Beatles, with the R & B debate in Britain and with the reception of Bob Dylan on both sides of the Atlantic. Obviously, some commercially successful artists could lay claims to being "serious" cultural producers. The question of whether rock was a respectable form of entertainment, which haunted the 1950s, metamorphosed into another: was not rock more than entertainment, even equal to what "high" art could offer?

That this question was increasingly answered in the affirmative had a great deal to do with the growth of strata of "new intellectuals" in the 1960s and the fact that some of these turned into rock critics who wanted to speak up for the value of their musical experience. Their struggle established a distance to entertainment journalism and allowed for alliances with particular strands or agents representing an autonomous position, some within the fields of journalism and popular music, others through crossing over into adjacent cultural fields or the political field. This struggle had its heroic phase in the latter half of the decade as intentionalist (Welch) and hedonistic (Cohn) appraisals of rock in the British press paved the way for the far more radical position of some, primarily American, writers who understood rock as a crucial element in a contemporary cultural revolution. Among these "founding fathers," rock songs were held to shape a generation's mental patterns as well as to unite the mind and the body in an ecstatic experience. The objective of social change was crucial in providing the embryonic field with strength enough to attain a certain amount of autonomy. But already with the founding fathers, the social promise of rock was transformed into a symbolic cultural promise, which ensured the longevity of the rock discourse beyond the counterculture context. This phase lasted till the end of the 1960s, when it seemed clear that the links between rock and counterculture were dissolving after the quest for cultural revolution had become compromised.

The rock criticism of the founding fathers has often been characterized as the expression of a shared authenticity ideology. Though largely correct, this picture has often resulted in simplifications used to invent new, oppositional positions. Also, some contributions with scientific ambitions (Laermans, Regev, Mazullo) tend to reduce the many shades involved in this ideology.[1] It has been shown here that the founding fathers agreed in understanding rock music as (a) body music, which becomes "authentic" by virtue of (b) its roots in the music of oppressed people, (c) anchorage in contemporary communities or (d) as the artistic expression of individuals or groups, at the same time as it has (e) a social message, communicated more through the cultural context than through the lyrics, the core of this message being (f) the unification of black music and low status white music.

This platform was by no means univocal but should rather be understood as reflecting a consensus on what were the focal issues in rock criticism—the question of social relevance beyond immediate political issues, the question of the relationship between individual artists and a relevant community, and the questions raised by the notion of a specific rock aesthetic—while weight could be put on different aspects. Each critic could lay his/her emphasis somewhat differently and thus form a distinct position. Landau stressed the auteur perspective and the belief in objective criteria for judging the qualities of rock music. Christgau insisted on taste as the critic's primary tool. To Marcus, rock built not only the local and subcultural but also gave voice to tacit elements of American common culture. Marsh developed the tales of rock as an expression of underprivileged black people and the white working class, while Bangs excelled in a prose style that gave voice to rock's specific tensions between structure and subject. These can be seen as different legitimation strategies, which also goes for the difference between appealing to the rock community, as Marsh, Bangs and Christgau mostly do, building bridges to the record industry and to established forms of art criticism, as Landau does, or writing about rock as an extremely significant part of American culture, as Marcus does. These positions were not fixed but mobile, and most likely the plural-

1 In particular, the emphasis on the notion of a shared canon is misplaced. The founding fathers and most of their disciples only agree on three names within a canon: the Beatles, the Stones and Dylan, and this trinity were already consecrated in the period of the "absolute beginners." In addition Landau and Marsh would insist on black soul, Marcus on Elvis, Christgau on early 1960s pop and Bangs on "white noise" bands like the Troggs and MC5. The canon referred to by Regev and Mazullo is rather based on the late 1970s *Rolling Stone History of Rock.*

ism and flexibility promoted the common cause. Legitimacy was clearly sealed within radical intellectual circles when Christgau was hired to make the music section essential to the *Village Voice* in 1974 and with the reception of Marcus's *Mystery Train* in 1975, and in the broader public sphere when Bruce Springsteen (the critics' rock star) appeared simultaneously on the covers of *Newsweek* and *Times* in late October 1975.

While the American field of rock criticism depended on an autonomous clergy that roughly agreed on critical standards and focal issues, enjoyed credibility within the rock culture and were increasingly acknowledged from the outside, field constructions followed different pathways in other countries. In Britain strands from the popular press and the counterculture merged into a field characterized by strong tensions, which expanded its autonomy aggressively through the 1970s.[2] However, the diverse national developments of the rock discourse should not be seen as evidence of lacking common ground, but rather in terms of different applications in different cultural settings. Though uneven, the sociocultural development was quite similar, and it showed more and more signs of convergence, most importantly for our topic because of the rise of upwardly mobile, radicalized new intellectuals, alienated by a consensus-seeking majority but fueled by cultural release. The youth revolt that shook the Western world was largely a product of the discrepancy between such developments and stagnated institutions and cultural hegemony. In Europe the revolt was steeped in a by now largely obsolete, revolutionary political discourse, while in the U.S. the political implications of the youth revolt were rather underplayed after the assassinations of John F. Kennedy and Martin Luther King Jr., resulting in a stronger inclination for a cultural interpretation of social changes.

From early on impulses were exchanged between the embryonic U.S. and British national fields. Here two rather different approaches to rock evolved. In the U.S., the pure pole was predicated on an adult, "objective" stance; in Britain, where rock criticism allied itself with less well-educated youth, play-

2 In Denmark the heritage of cultural radicalism helped to establish a relative autonomy already by the end of the 1960s. In Sweden and Norway rock criticism in the early and mid-1970s was partly based on international left-wing politics, partly predicated on an autonomous discourse that slowly took over as the political counterculture dissolved in a process comparable to the one in the U.S. some years earlier. In Iceland the question of national culture against Americanization tended to overshadow other questions, but also here the relative autonomy of the field of rock criticism had been established by the end of 1970s.

ful subjectivism came to rule. On the peripheries—English-speaking critics were read at least from the mid-sixties in the Nordic countries and certainly elsewhere, too—these discourse types could be played out against another by different critics.

Much early rock writing focused on rock in its local contexts. Charlie Gillett's influential *The Sound of the City* (1970) outlines the rise of rock 'n' roll and the musical idiosyncrasies of various styles in terms of West and East, uptown and downtown, Memphis, Nashville, St. Louis, New Orleans, Chicago, Detroit, and other cities; and the first rock periodicals all had clear local identities. To some critics (like Cohn and Bangs), rock was primarily a means of breaking out of the local to become a participant in a larger, imagined rock community; but all profited from the spatial-emotional closeness to the object under study. In retrospect Simon Frith observes with an ironic slant how this embeddedness has been incorporated into cultural studies as the self-understanding of "the organic intellectual of the high street" (1991:180). Today there is a rich body of studies in popular music that focuses on the relation of music to the cultural construction of place and notions of identity.[3]

However, in the early 1970s, an "international jet set" of rock critics emerged, primarily along a New York–London axis. Especially Lester Bangs, but also Greil Marcus, Dave Marsh, Robert Christgau and others became role models for British rock critics and wrote for British publications, while Simon Frith, Nick Kent and Charles Murray were among those who traveled the other way. All these rock writers held positions at the autonomous pole of their national fields and were seeking recognition primarily with colleagues, musicians and rock aficionados. They can be said to form the beginning of an autonomous pole of a transnational field, a counterweight to a heteronomous pole of marketing and transnational media coverage, which was seminal to the spread of doxa to other embryonic national fields. Thus rock criticism on the peripheries could gain some autonomy through a delicate balance between forming alliances with British and American critics and stressing specific national themes.

Hordes of disciples were to follow in the footsteps of this clergy, but at the same time the field construction allowed for repeated reinventions of the au-

3 Among them Finnegan (1989), Cohen (1991), Robinson et al. (1991), Straw (1991), Berkaak and Ruud (1992, 1994), Manuel (1993), Carney (1994), Stokes (1994), Lipsitz (1994), Feld and Basso (1996), Hall and duGay (1996), Mitchell (1996), Taylor (1997) and Fox (2000).

tonomous pole through new definitions of "the promise of rock."[4] In the middle of the 1970s the clergy was mainly split between the promise of a new-old authenticity, propagated by Springsteen prophets Landau and Marsh, and a lifeline of alternative acts, outlined by irreverent critics like Bangs and supported to some extent by Kent and Murray. This countercanon bypassed the megastars of progressive rock, stretching from early rock and the British invasion via 1960s garage bands, Lou Reed, Iggy Pop and the New York Dolls to the CBGB groups and the Sex Pistols. For a moment the punk wave seemed to confirm the triumph of the last position, but it turned out to be an agent of transition rather than the beginning of a new heroic epoch.

One consequence was that in the early 1980s rock critics were again mostly writing in national arenas with aesthetic preferences and focal topics open to revaluation. The media picture varied widely, the alternative-rooted *Rolling Stone* and *Voice* dominating the U.S. market and the glossy *Face* introducing popular postmodernism in Britain. After the turn of the millennium, critics still appear to be agents in national fields, at least at first glance. Their arenas are dominated by widely different discussions and populated with positions marked by national eccentricities, although articles, magazines and books in the Internet age are distributed transnationally to a greater extent than ever before. But there are countertendencies. A long-term perspective on the 1980s and 1990s reveals a common ground in the shape of a sort of meta-agenda, which still makes it meaningful to conceive of one transnational field of rock criticism. Thus the original social-promise-turned-cultural still serves as a strong reference point. New critical positions can be invented by applying it to alliances with new musical styles in a straightforward (rap) or ironic (punk) manner, as an object of ridicule (New Pop), or by turning the promise into pure bodily pleasure (dance). In all national fields such moves presuppose a shared stock of constructions that serves agents as a frame of reference for their discourse. Further, the doxa of authenticity is modified in various ways in both national fields under study here (a move from innocence to a postmodern reflexivity that marked a distinct turning point around 1980). Finally there is a tendency towards the development of transnational, genre-specific fields.

On the one hand, the autonomy of present national fields is under heavy pressure from the increasing marketing skills of the industry, media entrepre-

4 As in other fields these processes can seemingly be reinvented ad infinitum. In Bourdieu's terms they are converted from the dispositions and actions of individuals into "objective mechanisms, immanent in the logic of the field" (1992/1996:113).

neurs and self-conscious artists. On the other, a growing amount of academic, in-depth analysis is produced outside the field of criticism. Another common development is the expansion and differentiation of the market, which produces an increasing need for broad consumer guidance. In this situation the task for contemporary criticism is not so much to play the losing game of trying to influence who sells the most, but to establish at least a semiautonomous counterpart to the market and at the same time challenge the academic approach by benefiting from being on the spot. The tension between artistic autonomy, subcultural milieus and a strong commercial pole that has survived many transformations of popular music gives more importance to such an intermediary position than most other cultural fields would be able to. While "the rock formation" (Grossberg 1992) has lost its privileged position in relation to other popular music, the institution of rock criticism remains strong, and the quantity of criticism is increasing. It must be borne in mind that, except for a brief period in the 1970s that mostly involved the metropolitan centers of London and New York, rock discourse has developed a long tradition of mediating between the global and the local. In fact, rock criticism in the national fields gains its strength to a great degree from this mediation. A center/periphery formation is still at work, as an Anglo-Saxon canon from Marcus to Toop remains a reference point for various national and genre-specific discourses. However, some of these discourses (on dance, for instance) have also acquired semiautonomy with some potential to influence the meta-agenda that constitutes the overarching frame of reference.

Rock has become a model contemporary cultural field because more than any other it keeps one foot firmly in consumption and the other in artistic expression, so that the separation of production and consumption is intentionally overcome. But this unity coexists with persistent tendencies to divide the field between high and low. The rock field is at the same time subject to traditionalization in the sense of reproducing the great divide of modernist culture and a central arena for the late modern aestheticization of the everyday. Such contradictions have been topics for debate in rock criticism from the outset and added to its weight as a form of cultural discourse. Others, raising questions to do with representation, have not surfaced until the last two decades. Who speaks, or is given the authority to speak, to narrate and interpret musical events and experiences and to write music history?

Many have observed that rock criticism is by and large a predominately white and male discourse. Considering the overwhelming African American impact on the development of American and European popular music in the previous century, the number of African American critics with powerful positions in the

field as a whole is small indeed, which cannot but affect the way rock history and criticism has been written.[5] As Robert Christgau observes, it is only with the Hip-Hop press in the late 1990s that "for the first time ever in American history black people have got to write about their own music" (personal interview, April 19, 2004). The slight representation of female rock critics has been, if not equally disturbing, another structural factor determining the characteristics of the discourse. Thus, according to Ann Powers (personal interview, April 18, 2004), women rarely write from the "center" but more commonly from some kind of outsider perspective. Another, less discussed problem is the British-American field hegemony, which surpasses that of rock music.

The peculiarities of the rock field endow rock criticism with a specific form for autonomy compared to older cultural fields. Throughout its almost 40 years, rock criticism has demarcated itself from the dominant field of power, the commercial poles of popular music and journalism and the practices of other cultural fields by a range of now familiar mechanisms. Above all, peculiarities include a certain understanding between the poles of autonomy and heteronomy. Autonomy has not least been established through the appraisal and reinterpretation of cultural production in the heteronomous part of the field. This results in a small space for experimental heterodoxy and gives more importance to the center and to the dynamics between the poles. Rock criticism is certainly attached to artistic subcultures, but it has neither turned its back on mainstream megastars nor abandoned the vision of a dialectics between the poles.

Finally, our application of the field theory to rock criticism has demonstrated the need to develop Bourdieu's approach into a more dynamic framework than is usual in cultural studies. Focus should be set on field mechanisms imposed

5 For instance, there is a long tradition of viewing African American musical expressions—jazz as well as blues, early R & B and so on—through the lenses of "authenticity," a factor that might well be considered to have certain racial implications. Another ubiquitous consequence of this structural/racial factor is *what* music and *which* artists are featured and written about. Very few African American artists have been given the same kind of press coverage as the most acknowledged white rock bands (the rare exceptions include Michael Jackson and Prince); the vast majority have not even been in such a position that they could complain about their situation. However, the canon debate of the last decade has meant some belated recognition of their achievements, as witnessed by a recent statement from Christgau: "I spent years first with Funkadelic and then with James Brown listening and listening to that music because I was persuaded I was missing something. And I was. If you ask me today who the greatest rock 'n' roll musician of all time is, I would say James Brown without hesitation, and I am positive" (Robert Christgau, at a rock criticism seminar held in Bergen, Norway, February 15, 2004).

by cultural habitus, the underlying contradiction between use value and exchange value, and class conflict as reshaped by the confluence of consumption and cultural practices within late modernity. We would also like to point out that the reproduction of field mechanisms in discourses on rock makes the concept of a field of rock criticism meaningful in an era when the early rock formation has given way to a far more variegated picture.

9.2. Aesthetic Beliefs and Discursive Practices

A secondary aim of our study was to characterize rock criticism as a form of discourse. As observed in the Introduction, this involves an investigation of the specific means at the disposal of the field's agents. To some extent this "space of possibilities" has been traversed already in the previous section. Here we will enlarge on the aesthetic ideology that informs rock criticism and on critics' stylistic practices.

Briefly, the aesthetic credo of rock criticism has developed from being relatively homogeneous, formulated by 1960s American critics and based on notions of authenticity, to being relatively heterogeneous and based on notions of artificiality (the recognition that performance means role-play) both in and outside the U.S.

As we have shown, the public discourse on rock was created from a number of sources (e.g., previous popular cultural journalism, film, jazz and folklore discourse, established art discourse, New Journalism and contemporary debates on aesthetics, youth culture, politics and American culture). It is no coincidence that rock became subject to aesthetic reflection in the 1960s at a time when popular culture appeared democratic and dynamic while high modernism seemed stuck in an elitist blind alley. In this open climate the rock critics managed to stake out a route of their own somewhere between the neo-avant-gardism of Susan Sontag and the populism of Tom Wolfe, which in important respects made them harbingers of postmodernism as well as cultural studies in America.

A few chosen artists triggered the process. The impact of the Beatles after their breakthrough in England and America in 1963 and 1964 is particularly striking. It resounded in other cultural fields and gave rise to temporary alliances with "high cultural" intellectuals, who helped to establish as a fact that at least some rock was worthy of serious consideration. Yet their arguments were a bit tangential and their efforts did not have any lasting effect on later criticism. It became the task of writers "grown up all wrong"—that is, immersed in popular culture—to work out the instruments necessary to deal with rock music as a more or less "serious" form of expression.

As pointed out above, this reflexive move does not question the fact that rock is popular music. Rather, it turns it to its advantage. To say that rock criticism advocates an "intermediary aesthetic" is to focus on a seminal feature of the field's self-understanding: the common belief that the constant tension between the autonomous pole and the heterogeneous pole in the field, between the "rock" approach that wants to situate the music in a context of social and/or aesthetic revolt and the original "pop" approach to it as part of a consumerist lifestyle, is not only distinctive in relation to other cultural fields (except, perhaps, that of film) but even productive for the music's ability to register signs o' the times and renew itself. It was vital to stress the opposition and set up "authentic" rock against "commercial" pop when the field was founded, but the construction felt increasingly problematic in the 1970s, and significantly it was a self-conscious return to pop that broke it up and ushered the field into its postmodern phase.[6]

Within a few years (the mid- to late 1960s) quality criteria were formed that competed with sales numbers. Before the appearance of the Velvet Underground, there was no necessary conflict between large-scale and small-scale production. It was part of doxa that good rock sold well, as illustrated by the Beatles, the Rolling Stones and Bob Dylan, and critics had to justify themselves when they wrote about minor artists. Broadly speaking, the focus of the new criteria moved from style/image over craftsmanship to questions of authenticity. To Nik Cohn pop still belonged in the realm of everyday consumption, though style was held magically to transcend it. In the U.S. rock was grappling with the counterculture and American popular culture, which gave rise to the various authenticity discourses detailed above. In most cases whether rock was art was a secondary question. Rather, the American founding fathers situated themselves on par with, but somewhat different from, jazz and film critics.

Outside the U.S. different interpretations of "authenticity" caused center/periphery problems, as an aesthetic favoring origins collided with one favoring individual expression. Which was the more "authentic": to sound American or rock in one's own idiom? Such questions, which haunted the British Isles in the early 1960s, created a lasting tension also in the Nordic countries. On the whole, authenticity as a superior value never settled comfortably in Britain with its

6 It would not be difficult to construct a table of opposites between the two poles: modernist/postmodernist, romantic/avant-garde, focus on work/focus on reception, seriousness/fun, disinterested judgment/immediate consumption, etc. That would not be entirely wrong, but nonetheless a simplification.

complex relationship to the U.S., its art schools, pop heritage and well-developed sensibility for fads. While the demand for authenticity was consolidated with major agents of the U.S. field in the 1970s, particularly in *RS*, it was challenged on the other side of the Atlantic, first by glam, later by punk, giving established critics trouble sorting out the posers. That doxa had got undermined became evident in the early 1980s, from which point "the rock era" slowly came to a halt.

The impetus for this turn—the most important one in rock aesthetics since 1967—was pop art and other avant-garde strategies of subversion from within, introduced by British punk svengalis such as Malcolm McLaren. Once again rock became one element in a total, visually dominated lifestyle, much like it had been to Nik Cohn (minus the transcendence part). A new, postmodern pop sensibility developed in connection with the "smart" consumption celebrated by *The Face* and its likes, a sort of mass cultural dandyism that made it possible for (white) youths of most social strata to apply the aesthetic gaze to diverse practices of their everyday life. In criticism, at a level of theorization not known before, some post-punk writers celebrated the "loss of the signifier" and the experience of "jouissance," using poststructuralist theory to inform on everyday experiences like dancing and concertgoing, while others ditched theory and took to ironic play, celebrating themselves on par with the artists.[7] In the U.S. it took less conspicuous routes than in Britain, but here, too, the effect was an opening up for numerous new positions, whose occupants (Chuck Eddy is a prime example) sometimes resort to bizarre, provocative and often contradictory investments in distinction. At the same time value scales have become increasingly relative, which can also be observed in the general return to a state of precriticism on the part of numerous anonymous music journalists publishing in high street magazines.

Knowledge in late modern societies appears irredeemably plural; the growth of cultural studies, where rock has found a university home, is significant. Reduced to a nexus of positions offered by a crossfire of age, class, gender, ethnic, geographic, institutional and other discourses, the subject can no longer lay claim to universal authority. As a consequence history writing and canon formation have become objects of heavy attack, also in rock criticism—Robert Palmer's televised rock history *Dancing in the Street* (1996) is but one conspicuous example. Nevertheless, the bulk of rock criticism remains safely within the long tradition of Western philosophy that Jacques Derrida has named "phonocentric," since it assumes that a voice represents the presence of a human sub-

7 A similar postmodernization of rock criticism can be seen developing in the mid-1980s in some of the Nordic countries, particularly in Sweden, but without the ballast of theory.

ject. A highly stylized discourse, based on traditional notions of authenticity, is still found in rap criticism and occasionally in other criticism as well. However, it is much more common that what is at stake is some form of self-conscious "meta-authenticity" whose markers may be (a) subcultural (Powers's "alternative nation," Reynolds's myriads of dance cultures, George's hip-hop culture); (b) causal historical explanations and references to theory (e.g., identity politics), because music is still regarded as part of a political process, namely the liberation of minorities (Savage, Powers, George and, to some extent, Reynolds); or (c) originality as a central value criterion (Toop and other *Wire* critics). That such distinctions are still at work within the field indicates that although high/low hierarchies have become jumbled, the ghost of authenticity still lurks in the shadows, as does at least a faint promise of transcendence.

To Cohn (1969/1996:31) boredom was the only taboo. All through the story of rock runs a wish to escape boredom and transcend everyday life, which was associated with the modern condition already in the works of Baudelaire. In rock aesthetic escape is achieved only in moments. Thus Marcus's myths articulate themselves at such moments (e.g., the Sex Pistols at Winterland, 1990:440–441). Back in 1969, rock to Marcus was the music of "the now" as it tried to "establish and confirm, to heighten and deepen, to create and re-create the present moment" (15). When this happens, the music creates a kind of freedom in the listener, a "joyful immediacy" (23) that involves knowledge both of one's self and of togetherness. Later on, the moments came to lose their discursive meaning, but retain their intensity, for example in Reynolds's moments or flashes of "bliss." Discursive language could no longer explain what happened, and only stammering or babbling (in writing!) was left, as in Morley's case. Here the moment becomes "sublime." It seems that on the one hand late modern aestheticization of everyday life has made the moment ubiquitous, even routinized as a possibility; on the other hand, the media's expropriation of released cultural material and its concurrent commodification has made it harder to attain anything reminding of transcendence. As Grossberg (1992:237–238) remarks about 1980s rock:

> Rock offers neither salvation nor transcendence, neither an anarchy of fun nor a narcotic of bliss. Rock is a site of temporary investment, without the power to restructure everyday life. [...] Rock will, by placing you within its own spaces, free you from the moment, but it will not promise any alternative spaces. It remains forever ensconced in its own reproduction of the very conditions of everyday life it once sought to transcend. But it still promises, however briefly and weakly, that there is something beyond everyday life.

Perhaps one could say that in rock the task of aesthetics as a pointer towards other possible worlds has diminished, while it has become more important as a pointer towards a desired state of heightened sensibility.

Is there an "intermediary style" corresponding to the "intermediary aesthetic" outlined above? We think so. But the first thing to be established is the wealth of individual styles, which offers wannabes a great potential freedom of expression. However, the field's doxa restricts this freedom and makes it possible to find schools and traditions. Second, most rock critics estimate style highly, both in the (primarily U.S.) sense of good reporting and in the (primarily British) expressive sense. Mastering style is therefore an important means of conquering a position in the field, while it works on behalf of the field in relation to other fields, especially that of journalism.

From the outset, artful prose inspired by fiction and New Journalism was a strategic asset (the contributions of writers like Hunter S. Thompson most likely meant more than those of any rock critics to make *Rolling Stone* attractive reading). Its counterpoint was *Crawdaddy!*'s fan criticism, to which stylistic excellence was less important than enthusiasm. The third major American specialist magazine, *Creem*, situated itself somewhere in between, in an "erratic" position that the British were to find interesting. Essentially, a common rockspeak was established in the early 1970s, and later outbursts of heterodoxy (like punk critics' tabloid prose and explorations in stream-of-consciousness techniques and "theory") have brought about no substantial changes.

In broad terms rock criticism strikes a lighter tone than high cultural criticism, in whose eyes it tends to be disparaged as a kind of "pop discourse." This lightness is an important effect of the field's doxa. Rock critics should beware of becoming "way too serious" (Chris Welch) and endanger the aim of providing "a reading experience." Of course, this ambition need not result in superficial texts. It varies, as always, with who writes on what, where and when. However, much stuff will pass the editor's eagle eye if it is entertaining enough. As we have noted, abuse, which is often more fun to read than praise, appears lavishly in the British tradition. High cultural critics are more bound to show some manners. In rock writing it is all right to treat an artist as common property.

Sometimes the lightness effect may be a matter of lack of space. But in most cases it is a matter of what Bakhtin (1986) calls "the adressivity of an utterance," that is, the inscription of a specific receiver in the text. Recall Frith's characterization of rock criticism as an orchestrated collusion of chosen artists with chosen segments of the public. Not only texts, but also the outlets where they appear could be regarded as such "orchestrations," addressing, as we have suggested,

specific taste publics or interpretive communities. Obviously Goldstein and Christgau performing as a fifth column in the middlebrow press could not write exactly the same way as they did in the *Village Voice*. Nevertheless, the more rock criticism becomes institutionalized, the more it settles for a conversational mode of address, an "informed familiarity," which is the outcome of thematic and compositional as well as stylistic conventions. At its core lies a ban on musicological terminology, a black hole that breeds metaphoric circumscription. According to Steven Feld (1994:93) speech and writing about music are attempts at constructing a metaphoric discourse designated to interpret, "recreate, momentarily fix, or give order to emergent recognitions of the events that take place so rapidly when we experience musical sounds." Of this rock criticism seems a paradigmatic example. Many 1950s commentators like Steve Race in *Melody Maker* simply did not understand rock 'n' roll, while Race's successor Ray Coleman suggested that the Rolling Stones did not "swing" (like jazz) as much as "drive" or "generate." Such switches of metaphors were and still are important markers in the business of how to make sense of rock.

What can be said is also restricted by a view of knowledge that privileges both encyclopedic hardware and the software of proximity to artists and milieus. For these reasons, the site of meaning is commonly displaced from "text" to different types of "context." Even in record reviews where the work is focal, the account tends to wrap it up in some kind of narrative (relying on biographical information, recording anecdotes, imaginary scenes, etc.); description and interpretation become impressionistic and synthetic, stressing the lyrics and the overall impact; classification increasingly seems to prefer an intertextual shorthand ("Q sounds like X with a dash of Y and Z") to stylistic discussion; academically sounding references are avoided (when not dropped as signs of an act's "avant-gardism"); the genre-determined, loosely argumentative structure easily fractures under the attack of a style favoring wit and intensity; and the adjective-abounding vocabulary, whose task it is to ensure that the text will make the right, "hip" or "confessional" impact on the implied reader, tends towards a tension-filled mixture of high and low idioms—a "secondary speech genre," Bakhtin would say, that has incorporated various "primary genres" during its formation.

The best writers are often those whose styles are able to convey some of the feelings that the music triggers. This involves an approach to literary—lyrical or, more commonly, narrative—tools. A close examination would probably show some predilection for expressive tropes (metaphor, irony, hyperbole) over figures that impose some kind of syntactic (antithesis, anaphora, parallelism) or sound (various kinds of rhyme) patterns on the text. However, there is a

carnivalesque tradition (a "carnival of words") that runs from Tom Wolfe through Bangs, Kent and Murray to Burchill and Parsons, which foregrounds sound patterning in combination with heteroglot vocabulary (the idiomatic collisions mentioned above). As for narrative techniques, some New Journalist devices like openings in medias res, progression by scenes and the use of symbolic detail have become stock assets; others, especially the third-person point of view, seem rare. If narrators, milieus and events are represented in a twisted or parodic way, we have chosen to speak of a "carnival of events." There is such a tradition in rock criticism, too, which runs from Thompson through, again, Bangs, Kent and Murray at least to the Morley of *Ask*.[8]

By bringing a "dialogical," multivoiced character to texts, heteroglossia also offers a rich register for the construction of a public "I." From Chris Welch's gentleman-who-respects-good-craftsmanship to Nik Cohn's ruthless style-consumer, from Jon Savage's sober humanist to Paul Morley's pain-in-the-artist's-ass, from Dave Marsh's proletarian male to Ann Powers's highbrow feminist, from Lester Bangs's adolescent freak to Nelson George's "B-Boy intellectual" critics have hung on to the stylish self-invention of the early rockers, mods, art-school affiliates and punks, situating themselves in the middle of the events and on rare occasions (Bangs) even bringing the performative act of writing to the rock stage itself.

To make a narration more powerful, writers often resort to myth, widely understood as "great narratives" whose presence may be discovered beneath as well as on the surface of utterances. Consequently myth has both structuring and authorizing functions. Some accounts stress its conservative nature: as a representation of the ways subjects relate to their real conditions of existence it tends to "naturalize" (dehistoricize) these relations. However, like ideology in general, myth is contradictory. It may serve to transform existing systems of beliefs and social relations as well as to sustain them, and it constantly offers models for new narrations.

It is no secret that rock culture is pervaded by myth and that much of its appeal derives precisely from that fact. According to Greil Marcus (personal interview, April 17, 2004) as well as anthropologists and narratologists, "a culture without stories is not really a culture." Marcus himself is a prominent trader

8 Other possible divisions include American populists (Christgau, Marsh, Eddy), academic mythologists (Marcus, Reynolds, Toop), engaged reporters (Welch, Landau, Savage, Frith, Powers) and "cool" (Cohn), "hot" (Williams) and "narcissistic" subjective impressionists (Bangs, Burchill and Parsons, Morley, Eddy).

and maker of myths, especially in *Mystery Train*.[9] Structurally critics seem to favor myths of effect, origins and evolution. Myths of *effect* capture the ways that rock matters. They appear, for instance, as metamorphoses (the magic transformation of nobody into somebody through the acquisition of style with Nik Cohn), as epiphanies in which some hidden truth is revealed (from the founding fathers over Savage and Morley to Reynolds) and as subversion of ruling beliefs and practices (from the founding fathers to feminist and black criticism). Myths of *origin* refer to artistic genius (conspicuous with Nick Kent), to history ("on the road" stories resound with the overtones of pioneer America) or to some kind of community, which involves constructions of blackness, Britishness, "Detroitness," and so forth (this is Marcus's home ground). Finally, myths of *evolution* echo the trajectory of Birth/Innocence (the story of the Next Big Thing), Maturation (artistic or commercial success), Death/Fall (selling out/fading away) and, sometimes, Resurrection or Eternal Youth. But they also count Lester Bangs's and Nick Kent's melodramatic visions of the world as a stage where Good and Evil forever clash and the outcome is uncertain.

In fields of cultural struggle, strategies and ways of relocating and negotiating conceptions of "high" and "low" become crucial. We have witnessed a rich variety of such strategies. Many of them take an ambiguous attitude to academic theory, but not necessarily to theorizing. In all, the road from Adorno's dismissal of mass culture per se in the 1940s to the nuanced and theoretically informed criticism of writers like Ann Powers some 50 years later is a long one. Nevertheless, there is another side to this coin. The history of popular music has been written to a far greater extent by critics than by academics. As an academic discipline popular music studies is comparatively young (it did not come about until the 1980s). Inevitably, popular music studies have drawn on the writings of rock critics (the celebrity academic in this field, Simon Frith, in fact started out as a critic), which span the whole gap between utopian fantasy and pointed cultural commentary. Given this, one might ask to what extent popular music studies have adopted too uncritically the myths and narratives consciously or unconsciously propagated by rock critics.

9 In addition to writing American cultural history by means of rock music, Marcus also furthered such myths as that of the late delta blues singer Robert Johnson selling his soul to the devil. On the whole Marcus greatly contributed to the identification of Johnson as *the* ancestor of rock 'n' roll.

References

Literature

Abrams, M.H. (1993): *A Glossary of Literary Terms*. Fort Worth, Texas: Harcourt Brace.

Alloway, Lawrence (1975): *Topics in American Art Since 1945*. New York: Norton.

anon. (1964–1999): *Benn's Press/Media Directory*. Tonbridge, Kent: Benn Business Information Services.

anon. (1980): *The Rolling Stone Illustrated History of Rock & Roll*. New York: Random House.

anon. (1998–1999): *The National Directory of Magazines 1999*. New York: Oxbridge Communications.

Appadurai, Arjun (1990): "Disjuncture and Difference in the Global Cultural Economy." *Public Culture*, 2/2.

Aronowitz, Stanley (1993): *Roll Over Beethoven: The Return of Cultural Strife*. Hanover, N.H., and London: Wesleyan University Press.

Auerbach, Erich (1946/1957): *Mimesis: The Representation of Reality in Western Literature*. New York: Doubleday Anchor.

Bakhtin, Mikhail (1968): *Rabelais and His World*. Cambridge, Mass.: MIT Press.

Bakhtin, Mikhail (1981): *The Dialogic Imagination*. Austin: The University of Texas.

Bakhtin, Mikhail (1986): "The Problem of the Text in Linguistics, Philology, and the Human Sciences: An Experiment in Philosophical Analysis." *Speech Genres & Other Late Essays*. Austin: University of Texas.

Bangs, Lester (1988): *Psychotic Reactions and Carburetor Dung*. London: Serpent's Tail.

Barthes, Roland (1957/1993): *Mythologies*. London: Vintage.

Barthes, Roland (1972/1977): "The Grain of the Voice." In Barthes, Roland (1978): *Image, Music, Text*. London: Fontana.

Barthes, Roland (1973/1990): *The Pleasure of the Text*. Oxford: Basil Blackwell.

Beck, Ulrich (1986/1992): *Risikogesellschaft: Auf dem Weg in eine andere Moderne* (Risk Society: Toward a New Modernity). Frankfurt am Main: Suhrkamp.

Belz, Carl (1969): *The Story of Rock*. New York: Oxford University Press.

Bergman, Billy and Horn, Richard (1985): *Experimental Pop: Frontiers of the Rock Era*. Poole, Dorset: Blandford Press.

Berman, Marshall (1982): *All That Is Solid Melts into Air: The Experience of Modernity*. London: Penguin.

Betrock, Alan (1991): *Hitsville: The 100 Greatest Rock 'n' Roll Magazines 1954–1968*. New York: Shake Books.

Bjerrum Nielsen, Harriet and Rudberg, Monica (1994): *Psychological Gender and Modernity*. Oslo: Scandinavian University Press.

Bjurstöm, Erling (1997): *Högt & lågt: Smak och stil i ungdomskulturen* (High and Low: Taste and Style in Youth Culture). Umeå: Boréa.

Bloomfield, Terry (1992): "It's Sooner Than You Think, or Where Are We in the History of Rock Music?" *New Left Review*, 190.

Boethius, Ulf (1990): "Populärlitteraturen—finns den?" (Popular Literature—Does It Exist?). *Tidskrift för litteraturvetenskap*, 2.

Boethius, Ulf (1991): "Högt och lågt inom kulturen: Moderniseringsprocessen och de kulturella hierarkierna" (High and Low in Culture: The Modernization Process and Cultural Hierarchies). In Fornäs, Johan and Boethius, Ulf (eds.) (1991): *Ungdom och kulturell modernisering.* Stockholm and Stehag: Symposion.

Bolin, Göran (1998): *Filmbytare:Videovåld, kulturell produktion & unga män* (Film Swappers: Video Violence, Cultural Production & Young Men). Umeå: Boréa.

Bourdieu, Pierre (1979/1984): *Distinction: A Social Critique of the Judgement of Taste.* London: Routledge & Kegan Paul.

Bourdieu, Pierre (1992/1996): *The Rules of Art: Genesis and Structure of the Literary Field.* Cambridge: Polity Press.

Bourdieu, Pierre (1993): *The Field of Cultural Production: Essays on Art and Literature.* Cambridge: Polity Press.

Bourdieu, Pierre (1996/1998): *On Television and Journalism.* London: Pluto Press.

Braun, Werner (1972): *Musikkritik: Versuch einer historisch-kritischen Standortbestimmung* (Music Criticism: An Attempt at a Historical-Critical Definition). Köln: Musikverlag Hans Gerig.

Broady, Donald (1990): *Sociologi och epistemologi: Om Pierre Bourdieus författarskap och den historiska epistemologin* (Sociology and Epistemology: On Pierre Bourdieu's Works and the Historical Epistemology). Stockholm: LHS.

Brooks, Peter (1976/1995): *The Melodramatic Imagination: Balzac, Henry James, Melodrama, and the Mode of Excess.* New Haven and London: Yale University Press.

Burchill, Julie (1985): *The Best of Julie Burchill: Love It or Shove It.* London: Century Publishing.

Burchill, Julie and Parsons, Tony (1978): *The Boy Looked at Johnny: The Orbituary of Rock and Roll.* London: Pluto Press.

Bürger, Peter (1974/1984): *Theory of the Avant-Garde.* Minneapolis: University of Minnesota Press.

Burke, Peter (1978): *Popular Culture in Early Modern Europe.* New York: Harper & Row.

Burnett, Robert (1996): *The Global Jukebox.* London: Routledge.

Cagle, Van M. (1995): *Reconstructing Pop/Subculture: Art Rock and Andy Warhol.* London: Sage.

Carney, George O. (ed.) (1994): *The Sounds of People and Places: A Geography of American Folk and Popular Music.* Lanham, Md.: Rowman & Littlefield Pub.

Carson, Tom, Rachlis, Kit and Salamon, Jeff (eds.) (2002): *Don't Stop 'til You Get Enough: Essays in Honor of Robert Christgau.* Austin: Nortex Press.

Casey, Edward S. (1987): *Remembering: A Phenomenological Study.* Bloomington and Indianapolis: Indiana University Press.

Casey, Edward S. (1993): *Getting Back into Place: Toward a Renewed Understanding of the Place-World.* Bloomington and Indianapolis: Indiana University Press.

Casey, Edward S. (1997): *The Fate of Place: A Philosophical History.* Berkeley: University of California Press.

Chambers, Iain (1985): *Urban Rhythms: Pop Music and Popular Culture.* London: McMillan.

Chambers, Iain (1994): *Migrancy, Culture, Identity.* London: Routledge.

Chapple, Steve and Garofalo, Reebee (1977): *Rock 'n' Roll Is Here to Pay: The History and Politics of the Music Industry.* Chicago: Nelson Hall.

Charters, Samuel (1959): *The Country Blues.* New York: Da Capo Press.

Christgau, Robert (1973): *Any Old Way You Choose It: Rock and Other Pop Music, 1967–73.* Baltimore: Penguin.

Christgau, Robert (1981): *Rock Albums of the 70s.* New York: Ticknor & Fields.

Christgau, Robert (1990): *Christgau's Record Guide: The 80s.* New York: DaCapo Press.

Christgau, Robert (1998): *Grown Up All Wrong.* Cambridge, Mass., and London: Cambridge University Press.

Cohen, Sara (1991): *Rock Culture in Liverpool.* Oxford: Clarendon Press.

Cohn, Nik (1969a): *Pop from the Beginning.* London: Weidenfeld and Nicolson.

Cohn, Nik (1969b): *Rock from the Beginning.* New York: Stein and Day.

Cohn, Nik (1969/1996): *Awopbopaloobop Alopbambboom: The Golden Age of Rock.* New York: Da Capo Press.

Cohn, Nik (1970): *Arfur: The Teenage Pinball Queen.* London: Weinfeld & Nicolson.

Cohn, Nik (1971): *Today There Are No Gentlemen: The Changes in Englishmen's Clothes Since the War.* London: Weinfeld & Nicolson.

Cohn, Nik (1989): *Ball the Wall: Nick Cohn in the Age of Rock.* London: Picador.

Cohn, Nik (1992): *The Heart of the World.* London: Chatto & Windus.

Cohn, Nik (1999): *20th-Century Dreams.* London: Secker & Warburg.

Cohn, Nik and Peellaert, Guy (1973): *Rock Dreams.* London: Pan Books.

Cohn, Norman (1961/1970): *The Pursuit of the Millennium.* New York: Harper & Brothers.

Coleman, Ray (1984/1995): *Lennon: The Definite Biography.* London: Pan Books.

Collins, Jim (1989): *Uncommon Cultures: Popular Culture and Post-Modernism.* New York: Routledge.

Collins, Jim (1992): "Television and Postmodernism." In Allen, Robert C. (ed.) (1992): *Channels of Discourse: Television and Contemporary Criticism.* Chapel Hill and London: University of North Carolina Press.

Cooper, Sarah (ed.) (1997): *Girls! Girls! Girls! Essays on Women and Music.* London: Cassel.

Crane, Diana (1987): *The Transformation of the Avant-Garde: The New York Art World, 1940–1985.* Chicago and London: University of Chicago Press.

Crow, Thomas (1996): "Modernism and Mass Culture in the Visual Arts." In Crane, Thomas (ed.) (1996): *Modern Art in the Common Culture.* New Haven: Yale University Press.

Culler, Jonathan (1988): *Framing the Sign: Criticism and Its Institutions.* Oxford: Blackwell.

Davies, Hunter (1968/1985): *The Beatles: The Only Authorized Biography.* London: Arrow Books.

Davis, Robert Con and Schleifer, Ronald (1991): *Criticism and Culture.* London: Longman.

DeCurtis, Anthony (ed.) (1992): *Present Tense: Rock & Roll Culture.* Durham, N.C., and London: Duke University Press.

Denisoff, R. Serge (1975): *Solid Gold: The Popular Record Industry.* New Brunswick, N.J.: Transaction Books.

DeRogatis, Jim (2000): *Let It Blurt: The Life and Times of Lester Bangs, America's Greatest Rock Critic.* New York: Broadway Books.

Docker, John (1994): *Postmodernism and Popular Culture: A Cultural History.* Cambridge: University of Cambridge Press.

Draper, Robert (1991): *Rolling Stone Magazine: The Uncensored History.* New York: HarperPerennial.

Eagleton, Terry (1985): *The Function of Criticism: From "The Spectator" to Post-structuralism.* London: Verso.

Eddy, Chuck (1991/1998): *Stairway to Hell: The 500 Best Heavy Metal Albums in the Universe.* New York: Da Capo Press.

Eddy, Chuck (1997): *The Accidental Evolution of Rock 'n' Roll: A Misguided Tour Through Popular Music.* New York: Da Capo Press.

Edelstein, Wolfgang (1988): *Skóli—nám—samfélag* (School—Education—Society). Reykjavík: Idunn.

Eisen, Jonathan (ed.) (1969): *The Age of Rock: Sounds of the American Cultural Revolution,* vol. I. New York: Vintage Books.

Evans, Liz (ed.) (1997): *Girls Will Be Boys: Women Report on Rock.* London: Pandora.

Featherstone, Mike (1991): *Consumer Culture & Postmodernism.* London: Sage.

Feld, Steven and Basso, Keith (eds.) (1996): *Senses of Place.* Santa Fe: School of American Research Press.

Feld, Steven and Keil, Charles (1994): *Music Grooves.* Chicago: University of Chicago Press.

Fenster, Mark and Swiss, Thomas (1999): "Business." In Horner and Swiss (1999).

Finnegan, Ruth (1989): *The Hidden Musicians: Music-making in an English Town.* Cambridge: Cambridge University Press.

Fish, Stanley (1980): *Is There a Text in This Class? The Authority of Interpretive Communities.* Cambridge, Mass. and London: Harvard University Press.

Fiske, John (1993): *Power Plays Power Works.* London: Verso.

Flippo, Chet (1974): "The History of Rolling Stone," parts I–III. *Popular Music and Society,* 3/3 and 3/4.

Flippo, Chet (1991): *Everybody Was Kung-Fu Dancing: Chronicles of the Lionized and the Notorious.* New York: St. Martin's Press.

Fornäs, Johan (1995): *Cultural Theory & Late Modernity.* London: Sage.

Forser, Tomas (2002): *Kritik av kritiken: 1900-talets svenska litteraturkritik* (A Critique of Criticism: 20th-Century Swedish Literary Criticism). Gråbo: Anthropos.

Fox, Aaron (2004): *Real Country. Music, Language, Emotion and Sociability in Texas Working Class Culture.* Durham, N.C.: Duke University Press.

Frith, Simon (1978): *The Sociology of Rock.* London: Constable.

Frith, Simon (1981/1983): *Sound Effects: Youth, Leisure and the Politics of Rock 'n' Roll.* London: Constable.

Frith, Simon (1988): *Music for Pleasure: Essays in the Sociology of Pop.* Cambridge: Polity Press.

Frith, Simon (1991): "The Good, the Bad, and the Indifferent: Defending Popular Culture from the Populists." *Diacritics* 21/4.

Frith, Simon (1996): *Performing Rites: On the Value of Popular Music.* Oxford and New York: Oxford University Press.

Frith, Simon (ed.) (1988): *Facing the Music.* New York: Pantheon Books.

Frith, Simon and Goodwin, Andrew (eds.) (1990): *On Record: Rock, Pop and the Written Word.* London: Routledge.

Frith, Simon and Horne, Howard (1987): *Art into Pop.* London and New York: Routledge.

Frith, Simon and Savage, Jon (1993): "Pearls and Swine. The Intellectuals and the Mass Media." *New Left Review,* 198.

Frow, John (1995): *Cultural Studies and Cultural Value.* Oxford: Clarendon Press.

Gabbard, Krin (1995): "Introduction: The Jazz Canon and its Consequences." In Gabbard (ed.).

Gabbard, Krin (ed.) (1995): *Jazz Among the Discourses.* Durham, N.C., and London: Duke University Press.

Gans, Herbert J. (1974): *Popular Culture and High Culture: An Analysis and Evaluation*. New York: Basic Books.

Gendron, Bernard (1995): "'Mouldy Figs' and Modernists: Jazz at War (1942–1946)." In Gabbard (ed.).

Gendron, Bernard (2003): *Between Montmartre and the Mudd Club: Popular Music and the Avant-Garde*. Chicago and London: University of Chicago Press.

George, Nelson (1986): *Where Did Our Love Go? The Rise & Fall ot the Motown Sound*. London: Omnibus.

George, Nelson (1988): *The Death of Rhythm & Blues*. New York: Plume.

George, Nelson (1992/1994): *Buppies, B-boys, Baps & Bohos: Notes on Post-Soul Black Culture*. New York: HarperPerennial.

George, Nelson (1993): *Urban Romance*. New York: Ballantine Books.

George, Nelson (1998): *Hip Hop America*. New York: Penguin.

George, Nelson (2004): *Post-Soul Nation: The Explosive, Contradictory, Triumphant, and Tragic 1980s as Experienced by African Americans (previously known as blacks and before that negroes)*. New York: Viking.

Giddens, Anthony (1991): *Modernity and Self-Identity*. Cambridge: Polity Press.

Gillett, Charlie (1970): *The Sound of the City*. London: Sphere.

Gilmore, Mikal (1998): *Night Beat: A Shadow History of Rock & Roll*. London: Picador.

Glover, Tony (1998): liner notes in CD booklet, Bob Dylan: *Live 1966*. Columbia C2K 65759.

Goldstein, Richard (1966): *Drugs on Campus*. New York: Walker and Co.

Goldstein, Richard (1969): *Poetry of Rock*. New York: Bantam.

Goldstein, Richard (1970): *Goldstein's Greatest Hits: A Book Mostly About Rock 'n' Roll*. Englewood Cliffs, N.J.: Prentice-Hall.

Goldstein, Richard (1989): *Reporting the Counterculture*. Boston: Unwin Hyman.

Goldstein, Richard (1994): *America at D-Day: A Book of Remembrance*. New York: Delta.

Goldstein, Richard (ed.) (1969): *US: The Paperback Magazine*. New York: Bantam Books.

Goldstein, Richard (ed.) (1997): *Mine Eyes Have Seen: A First-Person-History of the Events That Shaped America*. New York: Simon & Schuster.

Goodman, Fred (1997): *The Mansion on the Hill: Dylan, Young, Geffen, Springsteen, and the Head-on Collision of Rock and Commerce*. New York: Times Books.

Goodwin, Andrew (1991): "Popular Music and Postmodern Theory." *Cultural Studies*, 5/2.

Goodwin, Andrew (1993): *Dancing in the Distraction Factory: Music Television and Popular Culture*. London: Routledge.

Gorman, Paul (2001): *In Their Own Write: Adventures in the Music Press*. London: Sanctuary.

Gottlieb, Robert (ed.) (1996): *Reading Jazz*. New York: Pantheon Books.

Green, Jonathon (1998): *All Dressed Up: The Sixties and the Counterculture*. London: Jonathan Cape.

Grossberg, Lawrence (1992a): *We Gotta Get Out of This Place: Popular Conservatism and Postmodern Culture*. New York: Routledge.

Grossberg, Lawrence (1992b): "Is There a Fan in This House? The Affective Sensibility of Fandom." In Lewis, Lisa A., (ed.) (1992): *The Adoring Audience*. London and New York: Routledge.

Gudmundsson, Gestur (1999): "To Find Your Voice in a Foreign Language: Authenticity and Reflexivity in the Anglocentric World of Rock." *Young*, 7/2.

Guralnick, Peter (1971/1981): *Feel Like Going Home: Portraits in Blues & Rock 'n' Roll*. New York: Vintage Books.

Guralnick, Peter (1994): *Last Train to Memphis: The Rise of Elvis Presley*. London: Abacus.

Guralnick, Peter (1999): *Careless Love: The Unmaking of Elvis Presley*. London: Little, Brown & Company.

Habermas, Jürgen (1962/1989): *The Structural Transformation of the Public Sphere: An Inquiry into a Category of Bourgeois Society*. Cambridge, Mass.: MIT Press.

Habermas, Jürgen (1981–1984/1988): *The Theory of Communicative Action*, vols. I–II. Cambridge: Polity Press.

Hall, Stuart and Jefferson, Tony (eds.) (1975): *Resistance Through Rituals: Youth Subcultures in Post-War Britain*. Birmingham: Centre for Contemporary Cultural Studies.

Hall, Stuart and duGay, Paul (eds.) (1996): *Questions of Cultural Identity*. London: Sage.

Hannerz, Ulf (1992): *Cultural Complexity: Studies in the Social Organization of Meaning*. New York: Columbia University Press.

Hannerz, Ulf (1996): *Transnational Connections: Culture, People, Places*. London and New York: Routledge.

Harris, Wendell V. (1992): *Dictionary of Concepts in Literary Criticism and Theory*. New York, Westport, Conn., and London: Greenwood.

Hebdige, Dick (1979): *Subculture: The Meaning of Style*. London: Methuen.

Hebdige, Dick (1987): "The Impossible Object. Towards a Sociology of the Sublime." *New Formations*, 1/1.

Hebdige, Dick (1988): "The Bottom Line on Planet One. Squaring up to *The Face*." In Hebdige, Dick (1989): *Hiding in the Light: On Images and Things*. London and New York: Routledge.

Herrnstein Smith, Barbara (1987): *Contingencies of Value: Alternative Perspectives for Critical Theory*. Cambridge and London: Harvard University Press.

Heylin, Clinton (ed.) (1992): *The Penguin Book of Rock & Roll Writing*. London: Viking.

Hibbert, Tom (1994): *Best of Q: Who the Hell...?* London: Virgin Books.

Hill, Dave (1991): "Rock Journalists and How to Use Them." In York, Norton (ed.) (1991): *The Rock File: Making It in the Music Business*. Oxford: Oxford University Press.

Horkheimer, Max and Adorno, Theodor W. (1944/1979): *Dialectic of Enlightenment*. London: Verso.

Hornby, Nick (1996): *High Fidelity*. London: Indigo.

Horner, Bruce and Swiss, Thomas (eds.) (1999): *Key Terms in Popular Music and Culture*. Malden, Mass., and Oxford: Blackwell.

Hoskyns, Barney (ed.) (2003): *The Sound and the Fury: A Rock's Backpages Reader—40 Years of Classic Rock Journalism*. London: Bloomsbury.

Hoy, Mikita (1992): "Bakhtin and Popular Culture." *New Literary History*, 23.

Huyssen, Andreas (1986): *After the Great Divide: Modernism, Mass Culture and Postmodernism*. London: McMillan.

Huyssen, Andreas (2002): "High/Low in an Expanded Field." *Modernism/Modernity* 9:3 (also: http://muse.jhu.edu/journals/modernism-modernity/v009/9.3huyssen.html, 363–374).

Jameson, Fredric (1991): *Postmodernism, or the Cultural Logic of Late Capitalism*. London: Verso.

Jasper, Tony (comp.) (1986): *Great Rock and Pop Headlines*. London: Willow Books.

Jewell, Derek (1980): *The Popular Voice: A Musical Record of the 60s and 70s*. London: Andre Deutsch.

Jones, Allan (ed.) (1994): *Melody Maker Classic Rock Interviews*. London: Mandarin.

Jones, Dylan (1996): "Introduction." In Jones (ed.) (1996).

Jones, Dylan (ed.) (1996): *Meaty, Beaty, Big & Bouncy!: Classic Rock Writing from Elvis to Oasis.* London: Hodder & Stoughton.

Jones, Nick (1965/1995): "Well, What is Pop Art?" In Kureishi and Savage (eds.) (1995).

Jones, Steve (1992): "Re-viewing Rock Writing. The Origins of Popular Music Criticism." *American Journalism*, winter/spring 1992–1993.

Jones, Steve (1993): "Popular Music, Criticism, Advertising and the Music Industry." *Journal of Popular Music Studies*, 5.

Jones, Steve (ed.) (2002): *Pop and the Press.* Philadelphia: Temple University Press.

Jørholt, Eva, (ed.) (1998): *Ind i filmen* (Into Film). København: Medusa.

Jørgensen, John Christian (1971): *Literær vurderingteori og vurderingsanalyse: En introduktion* (Literary Evaluation Theory and Evaluation Analysis: An Introduction). København: Borgen.

Kallioniemi, Kari (1998): *"Put the Needle on the Record and Think of England": Notions of Englishness in the Post-War Debate on British Pop Music.* Turku: University of Turku.

Kant, Immanuel (1790/1987): *Critique of Judgment (Kritik der Urteilskraft).* Indianapolis and Cambridge: Hackett.

Keightley, Keir (2001): "Reconsidering Rock." In Frith, Simon, Straw, Will and Street, John (eds.): *The Cambridge Companion to Rock and Pop.* Cambridge: Cambridge University Press.

Keil, Charles (1966/1991): *Urban Blues.* Chicago: University of Chicago Press.

Kelly, Karen and McDonnell, Evelyn (1999): *Stars Don't Stand Still in the Sky: Music and Myth.* London: Routledge.

Kent, Nick (1994): *The Dark Stuff: Selected Writings on Rock Music 1972–1993.* London: Penguin.

Kofsky, Frank (1998): *Black Music, White Business: Illuminating the History and Political Economy of Jazz.* New York: Pathfinder.

Kureishi, Hanif and Savage, Jon (eds.) (1995): *The Faber Book of Pop.* London and Boston: Faber & Faber.

Laermans, Rudi (1992): "The Relative Rightness of Pierre Bourdieu: Some Sociological Comments on the Legitimacy of Postmodern Art, Literature and Culture." *Cultural Studies*, 6/2.

Laing, Dave (1985): *One Chord Wonders: Power and Meaning in Punk Rock.* Milton Keynes: Open University Press.

Landau, Jon (1972): *It's Too Late To Stop Now: A Rock and Roll Journal.* San Francisco: Straight Arrow Books.

Lanza, Joseph (1995): *Elevator Music: A Surreal History of Muzak, Easy Listening and Other Moodsong.* London: Quartet Books.

Larkin, Colin (ed.) (1995): *The Guinness Encyclopedia of Popular Music.* London: Guinness Publications.

Lennon, John (1964): *In His Own Write.* London: Jonathan Cape.

Lennon, John (1965): *Spaniard in the Works.* London: Jonathan Cape.

Levine, Lawrence M. (1988): *Highbrow/Lowbrow.* Cambridge, Mass.: Harvard University Press.

Lewis, Roger (1972): *Outlaws of America: The Underground Press and Its Context.* London: Heinrich Hanau Publications.

Lewisohn, Mark (1992): *The Complete Beatles Chronicle.* London: Pyramid Books.

Lindberg, Ulf, Gudmundsson, Gestur, Michelsen, Morten and Weisethaunet, Hans (2000): *Amusers, Bruisers & Cool-Headed Cruisers: The Fields of Anglo-Saxon and Nordic Rock Criticism.* Århus: Department of Scandinavian Studies, University of Århus.

Linneberg, Arild (1994): *Bastardforsøk* (Bastard Attempts). Oslo: Gyldendal.

Lipsitz, George (1994): *Dangerous Crossroads: Popular Music, Postmodernism and the Poetics of Place*. London: Verso.

Lydon, Michael (1971/1990): *Rock Folk: Portraits from the Rock 'n' Roll Pantheon*. New York: Citadel Underground.

MacDonald, Ian (1994): *Revolution in the Head: The Beatles' Records and the Sixties*. London: Fouth Estate.

Manuel, Peter (1993): *Cassette Culture: Popular Music and Technology in North India*. Chicago: University of Chicago Press.

Marcus, Greil (1969): "Who Put the Bomp in the Bomp De-Bomp De-Bomp?" In Marcus (ed.).

Marcus, Greil (1975/1991): *Mystery Train: Images of America in Rock 'n' Roll Music*. London: Penguin Books.

Marcus, Greil (1990/1997): *Lipstick Traces: A Secret History of the Twentieth Century*. London: Picador.

Marcus, Greil (1993): *Ranters & Crowd Pleasers: Punk in Pop Music, 1977–92*. New York: Doubleday.

Marcus, Greil (1995): *The Dustbin of History*. Boston: Harvard University Press.

Marcus, Greil (1997): *Invisible Republic: Bob Dylan's Basement Tapes*. London: Picador.

Marcus, Greil (ed.) (1969): *Rock and Roll Will Stand*. Boston: Beacon Press.

Marcus, Greil (ed.) (1979/1996): *Stranded: Rock and Roll for a Desert Island*. New York: DaCapo Press.

Marcuse, Herbert (1955/1969): *Eros and Civilization*. London: Sphere Books.

Marcuse, Herbert (1969): *An Essay on Liberation*. London: Allan Lane/Penguin Press.

Marcuse, Herbert (1972): *Counterrevolution and Revolt*. Boston: Beacon Press.

Marmer, Nancy (1966): "Pop Art in California." In Lippard, Lucy R. (ed.) (1966): *Pop Art*. London: Thames and Hudson.

Marsh, Dave (1979): *Born to Run: The Bruce Springsteen Story*. New York: Delilah.

Marsh, Dave (1983): *Before I Get Old: The Story of the Who*. London: Plexus.

Marsh, Dave (1985): *Fortunate Son: Criticism and Journalism by America's Best-known Rock Writer*. New York: Random House.

Marsh, Dave (1987): *Glory Days: Bruce Springsteen in the 1980s*. New York: Pantheon Books.

Marsh, Dave (1989): *The Heart of Rock & Soul: The 1001 Greatest Singles Ever Made*. New York: New American Library.

Martin, Christopher (1993): "Traditional Criticism of Popular Music and the Making of a Lip-synching Scandal." *Popular Music and Society*, 17/4.

Marx, Karl (1845/1932): *Die deutsche Ideologie* (The German Ideology). Berlin: Dietz Verlag.

Marx, Karl (1857/1939–1941): *Grundrisse der Kritik der Politischen Ökonomie* (Foundations of the Critique of Political Economy). Berlin: Dietz Verlag.

Mazullo, Mark (1997): "Fans and Critics: Greil Marcus's Mystery Train as Rock 'n' Roll History." *The Musical Quarterly*, 81/2.

McDonnell, Evelyn (1995): "The Feminine Critique: The Secret History of Women and Rock Journalism." In McDonnell and Powers (eds.).

McDonnell, Evelyn and Powers, Ann (eds.) (1995): *Rock She Wrote: Women Write about Rock, Pop, and Rap*. New York: Delta Books.

McHale, Brian (1992): *Constructing Postmodernism*. London and New York: Routledge.

McLeod, Kembrew (2002): "Between Rock and a Hard Place: Gender and Rock Criticism." In Jones (ed.).

McLeod, Kembrew (2002): "The Politics and History of Hip Hop Criticism." In Jones (ed.).

McLuhan, Marshall (1964): *Understanding Media: The Extensions of Man*. New York: McGraw-Hill.

McRobbie, Angela (1989): "Introduction." In McRobbie (ed.).

McRobbie, Angela (1999): *In the Culture Society: Art, Fashion and Popular Music*. London and New York: Routledge.

McRobbie, Angela (ed.) (1989): *Zoot Suits and Second-Hand Dresses: An Anthology of Fashion*. London: McMillan.

Mellers, Wilfrid (1968): *Caliban Reborn: Renewal in Twentieth-Century Music*. London: Gollancz.

Mellers, Wilfrid (1973): *Twilight of the Gods: The Beatles in Retrospect*. London: Faber.

Melly, George (1970): *Revolt into Style: The Pop Arts in Britain*. London: Penguin.

Meltzer, Richard (1970): *The Aesthetics of Rock*. New York: Something Else Press.

Michelsen, Morten (1993): *Autenticitetsbegrebets historie med særlig henblik på dets status i rockmusikkens æstetik* (The History of the Concept of Authenticity with Specific Regard to Its Status in the Aesthetic of Rock). København: University of Copenhagen.

Middleton, Richard (1990): *Studying Popular Music*. Milton Keynes and Philadelphia: Open University Press.

Miller, Jim (ed.) (1976/1980/1992): *The Rolling Stone Illustrated History of Rock & Roll*. New York: Rolling Stone Press.

Mitchell, Tony (1996): *Popular Music and Local Identity: Rock, Pop and Rap in Europe and Oceania*. London and New York: Leicester University Press.

Mørch, Søren (1996): *Den sidste Danmarkshistorie* (The Last History of Denmark). København: Gyldendal.

Morley, Paul (1986): *Ask: The Chatter of Pop*. London: Faber & Faber.

Morley, Paul (1997): *77: A Story of Punk*. London: Hodder & Stoughton.

Morley, Paul (2000): *Nothing*. London: Faber.

Morley, Paul (2003): *Words and Music: A History of Pop in the Shape of a City*. London: Bloomsbury.

Morthland, John (ed.) (2003): *Mainlines, Blood Feasts and Bad Taste: A Lester Bangs Reader*. London: Serpent's Tail.

Murray, Charles Shaar (1989): *Crosstown Traffic: Jimi Hendrix and the Rock 'n' Roll Revolution*. New York: St. Martin's Press.

Murray, Charles Shaar (1991): *Shots from the Hip*. London: Penguin.

Murray, Charles Shaar (1992): "What Have They Done to My Blues, Ma?" In Heylin (ed.).

Murray, Charles Shaar (1999): *Boogie Man: The Adventures of John Lee Hooker in the American 20th Century*. London: Viking.

Negt, Oskar and Kluge, Alexander (1972/1993): *The Public Sphere and Experience*. Minneapolis: University of Minnesota Press.

Negus, Keith (1992): *Producing Pop: Culture and Conflict in the Popular Music*. London: Edward Arnold.

Negus, Keith (1996): *Popular Music in Theory*. Hanover, N.H.: University Press of New England.

Negus, Keith (1999): *Music Genres and Corporate Cultures*. London: Routledge.

Nehring, Neil (1997): *Popular Music, Gender, and Postmodernism: Anger is an Energy*. Thousand Oaks, Calif., and London: Sage.

Neville, Richard (1971): *Play Power*. London: Paladin.

Nowell, William Robert, III (1987): *The Evolution of Rock Journalism at the New York Times and the Los Angeles Times, 1956–1978: A Frame Analysis*. Bloomington: Indiana University (Ph.D. dissertation).

Nuttall, Jeff (1968): *Bomb Culture*. London: MacGibbon & Kee.

Oliver, Paul (1960): *Blues Fell This Morning*. London: Cassell & Company Ltd.

Osgerby, Bill (1998): *Youth in Britain Since 1945*. Oxford: Blackwell.

Palmer, Robert (1996): *Dancing in the Street: A Rock and Roll History*. London: BBC Books.

Panassié, Hugues (1934/1936): *Hot Jazz: The Guide to Swing Music*. London: Cassell.

Pareles, Jon and Romanowski, Jill (eds.) (1983/1995/2001): *The Rolling Stone Encyclopedia of Rock & Roll*. New York: Rolling Stone Press/Summit Books.

Parsons, Tony (1995): *Dispatches from the Front Line of Popular Culture*. London: Virgin.

Pattison, Robert (1987): *The Triumph of Vulgarity: Rock Music in the Mirror of Romanticism*. New York and Oxford: Oxford University Press.

Peck, Abe (1985): *Uncovering the Sixties: The Life and Times of the Underground Press*. New York: Pantheon Press.

Penman, Ian (1998): *Vital Signs: Music, Movies and Other Manias*. London: Serpent's Tail.

Perry, Mark (2000): *Sniffin' Glue: The Essential Punk Accessory*. London: Sanctuary.

Petersen, Karen (2000): "Popmodernisme: Æstetiske overvindelser i populærmusikken" (Pop Modernism: Aesthetic Transgressions in Popular Music). *Æstetikstudier*, 8.

Ping Huang, Marianne (1998): "Anmeldelsens kritik: Kritikkens profil" (The Criticism of the Review: The Profile of Criticism). *Fantomtidsskrift*.

Plant, Sadie (1992): *The Most Radical Gesture: The Situationist International in a Postmodern Age*. London and New York: Routledge.

Powers, Ann (1993/1995): "Houses of the Holy" (review). In McDonnell and Powers (eds.) (1995).

Powers, Ann (1995): "Who's That Girl?" In McDonnell and Powers (eds.) (1995).

Powers, Ann (2000): *Weird Like Us: My Bohemian America*. New York: Simon & Schuster.

Radway, Janice (1974/1991): "Interpretive Communities and Variable Literacies. The Function of Romance Reading." In Mukerji, Chandra and Schudson, Michael (eds.) (1991): *Rethinking Popular Culture: Contemporary Perspectives in Cultural Studies*. Berkeley: University of California Press.

Radway, Janice (1984): *Reading the Romance: Women, Patriarchy and Popular Literature*. London and New York: Verso.

Reeh, Henrik (1988): "Billede, sprog, begreb: Walter Benjamins hash-overvejelser" (Picture, Language, Concept: Walter Benjamin's Reflections on Hash). *Alkoholpolitik: Tidsskrift for Nordisk Alkoholforskning*, 5/1.

Regev, Motti (1994): "Producing Artistic Value: The Case of Rock Music." *Sociological Quarterly*, 35/1.

Regev, Motti (1997): "Rock Aesthetics and Musics of the World." *Theory, Culture and Society*, 14/3.

Reynolds, Simon (1990): *Blissed Out: The Raptures of Rock*. London: Serpent's Tail.

Reynolds, Simon (1998): *Energy Flash: A Journey Through Rave Music and Dance Culture*. London: Picador.

Reynolds, Simon and Press, Joy (1995): *The Sex Revolts: Gender, Rebellion and Rock 'n' Roll*. London: Serpent's Tail.

Riesman, David (1950/1990): "Listening to Popular Music." In Frith and Goodwin (eds.).

Robinson, Deanna Campell, Buck, Elizabeth B., Cuthbert, Marlene (1991): *Music at the Margins: Popular Music and Global Cultural Diversity*. London: Sage.

Rockwell, John (1983/1996): *All American Music: Composition in the Late Twentieth Century*. New York: Da Capo Press.

Roe, Keith (1993): "Academic Capital and Music Tastes Among Swedish Adolescents." *Young*, 1/3.

Roe, Keith and Carlsson, Ulla (eds.) (1990): *Popular Music Research*. Göteborg: Nordicom-Sweden.

Rose, Tricia (1994): *Black Noise: Rap Music and Black Culture in Contemporary America*. Hanover, N.H., and London: Wesleyan University Press.

Ross, Andrew (1989): *No Respect: Intellectuals and Popular Culture*. New York and London: Routledge.

Sarris, Andrew (1968): *The American Cinema: Directors and Directions, 1929–1968*. New York: Dutton.

Savage, Jon (1984): *The Kinks: The Official Biography*. London: Faber & Faber.

Savage, Jon (1991): *England's Dreaming: Sex Pistols and Punk Rock*. London and Boston: Faber & Faber.

Savage, Jon (1995): "The Simple Things You See Are All Complicated." In Kureishi and Savage (eds.).

Savage, Jon (1996): *Time Travel: Pop, Media and Sexuality 1976–96*. London: Chatto & Windus.

Schumacher, Michael (1998): *Crossroads: The Life and Music of Eric Clapton*. London: Warner Books.

Shapiro, Harry (1996): *Alexis Korner: The Biography*. London: Bloomsbury Publishing.

Shelton, Robert (1987): *No Direction Home: The Life and Music of Bob Dylan*. New York: Ballantine Books.

Shuker, Roy (1994): *Understanding Popular Music*. London and New York: Routledge.

Shuker, Roy (1998): *Key Concepts in Popular Music*. London: Routledge.

Smith, Eric Von and Rooney, Jim (1979): *Baby Let Me Follow You Down: The Illustrated Story of the Cambridge Folk Years*. New York: Anchor Press.

Smith, Patti (1974/1995): "Masked Brawl" (review). In McDonnell and Powers (eds.) (1995).

Sontag, Susan (1964): "Notes on Camp." In Sontag, Susan (1969/1990): *Against Interpretation and Other Essays*. New York: Anchor Books.

Spencer, Neil (1991): "Introduction." In Murray (1991).

Stallybrass, Peter and White, Allon (1986): *The Politics and Poetics of Transgression*. Ithaca, N.Y., and New York: Cornell University Press.

Stjernfelt, Fredrik (1998): "Højrøvet men god—den akademiske kritik" (Highbrow but Good—Academic Criticism). *Fantomtidsskift*.

Stokes, Martin (ed.) (1994): *Ethnicity, Identity and Music: The Musical Construction of Place*. Oxford: Berg Publishers.

Stratton, Jon (1982): "Between Two Worlds. Art and Commercialism in the Record Industry." *The Sociological Review*, 30.

Straw, Will (1991): "Systems of Articulation, Logics of Change: Communities and Scenes in Popular Music." *Cultural Studies* 5:3.

Sullivan, Caroline (1995): "The Joy of Hacking: Women Rock Critics." In Cooper.

Tadday, Ulrich (1993): *Die Anfänge des Musikfeuilletons: Das kommunikative Gebrauchswert musikalischer Bildung in Deutschland um 1800* (The Beginnings of the Music Magazine: The Communicative Use Value Among the Musically Educated in Germany Around 1800). Stuttgart and Weimar: Metzler.

Tadday, Ulrich (1997): "Musikkritik." In Finscher, Ludwig (ed.) (1997): *Musik in Geschichte und Gegenwart*, 6. Kassel and Stuttgart: Bärenreiter & Metzler.

Tagg, Philip (1982): "Analysing Popular Music: Theory, Method and Practice." *Popular Music (Theory and Method)*, 2.

Taylor, Timothy D. (1997): *Global Pop: World Music, World Market*. London: Routledge.

Thavenius, Jan (1995): *Den motsägelsesfulla bildningen* (The Contradictions of *Bildung*). Stockholm and Stehag: Brutus Östlings Bokförlag Symposion.

Thébèrge, Paul (1991): "Musicians' Magazines in the 1980s: The Creation of a Community and a Consumer Market." *Cultural Studies*, 5/3.

Thomson, Elizabeth and Gutman, David (1987): *The Lennon Companion: Twenty-five Years of Comment*. New York: Schirmer Books.

Thompson, Ben (1998): *Seven Years of Plenty: A Handbook of Irrefutable Pop*. London: Victor Gollancz.

Thompson, Hunter S. (1972): *Fear and Loathing in Las Vegas*. San Francisco: Straight Arrow Books.

Thompson, Hunter S. (1973): *Fear and Loathing on the Campaign Trail*. San Francisco: Straight Arrow Books.

Thompson, Hunter S. (1980): *The Great Shark Hunt: Strange Tales from a Strange Time*. London: Picador.

Thorburn, David (1989): "Series Editor's Introduction." In Goldstein.

Thornton, Sarah (1990): "Strategies for Reconstructing the Popular Past." *Popular Music*, 9/1.

Thornton, Sarah (1995): *Club Cultures: Music, Media and Subcultural Capital*. Cambridge: Polity Press.

Tocqueville, Alexis de (1835–1840/1990): *Democracy in America*, vol. 2. New York: Vintage Books.

Toop, David (1984/1991/2000): *Rap Attack # 3*. London: Serpent's Tail.

Toop, David (1995): *Ocean of Sound*. London: Serpent's Tail.

Toop, David (1999): *Exotica: Fabricated Landscapes in a Real World*. London: Serpent's Tail.

Tosches, Nick (1984/1991): *Unsung Heroes of Rock 'n' Roll: The Birth of Rock in the Wild Years Before Elvis*. London: Secker & Warburg.

Toynbee, Jason (1993): "Policing Bohemia, Pinning up the Grunge: The Music Press and Generic Change in British Pop and Rock." *Popular Music*, 12/3.

Trondman, Mats (1990): "Rock Taste. On Rock as Symbolic Capital. A Study of Young People's Music Taste and Music Making." In Roe and Carlsson (eds.).

Walser, Robert (1993): "Out of Notes. Signification, Interpretation, and the Problem of Miles Davis." *Musical Quarterly*, 77.

Walser, Robert (ed.) (1999): *Keeping Time: Readings in Jazz History*. New York: Oxford University Press.

Walser, Robert and McClary, Susan (1988/1990): "Start Making Sense! Musicology Wrestles with Rock." In Frith and Goodwin (eds.).

Ward, Ed, Stokes, Geoffrey and Tucker, Ken (1986): *Rock of Ages: The Rolling Stone History of Rock & Roll*. New York: Rolling Stone Press/Summit Books.

Weinstein, Deena (1991): *Heavy Metal: A Cultural Sociology*. New York: Lexington Books.

Weisbard, Eric (2004): *This Is Pop: In Search of the Elusive at Experience Music Project*. Cambridge: Harvard University Press.

Welch, Chris (1972): *Hendrix: A Biography by Chris Welch*. London: Ocean Books.

Welch, Chris (1986/1994): *The Tina Turner Experience: The Illustrated Biography*. London: Virgin Books.

Welch, Chris (1989): *Steve Winwood: Roll with It*. New York: Omnibus Press.

Welch, Chris (1994): *Cream: Strange Brew*. Surrey: Castle Communications.

Wenner, Jann (1981): "Interview with John Lennon." In Rolling Stone Editors (1981): *The Rolling Stone Interviews 1967–1980: Talking with the Legends of Rock & Roll*. London: Arthur Barker.

White, Timothy (1983): *Catch a Fire: The Life of Bob Marley*. New York: Holt, Rinehart and Winston.

White, Timothy (1984): *Rock Stars*. New York: Stewart, Tabori & Chang.

White, Timothy (1990): *Rock Lives: Profiles & Interviews*. New York: Henry Holt.

White, Timothy (1994): *The Nearest Faraway Place: Brian Wilson, the Beach Boys, and the Southern California Experience*. New York: Henry Holt.

White, Timothy (1996): *Music to My Ears: The Billboard Essays—Profiles of Popular Music in the '90s*. New York: Henry Holt.

White, Timothy (1998): *The Entertainers*. New York: Billboard Books.

Whiteley, Sheila (1992): *The Space Between the Notes: Rock and the Counterculture*. London: Routledge.

Whiting, Cecile (1997): *A Taste for Pop: Pop Art, Gender, and Consumer Culture*. Cambridge: Cambridge University Press.

Williams, Paul (1969): *Outlaw Blues: A Book of Rock*. New York: E.P. Dutton.

Williams, Paul (1973): *Das Energi*. Encinitas, Calif.: Entwhistle Books.

Williams, Paul (1984): *Waking up Together*. Encinitas, Calif.: Entwhistle Books.

Williams, Paul (1986): *Only Apparently Real: The World of Philip K. Dick*. New York: Arbor House.

Williams, Paul (1987): *Remember Your Essence*. Encinitas, Calif.: Entwhistle Books.

Williams, Paul (1988): *The Map: Rediscovering Rock and Roll (A Journey)*. South Bend, Ind.: And Books.

Williams, Paul (1990/1994): *Bob Dylan: Performing Artist—Vol. 1*. London: Omnibus Press.

Williams, Paul (1992): *Bob Dylan: Performing Artist—The Middle Years*. London: Omnibus Press.

Williams, Paul (1996): *Bob Dylan: Watching the River Flow—Observations on His Art-in-Progress 1966–1995*. London: Omnibus Press.

Williams, Paul (1997a): *Brian Wilson & The Beach Boys: How Deep is the Ocean?* London: Omnibus Press.

Williams, Paul (1997b): *Neil Young: Love to Burn*. London: Omnibus Press.

Williams, Paul (2000): *The 20th Century's Greatest Hits*. New York: Forge.

Williams, Raymond (1977): *Marxism and Literature*. Oxford: Oxford University Press.

Willis, Ellen (1981/1992): *Beginning to See the Light: Pieces of a Decade*. New York: Alfred E. Knopf.

Wilmot, Richard (1985): "Euphoria." *Journal of Drug Issues*, spring 1985.

Wolfe, Tom (1965/1992): "The First Tycoon of Teen." In Heylin (ed.).

Wolfe, Tom (1968): *The Pump House Gang*. New York: Farrar, Straus & Giroux.

Wolfe, Tom (1973/1990): "The New Journalism." In Wolfe and Johnson (eds.).

Wolfe, Tom and Johnson, E.W. (eds.) (1973/1990): *The New Journalism*. London and Basingstroke: Picador.

Wollen, Peter (1989): "The Situationist International." *New Left Review*, 174.

Wood, Scott (1997): "Talk Eddy to Me. The World's Most Iconoclastic Rock Critic Speaks Out" (interview with Chuck Eddy). http://popped.com/articles96-97/talkeddy/index.html, downloaded 2/8/99.

Zanes, Warren J. (1999): "Too Much Mead? Under the Influence (of Participant-Observation)." In Dettmar, Kevin J. H. and Richey, William (eds.) (1999): *Reading Rock and Roll: Authenticity, Appropriation, Aesthetics*. New York: Columbia University Press.

Ziehe, Thomas (1975): *Pubertät und Narzissmus* (Puberty and Narcissism). Frankfurt am Main: Europäische Verlagsanstalt.

Ziehe, Thomas (1989): *Kulturanalyser: ungdom, utbilding, modernitet* (Cultural Analyses: Youth, Education, Modernity). Stockholm and Stehag: Symposion.

Ziehe, Thomas and Stubenrauch, Herbert (1982): *Plädoyer für ungewöhnliches Lernen: Ideen zur Jugendsituation* (A Plea for Uncommon Learning: Some Ideas on the Situation of Youth). Reinbek bei Hamburg: Rowolt.

Interviews

Charlesworth, Chris (telephone interview, London, December 9, 1998). Interviewed by Hans Weisethaunet.

Christgau, Robert (New York, May 22, 1998). Interviewed by Ulf Lindberg.

Christgau, Robert (Bergen, Norway, February 15, 2004). Interviewed by Hans Weisethaunet.

Christgau, Robert (Seattle, April 17, 2004). Interviewed by Hans Weisethaunet.

Gehr, Richard (New York City, June 23, 1999). Interviewed by Morten Michelsen.

Herrington, Tony (London, January 22, 1999). Interviewed by Morten Michelsen.

Marcus, Greil (Seattle, April 17, 2004). Interviewed by Hans Weisethaunet.

Marsh, Dave (Norwalk, Conn., November 22, 1999). Interviewed by Gestur Gudmundsson.

Powers, Ann (Seattle, April 18, 2004). Interviewed by Hans Weisethaunet.

Reynolds, Simon (New York City, June 21, 1999). Interviewed by Morten Michelsen.

Welch, Chris (telephone interview, London, December 9, 1998). Interviewed by Hans Weisethaunet.

Welch, Chris (London, January 20, 1999). Interviewed by Hans Weisethaunet.

Williams, Paul (telephone interview, Encintas, Calif., November 24, 1998). Interviewed by Hans Weisethaunet.

Index

General Editor: **Steve Jones**

Digital Formations is an essential source for critical, high-quality books on digital technologies and modern life. Volumes in the series break new ground by emphasizing multiple methodological and theoretical approaches to deeply probe the formation and reformation of lived experience as it is refracted through digital interaction. **Digital Formations** pushes forward our understanding of the intersections—and corresponding implications—between the digital technologies and everyday life. The series emphasizes critical studies in the context of emergent and existing digital technologies.

Other recent titles include:

Felicia Wu Song
 Virtual Communities: Bowling Alone, Online Together

Edited by Sharon Kleinman
 The Culture of Efficiency: Technology in Everyday Life

Edward Lee Lamoureux, Steven L. Baron, & Claire Stewart
 Intellectual Property Law and Interactive Media: Free for a Fee

Edited by Adrienne Russell & Nabil Echchaibi
 International Blogging: Identity, Politics and Networked Publics

Edited by Don Heider
 Living Virtually: Researching New Worlds

Edited by Judith Burnett, Peter Senker & Kathy Walker
 The Myths of Technology: Innovation and Inequality

Edited by Knut Lundby
 Digital Storytelling, Mediatized Stories: Self-representations in New Media

Theresa M. Senft
 Camgirls: Celebrity and Community in the Age of Social Networks

Edited by Chris Paterson & David Domingo
 Making Online News: The Ethnography of New Media Production

To order other books in this series please contact our Customer Service Department:
(800) 770-LANG (within the US)

(212) 647-7706 (outside the US)
(212) 647-7707 FAX

To find out more about the series or browse a full list of titles, please visit our website:
WWW.PETERLANG.COM